ADOBE® CAMERA RAW FOR DIGITAL PHOTOGRAPHERS ONLY, 2ND EDITION

Rob Sheppard

WILEY

Wiley Publishing, Inc.

Adobe® Camera Raw For Digital Photographers Only, 2nd Edition

Published by
Wiley Publishing, Inc.
10475 Crosspoint Boulevard
Indianapolis, IN 46256
www.wiley.com

Copyright © 2008 by Wiley Publishing, Inc., Indianapolis, Indiana

Published by Wiley Publishing, Inc., Indianapolis, Indiana

Published simultaneously in Canada

ISBN: 978-0-470-22457-1

Manufactured in the United States of America

10 9 8 7 6 5 4 3 2 1

For general information on our other products and services or to obtain technical support, please contact our Customer Care Department within the U.S. at (800) 762-2974, outside the U.S. at (317) 572-3993 or fax (317) 572-4002.

Wiley also publishes its books in a variety of electronic formats. Some content that appears in print may not be available in electronic books.

Library of Congress Control Number: 2007942429

about the author

Rob Sheppard has been a long-time photographer working in publications and for businesses for over 30 years. He is also the author/photographer of over 20 books, an internationally known speaker and workshop leader, and was the editor of the prestigious *Outdoor Photographer* magazine for twelve years (he is now editor-at-large).

Sheppard has had a long-time and nationally recognized commitment to helping photographers connect with digital imaging technology. He was one of the small group of people who started *PCPhoto* magazine 10 years ago to bring the digital world to photographers on their terms. He was the first editor of *PCPhoto* while also editing *Outdoor Photographer*.

As author/photographer, Sheppard wrote and photographed some of the first books for photographers to understand digital photography, including the *Computer Photography Handbook* in 1998. He has written hundreds of articles about photography and nature, plus a wide range of books, from guides to photography such as the *PCPhoto Digital SLR Handbook* and the *National Geographic Field Guide to Digital Photography* to books about Photoshop including *Outdoor Photographer Landscape and Nature Photography with Photoshop CS2* and *Adobe Photoshop Lightroom for Digital Photographers Only*.

As a photographer, Sheppard worked for many years in Minnesota (before moving to Los Angeles), including doing work for the Minnesota Department of Transportation, Norwest Banks (now Wells Fargo), Pillsbury, 3M, General Mills, Lutheran Brotherhood, Ciba-Geigy, Andersen Windows, and others. His photography has been published in many magazines, ranging from *National Geographic* to *The Farmer* to, of course, *Outdoor Photographer* and *PCPhoto*.

He also writes a digital photography column in *Outdoor Photographer* called Digital Horizons, has consulted for a number of publications regarding digital photography (including National Geographic) and teaches around the country, such as workshops for the Palm Beach Photographic Centre, Santa Fe Workshops, and the Great American Photography Workshop group. His Web site for photo tips, plus workshop and book information, is at www.robshepppardphoto.com.

credits

Senior Acquisitions Editor
Kim Spilker

Senior Project Editor
Cricket Krengel

Technical Editor
Mark Comon

Copy Editor
Lauren Kennedy

Editorial Manager
Robyn Siesky

Business Manager
Amy Knies

Vice President & Executive Group Publisher
Richard Swadley

Vice President & Publisher
Barry Pruett

Senior Marketing Manager
Sandy Smith

Book Designer
LeAndra Hosier

Project Coordinator
Lynsey Stanford

Graphics and Production Specialists
Andrea Hornberger
Jennifer Mayberry
Ronald Terry

Quality Control Technicians
John Greenough
Dwight Ramsey

Proofreading
Broccoli Information Management

Indexing
Becky Hornyak

*This book is dedicated to my really terrific workshop students
who have taught me much about how to communicate all things digital
to photographers; and I must include my very supportive wife and two kids
who have really made my work possible.*

foreword

As pilgrim photographers, we see a lot of beautiful locations and meet many people. Meeting some people is like finding a precious gem; Rob Sheppard has been that kind of discovery for me.

Rob is a talented writer, technician and photographer as you will soon discover in this book! He truly cares about photographers learning and applying his teaching to real world application. His genuine concern for his students is what makes him such a gifted photo educator.

What you won't learn from this book is what a terrific person he is. I've had the pleasure of working with Rob on a number of occasions, and he is always a joy to spend time with in the field and in classroom.

Take the time to slowly and carefully work through this text and his teaching examples, and you will discover exciting information about both Adobe Photoshop Camera Raw and about taking pictures that will take you beyond simply understanding software. He will help you to become a better photographer than ever before. If you ever have the opportunity to take a class or workshop with Rob, you, too, can get to know the man behind the books and images!

I hope you enjoy this book as much as I've enjoyed counting Rob a friend!

~ Bill Fortney
 Photographer/author of *America from 500 Feet* I and II
 CEO of the Great American Photography Workshops

acknowledgments

Any book takes a lot of work to complete. The writing and photography go through multiple editors and technical people. I owe them all much thanks. I especially thank editor Cricket Krengel who has really been a huge help throughout the editing process and keeps my words in line. I also thank Kim Spilker and Barry Pruett at Wiley for their support.

That's the production side. I have to thank my long-time collaborators who worked with me at Werner Publishing, including Steve Werner, Chris Robinson, Wes Pitts, and George Lepp. They always challenged me to do my best and to work hard to communicate well with all photographers (and still do while I work independently). I also have to thank my good friend, Rick Sammon, who is always incredibly supportive and a very giving photographer. I thank Bill Fortney for all of his support over the years, which has helped me gain some respect for my books. There are many, many others who have done much for me, and I thank you all, even though I can't list everyone.

Finally, I have to acknowledge my wife of 27 years — she is always terrific and supportive, and my kids, who challenge me to do my best. And of course, I thank God for the beauty of this world that we photographers are blessed to have as subject matter.

contents

Part I Capture Workflow 1

chapter 1 What are Raw Files Really About? 3

chapter **2 Shoot RAW Right from the Start 17**

chapter **3 Color and RAW 43**

chapter **4 What's New in Adobe Camera Raw? 55**

Part II Camera Raw Workflow 69

chapter **5 A Quick Look at Camera Raw Tools and Workflow 71**

chapter **6 Workflow Applied 103**

chapter 7 **Advanced Tonal Control** 137

chapter 8 **White Balance Decisions** 157

chapter 9 The Noise Problems No One Talks About 185

chapter 10 Special Features of Camera Raw 199

Part III Making Camera Raw Work Harder for You 223

chapter **11 Tough Decisions 225**

chapter **12 Black-and-White Processing** **253**

chapter **13 Double Processing for Exposure** **271**

chapter **14 Post Camera Raw Processing 317**

appendix **A Alternatives to Camera Raw 337**

Pro Glossary 345

Index 351

introduction

There are a lot of books on Camera Raw or about Photoshop that include reference to Camera Raw. When I did the original version of this book, I really had to ask myself why another? Sure, I could add another text to my resume, but why would any reader care? I want readers to care because my passion is helping photographers learn and use digital technologies. So much of what I have seen is geared toward a very specific type of work (the author's) or is very strongly computer-tech oriented (and you don't see many photos from the author because he or she is not a photographer). These are important books and valuable for their audiences, but what I always have wanted to do is to talk directly to my fellow photographers and share the wonderful tools of the digital darkroom.

When Adobe came out with Photoshop CS3, they also introduced a Camera Raw with whole new features. So now I have updated my book for photographers on Camera Raw to version 4 and beyond. There are more technical books; I felt little need to duplicate them. There are more basic books; there was no point in making another book like them. I work to try to give you a unique perspective on how photographers can really benefit from RAW files and using Camera Raw. I have worked as a professional photographer, but more important, I have seen how photographers have adapted to and adopted digital technologies as I have worked on *Outdoor Photographer* and *PCPhoto* magazines.

So I wanted to update this book to continue to address photographers' needs and concerns, a book that made photography as important as the technology. I have put together a series of ideas from the actual photography to the completion of working on an image in Photoshop that reflect what I have learned about how photographers can respond to and benefit from this technology. I truly want photographers to say, "I can!" and believe it. I do — I believe that every photographer who wants to master digital photography, to tame Photoshop, to benefit from RAW files can do it. As Henry Ford is quoted as saying, "If you think you can or you think you can't, you are probably right." I think you can!

One caution I do want to make. Photography is a creative endeavor. It cannot be controlled by formulas and recipes, whether written in this book or any other. The master of your images has to be you. Even if I say it is best to have a strong black in your photo, for example, and you don't like what that does to a particular image, don't do it! The idea of good or bad for your photos has to start with you. Anything written on these pages can only be a guideline because I cannot see your pictures. I will say that everything here is tested and does work, but I can never say whether something will work 100% of the time in your particular situation. Art and craft are just too subjective to allow that.

Many of the photos that are demonstrated in this book are available for download at www.robsheppard photo.com. These are full-size, RAW files, so you're going to need a broadband, high-speed connection to the Internet or else a lot of patience.

I hope you find these pages fun and informative. Don't be afraid to play with your photos to see how Camera Raw will work for you. It can work very well, indeed, but you'll get the most out of it and this book by trying lots of photos in Camera Raw.

CAPTURE WORKFLOW

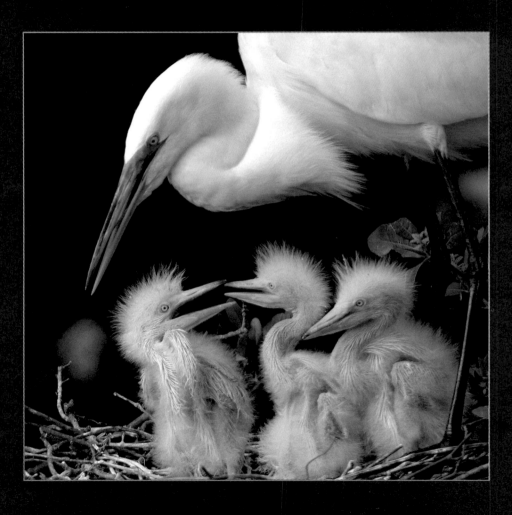

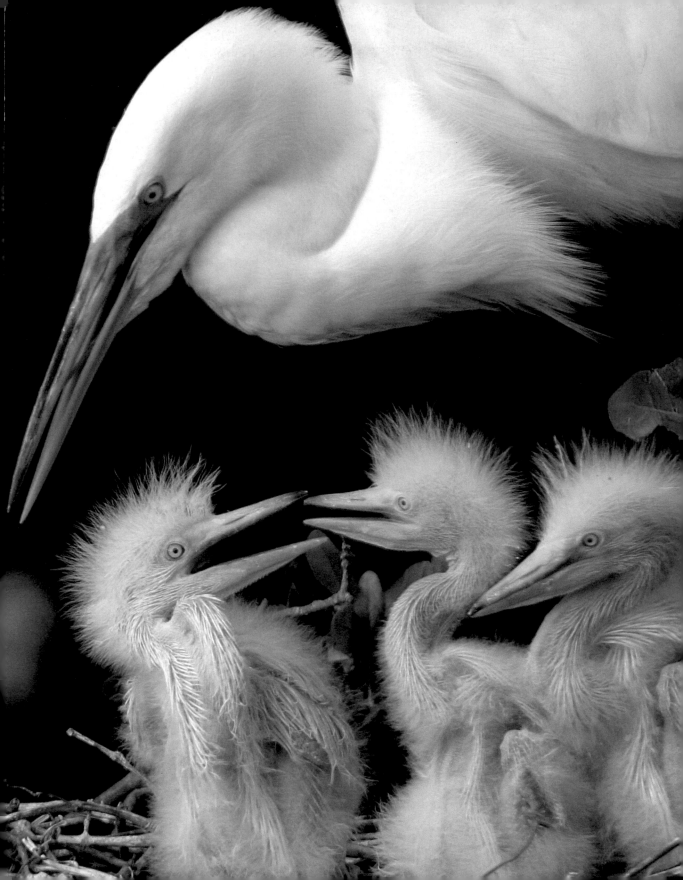

WHAT ARE RAW FILES REALLY ABOUT?

The RAW format has become the format of choice for most photographers today. JPEG still has its place, but the flexibility and power of RAW makes it extremely valuable for the photographer who wants the most from an image file. Yet, it is also critical to understand that RAW is no magic bullet that can correct any problem with the original photography. The photo must be shot right from the start to get images like figure 1-1.

The old debate of JPEG versus RAW still has a lot of misinformation in it, but it seems to be less of an issue for most photographers today. In fact, the newest version of Adobe Camera Raw lets you process JPEG files in it. Raw offers the thoughtful photographer a good deal of control, but also demands more in the workflow. JPEG can be used quickly and easily for those situations that require speed over adaptability and advanced control.

1-1

A RAW START

This is a tremendous time to be photographing. Cameras are better than ever and the whole digital transition has brought a new excitement to the craft. Digital capture of images offers so many great advantages, in everything from nature to people photography as shown in figure 1-2, that film is rapidly becoming only a specialized way of shooting.

One terrific innovation that came with digital photography is the RAW format, although technically, it is really the RAW formats. Every camera manufacturer has its own RAW format unique to its products, and each company keeps tweaking it with every new camera. Confusing, true, but it only has to be if you want to know all the formats. Really, all you need to know is the one specific to your camera model.

Adobe's DNG (digital negative) format was introduced to potentially become a universal RAW format. However, that has not happened, and given the camera manufacturers' penchant for keeping their files proprietary, this seems unlikely. For now, DNG is mostly used as an archiving RAW format.

This book covers RAW as if it were one format. That's easy to do in a book specifically about Adobe's Camera Raw program that comes with Photoshop CS3 because Camera Raw treats all RAW formats equally well. It also deals with them seamlessly, without any need to think about format variations.

NOTE

RAW is not an acronym, but simply the name for the format type. You will see it as RAW and Raw in various publications. This book uses RAW as the convention for referring to the files.

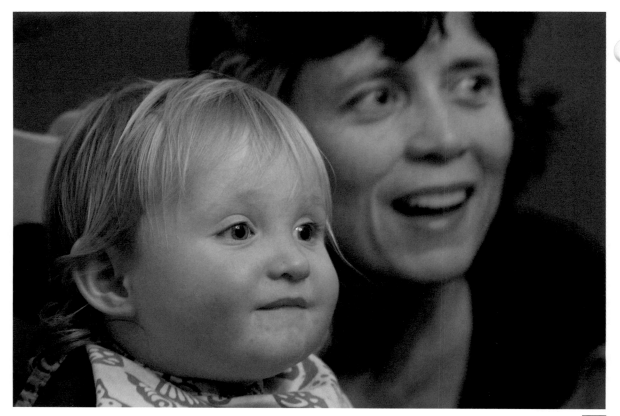

1-2

WHY USE RAW?

RAW is an extremely valuable tool for the digital photographer. There is some serious math involved because of the way the file is put together digitally. A RAW file is a 16-bit file that holds a huge amount of data compared to the 8-bit JPEG file. I could give you the actual numbers here, but I think they are misleading. They sure would seem impressive (and they are revealed later in the chapter). But photography is not about math unless you are a camera designer. Photography should be about the images. Yes, the higher bit depth in a RAW file can help, but that shouldn't be the only reason for using a RAW file. There are some reasons that figure 1-3 does well coming from a RAW file, as you'll discover in this book, but if the photograph isn't adequate, no amount of RAW math will help it. I believe that the photograph

and your connection to it should rule the process, not what you can do to it because of the technology.

RAW is remarkable and important for its broad photographic capabilities. There are four key photographic reasons to use it:

> You gain some serious processing power for the image file.

> You need the increased flexibility that RAW offers.

> You avoid problems due to the limitations that can come with shooting JPEGs.

> You like working through an image to get the most from it.

Once you do decide to work with RAW, it is very important to understand RAW requires a certain workflow to get the most out of it — a workflow you learn in this book.

5

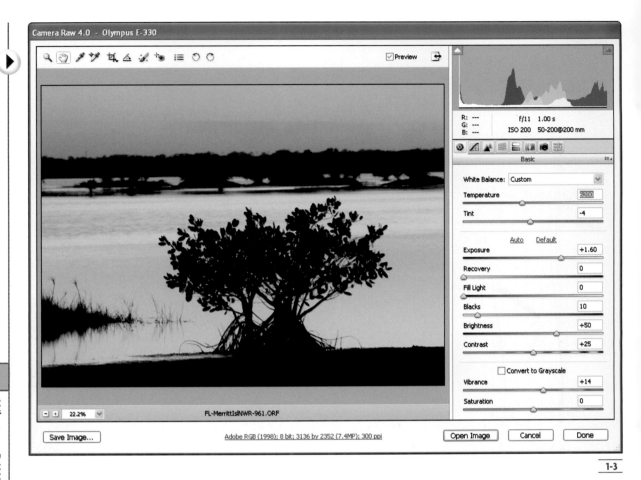

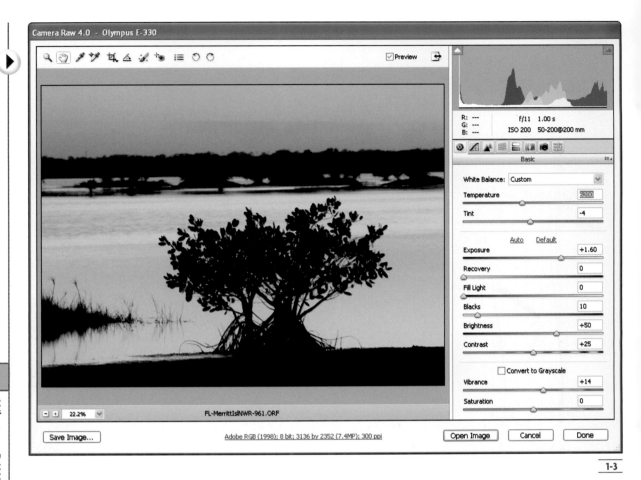

Camera Raw 4.0 - Olympus E-330

☑ Preview

R: ---
G: ---
B: ---

f/11 1.00 s
ISO 200 50-200@200 mm

Basic

White Balance: Custom

Temperature 5200
Tint -4

Auto Default

Exposure +1.60
Recovery 0
Fill Light 0
Blacks 10
Brightness +50
Contrast +25

☐ Convert to Grayscale
Vibrance +14
Saturation 0

22.2% FL-MerrittIsINWR-961.ORF

Save Image... Adobe RGB (1998); 8 bit; 3136 by 2352 (7.4MP); 300 ppi Open Image Cancel Done

1-3

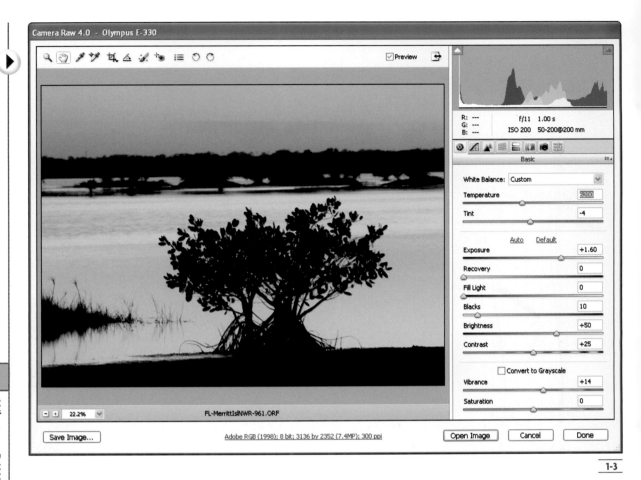

UNDERSTANDING RAW

To use RAW to its best advantage, it helps to know a little about it. RAW cannot fix every lighting or exposure flaw in an image. Unfortunately, a mythology around RAW implies it can do this.

"Don't worry about exposure or color; you can fix it when you shoot and process in RAW!" That way of thinking is seductive, yet very dangerous. An image like that in figure 1-4 is a problem, no matter if it's shot in RAW or not.

RAW is

> A type of image file with minimal change to the data coming from the sensor.

> Not unprocessed data as you may have read. The sensor creates analog information that must be processed into digital data.

> Image data that is converted from analog information with the A/D (analog/digital) converter and is a complex engineering challenge that, luckily, camera manufacturers have mastered for you.

> Affected by exposure as it is increased or decreased to the sensor's limits; the A/D converter will have problems dealing with those conditions.

1-4

RAW Capabilities

A RAW file holds more tonal and color information than a JPEG — 16-bit versus 8-bit — and offers a great deal of flexibility in how you can work the tones and color in an image. With RAW, you can frequently extract tones and details from the brightest and darkest areas of an image that have no detail in a JPEG file. This can be quite remarkable because it can at times allow you to show information in your photo that more closely resembles the real-world subject you want to preserve compared to what you find in a JPEG file or even from slide film. Figures 1-5 and 1-6 are two examples where the higher bit-depth of RAW helps. The light tonalities in the image would be difficult to manage if I had shot these with JPEG.

Print film is a little different. Some people compared it to RAW, but there are significant differences between them. Both offer a great range of tones from black to

1-5

white, but they handle the tones somewhat differently. That is neither good nor bad; it is just different. Because this is a book about Camera RAW, you may wonder why I mentioned it at all. The reason: Some photographers, especially wedding photographers who have much to gain from RAW capabilities, traditionally shot print film and expected RAW (especially when it is compared directly to a film negative) to give them the same results. The two media require different approaches, so these photographers would become frustrated and disparage RAW. It is not RAW's fault, but misplaced expectations that are to blame. With proper use, shooting RAW can be easy and fun even for the traditional print-film shooter.

1-6

In addition, you can maintain the quality of image tonal changes through greater adjustments when you work with RAW. You can creatively push and pull the tones of a photo to make it better do what you want. This format also allows you to enlarge or interpolate digital images to a larger size with higher quality because it starts with more information that can be interpreted for enlargement.

DO NOT SHORTCHANGE RAW

The misconception that RAW is so adaptable that you do not need to worry about exposure or color shortchanges the capabilities of RAW, creates more work for you to do on the computer, and can result in less than the best tonalities and color. Let me tell you that I have no desire to spend more time working on a photo that I have to — I am a photographer, not a computer engineer. A poorly shot file is a frustrating image for me: I have to spend more time fixing it compared to a properly exposed image because I did not get it right in the first place.

Consider these three things:

> **RAW still comes from a sensor that has a finite range from black to white — if your exposure is outside of that range, nothing can bring it back, not even RAW.**

> **Because RAW comes from a digital translation of analog information given by the sensor (the A/D converter I mentioned previously), the old adage of garbage in, garbage out is definitely appropriate here.**

> **RAW does its best when it has good information coming from the sensor right from the start.** A sensor has its definite strengths and "sweet spot" for exposure of tonalities and colors, so if you miss that, the RAW file can never offer its best.

That's the key to any good picture, not just RAW: Shoot it right in the first place. If you have doubts, try another exposure. Following is a look at a few problems that come from poor photographic technique when shooting RAW.

I cover how to deal with all these issues in depth in the later chapters.

> **Underexposure.** This is the worst problem. If you underexpose a RAW file so that the tonal information is mostly in the dark areas, you do not have the best tonal or color information to work with (see figure 1-7). When you brighten those areas, you also bring out noise. Even the best of digital cameras shows annoying noise when an image is underexposed.

> **Overexposure.** Excess exposure causes tonal and color problems in later adjustments, again because of weaker colors and less tonal information. Added noise is not the problem here, but you get blocked-up, detail-less highlights that are a pain to deal with, as shown in figure 1-8.

Overexposed

1-8

> **White balance.** Shooting on Auto white balance does not cause quality problems when you're shooting RAW, but it can create workflow issues later. If you set a specific white balance on your camera when using RAW, no pixels are harmed. But a tag of information about that setting goes with the file so that when it opens, it opens in the RAW converter with a specific white balance. You now have a point of reference to adjust from rather than the arbitrary and sometimes capricious white balance the camera chooses, as shown in figure 1-9.

Underexposed

1-7

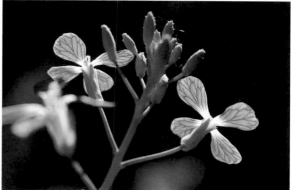

Wrong white balance

1-9

What is 16-Bit all About?

Image files work with data based on how many levels of gray tones exist between black and white for each of the three colors of digital: red, green, and blue (RGB). For a very long time, 8-bit data was the standard. It offers 256 distinct tones per color, for a total of more than 16 million color values. This is considered true photographic quality and it is a lot of colors, obviously; anyone who tells you that you can't get a quality image from 8-bit color is working by computer-ese and not photography. Photoshop was originally based on it, and digital camera files in JPEG use it. The use of 8-bit color does match how you see tonal and color information and can be perfectly capable of excellent results.

Problems with 8-bit occur if you have to stretch it a bit in processing as is the case in figure 1-10. There is very little stretch room because as you stretch data, you lose steps of color and tonal information, resulting in problems with gradations of brightness and colors. If your exposure is off or there are contrast issues in the image, you quickly run out of tonalities with which to adjust. In addition, the color of 16-bit expands the working range of colors and tones exponentially. You can do a lot of heavy-duty adjusting without the image suffering.

Technically, however, most digital cameras are only capable of capturing 12-bit color, which is still more than 8-bit (a few cameras are now 14-bit, which will probably become more common over the next few

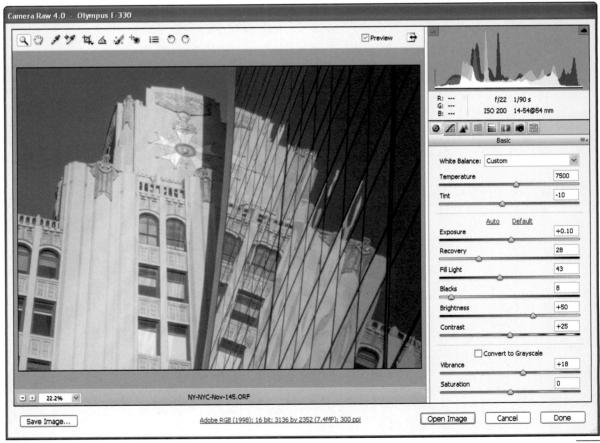

1-10

years). This 12-bit data is put into a 16-bit bucket, so to speak. At 12-bit, you get 4096 distinct tones per channel for a total of more than 68 billion color values. That's 4,000 times 8-bit, which is a lot.

PRO TIP

Remember that your camera meter wants to create an image with middle gray tones. It makes a bright scene darker and a dark scene lighter. Metering something with middle gray tones in a scene can give you a good starting point for exposure. If you use auto exposure, also use the plus and minus exposure compensation control — plus for bright scenes, minus for dark scenes.

But remember, this is not expanding the capture range of the camera. For example, pure white and pure black still correspond to the limits of the sensor. What 16-bit (or the actual 12-bit of captured data) does is give more steps in the working range, which increases the number of divisions between white and black, light and dark, and provides a huge amount of flexibility and control over the tonality of the image.

Those extra divisions of tonality and color really do matter when you want to find more detail in certain parts of the range. You can stretch that portion without damaging the overall tonality of the image. In addition, those extra steps allow you to make major changes anywhere along the range of tones without causing problems to the tonalities and colors that are left (because there will be a lot of them left). Figure 1-11 is a converted but unprocessed RAW image to give you an idea of an image with a lot of dark tones and a group of light tones, but much less in the mid-tone range. This is an ideal subject for RAW compared to 8-bit JPEG.

PRO TIP

If you use JPEG, use only the highest quality settings. In addition, remember that this is a capture format and should not be used as a working format in the computer. Once you open and work on a JPEG-captured image, save it as a TIFF or Photoshop PSD file.

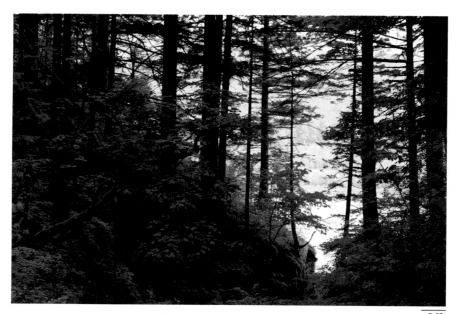

1-11

11

PROPRIETARY FORMATS

One of the big challenges for everyone shooting and processing RAW is that camera manufacturers have consistently refused to create a common RAW format that everyone can use. Here are some of the extensions associated with varied RAW formats to give you an idea of how many there are (versions unique to certain camera types actually extend this list): Nikon (NEF), Canon (CRW, CR2), Olympus (ORF), Sony (SRF), Pentax (PEF), Fuji (RAF), and Leaf Valeo (MOS).

I have used multiple camera types from several manufacturers to take photos and find their RAW formats all equally good. Hard-core marketing folks will tell you this isn't true and that significant differences exist that are worth worrying about.

Not really. Yes, there are differences, but image quality is high among all of these competing variations of RAW. I challenge anyone to show me or anyone else a photograph where you can see differences that significantly affect the photographer's results. You cannot. Image differences among RAW images are far more affected by the sensors the cameras use, A/D converters, lens quality, light, composition, and so forth. Different formats affect workflow, however, and some offer unique features that you can access only in a manufacturer's RAW conversion software.

Those features may or may not be worth it to you. They typically do little to affect actual image quality and more to affect how you work on an image. On the other hand, the convenience of working with Camera Raw directly in Photoshop is huge. In addition, Camera Raw has been tweaked and refined in every new version to give you improved control over the photo.

NOTE

Those pesky proprietary formats are a problem for Adobe. None of the camera manufacturers actually shares details of how the format is put together. It so happens that the computer engineers at Adobe are very bright and have figured out how to deal with all RAW formats by literally taking them apart and examining how they are constructed. The problem with this approach, unfortunately, is that when a manufacturer comes out with a new or revised format, you are unable to use Camera Raw until the Adobe engineers deconstruct the new format and program the software to recognize it.

THE VALUE OF DNG

I have to be straight with you. Manufacturers do not really care about Adobe's challenges with RAW files. As far as they are concerned, photographers will do just fine with their RAW conversion software programs and don't need Camera Raw. However, using multiple, changing RAW formats presents a challenge. First, you may have two cameras with two different RAW formats, even from the same manufacturer (especially if your cameras are very different in age). That can be a pain to deal with. Second, it is entirely possible that older RAW formats will be discontinued over time, making them difficult to use in the future.

For these reasons, Adobe introduced the DNG, or digital negative, format. Adobe's engineers thought a lot about creating a consistent RAW format that can be used by all camera manufacturers and can be archived by photographers without fear that they cannot access it in the future, as seen in the Save Options dialog box in Camera RAW shown in figure 1-12. They even included flexibility in this format to allow camera manufacturers to add their own unique tweaks to it as well.

In spite of DNG's potential to reduce confusion and make it easier for the average photographer to work with RAW now and in the future, camera manufacturers are not showing much interest in this format.

Save Options

Destination: Save in Same Location ▾ [Save]
 [Cancel]

[Select Folder...] N:\Digital Camera Pix\2006 e\SamGrad2006 e\

File Naming

Example: CA-SamGrad-0606-078.dng

Document Name ▾ + ▾ +

 ▾ + ▾

Begin Numbering: []

File Extension: .dng ▾

Format: Digital Negative ▾

☑ Compressed (lossless) JPEG Preview: Medium Size ▾
☐ Convert to Linear Image
☐ Embed Original Raw File

1-12

For now, many photographers use DNG as an archiving format for RAW files because Adobe has said it is committed to preserving this format for use into the future for just that reason. You can save any RAW format file to a DNG file in Camera Raw in Photoshop CS2 or CS3; or if you have Photoshop CS or 7, you can download a program from Adobe's Web site that can convert any RAW file to a DNG.

DOES JPEG HAVE A PLACE?

Digital offers so many new options that the choices are confusing at times. And sometimes the choices are not perfectly clear, such as to use RAW or JPEG. Photographers sometimes use RAW even when it does not meet their needs, but they feel guilty if they shoot JPEG. Well-meaning experts often promote one approach to digital, because that is how they do it, but unfortunately, they don't adequately explore alternatives as really used by photographers.

You need to understand a bit about using JPEG, because shooting 100 percent RAW is neither effective nor efficient for every photographer or in every situation. In spite of hype within the computer industry and from some Photoshop gurus, JPEG can be a high-quality format — it just is not as flexible and adaptable as RAW. In addition, Adobe Camera Raw can now process a JPEG image in the same nondestructive way it deals with RAW files.

Some photographers think that RAW is the format for professionals and JPEG is for amateurs. This can get you into trouble as it gives the wrong impression of what RAW does for you. Both formats are capable of providing high-quality images.

RAW is a tremendous tool when you need it, but if you arbitrarily use RAW at all times, and it doesn't always fit your needs, personality, or style, you may begin to find you have less enjoyment from working digitally. I don't shoot RAW all the time, and I have had many JPEG-shot photos published. Earlier in the digital changeover in photography, I shot mostly JPEG because the memory and processing overhead for RAW was a pain to deal with.

RAW no longer has that overhead problem. I like the rich capabilities of RAW, and now that large memory

cards have come down in price, I use it extensively because it is such a valuable tool. Cameras that shoot RAW and JPEG at the same time are very useful but require larger memory cards. RAW is very important for digital photography, but it should never be used as an odd way of separating the good photographers from the bad. That comes from what's in the RAW or JPEG file, not from the file itself. Don't let any photo guru bully you into using either RAW or JPEG when they're not appropriate to your needs.

PRO TIP

Many photographers now shoot RAW and JPEG to take advantage of the best of both — a great way to go (especially because memory cards now offer a lot of megabytes with less cost). This gives you the benefits of both formats — increased flexibility from RAW whenever you need it and the ability to work quickly with JPEG files when that is appropriate.

When should you shoot RAW or JPEG? Make that your own choice. Know that you can get top quality from both — figure 1-13 came from a JPEG file. RAW gives you a great deal of flexibility and control in processing your images to get the most from your subject, but it requires more work, more storage space, and slows down a camera. JPEG offers far less flexibility and control, but it is fast, requires less work, and needs less storage space. One reason I shoot both is because I can get prints anywhere from a JPEG almost immediately, which I can then give to people I have promised prints to, even while shooting in remote locations.

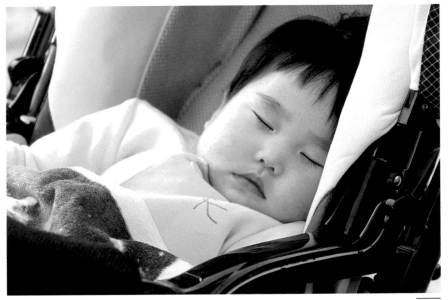

1-13

When JPEG Works

JPEG shot at the highest quality in modern digital cameras can give quite remarkable results from today's cameras. All camera manufacturers build some amazing processing capabilities into their cameras to convert sensor data for JPEG files. I know from talking to Canon folks, for example, that its DIGIC chip was designed to process RAW to JPEG while holding highlight detail very, very well and helping minimize noise. The very powerful processing capabilities built into the camera (which essentially is processing the RAW file for you) can offer great results when you're shooting high-quality JPEG. It does require you to pay attention to how you work — you have to expose right, choose the white balance correctly, and so forth, as shown here.

It is like having a little RAW expert doing conversions for you in the camera. That said, realize that this conversion is done automatically with no control on your part. Engineers working to maximize camera appeal and sales create algorithms that make good-looking JPEG files, but if you want to have this control, then you must shoot RAW and make the conversions yourself. As you will see from this book, there are many benefits to doing exactly that, and you will be able to get files impossible to achieve from JPEG.

When should I use RAW?

You can use RAW for any photography, but you should use it for its capability to make a good photographer better, not as a substitute for craft. It is extremely valuable for the photographer who really likes to work his or her image, prodding tones and colors to get the most from the image file. RAW offers the greatest amount of tones and colors possible from your digital camera.

But it can also waste time and memory space if you shoot quickly and expect to make minimal changes to your images later. It can be a problem to use when you want to work fast, such as you do with sports photography. When shooting JPEG, many cameras shoot faster and longer before having to stop to empty their buffers

RAW is especially valuable when shooting scenes with a lot of important highlight or shadow detail. Its 16-bit capabilities allow much more adjustment of such tonalities than the 8-bit capacity of JPEG. This format is also very valuable when you're shooting under changing conditions where you cannot precisely control exposure or white balance. Its versatility and adaptability mean even problem images can often be brought under control.

Can any photographer use the DNG format?

Absolutely. It just is not being used by any of the major camera manufacturers. What many photographers are doing is using this format as an archival RAW format. Some camera manufacturers have already changed their RAW formats in the relatively short history of digital cameras. Who knows if these variations of RAW will be supported in the future?

Because DNG is a broad-based format that any photographer can use at any time and can be made from any RAW format image, and because it is supported by Adobe, who does not make digital cameras, there is strong likelihood that this format will be around for a very long time. Adobe promises to always support it. This makes it ideal to use for important images that you want to archive in a RAW format. You can convert any RAW file into the DNG format in free software available from Adobe (www.adobe.com) or in Camera Raw.

What if I shoot in JPEG? Can it be changed to RAW?

The simple answer is no. You have to set the camera to RAW (or RAW + JPEG) in order to have an image recorded in RAW. You cannot convert a JPEG file to a RAW file once the image is recorded, either.

However, you can convert a JPEG file to a DNG file in Camera Raw. You don't gain any quality boost from doing that, and while you get a 16-bit file, you don't get any new benefits over 8-bit (because that's all the JPEG file has). However, you do get an archival format with more flexibility and potentially better processing capabilities in the future should you need to rework your file someday.

SHOOT RAW RIGHT FROM THE START

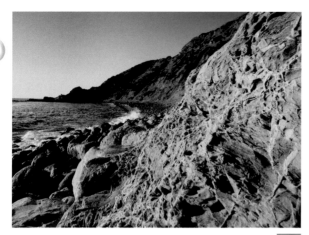

2-1

2-2

2-3

When digital photography entered the photographic world, some photographers became frightened of it and said that craft would be lost. Craft, the control of the medium through skill, practice, and knowledge, has long been a core element of photography. The fear was that the computer would do everything by making decisions for the photographer and creating stunning photography without any work by the photographer. Even a rank beginner would now be able to match the practiced pro.

That last sentence actually appeared in a major news magazine nearly ten years ago. It is as much nonsense today as it was then. It represented, however, a fear about loss of the craft because of automation.

I really believe that the craft and the pride of craft in photography has been enhanced by programs like Camera Raw. You learn very quickly that if you are to get the most out of Camera Raw, you must shoot RAW the best you can right from the start. The more you know about the craft of photography, the easier it will be for you to use Camera Raw.

I often tell my workshop students that I really am not fond of working in Camera Raw, Photoshop, or Lightroom, and they are surprised. Am I not supposed to be the expert who has written all those books and does all those workshops on these programs? I am, however, a photographer, and have been one since I was a kid. I love what these programs offer photographers and their photographs, but I am no computer junkie. I would rather be out photographing than spending extra time working an image in Camera Raw because I didn't shoot it right in the first place. In fact, I get really frustrated trying to "fix" a problem photo that just won't adjust right. This is why the need to know how to handle your medium is very important if you want to get consistently rich images like that in figure 2-1.

THE DIGITAL DARKROOM

2-4

Digital photography is quite like the traditional dark-room in many ways. It increases the number of points where the photographer can influence the image and offers new controls not possible before. It actually steps up the amount of craft that can go into an image. Using Camera Raw itself is a craft if you want to use it in the most photographic way to get the most from your photos. It increases the opportunities for adjustment as you can see in figures 2-2 and 2-3, which are variations of figure 2-1.

Those increased opportunities concern people about the amount of work it takes, even when the image is shot right from the start. While it is true that shooting RAW requires more computer memory and time spent at the computer, as with any craft, it becomes easier to use with practice. And you get better at it, too. Once you start using RAW and Camera Raw in a con-sistent manner, you find you can really do it quickly and efficiently. And if you shoot RAW + JPEG, you can always go the JPEG route when you have to do a lot of images in a hurry.

An enjoyment and appreciation of craft is one of the joys of photography. Meet a challenging subject or scene head-on in RAW, then master it in a great image, and you will feel satisfaction in that conquest, a conquest that comes from craft. Photography is part science and technology, part craft, and part art. The best images result when all of these work together.

UNDERSTANDING THE SENSOR

Because RAW files work with data that have had minimal processing coming from the processor, it can be helpful to understand a little about the sensor and how it works. This is not a technical discussion, but a quick overview of the key elements of a sensor as it affects the image in RAW. Figure 2-4 is an actual digital camera sensor used in a Canon digital camera.

Here's how a sensor works:

> A sensor is a light-sensitive electronic device with multiple photosites (the pixels that make up the megapixels).

> Each photosite sees light coming from the lens and translates that light energy into electrical impulses (it does not actually create this electrical energy, but modifies currents passing through it).

> The sensor can deal with a certain range of light from dark to light; too little light creates no reac-tion and too much light goes beyond its limits in handling brightness.

> The electrical charges are translated into digital data by the A/D converter, as mentioned in Chapter 1.

> No detail can be captured if too much or too little light strikes the photosites — this is why expo-sure is so critical.

> The sensor also deals with color in a unique way. The color pattern in figure 2-5 is called a Bayer pattern, the most common way a sensor is set up to interpret color.

2-5

> Each photosite only sees levels of brightness, not color.

> A pattern of colored filters (usually the Bayer pattern) is laid over the sensor, with green covering half of the photosites, and red and blue split evenly among the rest.

> Each photosite then sees a color because it is seeing the brightness of light through a particular filter.

> The green sites measure both color and luminance (brightness), which is why they are more populous.

> All sites contribute to the resolution of the image. (A unique sensor from Foveon promised all colors for every sensor point, but it never caught on in the industry.)

If the camera processes the digital data for a JPEG file, the color of an image is built from the information provided by the unique combination of green-, red-, and blue-filtered photosites. The file then has complete color data for each pixel. For a RAW file, this changes. Here, the data is saved with the color information separated by pixel and its original color. Then the colors are combined when the RAW file is opened and converted in the computer. This is why it is easy to make color corrections in RAW and why there is no quality change in doing it. The colors are actually reconstructed from the original data every time to make every color seen in an image like the crabapple blossoms in figure 2-6.

This does not, however, mean the RAW colors are always better — just more controlled. In most cases, that offers you a great deal of important flexibility. But the in-camera processing for JPEG sometimes makes certain colors look better, so pros often test both RAW and JPEG with varied colors to see when shooting RAW may be a limitation.

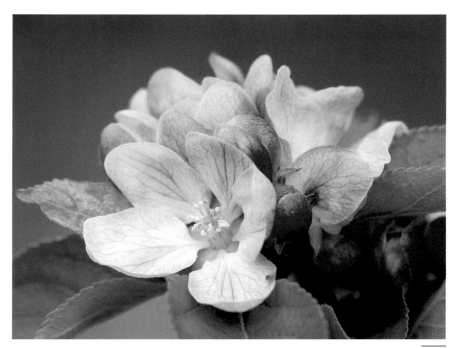

2-6

DEALING WITH LIMITATIONS

You can see from the way the sensor works that the RAW file only holds what the sensor is able to register. The sensor is not a magical device that sees everything in the world, so all that is needed is a RAW file that would include all that detail, detail to be adjusted to as needed to match the world. If only that were true! The limitations of the camera sensor require that your photo technique match the capabilities of that sensor to get the most from this technology. There is no sensor in the world that can handle the tonal range from the shadows to the backlit hair in figure 2-7, for example.

2-7

This also applies to color because color is constructed from the brightness of tones seen through color filters on the photosites of the sensor. It is important to realize that every photosite is affected by the limits of the sensor, regardless of the color filter in front of it. Proper exposure, then, also affects color.

I want to give you ideas on how to use better technique with your digital camera, no matter what brand, so you can optimize your photography when shooting RAW and processing in Camera Raw. That said, I don't want you to tighten up and over-worry your technique, either. No matter how much you try, there will be instances where your captured image is not optimum. But photography is a creative art, and you always have the choice to work with what you've got. If you like the shot, for whatever reason, but it isn't perfect or it even shows tonal or color weaknesses, you can always just tell everyone you were being creative and meant to do it!

EXPOSURE – MORE THAN GETTING BRIGHTNESS CORRECT

Exposure is the key to getting the best from a RAW file. Because of the processing power of Camera Raw, you can often get a good-looking photograph from under- or overexposed images. However, that can cause problems with limitations with tonalities, weaker colors, increased noise, and less-efficient workflow. This is a consistently misunderstood aspect of what a RAW file and Camera Raw can do.

It is important to understand what happens to an image file with exposure above or below the optimum for the sensor. The most obvious effect is that the sensor is now expected to perform its best with less than the best light on it. The middle range of tones in a sensor is very important to allow the sensor to best deal with a subject's tonal range and to capture the best colors. Under- or overexposed colors do not allow the sensor to capture the proper hues and saturations of a color. Underexposure like that shown in figure 2-8 is especially a problem.

2-8

This concept is so important to understand that it is worth doing a mental exercise. It is a simplistic exercise, but it provides a visual impression of what can happen with exposure problems:

1. Think of a ladder. The rungs on the ladder represent steps of tonality in a photo.

2. Imagine that the ladder can only have rungs no closer than every six inches, like those in the illustration in figure 2-9. This obviously limits how many rungs will fit on the ladder.

3. Compare this vision of a ladder to a digital image — it, too, has finite steps between tones and colors. The six-inch restriction is like JPEG in its bit-depth. As long as the ladder has rungs throughout its length, however, there is not a problem.

4. Now think of that ladder with steps only in the lower half (still six inches apart because the ladder can't have anything closer), as shown in figure 2-10. This represents what happens when underexposure reduces the steps of tonality to just the dark tones in a photo.

5. Of course, you could fix the ladder by moving the rungs. But like an exposure that has only limited steps left when it is reduced, the problem is you can only use the rungs that are on the ladder; this is demonstrated in figure 2-11. Because you can allow more than six inches between rungs, you can get away with moving them farther apart, but to stretch them all the way to the top requires you to move them a couple of feet apart. This is a real problem with poor exposure, or underexposure, with JPEG. There you have fewer original rungs, so there is less to work with to stretch to the top.

6. With RAW, to continue the analogy, you have more rungs to work with. On the RAW ladder, you could think of them as showing up every two to three

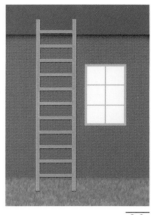

2-9

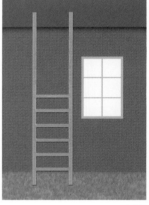

2-10

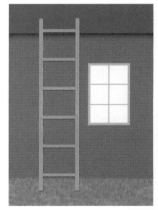

2-11

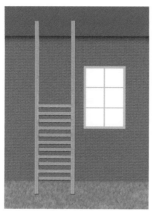

2-12

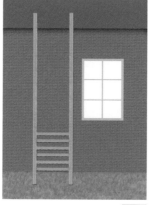

2-13

7. Now suppose this RAW ladder was limited to having rungs at the bottom (see figure 2-13). This is like a strongly underexposed RAW file. Sure, the rungs have the RAW spacing of three inches apart, but now there just aren't enough left to move to fill the ladder at the desired six-inch rung interval. Stretching them now puts the rungs too far apart for the ladder to be an effective tool — or for that matter, for the tonalities and color in a RAW file. Exposure problems will force tones to be stretched separately in dark, light, and middle tonalities and colors, and there simply won't be enough tones available for a quality image.

In a poorly exposed RAW file, this can mean you do not have the tones or colors you really want. The result means more work for you in Camera Raw, and, typically, in Photoshop as well. You move one control to where it looks good, but to correct problems, you need to make a counter-adjustment with another control. That may throw off color, so you need to make another counter-adjustment. Now, the first control looks off, so you have to go back and tweak it again. You may think you have it all right and make the conversion, but then find the file still doesn't look right and you have to start over again.

I can tell you from experience that this can quickly become a major workflow problem. Over the years, I have had my share of poorly exposed photos that I just had to keep for some reason. Invariably, this increased my time in front of the computer monitor and decreased my satisfaction with digital photography. I have learned that I must pay attention to my exposures as I go or I will be frustrated back at the computer.

inches. Take the same reduction in height of rungs that was forced on the ladder of figure 2-10, and you can see in figure 2-12 that there are now more rungs available that can be used to fill in the gap at top. You have more to work with using a RAW file compared to a JPEG file. However, you still don't have as many rungs to work with as if you had all of them to start with. Working with a "beat-up ladder" in RAW is no more fun than working with a "beat-up ladder" in JPEG.

READING THE HISTOGRAM WITHOUT BEING AN ENGINEER

The histogram is a terrific addition to the craft of photography, though some photographers are put off by its "techy" look. It offers you a very direct interpretation of exposure. The black-and-white chart in figure 2-15 is similar to what you will see on a camera as it comes directly from the photograph (see figure 2-14). While it is a technical graph, it is also a very visual way of seeing exposure in a very direct way.

A histogram is a graph of the number of pixels at certain brightness values, with dark values on the left and bright values on the right. You can read it without knowing any math, becoming an engineer, or even if graphing was not a highlight of your high school years! You simply compare one side to another. If most of the hills and mountains are at the left, the photograph is very dark. If they are in the middle, the image will be average gray in tone. If they are at the right, the photo is light.

As you work with digital photography, you eventually learn to read a histogram almost intuitively. At first, you may not remember which side is for the dark parts of the photo and which side is for the bright. Don't worry about that. The great thing about digital photography is that you can instantly see what a histogram does and do so at no cost. You can change exposure to make the scene lighter or darker and instantly see the effect on the histogram, as shown in figures 2-16 and 2-17.

Because few dSLRs have had live LCDs until recently, there is an exercise to help you understand how a histogram represents exposure:

1. Put the camera on a tripod so there is no variation in tonalities due to composition changes.

2-14

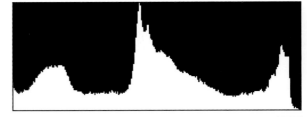

2-15

2. Take three photographs of the same scene: one exposed correctly according to the meter, one overexposed by one full stop, and one underexposed by one full stop (less than a full stop shows differences, but it will not be as dramatic for learning purposes).

3. Set your playback display to show the histogram (unfortunately, all cameras do this differently, so I cannot offer specific guidance as to how to do this — you'll have to consult your manual).

4. Compare the three shots as demonstrated by figures 2-18, 2-19, and 2-20. You see that overall the hills of the histogram shift to the right with more exposure (as the scene gets lighter) and to the left with less exposure (the shapes of the hills change, too).

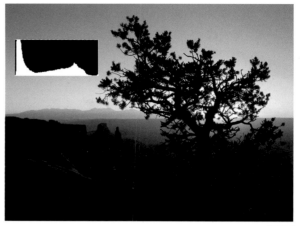

2-18

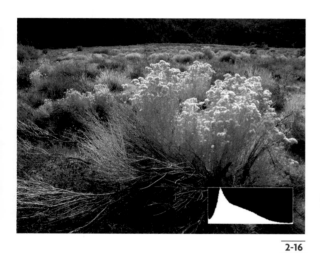

2-16

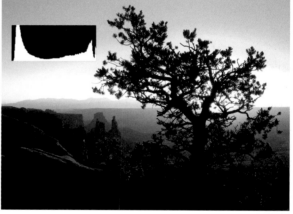

2-19

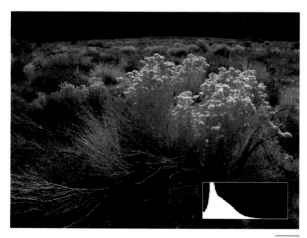

2-17

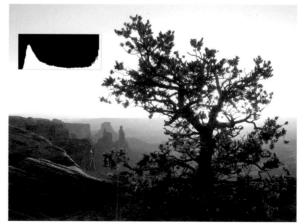

2-20

That's all there is to reading a histogram — data on the left is dark, data on the right is light. It is the interpretation of the histogram that is important to getting your exposure (and ultimately color and noise) right.

I have to add a note that relates back to being an engineer or a photographer. You will hear from some techy types that the histogram that appears on the camera is actually the histogram for the JPEG version of the file, and that because the RAW file is a linear form of data, that JPEG histogram can't interpret it. That is true (even if you are only shooting RAW), but their "warning" about this is more than a bit silly to me.

Okay, if you care more about the technology than the photography, this might be important. Otherwise, what is the point? The histogram you see gives you an indication of how the sensor is capturing the scene and you cannot get a histogram from the RAW file. As a photographer, I want to use whatever I have available to me to help me with my craft. The linear nature of the RAW file means you actually have more information to work with than is expressed in the histogram. So if I use that histogram conservatively, I know I have the exposure I need for the scene, and I will have plenty of data to work with when processing my RAW files.

INTERPRETING THE HISTOGRAM

Remember these things about exposure with digital photography:

> Underexposure causes problems with noise and weaker colors.

> Overexposure causes problems with tonalities, detail, and color.

> Good exposure makes the most of your sensor's capabilities.

If you keep these ideas in mind, you quickly learn to interpret any histogram, such as the range of graphs shown in figure 2-21. An underexposed image puts most of the histogram hills on the left side of the graph. An overexposed image puts the histogram hills to the right side of the graph.

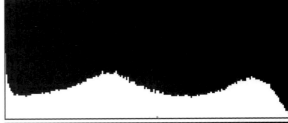
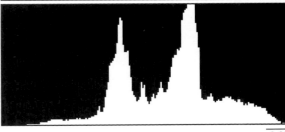

2-21

If the histogram starts from the bottom of the graph at the left (no cliff), moves into a hill or a series of hills of brightness values, and then drops down to the bottom of the graph before it hits the right (no cliff — small bits of graph may appear because of stray highlights, but that is not a cliff), then your sensor has captured a full range of tonalities, as shown in figure

2-22, and Camera Raw allows you to bring out a great deal of detail in the image.

If parts of a scene are so overexposed or underexposed that the sensor cannot record detail (tonalities are beyond its capabilities at that exposure), then the values are clipped. This means that detail is clipped from the image at that point and that the histogram is clipped off at either end (or both). The hills that make up the histogram's information are chopped off at the end when clipping occurs, such as is shown in figure 2-23. The right side of this histogram looks like the hill has changed to a cliff.

If this cliff is at the right side, as shown in figure 2-23, then highlights are clipped, meaning they lose detail. If the cliff is at the left, then shadows are clipped, also showing a loss of detail. By loss of detail, I mean total loss of detail at this point in tonalities. No amount of work in Camera Raw can get that detail back as the sensor can capture no detail in areas with brightness values beyond the ends of the histogram.

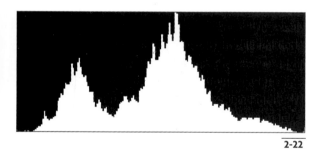

2-22

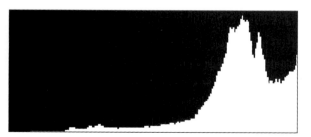

2-23

LOOKING AT HISTOGRAMS: EXAMPLES OF GOOD AND BAD EXPOSURES

A good exposure, obviously, is one that works for your subject. However, when you are shooting with digital capture, a good exposure is also one that respects the limits of the sensor. Any exposure that doesn't work with what you expect from a scene is a bad exposure. In the digital realm, a bad exposure is one that causes problems in the processing of the image. The mythology around RAW files is that they cannot have a bad exposure. This is definitely not true, as you will see.

This section shows you a series of photographs with histograms to give you a better idea of the range of good and bad exposures and what they mean to an image.

PERFECT EXPOSURE WITH IDEAL HISTOGRAM

Figure 2-24, wild lupines blooming along a Southern California highway, represents a perfect exposure with an ideal histogram, although most histograms (even good ones) do not look quite like this. Most of the tones and colors are captured by the optimum part of the sensor's range (the middle) and appear as a hill nearly centered on the histogram. That's key to this image because so many of the tones and colors of the actual scene have middle gray tonalities.

There is slight, unimportant clipping of blacks at the left and no significant clipping of whites at the right. This is critical for this photo as some very important bright tones are in the flowers (there actually is some minor clipping to the bright top-left of the front flower cluster, but this will not affect much).

The whole graph is slightly to the left side, which is normal for an image with a lot of darker gray tones. If more exposure is used, the graph shifts to the right, but that also shifts the brightest tones to the right. That would likely cause highlight problems that cannot be easily fixed.

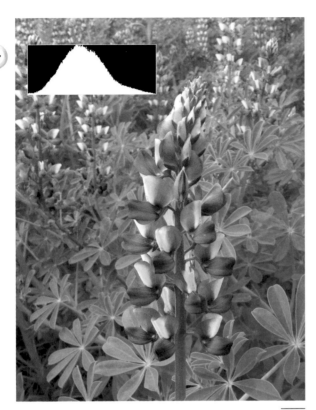

2-24

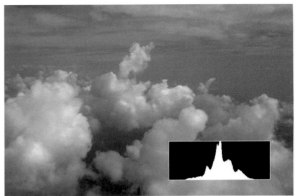

2-25

The picture may seem a little low in contrast, which is good for coming into Camera Raw with this look to the histogram. This range of full tonality in the sweet spot (the range of best sensitivity) of the sensor means you have a lot of flexibility with adjustments to change both tonality and color.

NICE RANGE OF TONES FROM LEFT TO RIGHT

Figure 2-25, clouds viewed from an airplane, shows a nice range of tones from left to right with no clipping. I love photographing clouds. They come in such fantastic shapes and forms — they can make flying an exciting time to be photographing (it is true they can represent turbulence, too, but I still love to fly among them). They can be a challenge for you because they can have a very large range of tones, especially in the light grays to white. Be careful not to clip important

highlights when you photograph them — pure white, burned-out areas of a cloud are not very attractive and you cannot fix them in Camera Raw.

Notice that the histogram fits completely between the left and right sides. It actually drops to the bottom line well before either end. This means there is no pure black (total underexposure) or pure white (total overexposure) in the image file. Most of the tones are, however, toward the right side, which is good because it means you are working with light grays exposed as light grays.

The reason the exposure does not have pure black or white is because of haze in the air (and from the airplane window). Sometimes the air has a bit of moisture or dust in it that can create some haze. The result is only dark and light grays at the extremes in the photo. You can easily correct this in Camera Raw, as long as you are careful that the exposure gives you a histogram with most of its range through the middle.

HISTOGRAM HAS VISUAL RELATIONSHIP TO SCENE

Overall, figure 2-26, a photo of pond lilies and the pond environment, is a good exposure. The left part of the graph slopes up from the bottom after the far-left side, but close to it, meaning no blacks are clipped and the exposure is not wasted with a big gap

on one side of the histogram. The right part slopes down to the bottom before the far-right side, also close to it, meaning that no tones on this side, the light side, are clipped and there is no wasted gap of information. The tonality of the scene essentially matches the capabilities of the sensor. You can readily adjust an image like this for more contrast and drama, but if you need the delicate details of highlights or shadows to work with, they are there.

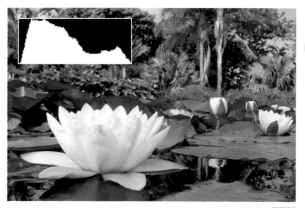

2-26

This picture is interesting because you can really see how the tonalities in the scene relate to the histogram. The large hump on the left side is basically all the dark tones of water, leaves, and shadows. There is a depression of fewer tones, then another hump to the right. This represents the lilies and the sky. This is also very important to note. Those subtle bright tonalities of the petals of the flowers can really make a difference in this sort of subject. Imagine if the very light grays were not in the white of the flower in the foreground. That would make it lose texture and form.

It is true that you can deliberately underexpose this image to ensure all tonalities in the white flowers register on the sensor. However, this shoves the big block of dark tones to the left. Some are then clipped, which might not be important because this photo is really more about the whites. However, the dark greens would drift into tones with less color so the overall image would have less color tonalities and would not adjust into as rich an image as is possible from this exposure.

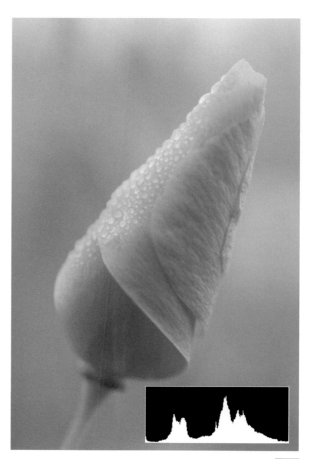

2-27

LIGHT TONES KEPT IN RANGE

Figure 2-27, a California poppy in the early morning, is almost an inverse of the previous shot of the pond lilies. California poppies do not open until they're fully exposed to the full sun for some time. On this day, light clouds were keeping the full sun away, which also left the dew on the closed flower. This is the reason for the photograph and influenced the exposure.

The image has two humps to the histogram like the one for the pond lilies, but in this case, the left side is smaller than the right (representing how many pixels hold certain tones). The image is not as clearly defined as to the dark and light areas as the previous example: the tonalities are more dispersed in the photo. Most of the darkness comes from the shadows on the flower itself, while the bright hump is from the large amount of light colors in the photo.

There is a slight bit of clipping at the right. This is mainly from the highlights on the dewdrops. You can give the image less exposure, but this causes a problem with the dark colors starting to move too close to the left side. A little bit of washed-out highlights on the tops of the dewdrops actually gives them some sparkle and certainly does not hurt them. By keeping the exposure bright enough, all the important colors (the two humps in this case) are well within the range of the sensor. It is easy to bring up the blacks on the left side in Camera Raw or Photoshop without killing the dark colors or the bright tonalities of the image.

BLACK-AND-WHITE CHALLENGE

A tough situation is exhibited in figure 2-28 — black and white appear, not as accents, but as the major part of the uniforms of the two soccer players. Luckily, the clouds in the sky knock down the contrast of the light somewhat and keep the tonalities within the range of the sensor. This is a difficult angle to shoot from on a bright, clear day because the shadows on the black uniform cover a large area, and the highlights on the white uniform are also big enough to create a problem if they're overexposed to no detail.

You see most of the exposure is to the left side of the histogram. In this case, that is quite important because of the low part of the graph that goes to the right side. Notice that while it is not as high as the peaks in the middle and at the left, it is also not at the bottom. This is no gap of data, but a range of very important whites to the uniform. If exposure headed to the right (which uncompensated automatic

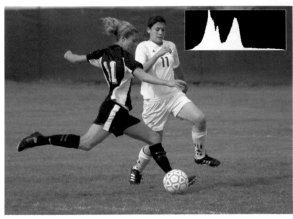

2-28

exposure may encourage), clipping would quickly start to occur on the white uniform. While it is true the action is what catches the eye, a glaring, detailless white uniform is very distracting.

The peak in the center is mostly the dark parts of the white uniform, the skin tones, and the light grass. The peak at the left is mostly the dark uniform and the dark windscreen behind the players. Because the graph is not clipped at the left, the blacks are fully revealed. The unadjusted image seen here is too gray, for sure. There should be a solid black somewhere, but that can be easily adjusted in Camera Raw.

RESTRICTED TONAL RANGE STILL NEEDS GOOD EXPOSURE

Foggy days can make for quite interesting photographs, as shown in figure 2-29. The tonalities of a scene can shift dramatically from the usual and allow you to capture quite striking images. The heavier the fog, the narrower the tonal range of the scene. Fogs, though, usually do not look their best if they're exposed to look too heavy. They need a bit of lightness to them, but you do not want to overexpose them, either. You'll find that most cameras set to auto exposure tend to underexpose a fog and give it an unneeded heaviness. If too dark, overall tonalities can be difficult to separate into the light tonalities expected in a photo of foggy conditions.

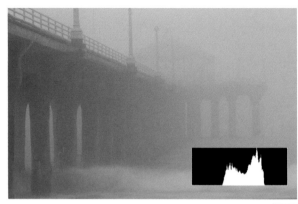

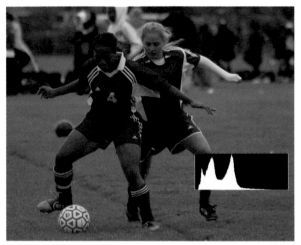

2-29

2-30

Probably the best thing to do is to get an exposure with the tonalities in the middle, but weighted toward the right side, as shown in this photo. The dark tones of the pier appear in the left hump of tonalities (which is nearly in the middle of the histogram) while the light grays of everything else appear in a hump to the right. This can easily be stretched in the 16-bit space of RAW when adjustments are made in Camera Raw.

Some people have the mistaken idea that a restricted tonality like this is just as easy to photograph with JPEG. While you might be able to get an acceptable image in that format with a bit of work, you are likely to find some tonal breaks or banding in the gentle fog tones because of the problems with stretching 8-bit tonality. This image needs to have some stretching of tones when adjusted to look right — how much is very subjective, because you will not have a pure white or black in such a photo.

POOR EXPOSURE CAUSES COLOR PROBLEMS

Figure 2-30 is poorly exposed. Because this is a RAW file, Camera Raw allows you to fix the image so it looks better than this, but it still will not match a better exposure. The light was changing this day due to a storm that had moved through, and I did not compensate for the change when this action happened. As a sports image, the action is more important than subtle color details, so the final image from this file may be okay, but it will take a bit of work.

Images like this can be a pain to deal with. Because the tones and colors are compressed to the left, dark side of the histogram, there is less chroma or color information in them. This means a lot of adjustments, and then readjustments are required to balance brightness and color just to make the image look normal, let alone good. You can see there is a significant gap of data to the right, meaning that the best part of the sensor has not been used.

In addition, noise hides in tones compressed into the dark tonalities, ready to reveal itself as the tones are expanded. Because action shots are often taken with higher ISO settings (as this one was), more noise is there anyway, so any adjustment to make these dark tones and colors just look normal also makes noise more visible.

BAD LIGHT CAUSES EXPOSURE PROBLEMS

Figure 2-31 probably should not have been taken. As a photographer, you always have the choice of not shooting a photo if conditions are bad for the subject. Truthfully, I deliberately shot this photo to push the camera a bit and see how it would handle a very extreme tonal range. I thought the out-of-focus tree was enough to knock down the brightness of the sky, but it was just too bright all over.

2-31

2-32

What happened is that the bright light behind the subjects overpower the dark areas. The exposure is low because of the influence of the bright light — you immediately notice the histogram has a big hump on the left side of the graph. This means all of the important skin tones of the people are recorded as dark grays, not the best place for light skin. More exposure can bring those tones up, but that causes another problem. Flare begins to cause problems around the man — more exposure makes this worse. In addition, there are very bright skin tones (especially at the edges of the man's head) that wash out with more exposure.

This composition is a no-win situation. You cannot expose it properly to capture the skin tones without other problems and there is no way even Camera Raw can make this a shot with great color and tonality. This is an example of a shot where it's better if you just move to find a different angle or add light. A fill flash on the subject would have helped. Otherwise, you can spend a lot of time in Camera Raw just making it look okay rather than enhancing an already good shot you might have gotten by choosing another angle.

POOR EXPOSURE CAUSES BACKGROUND PROBLEMS

Figure 2-32 is another shot that probably should not have been taken (or at least erased right away). The flowers are properly exposed with good middle tones and color that can be adjusted quite nicely.

But check out that background! You can see the histogram is weighted toward the right side. It is severely clipped, too, while pixel brightness levels continue to rise as they hit the right edge. The background will never have good color or tonality. Neither is in the image file. No matter what you do or how much work you do in Camera Raw, this image will always look bad because the background will have big, ugly, distracting areas of no-color, washed-out white.

If you must keep this shot, however, you must process the image twice in Camera Raw: for the flowers first, and then to get whatever you can from the background. You combine the two images in Photoshop to get the best tonalities from each. The final image still looks washed out, so you add a layer and paint in colors to the background. That is the only way you can do anything with this photo. You do not have to check every exposure with the histogram in order to avoid shots like this, but it helps to look regularly to be sure your photo technique is consistent, especially with such contrast as seen here.

X-REF

For more about processing your images twice, see Chapter 13.

EXPOSURE FOR SHADOWS WASHES OUT HIGHLIGHTS

Figure 2-33 is a very old structure that is part of the seventeenth-century Nijo Castle in Kyoto, Japan. The building has some fascinating detail that needs enough exposure to really show it off. You see immediately, however, that this exposure causes major problems. It shows a great example of this type of scene, but the exposure itself is actually part of a bracketed series. I knew the scene had too much range for the sensor, so I shot for the cloud and buildings separately with the idea of merging these shots together later. The use of a graduated neutral density filter would have improved the results, but because I had none, as well as no tripod, this idea did not work.

But you can see what happens to the histogram and the image with such an exposure. If you look at the left side, you can see that the important dark tones are recorded perfectly. There is no clipping and there is a significant hump of data on that side. The right side of the histogram is where the big problems appear. A very bright hump of bright tonalities climbs at the right, only to be abruptly cut off. Basically, the beautiful bright tones that make a cloud so attractive are totally gone. This cloud is a mere shell of itself.

There is nothing that you can do in Photoshop to fix such an image. Important bright highlights like the cloud must be exposed correctly, even if they are not such a big area in the photograph.

2-33

PRO TIP

As I mentioned, a graduated neutral density filter would have helped immensely with figure 2-33 and is an important tool for anyone who regularly photographs outdoors. A graduated neutral density filter is clear on one half and a dark neutral gray on the other. The two areas blend at the middle in a nice gradation of tone. The clear area goes over the dark part of the scene — like the buildings in this image — and the dark area goes over the bright part, the cloud (this doesn't always perfectly match the scene, but it helps). This brings such tonalities into a range that the sensor can capture.

FILTERS ARE STILL NECESSARY

A common digital "urban legend" is that if you shoot digital, especially RAW, you no longer need filters. While it is true that you really don't need filters to correct color, such as a special filter to shoot daylight film indoors and to get neutral color, there are other situations where a filter definitely helps. As to color correction, you can get that with white balance either when shooting or when processing in Camera RAW.

But because the sensor has its limits, filters can help create better images from the start. The sensor can only capture what it sees, so if it can see a better image from the lens, it will capture that better image. Two important filters for digital photographers are the polarizing and graduated neutral density filters.

A polarizing filter, like the one shown in figure 2-34, changes how the scene is recorded and can make the digital workflow easier. This filter darkens skies when you're shooting at right angles to the sun (that is, when the sun is to the photographer's left or right). You rotate the filter for the desired effect. This can really make clouds pop. That can be somewhat mimicked in Photoshop (and not easily in Camera Raw), but why take the time if you do not have to because the image came into the program already adjusted in that way? A darker sky can also set certain subjects off better. Figure 2-35 is a good example of how a polarizing filter can darken the sky nicely.

2-34

This filter also removes reflections from glass, water, or other reflective surfaces. That is done at the time of shooting as this effect cannot be duplicated or mimicked in Photoshop. By removing diffuse sky reflections from shiny surfaces (such as leaves), color saturation is also increased (which is also shown in figure 2-35), but in a very different way than you can control in the digital darkroom. Finally, a polarizer can reduce the effects of haze slightly, cutting its dulling effect.

The graduated neutral density filter (grad ND, grad, or split ND are other names) is a filter that is half clear and half gray in a specific neutral density amount, and is shown in figure 2-36. The line between the two is blended so it doesn't create a line in the image. The filter rotates to allow you to position it over specific parts of the composition. Typically, you can get one-, two-, and three-stop filters (sometimes labeled as 0.3x, 0.6x, and 0.9x). For digital photography, the two- and three-stop filters are most useful; the one-stop doesn't really do enough to make it worthwhile in the digital workflow. Figure 2-37 shows how a sunset is balanced with the lower part of the composition with a two-stop grad ND.

2-35

2-36

PRO TIP

When shooting with wide-angle lenses, a standard polarizer can be too thick and show up as dark corners to your photo. Look for special thin-mount polarizers for these lenses.

Shoot RAW Right from the Start

34

2-37

This filter allows you to bring tonalities of a scene into a range that is better captured by the camera sensor. It is commonly used by landscape and travel photographers to balance a bright sky with the ground. It can be used at any time to darken a bright area in a photograph to help the sensor better capture bright detail when the exposure for the darker areas may otherwise blow out the detail in that bright area. It is true that RAW and Camera Raw often allow you to pull out more detail in those areas, but that can also significantly increase your work time and adversely affect noise.

PRO TIP

Graduated neutral density filters come in screw-in circular models and square or rectangular forms. The square and rectangular types fit special holders that allow you to shift the position of the filter, which allows you to better match its tonal change with your scene. You can also rotate graduated filters to better align strong visual elements.

NOISE RAISES ITS UGLY HEAD

Modern digital cameras do quite well in controlling noise today, but problems with exposure and overprocessing of an image can bring noise back into an image from any camera. Noise looks like the grain of film, like a fine pattern of sand across the image. Unlike film, however, it doesn't always appear in a consistent way over the whole image. It appears most strongly in the dark areas of a photo. Figure 2-39 is a detail of figure 2-38 so you can see what noise can do to an image.

Noise is strongly affected by the type and size of sensor in the camera, the ISO setting, and the exposure. You can't change your camera's sensor, but you can be aware of its capabilities. Smaller sensors are inherently more sensitive to noise. The smallest sensors in the otherwise very capable advanced compact digital cameras used to show noticeable noise very quickly when exposure was off or ISO settings above 100 were used. This is much improved with the latest compacts.

With the larger sensors of dSLRs, noise has always been less of a problem. However, underexposure in even the best of them will reveal noise. In addition, certain dSLRs have a reputation for noise issues when they're used at specific ISO settings. If you are aware of how your camera reacts to these conditions, you can shoot around them or just be willing to accept noise.

Underexposure will typically add unwanted noise to any digital image. The reasons for this are related to how darker tones change with increases in light. A relatively small increase in the quantity of light at the sensor can raise the level of dark tones, yet it will have little effect on bright tones. This continues in the computer — as dark areas are brightened from exposure, it takes much less intensity to make them lighter as compared to making light tones lighter. The intensity of light seen by the sensor in the lightest tones is exponentially more than the dark tones. Greater amounts of light will obscure noise, although it is actually there all the time. When you make a bright area brighter, you are dealing with solid tonal information. When you make a dark area brighter, you deal with much weaker tonal information and noise is quickly amplified along with the brightness values.

2-38

2-39

Here's a way you can check your camera to see its noise characteristics:

1. Take photographs of several subjects with medium tones, and severely underexpose them. You should do this by setting your exposure at least three f-stops below what your meter suggests. Try scenes with very different subjects that are typical of what you normally shoot. Include dark areas in the image, as shown in figure 2-40.

2. Take one photograph that is exposed properly for your control, shown in figure 2-41.

3. Shoot RAW, Auto white balance, and at a normal ISO setting of 100-200.

4. Take another set of exposures using the highest ISO setting of the camera.

5. Process your photos very simply in RAW. Don't worry about perfect pictures. Just adjust exposure and brightness settings until the images are somewhat normal in brightness (ignore the fact that there may be other issues of contrast and color).

6. Use Unsharp Mask to sharpen all photos to Amount 150, Radius 1, and Threshold 0 (this will show the noise).

7. Now compare all of the photos against the properly exposed control. You'll see the underexposed images look harsher; their tonalities are not as smooth nor their colors as good as the properly exposed image, as can be seen even here when you compare figure 2-42 with the control, figure 2-41.

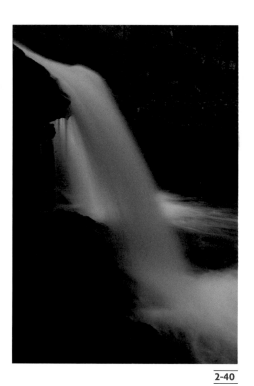

2-40

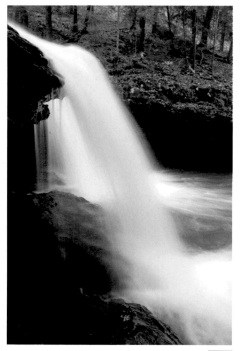

2-42

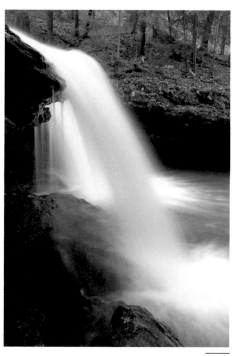

2-41

8. Enlarge the photos because they do not show all the differences when viewed at a small size. Look for the noise (which will be very obvious in many or even all parts of the photo). You can see a dramatic difference in the enlarged areas from the correctly exposed image (figure 2-43) and the underexposed shot (figure 2-44). Also compare the colors and tonalities to the control photo (figure 2-45 compared to figure 2-46). Admittedly these illustrations are extreme, but many photographers have never been advised of this effect at any exposures. These examples clearly demonstrate why proper exposure is so important.

Correct

2-43

Correct

2-45

Under

2-44

Under

2-46

It is true that you can limit the noise in the image to a degree in Camera Raw and in the noise reduction filter of Photoshop CS3. But this is not a simple fix, and there are trade-offs. The first is a workflow issue. You do not always see the noise until later in the process and you have to reprocess the image. At the minimum, you have to spend more time tweaking the photo in Camera Raw.

The second is that removing noise can affect details in a photo. Noise, in a sense, is a very fine detail in an image. If you remove it, other fine details will be affected as well. So you have limits as to how far you can go without causing problems to the photo. Overprocessing a photo to control noise can make it look very unnatural with odd-looking tonal and color transitions. You are much better off minimizing noise to begin with by shooting at the right exposure and minimizing your use of higher ISO settings.

VARIATIONS AMONG CAMERAS

As you might have guessed from the noise discussion, cameras vary in the way their sensors work to capture an image, and this affects what you can do in Camera Raw when processing their images. The size of a sensor's photosites, for example, has a big effect on image quality, although to really see differences, you have to compare two sensors at the same level of technological development. New innovations in sensor manufacturing allow manufacturers to pack more photosites into a given sensor size (which results in smaller photosites, too), yet gain increased performance from them.

Still, you see a difference in image capabilities when comparing a large-format dSLR to a small-format (APS-C) camera. Both are capable of superb image quality and offer some unique photographic advantages. However, the APS-C sensor size will have more limits on its sensitivity and will show more noise, as described previously. At low ISO settings, such cameras are capable of stunning results and even the lowest price "amateur" models have the facility to capture RAW files. This makes them very versatile, but also limited in range.

A large-format or full-frame dSLR has a larger sensor with corresponding larger photosites that allow it to react to larger amounts of light. That results in more sensitivity and greater response to light and color. But there is also a trade-off. These cameras are more expensive and require bigger and heavier lenses to get the same visual effect. The small-sensor cameras allow lens manufacturers to make smaller lenses and you can get more of a telephoto effect with less focal length in your lenses, too.

Sensor design also affects how a sensor sees light and color. Many of you will be surprised to discover that when you set two different camera models from the same manufacturer to the same white balance, for example, the colors do not match (regardless of whether the white balance is set in the camera or in Camera Raw). This does not always happen — it depends totally on specific camera models but is frequently noticeable when comparing a newer camera to an older model.

In addition, the response to various colors can change from one camera's sensor to another's sensor (different camera models — they will be consistent in a given model) so that you cannot precisely match images shot with two camera models. This can be a challenge when you deal with skin tones, as shown in figure 2-47. If you need images to match, you need to shoot with the same camera models at this point in digital camera development. Even the great flexibility of RAW and the power of Camera Raw do not allow you to otherwise easily match colors and tones. It can be a real workflow nightmare if you have not checked how your cameras match in color and tone.

2-47

Q&A

How can I know how the sensor of my camera deals with noise?

This is not an easy question to answer because there are no noise standards in the industry and camera manufacturers do not like to deal with it except to say their cameras have low noise. There is no way to directly compare cameras short of shooting the same scene at the same exposure with them to get a subjective feel for the noise. No one has established a noise meter that allows you to objectively compare different cameras. Even to interpret some of the hard-core digital camera Web sites, you have to know who is doing the review and have access to a camera that has been reviewed by that person to have a point of reference.

There are some guidelines to keep in mind, however. One is sensor size — you'll usually find that if you compare cameras with the same megapixels, that the one with the physically smaller sized sensor produces more noise. This is why a 10-megapixel compact digital camera produces more noise than a 10-megapixel dSLR. In general, camera manufacturers are aware of the noise issue and are working very hard to create new cameras with less noise. The latest cameras will typically have better noise characteristics to their images than older models, even when megapixels go up.

How can exposure affect color in Raw, even if the exposure is within the range of my camera's sensor?

A sensor captures color differently depending on the intensity of the light hitting the sensor (which is affected by exposure). Consider this: If a color is greatly underexposed, it looks nearly black. There is very little *chroma* or color information in it. You can make it as light as you want, but it still looks more gray than colored. No matter how hard you try, you cannot get the full color that was originally there in the actual subject. The same thing happens when you expose colors near the bright end of the tonal range — colors wash out so that even if you darken the tone, you can never fully show the original color of the scene. This is why proper exposure is important for colors, too, so that you can get the richest and most accurate colors from your scene.

Some histograms have colors for the graph. How can I use them?

The colored lines represent the color channels of your digital image file — red, green, and blue (RGB) — and tell you how exposure affects them. But reading them depends partly on the type of photography you do. For photojournalists, nature photographers, wedding photographers, and others who basically deal with natural light conditions occasionally enhanced with flash, the separate colors are of little value. If you can turn them off, you'll find the histogram easier to read and understand for these types of photography.

However, when there are critical issues with color, which can be an important concern for some types of advertising photography, the color histogram can provide additional information worth considering. It is harder to read than the standard histogram because the different colors interact. On a broad view, you can think of it as showing where the colors are in terms of tonalities in the photograph and if you are getting such bright colors that there is clipping in a channel.

Because the color channels of the histogram are not heavily used by most photographers in-camera, I am not going to go into much more analysis of them. I know very few photographers who pay much attention to them while shooting. If you want to experiment and see what happens with exposure, try photographing subjects with one solid red, green, or blue color, such as a blue ball. Change exposure and see how the colored histogram changes with these broad colors.

Can I measure how the sensor of a particular camera deals with tonal range?

To a degree, yes, although to get a really precise measurement, you need some sophisticated measuring tools. Here's one simple way to do this that works, though it isn't particularly for the really technical minded:

1. Set up a subject with a few different, but flat tones. A good way to do this is to put a middle gray, white, and flat black together. (You can buy special exposure cards with this combination.)

2. Set your camera to JPEG, not RAW, for this test. JPEG processes the file simply and the camera tries to get the most tonal range possible. Because it has trouble with the very bright and very dark when shooting directly to JPEG, the camera will give you an image that can be examined more to see tonal range extremes. This information provides a good feel for the tonal range possible from your camera even though the RAW file will do a better job.

3. Shoot the combination cards after metering (in manual exposure) on the middle gray card. Then gradually add half a stop of exposure for about five f-stops (this puts you out of range for the sensor). Repeat this by decreasing exposure by half a stop at a time, also for about five f-stops.

4. Examine your images on your computer screen (do not use the camera monitor). Find the exposure in the dark sequence when the middle gray turns to black and matches the tone of the black area.

5. Find the exposure in the light sequence when the middle gray turns to white and matches the tone of the white area.

6. Check the metadata for each of these exposures and compare them. See how many f-stops of exposure difference there is between these shots and you have a rough idea of the sensor range.

Chapter 3

COLOR AND RAW

From snapshots to advertisements, color is the main way we see photographs, as shown in figure 3-1. Black-and-white photography is still important, but now it is seen as something special and unique — not the everyday photography it used to be when *Life* magazine was at its peak.

Mostly, color has been connected to RAW when discussing white balance and the ability to change color in Camera Raw. RAW has not often been talked about in terms of color quality. This, I believe, is unfortunate. Colors in a photo are strongly affected by exposure, as I discuss in Chapter 2. In addition, exposure and white-balance choices you make while shooting will affect your workflow, and sometimes in a rather negative way. You may be able to get the colors you want, but at a cost of time and even frustration while you're working on the images.

This doesn't have to be a big burden. Understanding how you can deal with color in RAW and then keeping a few simple things in mind can be all you need. There is no question that shooting digital, and especially RAW, requires learning some new tools, and it elevates the level of craft in photography. But like any craft, after you work with it a while, it becomes second nature. Cameras used to be very simple, but over the years many great features have been added that complicates their operation. Still, photographers have learned the controls and gained new possibilities from them. The same is doable with digital.

3-1

Good RAW is Good Color

In Chapter 2, you learned why good exposure is important to getting the best results from RAW. I touched on color, although I didn't select the examples of good and bad exposure to show off color. The photos in figures 3-2 and 3-3 do this. The changes between these shots are strong — figure 3-3 is purposefully underexposed from the good exposure of figure 3-2. Such an exposure change allows you to see such color effects easily so you can recognize what can happen. You can compare your own camera's results by doing a similar exercise:

1. Set your camera to a specific ISO and white-balance setting (do not use Auto white balance). Shoot in RAW.

2. Shoot two exposures of a subject with a wide range of color tonalities and good gradations between them. Shoot one exposure correct for the subject (following the histogram guidelines of Chapter 2) and one that is 1 to 1.5 f-stops underexposed.

3. Process the good exposure in Camera Raw just enough to make it look good. Process the other exposure to match, as best you can, the good exposure.

4. Compare the two images.

The difference between the way the two images in figures 3-4 and 3-5 were shot is exposure. Adjusting a good exposure in Camera Raw takes very little time. Adjusting poor exposure can easily triple the time involved. Even then, you may discover the color does not match (it is not as obvious on the printed page of a book as on a print from an inkjet printer). There is a color shift with certain colors, but there shouldn't be. This is strictly because of the underexposure and the processing necessary to compensate.

3-2

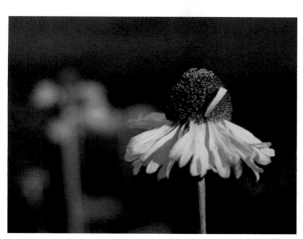

3-3

3-4

3-5

PRO TIP

Remember to regularly check your histogram. You
do not need to do it after every shot — that is a
waste of time. But check it as the light changes or
after a long set of shots to be sure your expo-
sures are giving you what you will need.

Figures 3-4 and 3-5 are the magnified versions of fig-
ures 3-2 and 3-3 — note the big problem of noise
from the underexposed image (figure 3-5). Some of
the problems with color also occur due to this
increase in noise and, even when problems do not
show up directly at a given image size, they still affect
the tonal gradations of the image. In addition, the
underexposed image's color is harsher and has poorer
tonal gradations. This also is not as obvious on a
printed page in a book as on an image produced by
your own printer. Good exposure always means you
have the best chance of getting the best color.

ADOBE RGB VERSUS SRGB

You have to make an important choice about color
space when shooting digital. It so happens that
you can change your mind when you're processing a
RAW file, but you still have to make this choice in the
camera. This is very important if you are shooting

RAW + JPEG as this will be the color space embedded
in the JPEG file. (When you're shooting RAW, this
choice is registered in the *metadata* — information
about the file — that is recorded when the camera
saves a RAW file. The RAW converter can then read
this to serve as a starting point for you to work with.)

Adobe RGB (red, green, blue) and sRGB (standard
red, green, blue) are color spaces that you can use to
control and adjust color. A *color space* is a defined
range of colors with which a digital file can work. The
Adobe RGB space is larger than sRGB. This means it
has a wider range of colors with which to work.
Figure 3-6 illustrates this point with two buckets of
pigments — Adobe RGB is a bigger bucket. Because
sRGB was developed to make good use of the capa-
bilities of the computer monitor, a myth has evolved
that sRGB is only for images that will be displayed on
the monitor, especially Web photos. Belief in this myth
can lead you down a path that may be inappropriate.

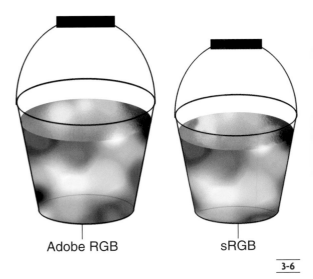

Adobe RGB sRGB

3-6

There are far more color challenges that come from
shooting the image at the wrong exposure than you
can ever get from choice of color space Adobe RGB
has versus sRGB. While sRGB offers a somewhat
smaller color space than Adobe RGB, this is no differ-
ent than choosing a film. Digital photographers who

once shot film touted one film over another because they liked the color, not because one film gave more color to work with than another. For example, Fujichrome Velvia has a far more limited color space than Fujichrome Astia, yet most professional nature photographers preferred Velvia for its color. You cannot look at a photograph and tell whether it comes from one working space or the other — it is actually difficult to show you the differences in a photo printed in a book like this, and the two spaces are not adjustable in ways to easily make them match. Figures 3-7 and 3-8 show the same image with different color spaces. If they weren't near each other, you would be hard pressed to say one is better than the other except for personal color preferences. They will adjust differently in Photoshop, with Adobe RGB offering more flexibility, but not every photograph needs it.

3-7

3-8

PRO TIP

When I try to balance the sRGB versus Adobe RGB claims, I receive odd comments from some professional digital processors that I favor sRGB and that this can lead the faithful astray. I do not favor sRGB over Adobe RGB. I actually use them both. What I defy is the blind recommendation of using Adobe RGB by everyone regardless of individual needs. Use whichever space works best for your particular situation.

COLOR SPACE FOR THE PURPOSE NEEDED

Since you can easily change color space in Camera Raw and Adobe RGB does give you more to work with, why should you even care about sRGB? The choice comes down to what you need in color, personal preferences, and workflow. I usually set my camera to give me JPEGs as sRGB even though I process my RAW files as Adobe RGB. I shoot RAW + JPEG because I gain a set of images in the JPEG files that can be processed quickly and easily, plus I can immediately print them directly from a small printer that handles direct printing or take the images to a local printer.

JPEG sRGB files can be handled much faster and easier with consistently better results when doing this sort of thing. I often need to make quick prints to give to folks that I met during my shooting. If you ever promise photos to someone, be sure you deliver on that promise. Otherwise you will sour those people on photographers so that they will be less friendly to the next photographer. If I shot only RAW, I would not be able to get these prints so quickly and easily, plus sRGB usually works better for the one-hour sort of lab prints.

Don't ever let any digital guru make you feel incompetent for using sRGB. If it gives you the results you want, then it is the color space to use.

WHITE BALANCE: A RAW WORKFLOW ISSUE

White balance is one of the greatest features of digital photography. In the days when film dominated photography, it was a real pain to balance the colors of the scene to the capabilities of the film. It took a lot of filters, special meters, and much trial and error. Many photographers just said, "Forget it!" and strictly shot under controlled light (usually electronic flash, which was balanced for daylight films).

PRO TIP

Color is always greatly affected by light. Sometimes the only way to achieve better color is with better light, such as using a flash or quartz light to control what is happening to your subject. This can range from flash fill outdoors to controlled indoor situations.

3-9

White balance changes all that. Now, you can get great-looking color from most natural light situations without filters or controlled light, plus you can control the rendition of that scene's colors for creative effect, as shown in figures 3-9, 3-10 and 3-11. You can do this in the camera or in Photoshop. Shooting RAW makes this very easy to do and with no quality loss. You can even change a setting made in the camera to a different setting in Camera Raw.

PRO TIP

White balance removes the need for many color correction filters. However, you can control color in interesting ways by shooting your camera on a white-balance preset, such as daylight, and then using a particular color filter, such as a fluorescent correction filter, for its unique characteristics.

3-10

3-11

> By choosing a white balance while on the scene with your subject, you can compare what you are seeing in the LCD with the actual scene, such as that shown in figure 3-12. You now can be confident that your white balance can be used as a solid reference for dealing with adjustments to the scene.

3-12

> Auto white balance can be a compromise and give you a weaker interpretation of the scene, which is then what you first see when opening Camera Raw.

> Locking down a white balance on critical color situations, such as product photography, can mean a much more efficient workflow in finishing the images in the computer.

> Auto white balance can often change white-balance readings as you select a new focal length or reposition your camera in a scene (so that it sees a different background, for example). If the resulting photos have to match, you have more work to do in the digital darkroom to make them the same.

White balance actually comes from the video industry. This has always been a standard part of professional video production. Cameras are pointed at a white card in the scene and the camera makes the white card a neutral white. White balance in a digital camera tries to do the same thing. When the camera sets white balance and you are shooting RAW, it keeps that information in the metadata recorded along with the actual image. Then when you open that photo in Camera Raw, the software recognizes that setting and adjusts the image appropriately.

WHITE BALANCE IN THE CAMERA

But why choose a white balance in the camera? You can, after all, change it at any time later in Camera Raw. There is no quality difference, and leaving the camera on Auto white balance just means one less thing to think about when photographing. While there is absolutely nothing wrong with working that way, I like to choose my white balance while shooting for several important reasons, all related to workflow and image consistency. Consider these ideas:

> **Choosing a specific white balance while shooting brings a stronger discipline to the craft.** This encourages you to get the shot the best you can, even in difficult white-balance situations, like that shown in figure 3-13. It leads to a more hands-on experience.

> **Auto white balance can be a compromise.** Color that looks right when the image is opened in Camera Raw can fool the photographer into thinking there is no need to go any further to find a better mix of color.

> **Apparent exposure can be affected by the white-balance setting.** Technically, white balance is only a set of instructions in the image file's metadata, so it can't actually change an exposure. But it will affect the appearance of brightness in an image: if you set it yourself at the time of photography, you can be sure you make the proper exposure corrections.

AUTO WHITE BALANCE

Manufacturers have worked very hard to make Auto white balance work well. It really is to their advantage to make cameras do well on automatic for the great mass of amateur photographers because that translates to satisfied customers and potentially more camera sales.

And Auto white balance is not just for amateurs. Pros use it in mixed and changing lighting such as that seen in figure 3-14 because, frankly, that is the only way to get good white balance. If you are a photojournalist following the president of the United States from meeting hall to hallway to outdoors and must constantly change white balance, you miss shots.

3-14

3-13

PRO TIP

Auto white balance often works best with JPEG shooting. This is because the camera includes additional in-camera processing with advanced white-balance algorithms to further tweak the colors before recording the image to the memory card.

For the photojournalist, good Auto white balance is a real help because it means acceptable color is always possible in an area where the action and context of the image is far more important than precise color. Plus, news photos are usually used singly so they do not need to match others.

But Auto white balance can have problems, as I discussed previously. When the colors are critical, important colors can have the wrong hues or an inadequate balance with the rest of the scene. In addition, Auto white balance frequently gives weak color renditions of natural scenes compared to the way you expect such scenes to look based on your experience with film. It does not know that you want a sunset rich with warm colors — it may try to neutralize some of the colors, for example. Finally, if you shoot three photos of the same scene, each with a different focal length or background, which color of your subject is correct?

PRESET WHITE BALANCE

Digital cameras come with a set of preset white-balance settings. These allow you to lock white balance to a specific adjustment. Most cameras include presets for daylight, shade, cloudy, tungsten, electronic flash, and fluorescent. The continuous quartz light used for the subject in figure 3-15 was balanced with a tungsten preset. Each preset produces a consistent and reasonable interpretation of the light under those conditions. You can change lenses or move around, but as long as the light doesn't change, the colors of your subject stay firm.

Some cameras include additional presets and controls to tweak the presets. This can be very useful for precise work as you can adjust a preset to better match the specific conditions you find in a particular shoot-

3-15

ing situation. The important thing to remember about a preset is that it locks your camera to a specific lighting condition, such as using a daylight preset for a sunset (figure 3-16), and in RAW, that preset is interpreted by Camera Raw when the file is opened in it.

PRO TIP

Keep in mind that how the group of predetermined or "preset" white-balance settings are named is not consistent in the industry. For example, Nikon uses the term *preset* when referring to custom white-balance settings, but other manufacturers usually call them *custom settings*. Whatever the manufacturer calls them, the predetermined white-balance settings always include choices such as sun, cloudy, fluorescent, and so on.

3-16

You can also use white-balance presets to change the response of the camera to the scene. For example, you can use a setting like cloudy when shooting in daylight to warm the scene, or at sunset to make the scene look richer in warm colors. Or, in daylight, the daylight preset keeps things pretty neutral, while shade, cloudy, and electronic flash warms things up and tungsten cools things down. Fluorescents have varied responses. If you aren't sure about this, try the setting, shoot a photo, and check the LCD. While the image in the LCD is not perfect in its renditions of color, it gives you a good idea of what is happening.

PRO TIP

Try custom white balancing on a pale color, such as a paint sample from the hardware store or white balance cards from specialty vendors, for controllable color effects. When the camera white balances on a pale blue color, for example, it removes that color, making the whole scene warm up dramatically.

CUSTOM WHITE BALANCE

This is a secret weapon of a select group of pros and photo enthusiasts. While custom white balance is available on all dSLRs (digital single lens reflex cameras) and most compact cameras, few photographers

use it or even know about it. I have even asked some pros about their experience with custom white balance and received a blank look in return.

Custom white balance allows you to precisely balance your camera's response to specific lighting conditions on your subject. This often gives you the most neutral colors possible for the scene. You use a white or gray card, have the camera measure the card's colors, and then make the card neutral. You can put that card in exactly the light on your subject, in exactly the position of your subject (or nearby if the subject doesn't allow this) so you can create a white balance customized for it.

Unfortunately, cameras, even models from the same manufacturer, do not have consistent ways of measuring a custom white balance, so I can't give a step-by-step outline for this process. You must check your camera's manual. But to give you an idea of the process and show you certain things to look for, here is the process used by a common Canon dSLR:

1. Shoot a photograph of something white or gray in the light that hits your subject. This does not have to be in focus in spite of some camera manual's recommendations, but it does have to fill most of the image area.

2. Push the Menu button and go to the Shooting menu.

3. In the Shooting menu, find the Custom WB entry and select it.

4. Now the image you just shot should open with some instructions.

5. Follow the instructions by pushing the Set button — the color in the card will be removed. Now, set the white-balance mode to the custom icon (it is a small black dot over a V-shaped depression in a small horizontal rectangle).

6. The camera saves this white balance as a preset for this particular light, even if you change to other settings, until you do a new custom white balance.

Color Temperature of Light

The color of light is referenced by a scale that starts at 0 and essentially goes to infinity. It is based on the heating of a theoretical sphere and is warmer (red or orange colors) at low temperatures, cooler (shades of blue) at high temperatures. This is the Kelvin scale, and though it uses "temperatures," numbers are not referenced with the degree sign.

Two things are critical for the photographer: the warm/cold color range and the relationship of different colors on the scale. Color temperature is based on a palette of warm and cold colors, which is essentially an amber to blue scale. Other colors, such as the magenta to green range, are affected, but are not directly related to it. In addition, if you compare two points on this scale, the one with the lower temperature is always warmer than the higher temperature.

This is directly applicable to color balance in a digital camera. If you balance to a specific color of light, that light will be neutral in color, but then other lights will be warmer (lower in temperature) or cooler (higher in temperature); this is one thing that separates real-world light from studio light (which is consistent in color temperature). Typical color temperatures include tungsten lights (2400K to 3800K), quartz lights (3200K), midday daylight (5000K to 5800K), cloudy day (6000K to 10,000K), and open shade (8000K to 20,000K).

■ **How much can I trust the camera's LCD for judging color?**

A simple answer is to use it as a guide, not an exact rendition of the image, but it also depends on the camera and LCD. I used to see cameras with horrible LCD output that gave little idea of what the color of the photo would look like, but you won't find that on today's digital SLRs. I have seen cameras now that have a great correlation between their LCD screens and image color.

You can test this very simply:

1. Shoot some casual photos within walking distance of your computer.

2. Check the LCD for all of them, and then download them immediately onto the computer.

3. Review the shots on the computer. Do they match what you remember?

4. Put the memory card back into the camera and play back the images on the LCD. Now compare them to the computer screen. I give you both steps 3 and 4 because they give you different reference points. You will not have a computer to compare images to when shooting most of the time, so it helps to consider both the direct comparison and the memory check.

5. See where the biases are with your camera's LCD and keep them in mind when evaluating images on it in the future.

Really, isn't Adobe RGB a better color space than sRGB?

That all depends on what the criteria for better is. If *more* is important, as in more color range to adjust, then Adobe RGB is better. On the other hand, if *faster* and *easier* is important, then sRGB may be the better color space.

A lot of things in the digital color world are very subjective. Having an absolute *better* only works when the criteria for that better are defined and known. For example, which is better — four-wheel drive or front-wheel drive? The answer depends on driving conditions and needs of the car owner. If you only drive the streets of Los Angeles, four-wheel drive has some distinct disadvantages, including poor gas mileage. But if you need to go off-road, four-wheel drive is the way to go.

The same thing applies to color space. When I am shooting quickly with JPEG, I use sRGB for its speed bene-fits. Because a RAW file can go either way, I can leave the camera set to sRGB, knowing that I can choose Adobe RGB with that file later in the processing with no loss in image quality. I do typically process RAW files to Adobe RGB, but depending on the situation, there is a strong benefit to just setting the camera set to sRGB when I shoot Raw + JPEG (which I frequently do).

WHAT'S NEW IN ADOBE CAMERA RAW?

Camera Raw got a major improvement with the release of Adobe Photoshop CS3. In many ways, this change to Camera Raw was reason enough for many of you to upgrade to CS3. Camera Raw has always been an excellent part of the Adobe Photoshop workflow for those of you working with RAW files, but before, it always felt like just a conversion program that supported Photoshop rather than a program that could stand on its own. Obviously, Camera Raw had a lot of power as a conversion program or there would not have been much in the first edition of this book. Still, Camera Raw seemed to act more like a supporting plug-in than its own program. Camera Raw 4.0 changed all of this when it was released with Photoshop CS3. And quickly after 4.0 came 4.1. Though Camera Raw is constantly getting upgrades to keep up with new proprietary RAW files from the latest cameras on the market, these are typically changes that allow the program to read the new files. This was not the case with 4.1 — some significant and highly useful features came with it.

MAKING RAW PROCESSING MORE PHOTOGRAPHIC

The good folks at Adobe are always at work striving to improve their products. Camera Raw has now achieved a new stature as a photographer's software program. You truly can work an image in Camera Raw, as shown in figure 4-1, never go to Photoshop, and get a great photograph, as shown in figure 4-2. Sure, you could do that with earlier versions of Camera Raw,

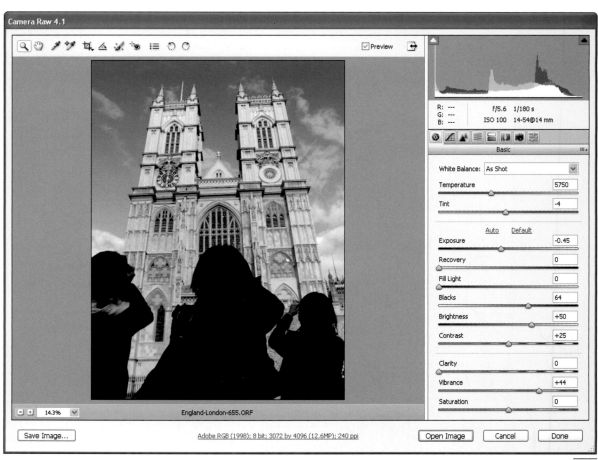

4-1

but truthfully, this was not its strong suit. I never used the old Camera Raw alone — I always felt I needed Photoshop to finish the image. With the new tools in Camera Raw 4.x (all version 4 variations), I feel confident that I can work with an image in Camera Raw and get a well-processed photo without going into Photoshop. (To be honest, I rarely work that way: I usually need the localized control that comes with Photoshop, but I really do like the confidence I have now in being able to do a lot in Camera Raw.)

Along with new tools, Adobe has changed many controls to be more photographic, meaning that they relate directly to photographers' needs in working an image. For example, Shadows is now Blacks. This control has always been for setting blacks in a photo, not adjusting shadows, but in this version, Adobe really got it right.

New adjustments have been added, including Recovery and Fill Light, shown in figure 4-3. Again, Adobe now uses terms that make sense — in this case, recovery of detail in bright areas and filling dark areas with light so more things can be revealed.

The Saturation control was always a little heavy-handed for photographers, no matter how you used it, in both Photoshop and Camera Raw. Now, you get a whole new control for saturation, Vibrance, and the ability to individually adjust the hue and saturation of colors. You can also adjust colors without losing tonal information, therefore getting much higher quality in colors. Another great new tool is the Retouch tool. Dust on the sensor can really damage a good photo. In the past, you had to go to Photoshop and use the Healing brush, Clone Stamp tool, or other tools to fix annoying dark blobs from dust. Now you can do it in Camera Raw. The Retouch tool might be better named the dust tool — Adobe engineers wanted a more generic name for the tool. I'll get into all of this in more detail in future chapters. The point is that Adobe has put together a really nice little program in Camera Raw that addresses the needs of the average photographer who simply wants to adjust his or her images and not get involved in the technical aspects of the computer or image processing.

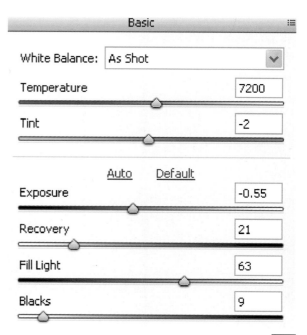

4-2

4-3

SOME CHANGES TO THE INTERFACE

Changes to the Camera Raw interface are more of an evolution than anything dramatic, but they do affect how you work with the program. In addition, these changes add to the impression that Camera Raw is increasingly becoming more photographer-oriented.

The first thing, as shown in figure 4-4, is the simplified bottom area of the interface. All of the information you see here used to be listed in multiple rows and columns of separate, changeable items. The new format cleans up the presentation considerably and makes it easier for you to use. The information in the center typically does not change for every image; you can change it by clicking on the words to get a dialog box as needed. This new format makes this information seem like a simple reference about data rather than added choices to think about every time you work on a photo.

The Open and Save buttons have now been rearranged, too, so that you can easily access and choose them. While this change is not huge, I do think it makes the workflow more efficient as most of you are likely to first use the buttons on the right versus the Save Image button on the left.

I really like the addition of color and tones to the sliders in the adjustment panel, as shown in figure 4-5. I don't care how advanced a user of Camera Raw you are, sooner or later, you blank on which way to make a control go. These colors and tones really help, and they are especially useful for those of you who are not so familiar with Camera Raw. This is especially true for the Temperature and Tint sliders. Now you don't have to guess or try to remember which direction does what. The colors show it to you.

The Adobe designers have done some interesting things with the tonalities of the controls, too. Exposure now goes from black to white (left to right) and reflects how it deals with highlights. Blacks goes from light to dark to show how it works the darkest parts of the image. Fill Light and Recovery do similar things to also visually display what they do.

Another change to the adjustment panel is the removal of the automatic check boxes. This was an annoying part of Camera Raw for most pros and serious amateurs. They did not want automatic adjustments coming up by default. Now, if you want to try automatic adjustments, you simply click the Auto link and you get them as needed. This really cleans up the interface and makes it work better. Sometimes the Auto link helps with problem pictures, but one problem is that it

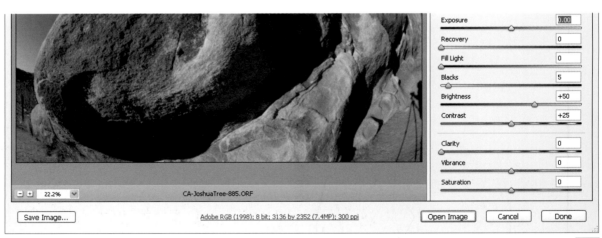

4-4

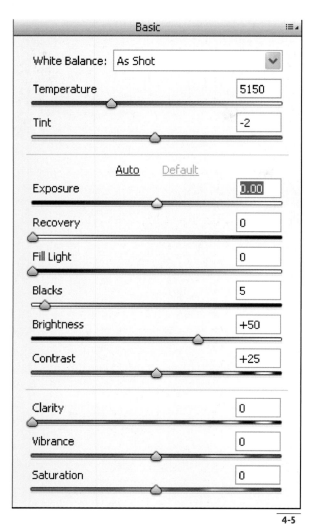

4-5

adjusts all the sliders and gives you no way of selectively making automatic changes except by going back and readjusting individual sliders.

The Default link appears next to the Auto link and becomes active as you work an image. It puts all of the sliders back to their default settings based on how the image came into Camera Raw.

PRO TIP

You can reset any adjustment using sliders in Camera Raw by double-clicking on the slider knob, — the control that you actually slide.

Two areas have been expanded to add controls: the Toolbox at the upper left, as shown in figure 4-6, and the tabs for adjustment groups, as shown in figure 4-7. This enabled Adobe engineers to add some tools and adjustments, while keeping the interface simple, accessible and well organized.

One very noticeable change for the tabs is that they are now icons and not words. I found this a little disconcerting at first because I could not remember which symbol meant which control. And frankly, the symbols are not all that intuitive. But after a bit, you get used to them. I don't consider this good or bad,

4-6

4-7

but can see why Adobe went this direction — there isn't enough space to include eight tabs with text descriptions. That would make a confusing set of tabs.

When you look at the Toolbox, you may notice it no longer includes buttons for highlight and shadow alerts. You may know from my other books that I do not like these alerts because of their strong color, but they are still available. Now they reside at the upper corners of the histogram, as shown in figure 4-8, which makes more sense.

4-8

FIRST TAB CHANGES — TONAL ADJUSTMENTS

The right panel of Camera Raw now has an added depth for tonal adjustments that it did not have before. You can see this immediately in figure 4-9. If you compare it to versions of Camera Raw earlier than 4.0, the older adjustment panels look sparse and simplistic.

Even though the tab for the panel shown in figure 4-9 is called Basic, the adjustments are not basic as in simplistic, but as in essential. This is where all good adjustments start and you now have some extremely valuable controls. As I mentioned before, Blacks is a better name for what it does: adjust the black point of the image. Exposure might be better named Highlights, but it stays the same as the past.

The really big changes are the controls that refine how the dark shadows and bright highlights of an image are adjusted: the Recovery and Fill Light controls. Such controls really first saw life in Adobe Photoshop Elements. Elements was (and is) a program designed to relate to the average photographer. Photographers

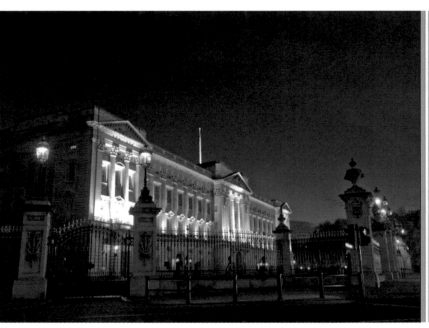
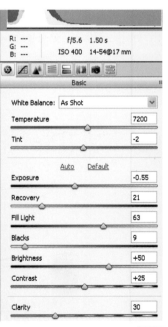

4-9

wanted bright backgrounds subdued and shadows lightened, but didn't know how to do it easily. Elements gave them a control for the background light and for easily brightening shadows.

Why not offer this for every photographer! Who doesn't run into problems with backgrounds and shadows? Camera Raw addresses that with Fill Light and Recovery (though with different algorithms than Elements). This is especially great with RAW files because you have more data to work with in the dark and light areas as compared to a JPEG file. Fill Light does just that, fills the dark areas with light, bringing out detail. Recovery is also aptly named as it allows you to recover the detail in the bright areas that might otherwise have been lost. The result is that you can often bring out detail in dark regions and bright areas that are at the edge of your sensor's capabilities.

Clarity is another new tonal adjustment, though curiously, the Adobe designers put it into a group with the color controls Vibrance and Saturation. That is odd because they recognize it as a tonal adjustment by giving it a slider with a visual representing a tonal change — nothing to do with color. Regardless, it is an interesting new control that gives you more ability to bring out small tonal details in the midtones of the image. This is reflected in the slider, which changes from blended grays at the left to contrasting tones at the right.

PRO TIP

A neat little adjustment trick that has now moved from Photoshop to Camera Raw is the ability to click and drag adjustments by clicking and dragging on a word rather than hitting a slider exactly. This speeds workflow. As you move your cursor over the adjustment title, such as Exposure, the cursor changes to a hand with an arrow. Now you simply click and drag left and right to make the adjustment do the same thing.

FIRST TAB CHANGES — COLOR ADJUSTMENTS

Vibrance may only be one slider in the first tab, as shown in figure 4-10, but it represents a significant change in the way Adobe products deal with color enhancement. Traditionally, Photoshop used Saturation as a control to increase or decrease the saturation or color intensity of all colors in a photo, and that control went into Camera Raw. That led to some challenges when some colors needed intensification but others did not. It was especially a problem with reds and other bright colors that were already saturated. Saturation adjustments made them even more intense and often garish.

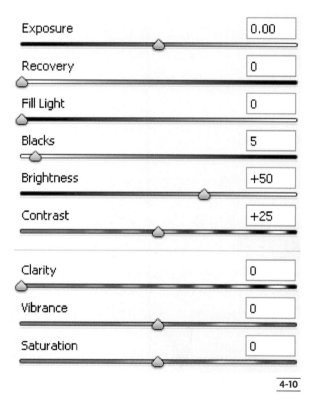

4-10

Vibrance comes from a RAW converter called RawShooter made by Pixmantec. Adobe bought the company and began to incorporate some parts of Pixmantec's products into their own. Vibrance first

showed up in Photoshop Lightroom, then came into Camera Raw. This control is a less heavy-handed adjustment compared to Saturation. It examines the existing intensities of color and intensifies the colors with less intensity than those that are already saturated or approaching saturation. It is a gentler and more appealing way of adding saturation for many photographs and photographers.

TONE CURVE CHANGES

As shown in figure 4-11, there is a major change in the Tone Curve, the second tab in the adjustment panel. It first opens to a "Curves"-looking graph, but you cannot click and drag on it. This is called the Parametric curve and has its own subtab on this panel. If you go to the Point tab, you will see the same Tone Curve as used in the earlier Camera Raw versions, a curve that you can click and drag.

While many Photoshop experts consider clicking and dragging on a curve just basic Photoshop, it is not exactly familiar or comfortable for photographers. Many who use it still feel they are not getting the most from it. The Parametric curve limits how the curve can be adjusted so that adjustments can be defined by Highlights, Lights, Darks, and Shadows. I had to look up parametric to see why the Adobe engineers chose that word, and in fact, it does refer to limiting the way something can be done, so it is indeed a right description for this new way of working a curve.

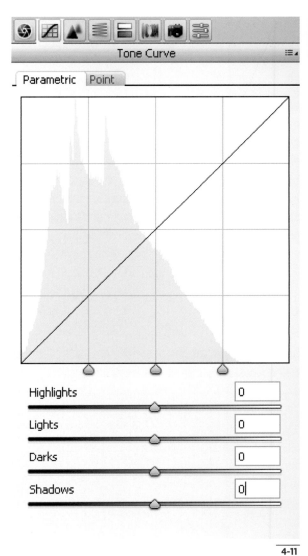

4-11

This way of adjustment was first seen in Photoshop Elements 5.0, and then further evolved in its application to Photoshop Lightroom. It is good to know that Adobe engineers are talking to each other from different work groups so that well-made designs for photographers carry through all of the programs. I have found that many photographers really like this parametric design because it better fits their way of thinking. They don't necessarily think in terms of how a curve can be changed to adjust a photograph; they think in terms of the photograph and its highlights,

midtones, shadows, and so on, then what needs to be done to those areas and how they are affected by a curve. The new Parametric Tone Curve answers that need.

CHANGES TO THE DETAIL TAB

The Detail tab of Camera Raw was a functional, though often rarely used, part of Camera Raw. For many photographers, the sharpening part of this tab seemed too simplistic and more controls were available in Photoshop or sharpening plug-ins. In addition,

there were good reasons not to sharpen in Camera Raw and to sharpen later in the workflow in Photoshop.

Now that Camera Raw has become more "independent" in the sense that you can use it to process images quite well without ever going to Photoshop, sharpening becomes more important. In Camera Raw 4.1, sharpening also gained some totally new tools. Adobe had purchased the rights to the PhotoKit plug-in, which is well-recognized and -received for its approach to sharpening. Adobe incorporated its capabilities into both Lightroom and Camera Raw.

Instead of the single, and seemingly simplistic (though the algorithms behind it were not) sharpening adjustment available previously, Camera Raw now has four sliders, shown in figure 4-12, that work together to give you a high level of sharpening control. These offer new algorithms for sharpening and even include a fresh look at how you visualize sharpening.

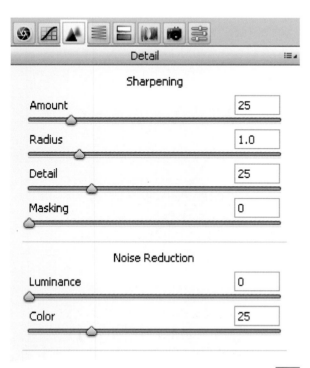

4-12

This now makes sharpening worth considering as a standard part of Camera Raw and to include this stage of sharpening in any image processing workflow. Sharpening can now be done with a great deal of control, precision, and capability. I would not hesitate to use Camera Raw's sharpening now even if I planned on doing a lot more work in Photoshop after the image was converted from RAW. The Detail tab still has the Noise Reduction section. While Adobe's new algorithms for luminance and color noise reduction offer improved results, the best noise reduction still comes from independent noise reduction software.

THE NEW HSL AND GRAYSCALE TAB

HSL/Grayscale is a new addition to Camera Raw and adds some important hue and saturation controls. At first, it may look a little intimidating, as shown in figure 4-13. (The tab is the fourth one in the adjustments panel.) All of a sudden you are confronted with a list of colors and associated sliders, plus you get three sets of them: one each for Hue, Saturation, and Luminance (and another set if you check Convert to Grayscale).

If you are familiar with Hue/Saturation in Photoshop, you will remember that you can adjust colors separately as to their hue, saturation, and color. HSL does the same thing, but instead of just working one color at a time with those controls as in Photoshop, you now have all the colors at once. This includes most of the same colors from Hue/Saturation, with some changes. Cyan is changed to a more user-friendly Aqua, plus Orange and Purple are new colors that you can individually adjust. Once you realize this, the controls become much more photographic and easy to use.

From a workflow aspect, this really does speed the process. You can quickly tweak specific colors, whether that is the hue or the saturation. This is a much better way to deal with color saturation than simply going to a master saturation control and moving it.

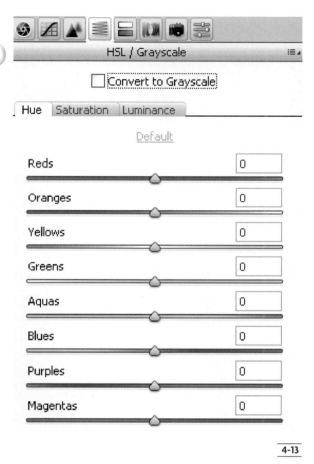

HSL / Grayscale

☐ Convert to Grayscale

Hue Saturation Luminance

Default

Reds	0
Oranges	0
Yellows	0
Greens	0
Aquas	0
Blues	0
Purples	0
Magentas	0

4-13

The Grayscale control is also quite a bit better than anything available in earlier versions of Camera Raw. Though I appreciated the quality I could get from converting an image to black-and-white in Camera Raw, I was never satisfied with the results compared to what I felt I could do in Photoshop. The key to doing a good conversion to black-and-white is how you control colors in their translations to black-and-white tones. This adjustment panel gives a whole range of colors that you can adjust separately so that each one changes its appearance as a darker or lighter tonality, as shown in figure 4-14. This allows you to go into the picture and change how colors look when they're converted to black-and-white.

THE NEW SPLIT TONING TAB

Split Toning, the fifth tab from the left in the adjustment panel shown in figure 4-15, is another brand-new feature for Camera Raw. It has been traditionally associated with black-and-white photography, but you can use it for color, too. Split toning is a way of adding color specifically to the highlights and shadows of a photograph. You can add color in terms of both hue (the actual color) and intensity. You can add this in both the amount and balance between highlights and shadows.

This allows you to color bright and dark areas of a photograph differently. For black-and-white, this offers some great color toning effects that offer a very rich black-and-white look. For color, this means you can change color balance between dark and light areas; for example, you can add warmth to highlights and coolness to shadows.

PRESETS

Adobe has been adding the ability to save preset sorts of controls to a number of their programs, most notably Photoshop Lightroom. A preset is essentially a set of standard adjustments that you want to save for use on other photos. Rather than processing every photo individually, you can set up presets to quickly process certain images with identical parameters. You

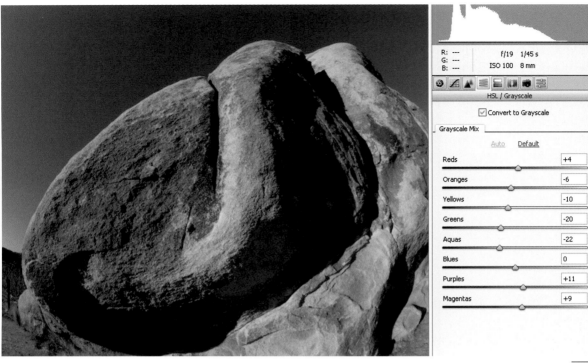

R: ---
G: ---
B: ---

f/19 1/45 s
ISO 100 8 mm

HSL / Grayscale

☑ Convert to Grayscale

Grayscale Mix

Auto Default

Reds	+4
Oranges	-6
Yellows	-10
Greens	-20
Aquas	-22
Blues	0
Purples	+11
Magentas	+9

4-14

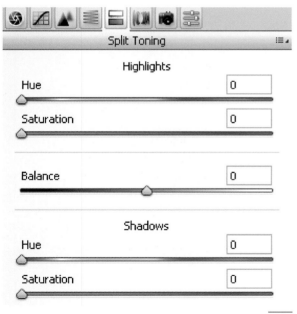

Split Toning

Highlights

Hue	0
Saturation	0
Balance	0

Shadows

Hue	0
Saturation	0

4-15

could create and use presets in earlier versions of Camera Raw, but it was a little clunky to do and to use. You had to go through some drop-down menus to save any sort of processing you wanted to keep as a preset.

Camera Raw 4.x really changes this and makes creating presets both easy to do and convenient to use. You create a preset based on any adjustments you regularly do to your photographs. You choose which adjustments to then keep in a preset, as shown in figure 4-16, with an extreme black-and-white adjustment. Name the preset and save it. It then shows up in the Preset tab, as shown in figure 4-17, ready for use.

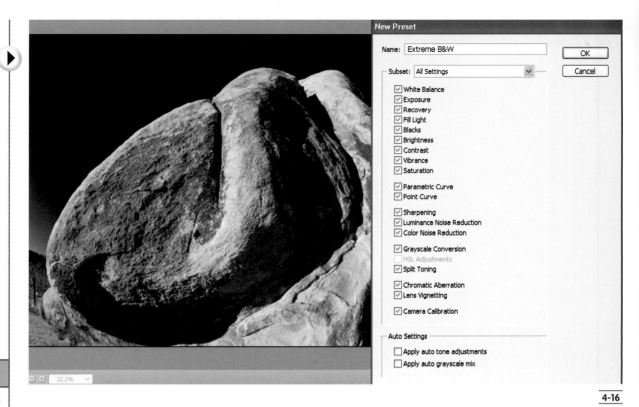

4-16

4-17

HOW LIGHTROOM AFFECTS CAMERA RAW

Photoshop Lightroom was developed by Adobe specifically for photographers. Photoshop was not originally developed and enhanced for photographers to use, but for people using photographs, such as graphic artists. That is significant — many a photographer has gotten frustrated by the way controls are set up and used in Photoshop.

Lightroom is a complete program designed to help photographers with their workflow when working with photographs from importing to organizing large groups of images to processing and printing them to use in slideshows and in Web galleries. My book *Adobe Photoshop Lightroom for Digital Photographers Only* (Wiley, 2007) offers a complete overview of how photographers can use this very powerful program.

Lightroom is also an excellent program for processing RAW files. But it handles image files quite differently than Photoshop and Camera Raw. For many photographers, Camera Raw is a simpler program to deal with, especially if they already know and use Photoshop extensively. Camera Raw plus Adobe Bridge (the browser program that comes with Photoshop) make an effective combination for working with RAW files, especially for the photographer who prefers to deal with images more on a one-by-one basis and does not need all of the features (or wants to learn them) that Lightroom has.

However, Lightroom has some excellent controls for processing RAW files, and Adobe engineers have included many of them in Camera Raw. In fact, the adjustment panels of Camera Raw are based, in many ways, on the controls in the Develop module of Photoshop Lightroom.

In addition, many of Camera Raw's adjustment controls came directly from Lightroom, as shown in figure 4-18. This includes Fill Light and Recovery, Clarity, Vibrance (originally from RawShooter), and HSL/Grayscale and Sharpening (by way of PhotoKit). I get the impression that working on Lightroom to make it very photographer-oriented made Adobe Camera Raw engineers more sensitive to the photographer as well. Both programs are valuable additions to the digital photography world and offer a great choice.

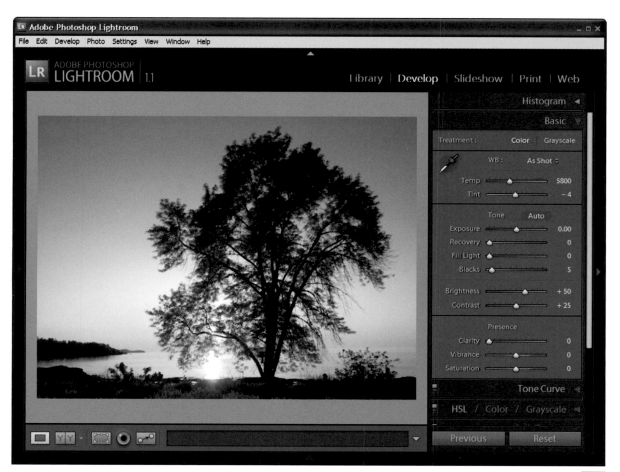

4-18

Q&A

■ **Over the years, it has been beat into my head that I should not sharpen an image until the end of the workflow, after sizing the photo for a specific use. I understand that Camera Raw has new sharpening capabilities, but I am still uneasy about using it for that purpose, which means timing of the sharpening now comes earlier in the process. What do you recommend?**

I was also reluctant to change my workflow and incorporate sharpening into it. Yet, the sharpening tools are so good and so well thought-out that I really had to reconsider.

Now, I generally set Camera Raw for an output size that is the largest I will typically be using for the image. I then use the sharpening capabilities in the Detail tab. By using the Alt/Option key as I use the sliders and setting the image at 100 percent, I get a black-and-white image that shows me exactly what the controls are doing. This is a big deal for me — I really like that control. Now when I output the image, I get a photo that is at the size I need and sharpened appropriately.

I find I can then make further adjustments to the image if I am careful not to try to do too much in Photoshop so that I do not have any problems from my timing of the sharpening, i.e., done in Camera Raw. However, if I need a photo at a significantly different size, I will usually go back to the original file and re-output it to that size so that I am not resizing a sharpened file. While I have done the latter without much problem at times, I can't recommend resizing your file if it has been sharpened. There is too much of a chance of having flaws introduced because of the process.

From what you say, it seems that Camera Raw and Lightroom have many similar capabilities. Do I need both programs or is one better than the other?

That depends on the criteria for *better*. Both will give quality images with workflow possibilities that will work for most photographers. But then it gets more complicated. Some photographers will prefer one, while other photographers will definitely prefer the other. It is hard to say which one any given photographer will like most. Both programs have distinct personalities in the way they work with data, and not everyone will like one personality over the other.

Frankly, I use both programs and really like them both. I would not have authored books on both if I did not. Lightroom is a complete workflow solution and great when you need that. But when you need to quickly adjust a couple of RAW files, Lightroom is probably more than you need. I typically use Camera Raw and Bridge (or ACDSee or Microsoft Expressions) to quickly access single images and process them quickly. Lightroom is not really designed for that.

However, Lightroom is superb for dealing with lots of images. Though you can set up Camera Raw to process multiple files, Lightroom is far better suited for that — you can do them faster and more efficiently there.

CAMERA RAW WORKFLOW

Part II

A QUICK LOOK AT CAMERA RAW TOOLS AND WORKFLOW

Workflow has become a real buzzword within image processing circles. Everyone wants to know what is the "best" workflow, how to optimize workflow, and so forth. Workflow, at its basic level, is simply how a photographer approaches working with his or her images. Because Photoshop is so complex and has so many different controls, plus cameras are gaining larger-size image files, workflow becomes more of a challenge.

Camera Raw, on the other hand, is both simple and complex. It is simple in that it uses an uncomplicated, easy-to-follow interface where all the controls directly relate to photographic concerns; with this interface, you can easily deal with workflow issues. If only Photoshop had such a straightforward interface! Unlike Photoshop, Camera Raw was designed strictly for the photographer dealing with a purely photographic need — processing an image directly from the camera. It is complex because it handles a great

deal of data in a RAW file and it offers multiple options on how to deal with it.

This chapter gives you a quick overview of Camera Raw and some of the key parts of its workflow. You can use it as a reference to the interface and how it can be interpreted. Although the figures show you many screen images from Camera Raw, you may find it helpful to open Camera Raw with one of your own images and follow along with this overview. (Many of the images in this book can be downloaded from my website at www.robsheppardphoto.com.)

It is important to note your version of Camera Raw. If you work with Camera Raw in Photoshop CS2 or earlier versions, you will be able to do much of what is described here; but you will also discover the latest versions of Camera Raw (Versions 4.0 and 4.1) include additional features such as the new tools and adjustment tabs shown in figure 5-1.

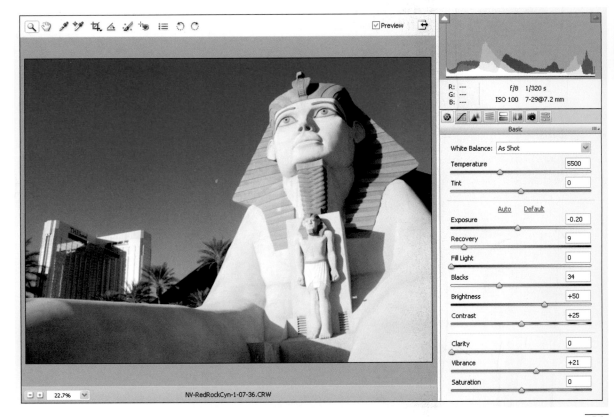

5-1

If you have not upgraded yet, use what you have and don't worry about the additional features until you can upgrade to Photoshop CS3. All of the major adjustment controls are in all versions of Camera Raw.

FINDING YOUR RAW PHOTOS

Before you can open a RAW photo, you obviously must know where to find it. Although filing and editing your photos is not of the focus of this book, it is an important part of your workflow. The computer really is just a virtual filing cabinet. If you had trouble finding slides or negatives before, you probably have the same problems on the computer, although there are some techniques that can make it easier to organize your images.

Browsers that recognize RAW files are an important way to deal with image files on the computer. These photographic programs show all files in a folder as small thumbnails on the screen. It is like looking at a lightbox, and just like on a lightbox, you can quickly sort, edit, and select the photos. Browsers let you rename whole groups of images, tag them with special edit criteria, print out contact or proof sheets, add IPTC data (photographer-specific information added to the metadata of a file), and much more.

Photoshop CS2 and earlier came with a unique browser called Bridge. It was actually a separate program that bridged multiple Adobe programs in the Creative Suite, such as InDesign or Illustrator if you had them. It was a versatile browser with a lot of power for organizing your images, but it had a serious downside. I rarely used it (most pros who understood this problem didn't, either) because it was slow, excruciatingly slow compared to other browsers on the market. It was fine for finding a specific image to open in Photoshop, but it was frustrating to use for editing unless you had some power to your computer.

Along came Photoshop CS3 with the promise of a better browser. I have to admit I was skeptical because the earlier Bridge was like working in molasses. But the new Bridge, shown in figure 5-2, is not the same program at all. It still functions the same, and gives you access to images on your hard drive, but it is now fast. Adobe engineers used some of the things they learned from creating Photoshop Lightroom to design Bridge so that it really would be useful for photographers. I'll show you how to use it in a bit.

Independent browser programs can also be a great option for sorting and editing photos. These include Microsoft Expressions (formerly known as iView Media Pro), Extensis Portfolio, and others. These programs access images quickly for editing and sorting. They also allow you to quickly tag and sort images into specific groups. Plus, they have many powerful and automated organizing tools.

Some things that affect how fast you can find images on your hard drive with any program are the size of the images and the speed of your hard drive itself. Big RAW files from some of the latest high-megapixel cameras can take time to read from the hard drive, especially if you have a lot of them. Slow hard drives, or external hard drives with slow connections to the computer, will also take time to read.

PRO TIP

Color-coding images in a browser is a very fast way of editing a shoot. In many browser programs, you go through either multiple thumbnails or full-size images on the screen as a slide show. You then quickly tag each image as it comes up; for example, you might tag red for selects, blue for trash, and black (default) for keeping for other reasons. Then you can sort for each group and refile them (or create a new browser catalog for them).

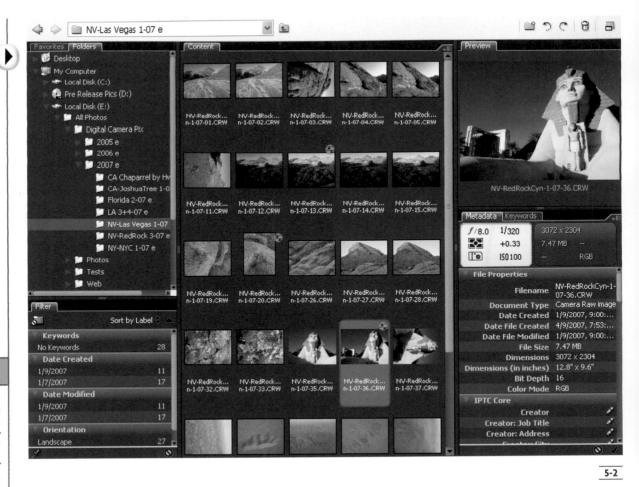

NV-Las Vegas 1-07 e

Favorites | Folders

🗔 Desktop
🖳 My Computer
 📷 Local Disk (C:)
 💾 Pre Release Pics (D:)
 🖴 Local Disk (E:)
 📁 All Photos
 📁 Digital Camera Pix
 📁 2005 e
 📁 2006 e
 📁 2007 e
 📁 CA Chaparrel by Hv
 📁 CA-JoshuaTree 1-0
 📁 Florida 2-07 e
 📁 LA 3+4-07 e
 📁 NV-Las Vegas 1-07
 📁 NV-RedRock 3-07 e
 📁 NY-NYC 1-07 e
 📁 Photos
 📁 Tests
 📁 Web

Filter

Sort by Label

Keywords	
No Keywords	28
Date Created	
1/9/2007	11
1/7/2007	17
Date Modified	
1/9/2007	11
1/7/2007	17
Orientation	
Landscape	27

Content

NV-RedRock... n-1-07-01.CRW
NV-RedRock... n-1-07-02.CRW
NV-RedRock... n-1-07-03.CRW
NV-RedRock... n-1-07-04.CRW
NV-RedRock... n-1-07-05.CRW

NV-RedRock... n-1-07-11.CRW
NV-RedRock... n-1-07-12.CRW
NV-RedRock... n-1-07-13.CRW
NV-RedRock... n-1-07-14.CRW
NV-RedRock... n-1-07-15.CRW

NV-RedRock... n-1-07-19.CRW
NV-RedRock... n-1-07-20.CRW
NV-RedRock... n-1-07-26.CRW
NV-RedRock... n-1-07-27.CRW
NV-RedRock... n-1-07-28.CRW

NV-RedRock... n-1-07-32.CRW
NV-RedRock... n-1-07-33.CRW
NV-RedRock... n-1-07-35.CRW
NV-RedRock... n-1-07-36.CRW
NV-RedRock... n-1-07-37.CRW

Preview

NV-RedRockCyn-1-07-36.CRW

Metadata | Keywords

f/8.0 1/320 3072 x 2304
+0.33 7.47 MB --
ISO 100 -- RGB

File Properties	
Filename	NV-RedRockCyn-1-07-36.CRW
Document Type	Camera Raw image
Date Created	1/9/2007, 9:00:...
Date File Created	4/9/2007, 7:53:...
Date File Modified	1/9/2007, 9:00:...
File Size	7.47 MB
Dimensions	3072 x 2304
Dimensions (in inches)	12.8" x 9.6"
Bit Depth	16
Color Mode	RGB
IPTC Core	
Creator	
Creator: Job Title	
Creator: Address	

5-2

BRIDGE CAPABILITIES

Bridge is now an important companion to Camera Raw, so it is worth looking at its features so you can use it effectively. Bridge is laid out in panels, as shown in figure 5-2. Starting from the upper left (and below the standard menus), they include:

> **Folders and Favorites.** Folders is the directory to your computer's storage and is the same as any program's open file directory or the computer's directory tree, as shown in figure 5-3. Favorites is a tab, shown in figure 5-4, you can modify by adding or subtracting folders that you use regularly so you can go to them instantly and not

search through the directory for them each time. You simply drag folders onto this space.

> **Filter.** This simple image-filtering system, shown in figure 5-5, allows you to sort images by a number of ways, such as the date created or labels you have added through Bridge.

> **Content.** This area, shown in figure 5-6, lets you see thumbnails of all the photos in a folder. You can change the size of the thumbnails by using the slider at the bottom.

> **Preview.** Here you see an enlarged photo of any image you selected in the Content area, as shown in figure 5-7.

5-3

5-4

5-6

5-5

> **Metadata/Keywords.** Metadata, shown in figure 5-8, is literally data about data. Here is where you can find information about the image such as the shutter speed, f-stop, and anything else the camera recorded. You can also add information to the metadata, such as your copyright, contact information, and more. Keywords are words that you can add to the metadata of an image file, words that describe the subject, the location, and anything else that you might use to help you find the photo later. They are an important part of making images searchable.

5-7

5-8

You can enlarge or reduce any of these panels by clicking and dragging on the lines separating them. This allows you to customize the interface, as shown in figure 5-9. You can, for example, reduce the width of the less used left panels, increase the width and height of the preview so you have a large preview, and then change the size of the thumbnails in the content panel. Make the program work for you so you can see and use it well.

PRO TIP

Bridge, and all other browser and cataloging programs, works best for you when you have a large monitor set to a high resolution. This allows you to keep everything fairly large, especially the photo panels, and makes working with all of the elements of Bridge much easier and efficient.

5-9

You can use Bridge simply as a way of seeing what you have in the way of photographs in any given folder. This is a great way to visually search for a photo. If you have named your folders descriptively — for example, by a location or client — this can be a quick and easy way to find a photo. You simply go to the appropriate folder by name, and then open it to review the photos in the content area. You can quickly go back and forth from seeing all panels, as shown in figure 5-10, to a view that shows only the thumbnails, as shown in figure 5-11, by simply pressing the Tab key. This gives you what is, in essence, a virtual light box that allows you to quickly and easily edit the good from the bad.

5-10

The thumbnail grid shows file names:

_7190229.JPG _7190229.ORF _7190230.JPG _7190230.ORF _7190231.JPG _7190231.ORF _7190232.JPG _7190232.ORF _7190233.JPG _7190233.ORF

_7190234.JPG _7190234.ORF _7190236.JPG _7190236.ORF _7190240.JPG _7190240.ORF _7190242.JPG _7190242.ORF _7190245.JPG _7190245.ORF

_7190246-Edit.psd _7190246.JPG _7190246.ORF _7190248.JPG _7190248.ORF _7190249.JPG _7190249.ORF _7190250.JPG _7190250.ORF _7190251.JPG

_7190251.ORF _7190254.JPG _7190254.ORF _7190255.JPG _7190255.ORF _7190257.JPG _7190257.ORF _7190258.JPG _7190258.ORF _7190260.JPG

_7190260.ORF _7190261.JPG _7190261.ORF _7190263.JPG _7190263.ORF _7190266.JPG _7190266.ORF _7190268.JPG _7190268.ORF _7190269.JPG

CA-Yosemite 7-07

Content

5-11

There are two other views of Bridge that you may find useful for reviewing your photos. You quickly access them using the little buttons labeled 1, 2, and 3 at the bottom right of the interface. The first, 1, is the standard setup I've described so far. The second, 2, is a filmstrip plus large image, as shown in figure 5-12. Use this view to go through images on the filmstrip while seeing each one enlarged. The third, 3, shows you camera-based metadata for each image if you want to check this quickly and is shown in figure 5-13.

5

A Quick Look at Camera Raw Tools and Workflow

78

5-12

You can rate all photos in Bridge and then sort them according to the rating. This makes editing digital photos quick and easy. You can go through all the photos first looking for images that are truly rejects — click on them and use Alt/Option + Delete to flag them for rejection. A big red Reject appears below the image.

You can also tag them with ratings of 1 to 5 stars — Ctrl/⌘ + 1 to 5 does that. Or you can use colors with Ctrl/⌘ + 6 to 9. Ctrl/⌘ + 0 removes any flag. This allows you to quickly sort images into groups based on what you need them for. You can find all of this in the Label menu, as shown in figure 5-14.

5-13

Bridge offers many other features that are worth learning, such as the slide show, batch renaming, metadata templates, stacking of image thumbnails to save space with duplicates, image rotation, and much more. It is a good place to start with your RAW files so you can edit and sort them to be ready for processing in Camera Raw.

5-14

OPENING CAMERA RAW

Photoshop automatically opens Camera Raw when it detects that the file you want to open is a RAW file. You can open the RAW file also through the standard file Open dialog box in Photoshop, as shown in figure 5-15. Simply click the desired file — a thumbnail appears that allows you to confirm this is indeed the photo you want — and then click Open.

This requires you to know the photo name and location. Unless you have an idea of which file or even folder you need, this can be a frustrating hunt. A better way in most cases is to use Bridge or whatever other browser you have. Just double-click a RAW image in Bridge and it opens in Camera Raw (this might not happen if your computer has associated your RAW files with a different program — in that case, just right-click the image and choose Open With from the menu that appears). Or you can drag images from Bridge to Photoshop. One advantage of programs such as ACDSee and Expressions is that you can make collections or catalogs of your photos to allow you to find them more easily. Adding keywords can also help: Bridge includes some simple cataloging tools in its Keyword panel, as shown in figure 5-16.

5-15

I find that it is important to name file folders for specific shoots or subject matter, then group them under larger folders, such as a month or a big project. For example, I have a section on my hard drive called Digital Photos — this is where I put all my images

that I download straight from the camera's memory card. (I download from a memory card reader.) Then I have folders for each year broken down into folders for projects and months. The browser helps me find the images quickly.

You can open multiple RAW images with Camera Raw. If you double-click individual shots one at a time you will open multiple Camera Raw windows. This is not the most efficient way to work (it uses more RAM, for example). A better way is to select multiple files in the Bridge (Ctrl+O click them one at a time), as shown in figure 5-15, then choose File⇨Open in Camera Raw. This opens the group in a new interface that shows Camera Raw with the one image open in Camera Raw and the others ready in a filmstrip to the left (shown in figure 5-17).

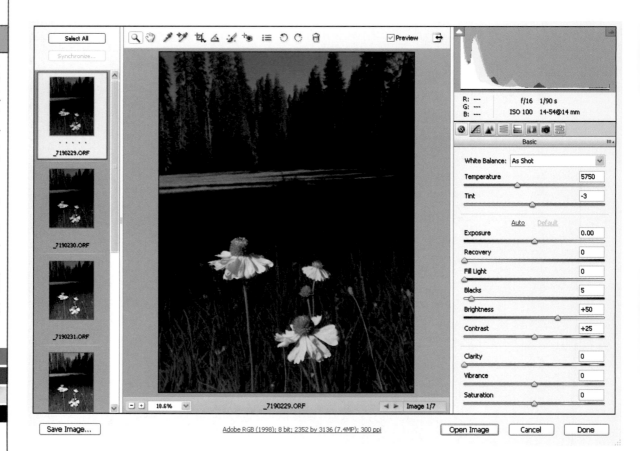

THE IMPORTANCE OF RESET AND UNDO

With both Camera Raw and Photoshop, there are two important and absolutely essential tools that you need to know about: Undo and Reset. These are decidedly not very exciting, but that makes them no less important.

Of course, most people who use the computer regularly know they can execute Undo by pressing Ctrl/⌘+Z or access by choosing Edit ⇨ Undo. That backs you up one step and undoes whatever you did last. It works the same within Camera Raw. This is really important because it means you don't have to worry about trying new things in the program. Not sure how something might work? Try it — you can always use Undo to remove that adjustment, as demonstrated by figures 5-18 and 5-19.

Reset is a complementary tool, a core part of Photoshop and Camera Raw, yet it is surprising how many photographers do not know it is there. It is a feature that lets you reset any open dialog box back to its original state when it opened with your photo. You can totally mess up your photo in Camera Raw and

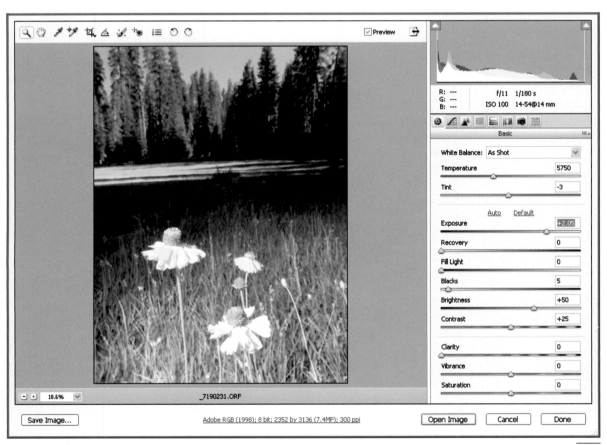

5-18

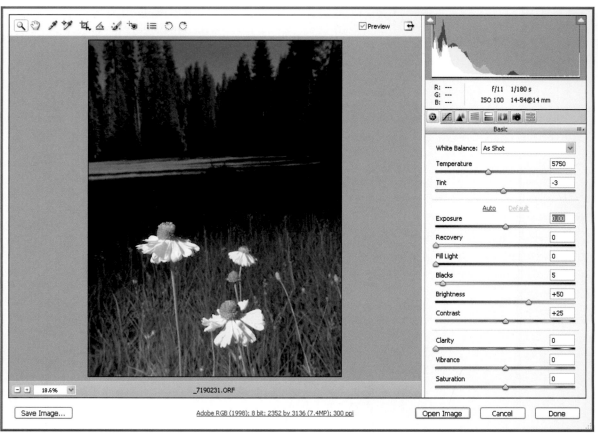

5-19

always have an out — Reset. This button isn't visible while you are working on your photo. But as soon as you press and hold Alt/Option, the Cancel button changes to Reset, as shown in figure 5-20. This resets everything you have done since opening the file to its original state. It can be a lifesaver.

5-20

PRO TIP

Right-clicking the image gives you a menu for whatever tool is active. Both Windows and Macintosh systems support a two-button mouse. Get rid of the stylish Apple mouse with the Mac (a one-button mouse) and purchase a USB two-button mouse for much more versatility.

5

A Quick Look at Camera Raw Tools and Workflow

CAMERA RAW IN SIX-PART HARMONY

It helps to mentally divide the Camera Raw interface into six sections, as shown in figure 5-21. This way the interface isn't just an amorphous bunch of stuff, and you can more quickly find and understand this software. Each section deals with similar aspects of the image controls, and each is quite different from the others. Take them from the top, left to right (earlier versions of Camera Raw look slightly different):

> **Camera Raw toolbar.** This toolbar includes the cursor tools that operate with a click or drag of the mouse. They are, from the left, the Magnifier (or Zoom tool), the Hand tool for moving around in the image, the White Balance tool (an eyedropper), the Color Sampler tool (another eyedropper), the Crop tool, the Straighten tool, the new Retouch tool for minor "cloning," the new Red Eye Removal tool, a Preferences button, and two image-rotating tools (counterclockwise and clockwise). At the far right of this toolbar the Preview check box and full-screen button appear.

> **Histogram section.** Four separate pieces appear here: a color histogram, shadow and highlight buttons (at the top left and right of the histogram), channel information for Red (R), Green (G), and Blue (B), and basic metadata of exposure information.

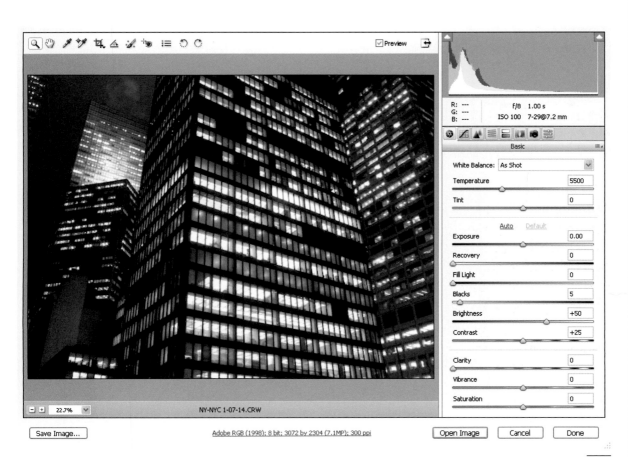

5-21

> **Image.** The image itself has a nice big view to show you what Camera Raw is doing.

> **Image adjustment panel.** This is a big block of very important adjustment tools below the histogram. The panel holds a wealth of adjustment capability, from exposure change to color correction and enhancement to noise reduction and much more, and is organized in tabs for different types of adjustments.

> **Workflow options.** This used to have its own panel in the overall Camera Raw interface. Now, it is hidden. A colored link in the middle of the interface appears that shows you information about the color space, bit depth, and so forth of the image. Click on this and you will get a dialog box with a group of choices: color space, color bit depth, final image size, and pixel resolution when the image leaves Camera Raw.

> **Execution commands.** Last are the basic, but key, controls to allow you to finish working on an image in Camera Raw. Starting at the left they include Save Image, Open Image, Cancel, and Done.

CAMERA RAW TOOLBAR

Start to look at the Camera Raw interface by opening a photo in it. The controls in the Camera Raw toolbar have a similar feel to those in the standard Photoshop toolbox, as shown in figure 5-22. (The actual name for the toolbar that is the default appears at the left side of the interface.) You are just going to see what they do before doing a lot of work on an image. However, remember that you can't hurt anything in Photoshop because you can always use Undo and Reset. This is very freeing because if you aren't sure about a particular control, try it! So try the toolbar controls:

1. Click the Zoom tool or Magnifier (shown in figure 5-23). This acts just like the Photoshop Magnifier/Zoom tool. Click the photo and it enlarges. Press and hold Alt/Option and click the photo and it gets smaller. Use the Magnifier like a cursor to outline a box on the photo (shown in figure 5-24) and that area enlarges (shown in figure 5-25).

5-22

5-23

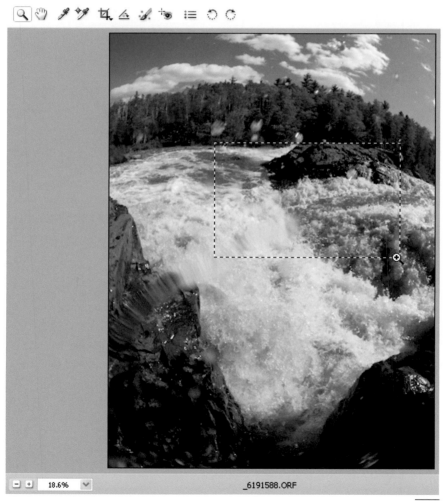

18.6% _6191588.ORF

5-24

5-25

2. After magnifying the image, click the Hand tool (shown in figure 5-26). Use it to move the magnified photo around inside the viewing area (it has no effect on the image). You can also instantly access the Hand tool at any time, no matter what tool you are using, by pressing the space bar.

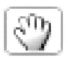

5-26

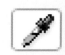

5-27

3. The White Balance tool (see figure 5-27) is designed to make neutral tones, such as white or gray, neutral. (It does not work as well on black.) Click anything that should be a neutral tone and Camera Raw makes it so.

4. You use the Color Sampler tool (shown in figure 5-28) to sample a color in the image that is particularly critical. As soon as you click, you find the preview image resizes to include a new feature in the interface: a box for RGB numbers. You can click up to four colors, and each one appears as a set of RGB numbers. Many photographers will never use this tool, while some who need very precise color, such as those doing advertising work, will use it to see how colors change as they make adjustments. Remove individual points by pressing and holding Alt or Option and clicking on a point. Remove them all by clicking the Clear Samplers button.

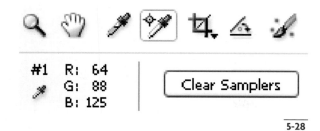

#1 R: 64
 G: 88
 B: 125

Clear Samplers

5-28

7. The Retouch tool shown in figure 5-31) is an automated healing and cloning tool. It allows you to either heal a problem (which blends the change more) or clone a problem by finding something nearby to copy over it. You change the size of the tool with the Radius slider or by clicking and dragging.

5. The Crop tool (shown in figure 5-29) allows you to crop an image without any permanent change. You click and drag for the crop, and then a cropped image appears in the preview (and in Adobe Bridge). The preview shows the cropped area, but the rest of the photo is still there. When the image is opened, it is cropped, but the original Raw file is not. You clear the crop by using the Escape key or by pressing and holding the cursor on the Crop tool so a shortcut menu appears with Clear Crop visible.

6. The Straighten tool (shown in figure 5-30) lets you do just that. Find a line in the photo that should (or could) be either horizontal or vertical. Click on one part of that line, and then move the cursor down the line and click again. A crop box appears at an angle that makes the lines horizontal or vertical. This is applied when the file is opened.

Radius 25 Type: Heal

5-31

8. The Red Eye Removal tool (shown in figure 5-32) is an automated tool for removing red eye problems in flash pictures of people.

9. The Preferences button (shown in figure 5-33) gives you quick access to the Preferences dialog box for Camera Raw.

5-32

5-33

5-29

5-30

10. The two Rotate tools shown in figure 5-34) simply rotate the photo 90 degrees at a time, either counterclockwise or clockwise.

5-34

PREVIEW OPTIONS

Camera Raw lets you see your image several ways to help you make decisions on how to adjust it. Previews are important when you use Camera Raw, although you might not use all of them. Still, it is worth playing around with all of them to understand how they work.

> **Image.** A preview shows you the image itself, as shown in figure 5-35.

> **Sizing.** You can enlarge the image in the preview to better see details. Use the Zoom tool, the size settings drop-down menu (at the bottom left of the preview), or the plus and minus buttons next

to the size settings, as shown in figure 5-36. Press Ctrl/⌘+0 to instantly go to the full image.

> **RGB data.** Specific RGB data lets you compare relationships among the Red, Green, and Blue channels when you move the cursor over the photo (any tool), as shown in figure 5-37.

PRO TIP

Right-clicking the image when the Zoom tool is active gives you a sizing menu immediately. This is a quick and easy way to resize the preview — and another reason why Mac users should get a two-button mouse.

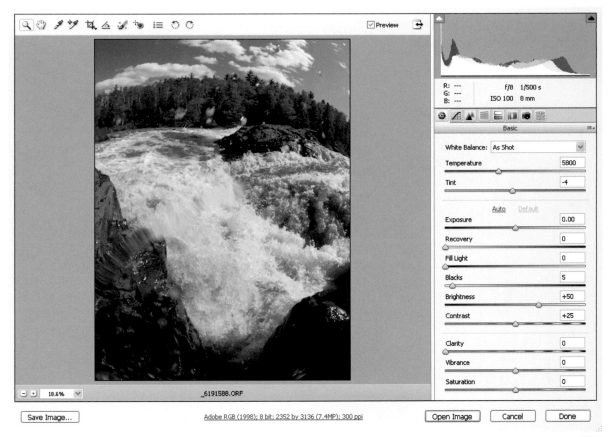

5-35

5 A Quick Look at Camera Raw Tools and Workflow

5-36

5-38

> **Histogram.** This histogram shows exposure information in the separate channels, as also shown in figure 5-38. This can be helpful in seeing where tonalities are in a photograph — highlights are at the right, shadows are at the left.

R: 110
G: 131
B: 165

5-37

> **Clipping warnings.** Shadow and Highlight clipping buttons are the small triangles at the upper corners of the histogram area, shown in figure 5-38. These show you where detail in shadows and highlights is lost, as shown in figure 5-39, but I have a hard time recommending their use other than to take a quick look, with them on and off. The clipping warnings show up as bright colors and I find them very distracting when working on the photo. I favor the techniques I describe in the next chapters for finding clipping thresholds. Try these warnings on one of your photos (set Exposure and Blacks high enough for them to appear) to see where your detail is clipping and see if it helps your workflow.

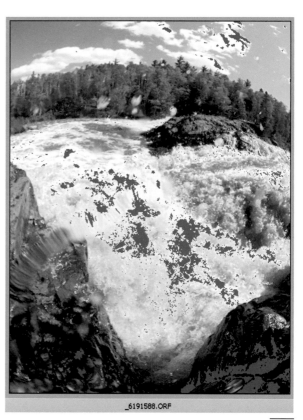

_6191588.ORF

5-39

THE IDEAL WORKFLOW

Starting in Chapter 6, you learn how to go through an image with Camera Raw from start to finish and experience workflow firsthand. However, because workflow overview is a popular subject, I present the ideal workflow in outline form. This is meant to offer you an overview of the process and not get into detail as to where all the controls are or how to use them. I want you to think about a process and way of working in this section.

My approach is photograph-based and not Camera Raw interface-based. I believe this method is what will give you the best results, opposed to simply memorizing controls in the order they appear and using them that way. However, I also believe that every photo and photographer is different, which often means you'll need to modify this ideal workflow to meet your individual needs. After opening the image in Camera Raw, you can follow these steps:

1. **Base settings.** Check your base settings at the bottom of the image, as shown in figure 5-40. Be sure you select the color space and bit depth you prefer, the size you expect the photo to be, and a resolution appropriate to your end use. Click on this blue, linked line and you will get a dialog box that lets you change these things.

_6191588.ORF

Adobe RGB (1998); 8 bit; 2352 by 3136 (7.4MP); 300 ppi

5-40

2. **Problems.** Check to see if there are any major problems with the photo. (If you are shooting to get the most from your file in the first place, this is rarely your problem.) Correct a very dark or light photo.

3. **Blacks.** Check black and dark areas and where they appear in your photo. This is a critical issue and something that I come back to again and again. One problem that I consistently see in images from workshop participants and even from pros contributing to *Outdoor Photographer* magazine is weak blacks. This results in poor color and contrast. Use the Blacks slider. In figure 5-41, the photo looks dark, which is okay, because the blacks have been set correctly. The overall darkness is corrected through a midtone adjustment, though the whites/Exposure adjustment, covered next, also affects this.

4. **Whites.** Check white and light areas and where they appear in your photo. Use the Exposure slider for whites. In figure 5-42, the highlights are corrected to bring detail back into the brightest areas without washing out the clouds or the brightest parts of the white water.

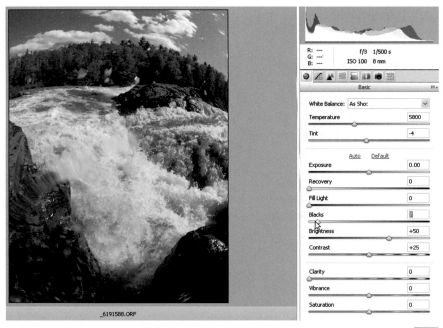

5-41

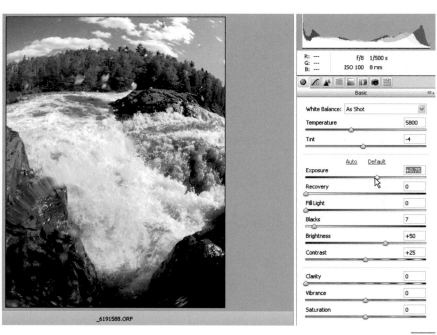

5-42

5. **Midtones.** Adjust midtones by setting the overall brightness of the image with the Brightness slider, or use the Curves tab to use curves for overall adjustment, as done in figure 5-43. I am using midtones as a simple way of describing all of the tonalities with detail in a photograph, which includes the dark, middle, and light tones.

6. **White balance.** It is difficult to fully evaluate white balance until the overall exposure is set. Tweak white balance as needed, as shown in figure 5-44.

7. **Vibrance and Saturation.** Use Vibrance to boost color if needed, then maybe a little Saturation, but use the latter cautiously.

8. **HSL (Hue/Saturation/Luminance).** This new feature lets you adjust individual colors for their hue, saturation, and luminance, as shown in figure 5-45.

9. **Sharpening.** The new tools for sharpening in the Detail tab are well worth using as they can really help you get optimum sharpness. Enlarge the image to 100% to best see the effects, as shown in figure 5-46.

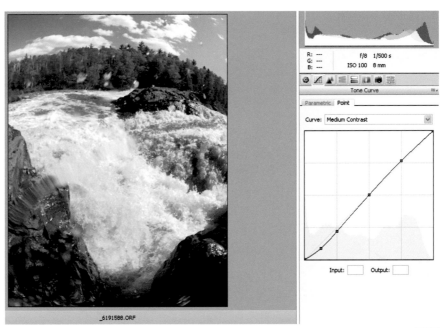

5-43

_6191588.ORF

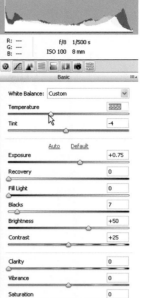

5-44

_6191588.ORF

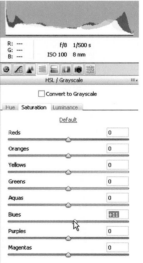

5-45

10. Noise. If noise is an issue, go to the Detail tab, too. Enlarge the image to find an area with noise, then adjust Luminance or Color Noise Reduction.

11. Finish. Save or open the image.

Base Settings

As you go through the rest of the book, you may notice that I do not discuss the base settings of color space and bit depth, the size you expect the photo to be, and a resolution appropriate to your end use repeatedly. These are settings that you change infrequently according to your way of working, and you access them by clicking the linked line of photo information below the image preview. This gives you the Workflow Options dialog box, shown in figure 5-47. The settings enable you to do the following:

> **Space.** Typically, you use one color space for most of your images. Most photographers choose Adobe RGB, though specific work requirements may mean choosing sRGB or ProPhoto RGB. A quick review: Adobe RGB is a larger space than sRGB and allows more adjustment of color; however, sRGB, which often looks better to photographers, is the Web space and may be required by certain labs. ProPhoto RGB is the largest color space, but it can be misleading if you are not outputting to devices (printers or other) that can handle it. You can achieve great images with any color space.

> **Depth.** You get a choice of 8-bit and 16-bit. You are adjusting the image in Camera Raw in a 16-bit color space, so you are working in 16-bit while there. If you do the big adjustments in Camera

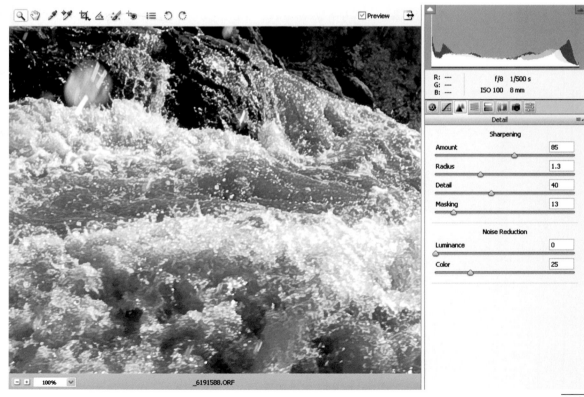

5-46

Workflow Options

Space: Adobe RGB (1998)

Depth: 8 Bits/Channel

Size: 2352 by 3136 (7.4 MP)

Resolution: 300 pixels/inch

☐ Open in Photoshop as Smart Objects

OK

Cancel

5-47

Raw, and only refine an image in Photoshop, you probably do not need 16-bit for most purposes when going to Photoshop. 8-bit usually works just fine and is easier to deal with than 16-bit. 16-bit will require a lot of memory and processor overhead but is not necessarily a benefit in Photoshop for the majority of photos. If you do have an image with delicate tones in the high-lights that are really critical to the photo, some dark tonalities that you want to continue to develop in Photoshop, or sensitive gradients, then 16-bit can be helpful. In addition, most programs that work with photos outside of Photoshop can-not open 16-bit files.

> **Size.** This is one area that you may change more than the others. Typically, you size your image to either the native size of the file (your original megapixels from the camera) or the most com-mon large usage of your photos — if you need larger prints than the native size gives you, for example. The actual pixel dimensions of the photo are given along with the megapixels. A plus sign shows the photo is bigger than the native size; a minus sign shows it is smaller, as shown in figure 5-48. No sign after the numbers represents the native size. Sizing a photo to a bigger image size than you need will cost you in terms of RAM and storage needs.

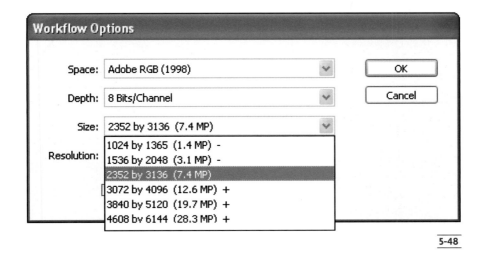

Workflow Options

Space: Adobe RGB (1998)

Depth: 8 Bits/Channel

Size: 2352 by 3136 (7.4 MP)

Resolution:

1024 by 1365 (1.4 MP) -
1536 by 2048 (3.1 MP) -
2352 by 3136 (7.4 MP)
3072 by 4096 (12.6 MP) +
3840 by 5120 (19.7 MP) +
4608 by 6144 (28.3 MP) +

OK

Cancel

5-48

> **Resolution.** Most photographers have one need for output resolution and leave this set to one number, typically either 240 or 300 pixels per inch (for inkjet printing) or 300 pixels per inch (for publication purposes). This is not a setting that affects image quality and can easily be changed later in Photoshop without affecting the photo. It only affects how the computer reads the pixels and spreads them out along a given dimension.

HOW TO APPROACH CAMERA RAW

All of these pages of computer screen shots, all of the numbers, the histograms, the sliders, and so forth, make processing a RAW photo seem very technical and computer-ish. But they can be a smoke-screen and distract you from the important and real purpose for using Camera Raw: better photos for you.

Not better photos by my standards, not better photos by any Photoshop guru's standards, but better photos that meet your specific needs, whether that is a great print for the wall or a submission to a photo buyer at a magazine. Only you can know what that ultimate goal is. All work in Camera Raw, then later in Photoshop, must be to support that goal. Figure 5-49 represents such a photo for me, following this philosophy.

I emphasize that the ultimate decision of what is a good photo really is yours even though there are some well-meaning Photoshop folks who give their way as the only way, implying that if you don't do it their way, you won't have a good photo. That is great if their way works for you, but sometimes it does not; and I have seen photographers get frustrated and unhappy with

5-49

the digital medium, thinking it is all their fault, when in reality, it is because they are trying to do something not really suited to their way of working.

This is definitely a craft that takes practice. This book gives you many ideas on how to do that practice and how to get the most from your RAW photos. But it is up to you as to how you interpret that information in your particular photos. Follow the workflow I describe in this book to get started, but do not be afraid to take off on your own path to better meet your photo needs.

MONITOR CALIBRATION

I have to spend a short time talking about monitor calibration. For those of you who have calibration hardware and software, and use it, you can skip this section. For everyone else — and I know there are a lot of you who have not calibrated — this is for you. Calibration will give you a consistent, predictable workspace for adjusting your images.

Monitor calibration used to be a painful, difficult process that required expensive tools. That is no longer true. Monitor calibration packages of software and sensor are available at reasonable cost from ColorVision, X-Rite, and Greytag. Less important than which one is best (they all work quite well, though at different levels of efficiency) is that you use at least one of them. You must let your monitor warm up

before calibration (even before serious adjustments) at least 15 minutes for an LCD and 30 minutes for a CRT. Figure 5-50 shows monitor calibration in progress.

Without a calibrated monitor, you will not get the best results from Camera Raw. Any concepts of color space or bit depth are meaningless because monitors that have not been calibrated throw colors off more than either. To repeat, because this is so important: a calibrated monitor gives you a consistent and predictable workspace for your image processing. It does not, however, guarantee perfect prints because that is a different medium, or for the pro, images that look the same on an art director's monitor because the photos have to leave your system (it is no longer closed and controllable), though it does make that work more predictable!

5-50

What monitor calibration does is make sure that the colors and tones you adjust are being adjusted from a standard, measured place. It allows your computer to know how to interpret the data it reads from an image file for display on your monitor. It is important to calibrate your monitor regularly. How often depends on the monitor type and how much it is on. CRT monitors need calibration much more often than LCDs. If a monitor is on continuously, a CRT may need calibration as often as every two to three weeks. If an LCD is on continuously, you might not need to calibrate it more than once a month or so.

Q&A

What is the best way to bring images into the computer from the camera?

Many photographers download photos directly from the camera. A high-speed connection to the camera, such as USB 2.0 or FireWire, is a good way of doing this, but I recommend using a memory card reader. A memory card reader is a simple device that plugs directly into the computer and then allows you to insert your memory card for direct download. If you use a USB 2.0 or FireWire reader, be sure your computer supports these standards before buying one. If you have any of the newest memory cards, such as the UDMA CF or SDHC cards, you need to be sure the reader will work to access data on them.

There are several reasons why I believe a memory card reader is a better solution than downloading directly from the camera:

> **Speed.** Card readers always work as fast as downloading from a camera and usually work faster.

> **Convenience.** The card reader is always plugged in. You never search for a cable or a space to put your camera.

> **Power.** Card readers need no external power. With a camera on batteries, a memory card can be corrupted if the camera loses power during the transfer of images. Using an extra power cord for the camera works, but it is a nuisance.

> **Drag-and-drop convenience.** Cameras are often recognized differently by the computer than a card reader. A card reader simply shows up as another drive. You can drag-and-drop photos from the card to your hard drive.

What if I change the order of the ideal workflow? Even though you say I can modify this to meet my needs, won't changing the order also affect the image?

Changing the order of the workflow affects how you adjust the individual elements of your image in Camera Raw. If you adjust color first, for example, this affects how you see tonalities, which may mean you make some changes to tonalities that you might not have done if you had done them first. But adjusting an image in Camera Raw is not a science. You are the ultimate arbiter of what is right or wrong about your image. If you find a different order of work is effective for you, then that is probably the right way for you to work. As you go through the next chapters, you see how to interpret an image as you adjust it. This is probably more important than any specific way of making the adjustments.

What if I change my mind about a photo after I have processed it in Camera Raw? If I then make additional changes, will the image quality suffer?

A great thing about Camera Raw is that no adjustment is permanent. This is not true for other formats. If you process the image and save that as a TIFF or PSD file, any further changes may affect the quality of the image because at this point, you are now working with the actual pixels in the photo rather than the RAW file that has to be converted to actually work on pixels.

You can always go back to Camera Raw and open that image again. You can go back to how the original file looked or make changes to the image as much as you want for everything from correction to creative options. There is then no change to the quality of the image as Photoshop records everything you do in Camera Raw as instructions. It is only when the photo is converted and saved to a specific file format that these instructions are translated into actual pixels.

WORKFLOW APPLIED

In this chapter, you look at a simple, uncomplicated image for processing in Camera Raw. The abstract, high-angle pool shot, shown unadjusted in figure 6-1, has a good range of tones throughout, and the exposure is correct for the scene. Because it was shot in RAW, it can be adjusted quite dramatically, if needed, without causing problems with tonalities or colors.

This chapter does more than take you step by step through processing an image in Camera Raw. You learn the basics of working with an image in terms of key Camera Raw controls, but you also consider the thought process involved as to why you choose certain controls. There has always been a good news/bad news mentality about processing digital images. The good news is that you have a lot of control and you can make adjustments in nearly infinite ways. The bad news is that you have a lot of control and you can

make adjustments in nearly infinite ways. Control lets you make your photos better, but many choices it provides can freeze your thought process so you're like a deer caught in the headlights.

Therefore I want to give you some ideas on how to approach all that control, how to think about your adjustments. You see how a good image — figure 6-1— is processed to reveal the true potential of the photo, which is shown in figure 6-2. It is impossible to give specific numbers or slider positions for your images, though I know some of you might want it to be simple like that. Unfortunately, every subject demands different approaches to its processing. With some practice and a thought process to deal with the choices, you develop a workflow that allows you to process most RAW images quickly and efficiently.

6-1

6-2

WHAT IS YOUR PHOTO ABOUT?

The abstract, fun summer image I use here is a good one for this chapter on Camera Raw basic workflow. I am not going to jump in and start changing this photo for you, though. How do you begin to think about adjusting a photo? I believe it is important to know what your photograph is about and why you shot it, as this influences your choices. Arbitrarily adjusting an image based on some sort of objective criteria sooner or later gets you into trouble, or at the least, gives you less-than-pleasing results. Know the purpose of the photo, and make adjustments that support that purpose. This is one reason why I am not fond of the Auto setting for Camera Raw and never recommend it. More on this in the next section.

This image used throughout the chapter is an example of using photography to see the world around us differently. I was in South Carolina during a very, very hot period, and our hotel room was on the 12th floor. This gave a most interesting perspective when I shot down on the pool with a telephoto lens.

What is this photo about? It is about summer, people enjoying a pool on a hot day, sure, because that is what is in the photo. But that does not evaluate the image as an actual photograph. By that, I mean that a photograph is its own thing and not simply a recording of reality. In this shot, the shapes of the walk, the water, the lounges, and the people all work together for an interesting, abstract composition. This is strongly emphasized by the angled shot showing the walk as a tilted, upside-down L shape. This is highlighted in figure 6-3. This shape then interacts with the people, the pool (and its color), and so forth. Any adjustment should then work to support these elements of the photograph.

6-3

There is no need to overanalyze every photograph you shoot before opening Camera Raw. That is counterproductive. However, you do need to respect your photograph. Using Camera Raw should be about getting the most from your photo, not getting the most from Camera Raw.

AUTO SETTINGS

When Camera Raw used to be opened in Photoshop CS2, all Auto settings were selected by default. That really changes in Camera Raw and Photoshop CS3. Most photographers, and especially pros, did not want anything opening automatically in Auto. So now you can choose Auto on the middle of the right panel in the Basic adjustments, just above Exposure, as shown in figure 6-4.

6-4

I know this is tempting for those of you who are new to RAW and Camera Raw. The auto settings work — but with varied amounts of success on different photos. I find that for many photographers, the Auto results can be very misleading and take you in wrong directions. You can always limit Auto settings to any individual setting to see if it helps (and sometimes it does). But it seems odd to use Auto settings for Camera Raw, because the program is the epitome of having control. Auto settings relinquish your control and allow arbitrary mathematical formulas to decide what your photo should look like. Frankly, why bother then with Camera Raw? You already get an automated RAW processing option when you have your camera shoot JPEG, and that in-camera processing can be very good.

I love what the Adobe engineers have done in creating Camera Raw and Photoshop. These are stunning, powerful programs. The engineers have tried to be helpful in creating auto settings that apply what they believe are effective ways of adjusting images. As much as I love the engineers' brilliant computer work (and it is brilliant — I can't begin to understand what happens under the hood of Photoshop), I don't think they are capable of looking into the future and know-

ing what you or I had in mind for a specific photo. Auto settings simply look at the tones of a photo and adjust them according to what Adobe engineers think a photo should look like based on arbitrary analysis of your photo compared to their mathematical ideal.

PRO TIP

In Windows, double-click the Space box to highlight it and use the up- and down-arrow keys to quickly move among the color-space choices while watching the photo.

WORKFLOW OPTIONS

Once you open the photo, start at the bottom of the Camera Raw interface and begin your adjustments from the blue, linked line under the photo, as shown in figure 6-5. Clicking on this link brings you to the Workflow Options dialog box shown in figure 6-6. This section of Camera Raw is pretty straightforward. It is definitely not the creative part. It defines how Camera Raw interprets standard parts of an image, such as the color space and image size. You usually set this once according to your most common workflow needs and leave it alone for most photos. The only part that you'll commonly change on even a somewhat regular basis is the Size choice to match specific image size needs. Follow these steps to set Workflow Options:

_8080404.ORF

Adobe RGB (1998); 8 bit; 2352 by 3136 (7.4MP); 300 ppi

6-5

1. Check the Space field. By clicking in this box or on the down arrow, you get a drop-down menu of a number of available color spaces, as shown in figure 6-7. You can use any of them, but I recommend Adobe RGB (1998) (the official name of this color space includes the number 1998, but most people just call it Adobe RGB, which will be done in this book, too — you are always safe with Adobe RGB). Adobe RGB (Red, Green, Blue) provides a wide color gamut that works well whether you are outputting to a print or to a publication where it has to be changed to CMYK (Cyan, Magenta, Yellow, Black), a small color space that you cannot access here (nor would you want to).

This can be very important when you're working with all the subtle colors that appear in your photo.

You could also choose ColorMatch RGB or ProPhoto RGB. These are wide-gamut color spaces that can be misleading to work in if you are doing photography for publication or printers that can't handle the space. You may see some master printers working in these spaces and you can certainly use the preview in Camera Raw to give you an idea of the difference. You can click back and forth between these color spaces. sRGB can be limiting in your processing so it is best to avoid it with Camera Raw.

It is important to note that choosing any of these color spaces has no effect on what you can or can't do with Camera Raw. It is capable of working with any of them and can change to adapt to a new color space at the click of a button. The choice you make here does strongly affect what happens to the photo once it is out of Camera Raw, however, which means that the colors are locked down when the image goes to Photoshop.

2. Click in the Depth field to choose a bit depth. You have a choice of 8 Bits/Channel or 16 Bits/Channel, as shown in figure 6-8. This is an output choice and has no effect on what you are doing in Camera Raw. That is really important to keep in mind. All processing done in Camera Raw is done in a 16-bit space. For most digital cameras, that means working with a 12-bit capture, though now there are some cameras offering 14-bit capture at the RAW level. Each step up changes the amount of tonal information available exponentially. The result is that you get a lot more adjustment power with more *bit depth*.

For most photographs, however, setting 8-bit here is most likely fine. The problem is that 16-bit doubles the file size in Photoshop and the computer. Because Photoshop is such a RAM-intensive program, increasing file size, even a little bit, greatly increases the stress on the processor and the amount of RAM needed. You may find your computer just dies in speed. There is no visual difference between 8-bit and 16-bit; therefore, you cannot identify one from the other by looking at a photo. The difference comes from the amount of information available behind the scenes that allows you to do more intense work on your image. If you don't typically do a lot of changes after leaving Camera Raw, you probably don't need 16-bit going out of the program.

3. Select an output size by clicking in the Size field, as shown in figure 6-9. You can start with the native file size that your camera produces by selecting numbers without a plus or minus sign. (Plus means the file is increased from the original; minus means it is decreased.) If you know you need a large file from your photo, this is a great place to upsize your image. While you can resize the photo inside Photoshop to get good results, resizing in Camera Raw builds the size using more basic data from the camera with superb sizing algorithms. When you do this, you get a much larger file, and if you decide to use 16-bit, it could be a problem if your computer lacks adequate processing power and RAM.

6-8

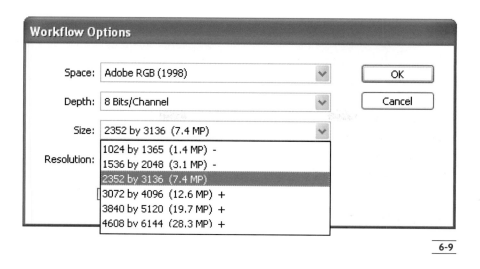

6-9

4. Click in the Size field to choose an output resolution. This has no effect on image quality; it is here purely for workflow reasons. For this photo, 300 pixels per inch is selected, as shown in figure 6-10, to process the photo for publication purposes. Having your image with an appropriate size (this used to be called Resolution in earlier versions of Camera Raw) for its final use means less work later checking image size. Output resolution only changes how close or far apart the computer puts pixels and does not affect their quality. You can always change this later without any harm to the photo.

5. Consider Smart Objects. This is a new option in Camera Raw and allows Adobe to further support their Smart Objects. Smart Objects are anything you can control in Photoshop and they are linked back to original adjustments or files so that you can change them within Photoshop and go back to the original image for the change. Photographers and designers doing things like montages, where they put a lot of photographs together in one image, tend to use it. Smart Objects allows you to go back, in this case to Camera Raw, to readjust a linked "object" so that you don't have to adjust on top of adjustments.

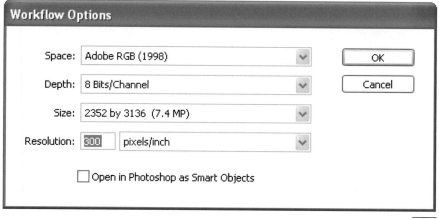

6-10

TONAL ADJUSTMENTS

The brightness (or darkness) of a photo and its contrast have a great impact on how a viewer perceives it. Composition is affected, but mood is probably the element of a photograph that's changed most dramatically when it is made brighter or darker, or the contrast is altered. Color also has a big effect, but generally, it is better to start with tonal adjustments unless there are color problems. Camera Raw now offers six key tonal adjustment controls (plus some weaker adjustments). The first, Exposure, is not particularly intuitively named for what it is used for, but the others are. Here is a quick summary of them. They start in the Basic panel, as shown in figure 6-11. I will not follow the exact order that appears there because some of the controls actually affect others, so I will get to them second.

6-11

> **Exposure.** This seems like it might be for overall adjustment, but it is actually used for highlights and bright areas of a photo. The whole image gets brighter or darker, to be sure, but use this slider to change highlights. If you press and hold Alt/Option while adjusting this, you can see where the bright areas clip detail — pure white is no detail against an all-black screen. Any colors you see represent channels that are full in the sense that they are at their maximum. Camera Raw in Photoshop CS2

introduced highlight warnings (select the Highlights option check box at the top left of the histogram). This can be helpful, but it can also be confusing compared to using Alt/Option.

> **Recovery.** Right under Exposure is the Recovery slider. This is a terrific new addition to Camera Raw. It uses some very sophisticated algorithms in the program to bring out detail in the brightest parts of the image, highlights that almost seem washed out before you try this. You won't use it with every photo, but when you need it, it is a wonderful adjustment to have. Often, this control works best when you use it in conjunction with Exposure so that you go back and forth between the two controls until you get what you like.

> **Blacks.** Finally, Adobe has named this slider for what it really does — adjust blacks in a photo. The whole image darkens as you move the slider, but the key to this adjustment is the dark parts of the photo. If you press and hold Alt/Option while moving the slider, you can see where the dark areas clip detail — pure black against an all-white screen is no detail. The colors represent channels that are at their minimum. Camera Raw in Photoshop CS2 introduced shadow warnings (select the Shadows option at the top right of the histogram). While this can also be helpful, I find it hard to use and much less clear compared to using Alt/Option.

> **Fill Light.** Right above Blacks is Fill Light. This is like Recovery for the dark areas. It allows you to bring out detail in the dark parts of the photo that might have appeared to be lost. Like Recovery, you won't use Fill Light for every photo, but when you need it, it's great to have. A caution, however — it is easy to overdo Fill Light, which will result in unnatural-looking shadows and possibly more noise.

> **Brightness.** Once highlights and shadows are adjusted, you can tweak the overall brightness of the image with this slider (it affects midtones). As you change it, you may find highlights (Exposure) and shadows affected such that they have to be slightly refined in their own adjustments. This is a weaker control in Camera Raw and is not really the best way to affect the middle tones of a photo. I rarely use it and prefer the Tone Curve described a bit later for this purpose. Most of the time you can leave it at its default setting.

> **Contrast.** This slider affects the overall contrast of the image, but it is a bit too heavy-handed for my taste. Like Brightness, this is a weaker control in Camera Raw and is not really the best way to affect the overall contrast of a photo. I rarely use it and, again, prefer the Tone Curve described a little later for this purpose. Most of the time you can leave it at its default setting.

> **Clarity.** Clarity is a brand-new control unlike anything ever used in Camera Raw or Photoshop before. It affects the contrast of the midtones and can help them pop in an image. But you do have to be careful of how you use Clarity, and not to overuse it, or your photos may start looking a little harsh.

Exposure, Shadows, and Brightness can be compared to Levels adjustments in Photoshop. The black slider at the left of Levels is like Shadows, the white slider to the right is like Exposure, and the middle slider is like Brightness. The Curves adjustment of Camera Raw (called the Tone Curve) is an excellent way to adjust the overall brightness of the image (affecting midtones), but it is in a different place in the interface.

The Tone Curve has its own tab, as shown in figure 6-12. It comes in two versions, the Parametric subtab shown in figure 6-12 and the Point subtab shown in figure 6-13. The Point curve works like Curves in

Photoshop. You click on a point on the middle line and pull it up to lighten the image, or down to darken it. The tones are nicely adjusted with a blend from full adjustment where the point is to none at the ends. In addition, you can click on more than one spot to refine the midtone adjustments, making the dark areas darker, for example, in proportion to the light areas. You can also try a series of preset curves by clicking on the Curve down arrow to get a drop-down menu.

6-12

6-13

Parametric is a new way of adjusting that is very photographic. With it, you can adjust multiple points on the curve, just as in the Point subtab, but now you do it by using sliders that fit the way a photographer thinks. Use the Highlights slider and the part of the curve that affects highlights is adjusted. Use the Darks slider and that part of the curve is changed. In addition, these parameters for adjustment limit how much you can change each section, also helping keep the control very flattering to your photography.

Here's how to continue work on this image:

1. Press and hold Alt/Option while you click and drag the slider for Blacks. The whole image turns white except for a few small areas, as shown in figure 6-14. This screen shows the threshold of tones as

they change to pure black or max out in channels. The black or colored areas represent the darkest shadows — the black is pure black, no detail.

2. While pressing Alt/Option, click and drag the Shadows slider to the right to increase dark areas, or to the left to decrease them. This is a very subjective decision, but generally you want at least something black or near black in most photos. Try alternately clicking on and off or pressing Alt/Option to see how these areas relate to the whole image. In this photo, the blacks look best when they show up in small areas throughout the photo, while the blue channel is maxed out in the lounge chairs. I often like picking up the blacks where they outline some key features. Figure 6-15 shows blacks that are going to be very weak in the image, while 6-16 shows them pretty heavy.

6-14

6-15

You can always try moving the slider too far and see how the image is affected, although the whole image will look rather dark at this point. Still, when working in RAW, you have a lot of flexibility in how you adjust an image because of the data available to you.

As I noted before, photographers often do not get the proper blacks in an image. Without a strong black, colors and contrast often look weak. Deep blacks in the shadows can be very attractive in the right image. This is not true for highlights. If highlights become washed out, they become pure white. That is generally a distraction to the image as people tend to be attracted by bright spots in an image. Plus, large areas of white can be very unattractive in a photo while large areas of black can just be dramatic.

3. Press and hold Alt/Option while you click and drag the Exposure slider. The whole image usually gets black except for a few small areas, as shown in figure 6-17. This screen shows the threshold of tones as they change to pure white. As you move the slider, the bright or colored areas represent highlights. The white is pure white, no detail. You can alternately click on and off or press Alt/Option on and off to see how these areas relate to the whole image.

PRO TIP

Whenever you want to reset any control to its default using sliders, double-click on the slider itself and it resets that control. In addition, you don't have to hit the slider exactly in order to use any slider-based control. If you move your cursor over the name of the adjustment, the cursor changes to a hand with a double arrow. You simply click and drag to make changes. This can speed up your workflow because you only have to land your cursor somewhere on the word, not on the precise graphic of the slider.

6-16

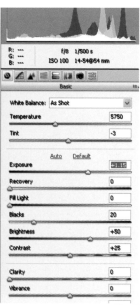

6-17

4. While continuing to press and hold Alt/Option, click and drag the Exposure slider right to increase bright areas, or left to decrease them. Generally you want at least something very bright in most photos, but you have to be very careful as to how much is this bright. White is very sensitive to overadjustment compared to black. In this photo, the edge of the pool should remain bright without clipping (losing detail and color). You can always try moving the slider too far and see how the image is affected, as shown in figure 6-18. This is way too far for any image unless you want some special effects. A lot of the image will be too bright and washed out.

5. Fill the shadows. Next, I like to work the Fill Light control and open up dark areas if needed. In this image, the dark blue lounge chairs got too dark with the Blacks adjustment, so I added some fill light to bring back their color, as shown in figure 6-19. Sometimes it can be important to readjust Blacks to be sure you have the right amount of black in the photo after using Fill Light.

6. Recover bright highlights. Now is the time to bring back overbright highlights with Recovery. In this image, I liked the overall brightness of the light areas. I felt it made it look more like a hot summer day, so I did no Recovery to this shot.

At this point, the image is actually looking pretty good, as shown in figure 6-20. I think, though, that there are some tweaks I could have made to the midtones and the colors. Notice, however, that the colors have been affected in a positive way by these first adjustments. This is why I use this order.

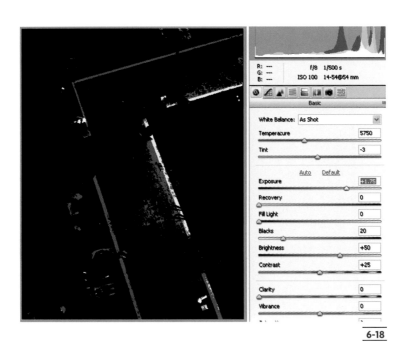

6-18

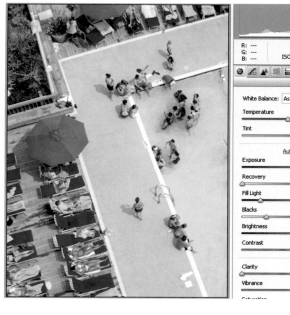
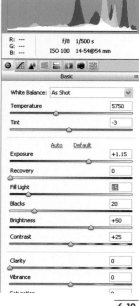

6-19

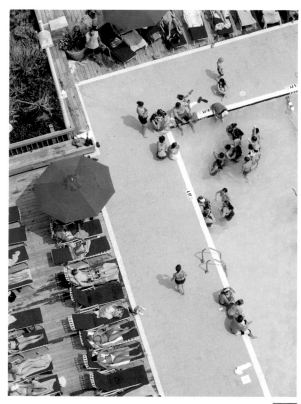

6-20

7. Tweak the midtones using the Tone Curve. I call all tones with detail midtones when looking at the overall process because they are adjusted the same way, by using the Tone Curve. Technically, these tones range from dark to middle to light grays (and the associated colors). The traditional way of using Curves is available with the Tone Curve Point subtab and even includes some pre-set curves you can try, as shown in figure 6-21.

I think a lot of photographers are going to like the Parametric curve adjustments. This way of adjusting the Tone Curve just makes a lot of sense in a photographic way. As a photographer, you know what highlights, lights, darks, and shadows are (or can easily guess). Then you can play with the curve by moving the sliders back and forth until you get the results you want. I liked gaining a little more brightness in the highlights, while bringing down the lights slightly. This gave the image a little more pop in the bright areas. Then I did something similar in the darks and shadows, as shown in figure 6-22. This will not show a lot of difference on the printed pages of this book as the reproduction of the photos here is not the same as a fine print or a high-quality, glossy magazine, but the difference will be noticeable in those situations.

6-21

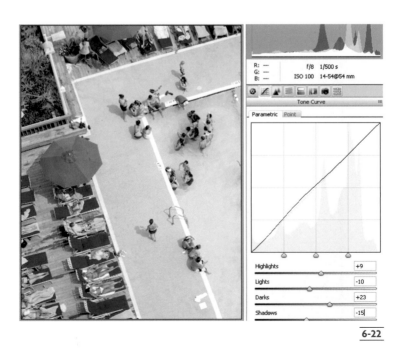

6-22

8. Adjust Clarity. This new control is similar to something some photographers used to do with the Unsharp Mask control in Photoshop. They set a very high radius and a very low amount. This would boost the internal contrast of midtones and give clarity to the image, hence the slider name Clarity. Not all photos look good with this control. Sometimes it makes the photo look too harsh. On the other hand, many images, such as this pool photo, look good with some Clarity added, as shown in figure 6-23. Look at the detail in your midtones and see what happens to them as you adjust this slider. You may need to enlarge the image to really see what is happening.

9. It also helps to see how the image has changed from how it came into the program. You can do this with Preview checked and unchecked to see what has happened in a given processing tab, but it will not show you what you have done overall if you have moved between tabs or you have closed the image (you can always close Camera Raw by clicking Done and the work you have done will be saved). If you want to see the overall adjustment,

PRO TIP

It can help to look at the histogram for additional information. Unfortunately, Adobe has not provided the ability to change it from a full-color, channel-based histogram to an overall, luminance-based histogram. The colors make reading the tonalities in the histogram more difficult unless you have had a lot of experience working with it. However, if you look closely at the colors, you can get an idea of what is happening to them at the extremes (shadows at the left and highlights at the right).

you need to use the Settings drop-down menu. You access it by clicking the little menu icon at the top right of the adjustment panel, as shown in figure 6-24. Now you can go between Image Settings (your adjustments) and Camera Raw Defaults (the original). The effect is shown in figures 6-25 and 6-26. If you find you have lost something in comparing the new with the old versions, you can readjust the image. *Warning:* Be careful you do not adjust anything when going to Camera Raw Defaults or you will mess up your image adjustments.

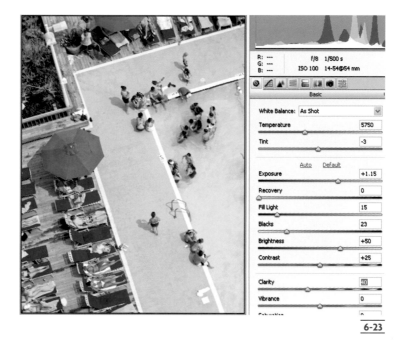

6-23

Basic			Image Settings

White Balance: As Shot

Temperature · 5750

Tint · -3

Auto · Default

Exposure · +1.15

Recovery · 0

Fill Light · 15

Blacks · 23

Brightness · +50

Image Settings
Camera Raw Defaults
Previous Conversion
Custom Settings
Preset Settings

Apply Preset ▶

Clear Imported Settings

Export Settings to XMP

Update DNG Previews

Load Settings...
Save Settings...

Save New Camera Raw Defaults
Reset Camera Raw Defaults

6-24

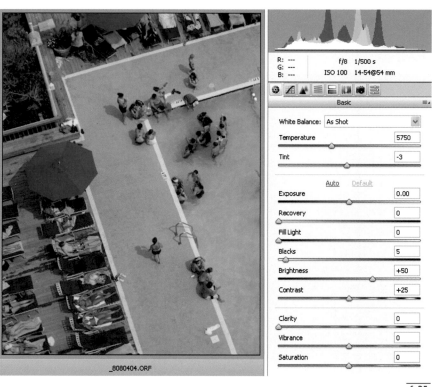

R: ---
G: ---
B: ---

f/8 1/500 s
ISO 100 14-54@54 mm

Basic

White Balance: As Shot

Temperature · 5750

Tint · -3

Auto · Default

Exposure · 0.00

Recovery · 0

Fill Light · 0

Blacks · 5

Brightness · +50

Contrast · +25

Clarity · 0

Vibrance · 0

Saturation · 0

_8080404.ORF

6-25

119

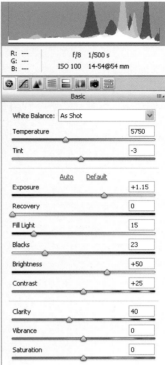

_8080404.ORF

6-26

Colorful Warnings in Camera Raw

Showing the whole image as black with light highlights or white with black shadows is using Camera Raw's ability to show you the threshold of when detail changes to pure white or black. Bright areas without any detail appear as pure white in the black field and dark areas without any detail appear as pure black in the white field. This is far easier to use than the highlight and shadow warnings that are included in Camera Raw. If you check the Highlights and Shadows check boxes above the histogram, you turn on these warnings. Colored areas now appear (red for highlights, blue for shadows) when highlights or shadows in your photo exceed the thresholds for white or black, respectively. These colored areas actually show you the same detail-less areas that the Alt/Option threshold technique shows you, but with less clarity because you have to disentangle these colors from the rest of the photo. You can quickly go back and forth from the threshold view to the real image to compare what is happening when using the technique described previously, but the colored parts of the warning settings make this a little harder to interpret. You can certainly try the warnings, and if they help you, use them, but for me, they add nothing to my work on an image.

10. Small adjustments can make a big difference. Sometimes I wish this interface had two sliders for each control — one for adjustment here now and another for finer tuning. But it doesn't, so realize that small changes can be enough. If you really have trouble doing a small enough adjustment with the slider, you can type new numbers in the box above the adjustment or you can highlight the number and use the up and down arrow keys to change it.

COLOR ADJUSTMENTS

The color of an image is a tricky thing. Some images, like a landscape at sunset, have a natural colorcast that any viewer of this type of photo expects to see. On the other hand, other photos demand a neutral tonality with no colorcast at all, such as an image with skin color that looks bad if it picks up green from fluorescent lights. Camera Raw lets you do both.

In Chapter 5, you learned about the main color tools for Camera Raw: White Balance (how the photo was shot, temperature, tint), and Saturation. The high-angle pool photo looks good right now, but there is more that you can do to get the most out of its color. For your own images, it is always worth looking at these key color tools and what they do for your photos. You may be surprised at how even a small adjustment for any of them can help. Here's how to deal with color using the pool photo:

1. White Balance set to As Shot looks pretty good. This was actually shot at the Cloudy white-balance setting, although if you set Camera Raw to Cloudy, a different look appears. The settings in figure 6-27 do not directly correspond to camera settings, but they give you a quick way of changing white balance. Looking at this image, I think it might look good with a little extra warmth — it was a hot day, after all. You can check this sort of thing quickly by trying different White Balance settings.

2. It often helps to try a little tweak of the Temperature slider. Adding a slight bit of warmth enriches the colors, but too much makes them look unnatural. A nice thing about the latest Camera Raw is that the slider bar actually shows you the colors as you change them. A photographer friend of mine loves to shoot many outdoor subjects with strong warming filters, so he is willing to go farther than I am with this adjustment. Be careful, however, that you do not go too far and make the photo look artificial. Strong Temperature adjustments usually need some Tint tweaking. I added a little Temperature change, as shown in figure 6-28, to warm up the photo, but did not change Tint.

White Balance: As Shot

As Shot
Auto
Daylight
Cloudy
Shade
Tungsten
Fluorescent
Flash
Custom

Temperature

Tint

Exposure

6-27

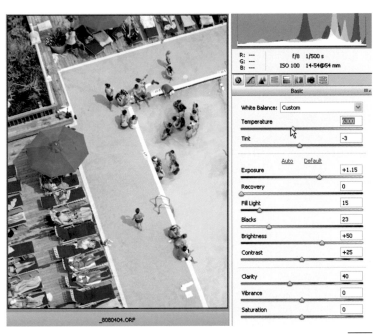

6-28

3. Check Vibrance and Saturation, although this is a very personal decision that you come to over time working with Camera Raw. For this shot, a big jump of about 10 points Saturation helps the color of the walkway (shown in figure 6-29). I rarely go much above +10 for Saturation here. Then adding some Vibrance makes some of the less-saturated colors pop, such as the blue umbrellas shown in figure 6-30. Vibrance is a nice control to check because it does not oversaturate already saturated colors the way that Saturation does.

4. Adjust the saturation and hue of individual colors. In the fourth tab from the left in the processing panel, you see to the HSL adjustment. This is a terrific addition to Camera Raw. It allows you to work individual colors, just like in Photoshop, without affecting other colors. There are more colors here to work with than in Photoshop's Hue/Saturation, and they have nice, tight limits for great control. I thought the path around the pool was getting too red, so I adjusted the hue of yellow, as shown in figure 6-31. Because this is really an abstract image, I decided to boost the color of the pool to make it a stronger graphic, as shown in figure 6-32. Play with the colors to see what works best with your photo. With experience, you select the right sliders quite quickly, but a good way of getting that experience is to just try the sliders, even going to extremes to see what happens.

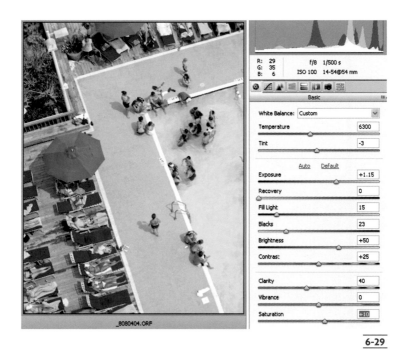

6-29

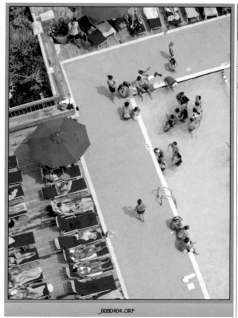

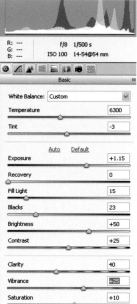

_8080404.ORF

6-30

6-31

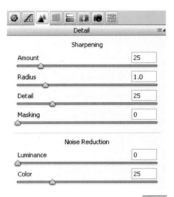

6-32

DETAIL ADJUSTMENTS — SHARPENING

For this photo, the last thing to adjust is noise and sharpness. Camera Raw's noise and sharpening algorithms changed greatly in version 4.2. You find these controls in the Detail tab, the third tab from the left in the adjustments panel. There are six new adjustments here: four sliders for Sharpness and two sliders for Noise Reduction, which are all shown in figure 6-33.

In the past, photographers would typically avoid sharpening too early in the process. However, two things change this for Camera Raw. First, you can do a lot more in Camera Raw, which means you are no longer doing as much in Photoshop that might affect sharpening. Second, the sharpening tools in Camera Raw really are superb.

6-33

Here's how to use them:

1. Enlarge your photo to 100%. There are some special things that happen when you do this, besides being able to see details better. Use the sizing drop-down menu at the bottom left of the interface, as shown in figure 6-34.

6-34

2. Use the Alt/Option key. By pressing the Alt/Option key as you move the Sharpening sliders, the preview changes to a special black-and-white that better shows how the sliders are working, as shown in figure 6-35. You must be at 100% or higher for this to work.

3. Set Amount. Amount is the intensity of the sharpening. When using the black-and-white view shown in figure 6-35, the image is at 100% to better see the change, plus distractions of colors are removed. As you change the amount, be wary of over-sharpening. How much is over-sharpening? That depends on the photograph. An amount of 100 might be perfect for a scene like this, as shown in figure 6-36, yet could over-sharpen a

6-35

6-36

portrait. You really have to watch the photo. For architecture and landscapes, you can sharpen at high amounts, while for portraits and soft flower compositions you would sharpen at lower amounts, for example.

Avoid being overly fascinated by sharpness so that you lose sight of what is really happening to the photo. Watch for artificial halos appearing around strongly contrasting edges. Be careful of sharpening to such a degree that important small

midtone details begin to look too edgy and harsh, losing subtle tonalities. Compare figures 6-37 and 6-38. These are enlarged details of the pool photo. Look especially at the towels. The over-sharpened image in 6-38 makes the towels look harsh, halos are beginning to form around some of the edges, and while it looks "sharper," important tonalities have been lost. Amount is also interconnected with Radius, so you cannot simply check on the amount independent of what you might do with Radius.

6-37

6-38

4. Adjust Radius. Radius is the distance in pixels that Sharpening looks for differences to enhance. This slider only goes to 3 and most of the time you are way below that. The size of your photo (how many megapixels) affects this because as you increase pixels, individual pixels become a much smaller part of the image, so you need to deal with more to have an effect. In the traditional Unsharp Mask sharpening, one needed to be very careful of getting halos around contrasting edges. Here, by using Alt/Opt with the slider, you can see the effect much better. Look for important edges showing up and then quit, as shown in figure 6-39.

5. Work Detail. Detail looks at how detail is seen by the sharpening algorithms now in Camera Raw. This is a bit like Threshold in Unsharp Mask, but in reverse. You see more detail coming out as you move the slider to the right, as shown in figure 6-40. If your image has important detail, it can be worth using this slider to enhance it. However, it can bring out the wrong detail, too, such as image noise or unflattering facial texture in a portrait. Use it with care.

6. Set Masking. Masking affects the areas where the sharpening occurs. By masking parts of the image, you can block sharpening in places it isn't needed and restrict it to important edges. This can be very important if an image has a lot of noise. There is not a lot of noise in this photo, however; if there were, you might find it in solid areas like the umbrella, which is masked in figure 6-41.

6-39

6-40

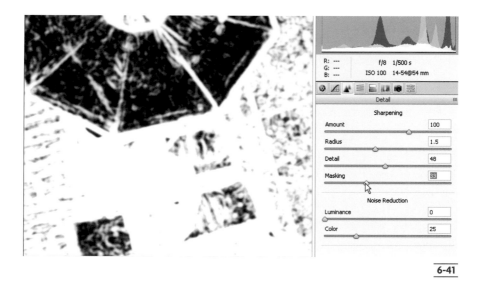

6-41

DETAIL ADJUSTMENTS – NOISE REDUCTION

Noise reduction is an important control for digital photography, although camera manufacturers are doing some amazing work to reduce noise coming from their sensors. Still, underexposed images can increase noise dramatically, regardless of how well a sensor works when exposure is right.

Adobe has refined the noise reduction algorithms for Camera Raw. They were okay in the past, but not great. Now, they are much more usable for all sorts of noise reduction. There are two controls under Noise Reduction, as shown in figure 6-42 (note, too, that the image has been magnified in order to look for noise):

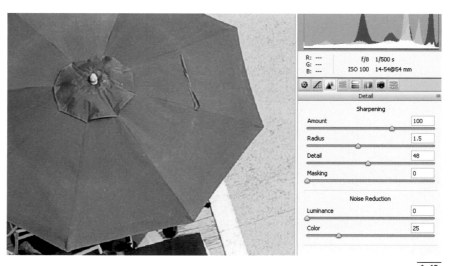

6-42

> **Luminance.** This affects the general noise that comes from a sensor and may be seen in skies and other smooth tones.

> **Color.** This affects color noise effects that often appear in dark parts of an image, especially when that image is underexposed.

These noise reduction settings really are not for getting rid of problem noise but to reduce normal levels of noise so that the image goes into Photoshop as good as possible. If you use these controls to try to remove high levels of noise, you can cause problems with details in the photo. You are better off, in those situations, using noise programs specially designed to deal with noise problems (including independent software such as Imagenomic Noiseware, Kodak ASF GEM, or Nik Software Dfine).

Back to the pool photo. It is very important to enlarge your image to see the noise. You usually cannot see noise if the image shows less than 100% in the preview. Good areas to see noise are in smooth toned segments of the image, such as sky. Noise can be hard to see in highly patterned areas. The noise is pretty tight in this image and does not show until magnification hits 200%, as shown in figure 6-43. I used the Zoom tool, or magnifier, to enlarge this particular area.

6-43

1. Check for Luminance noise. Greatly enlarge areas like sky to see what noise might be there. Because this image has very little, a setting of about 10 for Luminance works fine. You can try moving the slider in big jumps back and forth to see any changes that might be possible. I move the image around, looking for luminance noise, by pressing and holding the space bar, which transforms the cursor into the Hand tool. This allows you to click and move the photo inside its preview window.

2. Continue searching for Color noise. I again use the Magnifying tool, this time to greatly enlarge a dark area, as shown in figure 6-44. Now I look for chromatic or color noise. This image is very clean, so no Color Noise Reduction needs to be added. Actually, I reduce it to a minimal amount because Color Noise Reduction reduces color in the little details — in a photo like this, all of the color that comes from small details in the composition is important.

PRO TIP

When you greatly magnify an image in Camera Raw, it can be hard to move around to another location in the photo. Use Ctrl/Cmd+0 to get the full size of the photo. That way you can quickly find a new place to magnify in a totally different area; then use the Magnifying tool to go to a new area. This saves a lot of searching at magnified levels.

SAVE YOUR WORK

The default for Photoshop CS3 is to automatically update your adjusted Raw file's thumbnail in Bridge whenever you click Done, Open Image, or Save Image. This is not a permanent change — actually, nothing at all in the file itself is changed, only the instructions about processing this file have been changed so that this file reopens in Camera Raw with these settings.

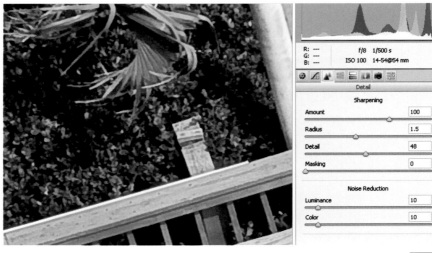

6-44

To keep this photo with its adjustments, you have several choices at the bottom of the Camera Raw interface; from the left: Save Image, Open Image, Cancel, and Done. Open simply applies the settings on your photo as it converts it to the Photoshop working space. This is the most common use of Camera Raw. Cancel cancels everything and returns you to Photoshop. Done merely updates the metadata of the file and returns you to Photoshop without actually opening or saving the image. All of your settings are retained, but this is a specialized and not very common way of using Camera Raw.

When you click Save Image, the Save Options dialog box appears, as shown in figure 6-45. It offers a few different options. Here you can choose a destination for your file, give it a new name, and save an adjusted image as one of four file types: DNG, JPEG, TIFF, and Photoshop (PSD):

> **Digital Negative.** This is Adobe's all-purpose Raw file, Digital Negative, or DNG, and keeps the RAW data of your original intact while saving to a new file. This format is still developing; it is good for archiving RAW files. For most purposes, you can use the default settings (lossless compression and medium JPEG preview).

> **JPEG.** This type of image file can be opened on any platform. JPEG also lets you compress the image when you quickly need a smaller file to send to someone over the Internet (or if you have to use a device with limited storage space).

> **TIFF.** This type of file can also be opened on any platform. A TIFF is an uncompressed (or losslessly compressed) larger file.

> **Photoshop.** This file is saved with a .psd extension and is the ideal working file for an image that you want to work on more in Photoshop. (You can just open the image to do this —click Save to keep a file to work on later.)

6-45

SETTING UP CAMERA RAW FOR YOUR CAMERA

Camera Raw recognizes image files from your digital camera. You can set up Camera Raw for some common ways you prefer to work on them. Once you set a new file to some standard adjustments, you can tell Camera Raw to save them by using the Save New Camera Raw Defaults. This choice is in the drop-down menu to the right of Settings, as shown in figure 6-46. However, do this at the beginning of processing an image so that only those repeatable settings have been saved, or you will include settings for adjusting a specific photo, adjustments you do not want to use for all images.

To set up Camera Raw for your camera, you need to do some very specific things to the interface, and then save those changes:

1. Be sure all automation is turned off.

2. In the Workflow Options box, select the most common color space that you want to use (if you are not sure, use Adobe RGB for now).

3. Choose a size that is appropriate for most of your photography. You may find it best to use the native size of the photo (the original megapixels — the choice that does not have a plus (+) or minus (−) after it) or the first larger size.

4. Choose a depth. Most work looks fine at 8 Bits/Channel.

5. Choose a resolution. If you are making prints from an inkjet printer, 240 is a good number. If you shoot for publication, use 300. Also, use pixels per inch.

6. Choose a white balance. Use the setting As Shot.

133

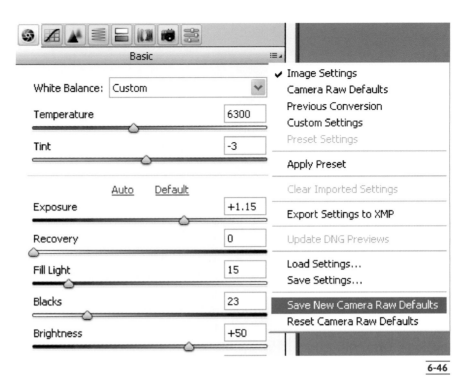

Basic

White Balance: Custom

Temperature 6300

Tint -3

Auto Default

Exposure +1.15

Recovery 0

Fill Light 15

Blacks 23

Brightness +50

✓ Image Settings
Camera Raw Defaults
Previous Conversion
Custom Settings
Preset Settings

Apply Preset

Clear Imported Settings

Export Settings to XMP

Update DNG Previews

Load Settings…
Save Settings…

Save New Camera Raw Defaults
Reset Camera Raw Defaults

6-46

7. Do not sharpen images now. Because sharpening is very subjective and based on the subject and photograph, don't set any sharpening controls in the Detail tab.

8. Go to the drop-down menu next to the right of Settings (click the circle/arrow button) and choose Save New Camera Raw Defaults. These settings now occur any time you open a RAW file from the same camera. There are several other options in this menu.

> **Load Settings, Save Settings, Save Settings Subset.** You can choose these when you work on an image from a shoot that has consistent conditions, such as a studio shoot. You can save the settings used to adjust one photo, and then use those same settings on other photos without changing the Camera Raw defaults. You simply make the adjustments needed, save the settings, open a new photo, and then load

the settings. You can even make variations of such settings by choosing Save Settings Subset.

> **Export Settings.** This allows you to save the settings for use on another computer. Use Auto Adjustments turns on all auto settings, which I do not find very useful. Reset Camera Raw Defaults takes you back to the original Camera Raw settings, which is useful if you think the default settings have changed and you need to return to the original starting place.

> **Preferences.** The Preferences button in the toolbar above the photo opens a Camera Raw Preferences dialog box (shown in figure 6-47) where you can control a couple of small features. One is how image settings — the adjustments you make to your file — are saved. Remember that when settings are saved with a RAW file, nothing is actually changed on that

6

Workflow Applied

134

6-47

file — this is only processing information or instructions that are applied when the file is opened. You can always change them. Sidecar XMP files are small system files that Photoshop keeps with your photo and lets Camera Raw and the Bridge know how you have adjusted this file, so an adjusted image appears as a thumbnail in the Bridge and when it is opened in Camera Raw.

Default Image Settings in Preferences have some interesting choices. Leave Apply auto tone adjustments off. The auto grayscale adjustments are okay. Make defaults specific to camera serial number can be helpful when you

are working with multiple cameras and need something like a specifc white balance setting adjusted specially for one. Make defaults specific to camera ISO setting can be helpful in setting noise reduction and sharpening settings to deal with noise at higher ISO settings. You can generally leave Camera Raw Cache set to the default, unless your main hard drive is short on space. This is the thinking room that Photoshop uses for working on Camera Raw images. If you have multiple hard drives, you can set it to your fastest, most open drive. Default settings work fine for the rest.

Q&A

■ **I'm confused. In your first book about Camera Raw, you say not to sharpen in this program. Now you do. Should I sharpen photos in Camera Raw?**

Sharpening affects everything in a photo, including noise and out-of-focus areas that should not be sharpened. By sharpening at this time because you are in Camera Raw, you are also potentially sharpening those things that you do not want to be sharpened. Having noise sharpened, for example, can cause problems as you do further work on an image because other adjustments find and enhance that noise.

In addition, sharpening is best applied to a specific size. A good workflow is to complete all of your adjustments to an image, then save that image as your master. Then you size that master to your finished image size and sharpen for that specific size.

That said, the new version of Camera Raw changes this a bit. You have to think about how many changes you are going to do in Photoshop and how strong you will be making adjustments. If you are doing a lot in Photoshop, you may get better results sharpening at the end of the process there. However, this new version of Camera Raw really does have an outstanding new set of sharpening controls that work very well. I recommend using them whenever you can. If you are doing minimal work to an image outside of Camera Raw, then absolutely use sharpening there. If you are doing more work, try it and see what results you get.

What if I use auto settings? They seem to give good results.

There is no question that the Adobe folks want users to succeed with Photoshop. They aren't going to create anything that automatically results in bad photos, so auto settings do work. The problem is that they are one-size-fits-all sorts of settings. They work by analyzing a photo and then arbitrarily making adjustments based on what is usually correct. But whose standards determine what is usually correct? That's the problem.

If the image looks okay, aren't these standards also okay? They can give you an image that does indeed look okay, but then so does the high-quality JPEG setting from your camera. It seems a waste of time and the power of RAW if you use the auto settings because you can get similar results with JPEG and the camera's internal processing. RAW offers so much more, that to relegate it to auto seems like such a waste.

In addition, the auto settings can be misleading. They can make the photo look acceptable and cause the photographer to miss important adjustments. That's why I turn them off so that they do not appear when I first open the photo. Getting a really good image, rather than one that is mediocre, comes from really interacting with the actual photo and not following auto paths.

ADVANCED TONAL CONTROL

In Chapter 6, you saw a complete adjustment of an image through a Camera Raw workflow. That image, however, was pretty straightforward. This chapter features a more challenging photo as the quest to master Camera Raw continues. You see some of the same things that were done for the high-angle pool shot for this chapter's photo, but it requires different decisions because the tones and colors are very different.

The photo, shown in before (figure 7-1) and after (figure 7-2) versions, is important for a number of reasons that affect how it should be processed. This image is of a small hedgehog cactus in the Mojave Desert. The Mojave Desert is a big place in the Southwest. This group of cactus stems was shot within a short distance of the lights of Las Vegas! A lot of people never realize how many incredible natural areas are very close to Las Vegas (and are threatened by the city's growth). These cacti are in the Red Rock Canyon National Conservation Area, a great place for photography.

I shot the image using flash on a sunny morning (the sun was hazy from light clouds). The flash is off-camera to the left and shot through a small, 10-inch diffuser. The flash controls the light on the cactus and allows the background to go dark. I wanted the mountains in the background, but not visually equal to the cactus. I wanted it to be the "star" of the photo. Making the cactus the star is also affected because I used a wide-angle lens up close to these low-growing plants. This photo presents a challenge because of the light and the range of dark and light tones. Given this, the photo is a great example for showing you how to apply a very practical workflow for Camera Raw.

7-1

7-2

EVALUATE THE IMAGE

You have probably noticed from this book that I strongly believe that as photographers, you and I must always remember we are working on photographs. Too often I have seen photographers get lost in the technology and lose sight of their ultimate goal: making photos look their best. In this book, and in my other books, I try to present more than techniques. I want to give you a philosophy for working digitally that will serve you well as a photographer no matter what you are doing with your images.

To be honest, I really get annoyed when digital experts get too much into workflows based on what "works" in the program and lose touch with the photography. My conversation with them might go something like, "Why are you working that way?" "Because of the numbers. I want to have the best histogram possible for my image," they would answer. "But the photo doesn't look that great," I would suggest. "But doesn't the histogram in the program look great!" they would answer.

Okay, so I exaggerate a bit. You do have to learn a bit about numbers and graphs as well as how to work the controls in any program. But ultimately, the true evaluation of your work in Camera Raw or any other program is, did you get a photo that you like and have you optimized it to look its best? If yes, then you have done your job. If no, then you have work to do. Yet, I have heard digital experts say that they process an image to "retain the best data possible for future use." Huh? Aren't we trying to make photographs, not work as data bankers?

For every photograph you open in Camera Raw, your first step should always be to look at the image and evaluate it as a photograph. Although photographers may follow all the rules and guidelines they have learned for using Camera Raw, they sometimes start to adjust the image too quickly, before they really appreciate what the photograph is all about.

This process does not have to take a lot of time, although like any craft, working with Camera Raw requires more time evaluating images at first if you have never done this before. You want to quickly look over an image to see what its strengths and weak-

nesses are. But even before that, you need to consider what the photograph is about. What is the subject? What are you trying to say about that subject? (This does not have to be anything deep, but it is important to know what you are trying to communicate.) Why is this photograph important to you? Look at the photographic details to gather additional information. What are the highlights? Where are the shadows? Are there contrast issues? What is happening to the color?

In the introduction to this chapter, I point out a few things about this photograph. This photo is important to me because it shows one of the "small things" in nature. I think these sorts of things are easy to overlook and I want a photograph that makes it hard to ignore this little cactus clump. The tonality and color of the image should enhance that idea and not take away from it. This especially supports the idea that you should avoid auto settings. A photograph of flash on cactus should have a different appearance than a simple flower portrait, for example.

Looking at the photo in figure 7-3, you can quickly see from the arrows some of the key concerns for

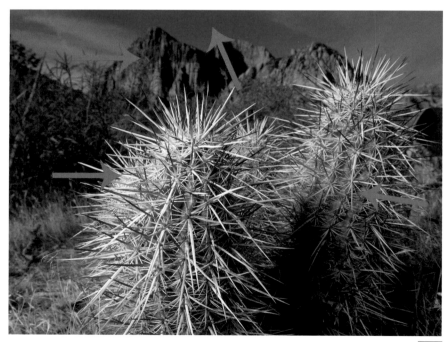

7-3

processing this image. The spines on the left side are bright from the flash. They need to stay bright but must retain detail. The dark mountains need to stay dark, but the tones and colors there can't be as muddy as the original image shows. The sky is also a bit muddy. Finally, the midtones of the cactus itself need some work to give them life.

FIRST ADJUSTMENTS — BLACKS AND HIGHLIGHTS

The first things I am always checking on a photo are the blacks and whites. I have found them to be critical to good tonality and color in photographs. I was heavily involved in the transition to digital in the printing of *Outdoor Photographer* magazine and consistently weak blacks and poor whites were problems. When I teach classes, I find that weak blacks and poor whites make too many photographs suffer and not achieve their best look.

7-4

7-5

So here are the basic adjustments for this photo:

1. **Set Blacks.** Press Alt/Option to check black areas in the photo as you move the Blacks slider. This photo has blacks throughout, though in small areas, as shown in figure 7-4. I felt the image could use a little more strength in the blacks, though; to create a good contrast in the spines of the cactus, I increased the setting slightly, as shown in figure 7-5.

2. **Set Whites.** Press and hold Alt/Option, and then click and drag the Exposure slider and watch for highlight action. This photo has some good high-

lights already, as shown in figure 7-6, but I wanted to be sure that the white spines were really white. Again, this was to be sure I was getting the right contrast in that part of the subject, as shown in figures 7-7 and 7-8. To try to hold detail in those areas is a pointless exercise for a photo like this. Every photo is different in how it responds to changes in whites; in some, you may need to increase them, in others, decrease them. You want to watch the whites to be sure you have detail when needed. But if you don't need that detail (such as pure white spines of a cactus), you can let certain tones go to pure white.

7-6

7-7

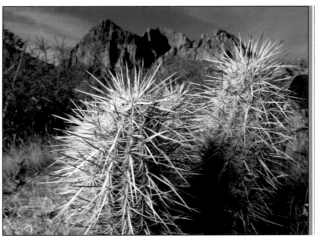

7-8

3. Bring back dark and bright tones as needed. In this photo, I was a little concerned about the dark detail, so I used Fill Light to bring some of them back, as shown in figure 7-9. I didn't think I needed any recovery, but I tried it just to be sure (there is never any harm in trying things to see what they look like). I did not like the results — it grayed down the spines and made them look less lively. These sorts of adjustments are subjective and will depend on your experience in working with a lot of images and what your goals are for a photograph.

TONE CURVE ADJUSTMENTS

Curves has always been an important part of Photoshop's adjustment capabilities (although Adobe's naming convention is a little confusing — the tonal curve control in Photoshop has always been called Curves, but in Camera Raw, it is in a tab labeled Curve and is called Tone Curve). You change this graph of tones from black (bottom) to white (top) by clicking on the line from the bottom left to top right and dragging it up or down.

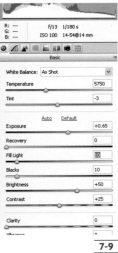

7-9

The advantage of the traditional Photoshop Curves adjustment is it gives you a high degree of flexibility in tonal adjustments and a highly blended way of adjusting. With Curves, you can make one tonality lighter and another darker, for example, and smoothly blend all the tones in between.

As I discussed in Chapter 6, you can use the Tone Curve two ways to adjust your photo: Parametric and Point. If you have used Curves in Photoshop, you will quickly understand how to use the Point Tone Curve. While you can adjust black and white with this curve, it mainly affects the gray tones from darkest to lightest tones (and the colors that match those tones). The adjustment interface does, however, have a few special choices not available in Curves. Here's how to use it:

1. Once the Tone Curve tab is opened, click on the Point tab and try the choices in the actual Tone Curve box first, as shown in figure 7-10. I think it is a great idea because it is automation that you can control! You can choose a curve to start and modify it as needed. There are four choices: Linear, Medium Contrast, Strong Contrast, and Custom. In Windows, you can quickly check the effect of each on your photo by double-clicking the box, then using your up- and down-arrow keys to go through the choices. Linear is very straightforward; Medium and Strong Contrast offer simple S-curves to give some contrast to the image; Custom automatically appears when you make any changes to the first three curves.

2. In this photo, Linear is a little too flat, Strong is too strong, and even Medium isn't quite right. But by going through these choices, you get a good idea of what might be needed.

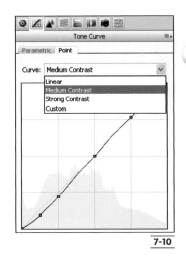

7-10

3. An adjustment of Medium Contrast works here by modifying the lower and upper points slightly, as shown in figure 7-11, to "bring up" or brighten the midtones. The Curve text box changes to Custom.

Here are some points to keep in mind when you use the Point Tone Curve:

> **Things get brighter as you drag control points up and darker as you move them down.**

> **You can select multiple points to change different tones in an image.**

> **Darker tones are at the bottom of the line; lighter tones are at the top.**

> **Small adjustments go a long way.**

> **Contrast increases when the bottom of the curve moves down and to the right while the top moves up and to the left (the curve gets steeper).** It decreases when the bottom moves up and to the left while the top moves down and to the right (the curve gets flatter).

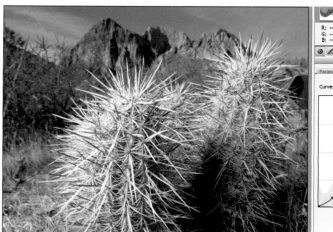
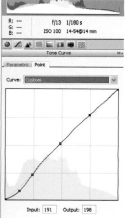

7-11

The new Parametric curve adjustment really works well for an image like this. You don't have to play around with random points on the curve, as shown in figure 7-12. You can go directly to specific tonalities and move those sliders. Here's how that works with this cactus photo, as shown in figure 7-13:

1. Adjust the curve for the most important midtones. This will really vary from photograph to photograph. I don't like to arbitrarily say that you should look at dark tones, or middle tones, or bright tones first. You need to look at the photo. But if you aren't sure, I hope you have the idea of what to do — try something and see what happens! You can always reset it.

2. Adjust the Highlight slider. In this photo, I found that adding a little brightness to the Highlights actually made the photo look livelier and did not hurt the highlights (the really bright areas are too small to affect much if pure white).

3. Adjust the Lights slider. Curiously, adding or subtracting brightness to the Lights hurt the image, so I left it at 0.

7-12

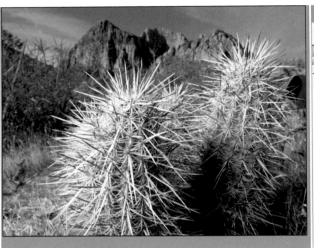

7-13

4. Adjust the Darks. I'd always been a little concerned about the dark areas in this image, and indeed, adding a bit to the Darks lifted them without hurting the contrast of the image. You have to be careful about overadjusting Darks. I have seen photographers use this to bring out detail that doesn't need to be brought out, just because they can.

5. Adjust the Shadows. When I adjusted the shadows in this photo to open them up (brighten them), it started to lose some of its structure and strength. These elements are strongly affected by dark tones in a photo. Again, some photographers try to get detail in the dark shadows because they can, when, in fact, such adjustments hurt the visual quality of the photo. On the other hand, making this photo have darker Shadows did give it more strength, though I felt it also made it harsher than I wanted. I found I liked the photo best when I kept Shadows at 0.

BACK TO BASIC AND CLARITY

Now go back to the Basic tab for a final midtone check with the Clarity slider. This particular photo has a lot of fine midtone detail throughout the photo, making it seem a good candidate for a Clarity adjustment. However, the spines have very strong natural contrast that the adjustments have enhanced so far. Adding Clarity actually makes the photo look too harsh, as shown in figure 7-14.

PRO TIP

The visual quality of an image is not the same as an arbitrary standard of quality based on what photographs should or should not be. Watch what happens to your photo as you adjust it and decide for yourself if any adjustment is appropriate to your subject and your vision.

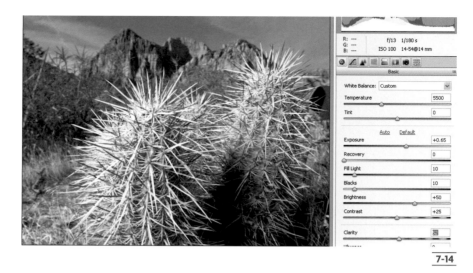

BACK TO COLOR

Now that the tonalities of the photo look good, I can go back to the Adjust tab. Adjusting color in this image is not an easy decision. It is not a "colorful" image, but then, color is not unimportant, either. Overall, the colors are okay, but they could be livelier.

This photo could use a slight White Balance adjustment. It looks reasonable using the As Shot setting, shown in figure 7-15, but it has a slight color cast that I am not sure helps the photo. You can always check other White Balance settings to see how the Temperature is affected and if any changes will help the photo. As I mentioned in Chapter 3, it helps your workflow and consistency if you choose a white balance when shooting. Once in Camera Raw, the photo may still need some tweaking to look its best, however.

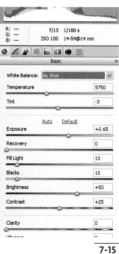

7-15

Here's how to work with White Balance in this workflow step to refine color:

1. Try different White Balance settings. In Windows, double-click the White Balance box to highlight the settings. Use your arrow keys to go quickly through the presets. This is not so much to choose a new preset for this photo but to see what changes seem to improve the image. Pay attention to the numbers for Temperature and Tint when you see versions you like. When using a Mac, you have to go through each choice down the menu by clicking open the drop-down menu every time.

2. Try the White Balance eyedropper. Clicking around the gray rocks of the mountains in the background gave a variety of color balances. The one

shown in figure 7-16 removes the color cast, but now the photo looks too cold.

3. Compare settings and use your own Temperature and Tint numbers. In this image, I noted that the Temperature was 5750 as shot and at 4900 as adjusted in Step 2, with tint at -3 and -10. I found I liked the photo when I set these sliders in between the Temperature numbers to 5500. Then I tried playing with tint between the -10 and -3. I liked the -3 better (it improved the red tones), so I tried a further adjustment to 0, as shown in figure 7-17.

4. Check Vibrance and Saturation. In spite of all the rules and guidelines you might hear, you still have to pay attention to your photo, and this image is a perfect example of this. Vibrance is a great new tool, but for this photo, it brings up the color of the sky (which is okay), but that change is not balanced with what it is doing to the colors of the rock and plants, as shown in figure 7-18. A slight adjustment to the Saturation slider works better for this shot, as shown in figure 7-19.

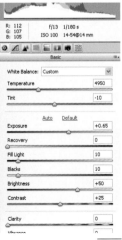

7-16

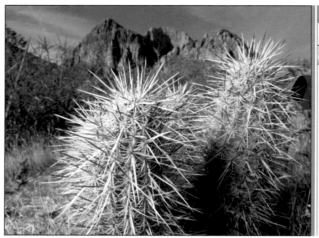
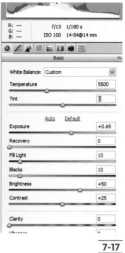

7-17

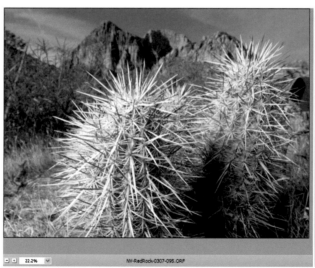
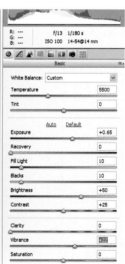

NV-RedRock-0307-095.ORF

7-18

REFINING COLOR

At this point, I could stop. The image looks good, but I think there are some better colors in here, so the next step is to go to the HSL tab. This gives you the ability to do some finer adjustments on the colors. For me, the sky needs a little work and the reds aren't as good as I think they could be. Here's how to work the HSL tab:

1. Go through the image color by color. Start with a weaker color first. If you adjust a strong color first, you are adjusting it against what you see of the weaker colors, which may mean you see and change color relationships based on weak colors with the result that your strong color is not adjusted properly. In this photo, the greens and reds are weaker than the blue of the sky. The warm colors look better and more real by adjusting the Oranges hue, shown in figure 7-20, than

adjusting the Oranges saturation, shown in figure 7-21. The Reds were not as affected (Camera Raw did not recognize them as red as much as orange).

2. Work the image color by color. In this photo of cactus, changing of green sliders had no effect on the photo. However, by changing Yellows more toward green with the Hue slider and increasing Yellows saturation slightly, the greens did improve, as shown in figure 7-22.

PRO TIP

Adobe products don't always isolate green as well as I would like, especially for nature photography. They want to mix it with yellow. While it is true that yellow is part of green, in color theory, yellow is a more distinct color than Adobe interprets it. While you cannot change that, you can be aware of the issue and try adjusting hue and saturation of both yellow and green to affect green.

149

7-20

7-21

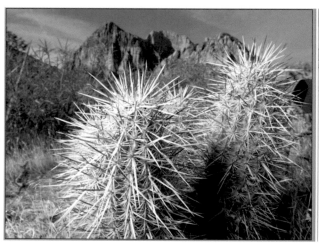

7-22

3. Finish with the stronger colors. Here, I tweaked the blue of the sky a bit to bring it more in balance with the rest of the photo. I added some red to the blue in Hue, as shown in figure 7-23, and then reduced the Blues saturation slightly to make the sky play a good supporting role to the rest of the photo.

Always be cautious in how you adjust the saturation of colors. It is easy to overdo it and make the photo look garish or out-of-balance for your viewers.

PRO TIP

If you close Camera Raw while working on an image by clicking Done, the settings are saved to the Camera Raw file (that is the sidecar XMP file in preferences). The original pixels of the file are not affected, but the Preview will not give you the original image. You must choose Settings ➪ Camera Raw Defaults to see it. You get back to your present settings by choosing Settings ➪ Image Settings.

SHARPENING WITH THE DETAIL TAB

Sharpening is important with any photo, but when you're looking at a spiny cactus, it had better look sharp! The sharpening controls in the Detail tab are excellent and well worth using when appropriate to your work flow (that is, when you are not doing extensive, additional work in Photoshop). Here's how to approach sharpening with the cactus photo:

1. Enlarge to 100% and find a good area to examine for sharpness, as shown in figure 7-24.

2. Set Amount. While holding down the Alt/Option key, slide the amount over to the right until the image looks sharp without looking bad, as shown in figure 7-25. The sharpening starts to look bad when it starts looking too edgy and harsh, and fine tonalities begin to get lost.

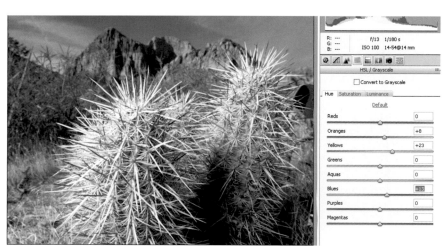

7-23

7-24

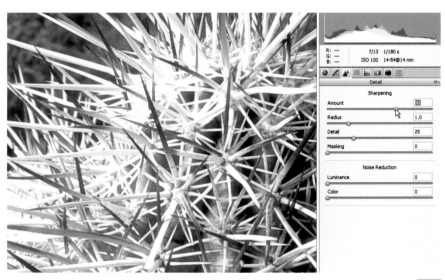

7-25

3. Set Radius. Again hold down the Alt/Option key as you slide the radius to the right. This image is so tight with sharp detail that the radius changes don't show up on the Alt/Option screen as on other photos. I used a pretty standard radius for an image of this size and type of 1.5, as shown in figure 7-26.

4. Determine Detail. The detail in this image is very high and there is little noise. I was able to increase detail, as shown in figure 7-27, while watching what happened to the image because I was, again, pressing Alt/Option as I made this adjustment.

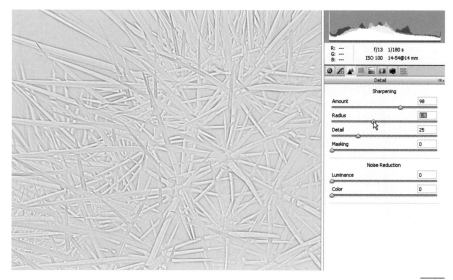

7-26

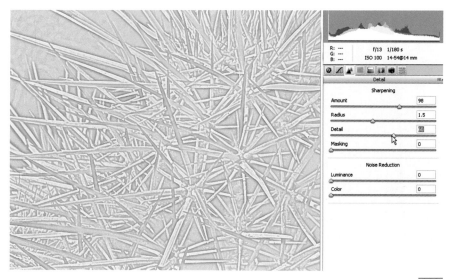

7-27

5. Check Masking. In this photo, there is detail in areas behind the cactus that don't need to be sharpened. By holding down Alt/Option once again, you get a black-and-white screen showing the effects of the slider, as shown in figure 7-28. In this case, it did help to add some masking after moving the active area of the preview to show both the spines and the out-of-focus plants behind the cactus.

6. Adjust the Noise Reduction sliders as needed. I enlarged the image to look for noise and found a slight bit of luminance in the sky. I increased the Luminance slider somewhat, as shown in figure 7-29. There was no significant color noise that I could find, so I made sure it was at 0.

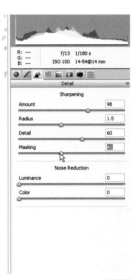

7-28

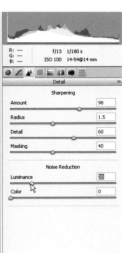

7-29

EVALUATE, AND THEN OPEN OR SAVE

I always like to make a final evaluation of the image before committing to opening it in Photoshop or saving it. There are three things you can do to check your shot before moving on:

> **Preview the image.** Select and deselect the Preview option to see the changes you just made. Use the Camera Raw defaults and image settings options in the adjustment panel drop-down menu (at the top right of the right side adjustments panel — the icon looks like a tiny bit of text) to see the overall changes from all adjustments.

> **Check highlights and shadows.** Are they appropriate to the image? Do you need more or less detail in them? Enlarge your image to better see these areas if needed.

> **Determine if the image works.** Are all the adjustments to the image appropriate to the subject? Look at the photo in the preview (figure 7-30): do your changes make a better photo that communicates more effectively? Are the creative effects you may have wanted doing the job you expected?

Now open the image in Photoshop if you plan on doing additional work or save it for later use.

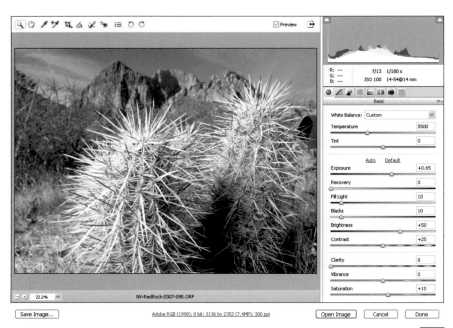

7-30

How does adjusting the Tone Curve affect color in an image?

This is a very important question. Colors are changed two major ways by adjusting the tonal curve:

> **Colors get darker and lighter.** Perhaps this is obvious, but as colors change in tonality, they also frequently shift slightly in hue. That may be of little consequence in many images, but for critical color work, that can be an issue. You may have to do final corrections in Photoshop.

> **As tones darken or lighten, the perception of adjacent colors changes.** This is a key visual tool of artists who often deliberately change tones around essential colors so that the latter colors literally look changed (even though no changes were made to them) and so have a different impact in the image.

When should Brightness be used and when should the Tone Curve be used to adjust midtones?

While there is no absolute rule for this, my tendency is to avoid Brightness altogether and use the Tone Curve. Obviously, if you have an older version of Camera Raw without a Tone Curve tab, there is no choice — you can only use Brightness and Contrast. But with CS2 on, you do have that choice, plus CS3 gives you additional options for using the Tone Curve.

In general, you could quickly do moderate midtone adjustments with the Brightness slider, although technically, you get better tonalities by using a curve. If you have an image that has a lot of gentle, blending colors and tones (for example, a portrait with skin tones), you often find that a curve is best from the start. If you have to do stronger midtone adjustments, the curve is usually the best way to go.

A lot of this depends on the subject. Portraits, as I mentioned, do well with curves, while you might easily (and effectively) adjust an architectural subject with the Brightness control.

What if I never use the Tone Curve? Brightness seems easier.

It is indeed easier. You just have to deal with one slider that affects midtones. It is a little like the middle tone slider of Levels in Photoshop. The Tone Curve, on the other hand, has infinite variety to its use because you can put multiple control points on the curve and use them to bend it every which way, or you can use multiple sliders in the Parametric option.

If you find that you get the results you want from the Brightness slider, don't worry about the Tonal Curve. After all, Camera Raw before Photoshop CS2 had no such adjustment and photographers did just fine with it, creating superb images. However, there are two basic advantages to the Tonal Curve:

> **Control over tonalities is definitely increased.** You can separately adjust the parametric sliders for separate tonal adjustments of shadow, dark, light, and highlight tones. Or you can click on a point at the bottom of the curve where the dark areas reside, increase their level, click on a point at the top of the curve, the home of highlights, decrease their level, and then click to add another point in a different place in the bottom of the curve to further adjust the dark areas. This offers you a lot of flexibility.

> **Gradations between dark and light tones are improved with the tonal curve.** This is because of the way it gradually makes the change between the dark and light tones, which can be especially helpful in images with a lot of fine gradations in tone.

WHITE BALANCE DECISIONS

Color is a critical issue for color photography, obviously. Yet, because it is so obvious, it is often taken for granted. Less than satisfactory color in digital images frequently appears because color balance (white balance) is treated too casually.

You have the ability to control color very critically in Camera Raw through the use of the white balance settings. White balance relates to a specific technique that originated in video production, but here it is essentially the same as color balance — creating a balance of colors based on how the color of light is captured that is appropriate for the subject and the

purpose of the photograph. As I mentioned before, a calibrated monitor is critical for the best results when you evaluate color.

Three examples in this chapter show the range of possibilities of color adjustment using the white balance controls. The finished versions of the three photos — a seascape on a cloudy morning, a dusk/night scene, and a very colored image at a public aquarium — are seen in figures 8-1, 8-2, and 8-3. The tonal adjustment process is included, but it is abbreviated from the previous chapters.

8-1

8-2

8-3

A Neutral Subject is Rarely Neutral

The photo shown in figure 8-4 was taken on a cloudy morning in Acadia National Park in Maine. When photographing nature, you sometimes just have to get up early and be on location at sunrise, at least hoping for sunrise, when the sun might not appear at all. This was the case here. I liked the clouds and the water, but the scene just didn't seem very interesting — nothing special anyway.

I thought to try something totally different — I used a Singh-Ray variable neutral density filter to allow me to use a very long exposure. I used the filter to knock down the light coming into the lens substantially. I started getting exposures of 15 to 20 seconds. The effects can be totally unpredictable given we do not see over time like that, but it gives wonderful flow patterns and wispy waves. And it gives a unique look to a landscape that has movement in it.

This is a fairly neutral-colored subject, though the exposure combined with the camera's capabilities created a bluish cast to the photo. Looking at water and waves in northern areas superficially, they seem to be mostly neutral white and gray, except under sunrise or sunset warm sun. This scene fits neither condition. In fact, this scene's rocks, trees, and clouds all look pretty neutral. A lot of photographers would accept this coloring because this is what the camera captured. But on closer examination, the "neutral" tones in the scene have slight color variations due to how the camera responded to the conditions. White balance changes to such an image become critical to how a viewer sees the photo, too.

There is no simple or easy way to discuss what is the best color for water, waves, rocks, and clouds because you respond quite differently to the same shot as slight changes occur in the color balance. You may prefer a different balance than another photographer. You interpret your image the best you can, and white balance is a key area of interpretation.

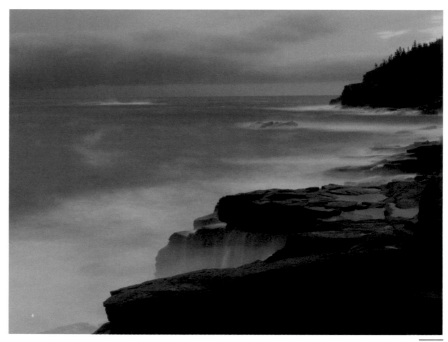

8-4

8

White Balance Decisions

8-5

WAVE TONALITIES INTERPRETED AND MORE

The Acadia shot will be adjusted from the beginning so that you can continue to examine how to evaluate an image as it is processed in Camera Raw. While the entire image is important, it is the waves that must always be watched as they are critical to the photo.

1. In this photo, the subtle tonalities among all the waves and clouds are a very important part of the photo. This is a good candidate for 16-bit output, as shown in figure 8-5, which allows further adjustment of subtle highlight tones, especially, without problems.

2. Check black levels. Click and drag the Shadows slider until blacks appear; remember to press Alt/Option to see the threshold screen shown in figure 8-6. Bringing some black into the image builds contrast between the darkest rocks in the foreground and the waves, clouds, and sky. As the image is adjusted, this early change will add depth to the image.

3. Adjust the Fill Light. I brought up the Fill Light slider a small amount to lift the values of the dark rocks, as shown in figure 8-7, especially in the distant Otter Cliffs. You have to be really careful about overdoing this fill in a moody image like this. You may gain detail, but you will lose the mood.

8-6

8-7

4. Adjust the bright areas. Overall, the photo really has no bright highlights. You have to be very careful about overadjusting highlights in a moody image like this, too. Figure 8-8 shows what happens when the highlights are adjusted "correctly" according to the "correct" use of the threshold screen and Exposure — this does not look good. The photo does need brightness in the bright areas, especially given it was underexposed somewhat (the camera misinterpreted the long exposure

and I did not catch it). Figure 8-9 brings in brightness to the bright areas through the use of Exposure, but without hurting the overall mood of the photo. This is not a simple thing because you can also adjust the bright areas by using Recovery (which doesn't really work here — the bright areas start to look muddy) or by using the Tone Curve. Sometimes you can't really know until you try. It's really critical in a photo like this to retain good, rich detail in the brightest areas, however.

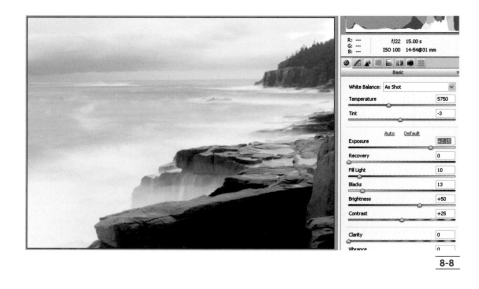

8-8

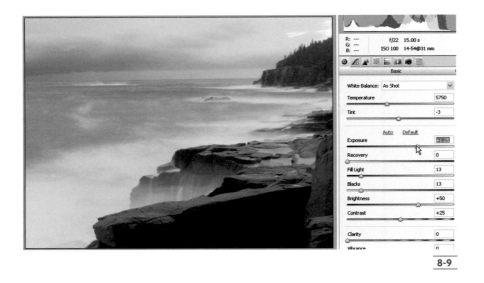

8-9

5. For midtones, a lot can be done with this photo. The bright tones are especially important as they define the sky and water. The dark tones affect the drama of the photo. The Parametric Tone Curve is perfect for this image and those needs. As you can see in figure 8-10, the parametric sliders have been moved quite a bit. This is an image that would be really difficult to make look its best if it were shot in JPEG. It really needs the added capabilities of RAW to allow this sort of adjustment.

Note that this is really an unexpected adjustment for the Tone Curve. Highlights are pushed up, while Lights are pushed down. This is done to bring out more contrast in the clouds and water. You can see how the bright wave action is now showing up better. Something similar was done in the dark tones. You will see Darks are lifted, lightening some of the rock, while shadows are pushed down, keeping the mood of the image.

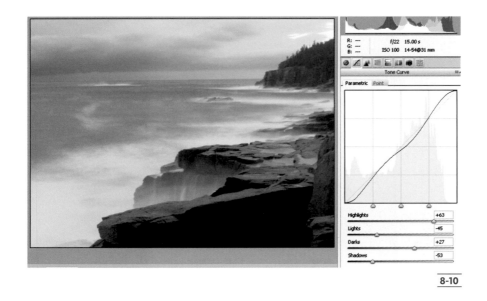

8-10

At this point, the image is looking good, but the color is not where I want it to be. There really is a range of color interpretation possible. Some photographers suggest correcting this color earlier in the process. I don't like to do that adjustment until I find the basic structure of the image, which comes from how tonalities range from dark to light (unless the color is really way off and affects judgement of those changes). This structure affects color, so I want it in place before I start changing color.

PRO TIP

I believe you must pay attention to what your photo is telling you as you adjust it. Don't adjust "by the numbers" or based strictly on what anyone tells you (including me!). Every photo has its own strengths and beauty. Your job is to uncover that during your processing.

CLOUD, WATER, AND ROCKS COLOR

Overall, the photo definitely looks a little blue at this point, but then, the image is an early morning shot, so that can be a valid interpretation of the image. I don't like the blue, however. Here's how to adjust this color:

1. This is an ideal job for the White Balance tool because there are so many different shades of white and gray to work with. This tool has minimal effect on tonalities, and it is mainly used to remove color from neutral tones. You can click in various places in the clouds, water, and rocks and see many different, though slight, variations in color. Both the Temperature and Tint settings change as you click.

 By clicking on the center, bluish waves to remove the cold in them, the photo gets very warm, as shown in figure 8-11. This does greatly increase the color temperature, warming up the photo, but I think it is perhaps to an excessive level.

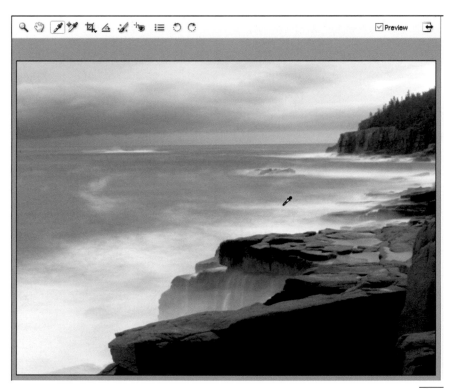

8-11

2. As the White Balance tool is clicked around the photo, you will see the Temperature and Tint numbers change. You can see that the overall effect of warming has a nice look on this photo, but finding what is best takes a little trial-and-error clicking in different places across the photo. This does not take a lot of time to do, especially with experience as you will learn to find the tones that should be neutral. The color in figure 8-12 comes from clicking on the rocks in the central part of the frame. Now the image still has the mood of a cloudy, bad-weather-on-the-horizon morning, but it has lost its blue cast. Notice, too, how the red in the foreground rocks has become more obvious, too.

DUSK LIGHT

When photographers shoot film, they are stuck with one basic interpretation of a night scene's colors, depending on the color balance of the film. Tungsten film has a different look than daylight film, for example. Some adjustment can be made with print film, but this is not always completely satisfactory.

Film and digital cameras see night a little differently than the eye does. The eye/brain connection compensates for color differences among lights and sees things more neutrally than film or digital capture. This is not so bad because it gives wonderful color to a scene by intensifying color differences among light sources. The problem: Which light source color is right? Different color- or white-balance settings change how the colors of lights appear (and their effects on surroundings) in the photograph.

The photo I'm using for this next example is affected by the warm, late light from the sunset sky (the sun has already set) as well as the street and building lights. One thing to keep in mind is that the color of the actual light source will not appear as anything except white if the exposure allows that light to wash out. That is normal, however, and trying to retain such color in most lights will likely damage other tonal relationships in the photo.

DUSK INTERPRETED

Figure 8-13, an image of Los Angeles about 20 minutes after sunset, captures colors of the western sky reflecting off the buildings, plus the mountains are enhanced by the light created by the afterglow of dusk. Street- and other city lights add contrast and color to the image.

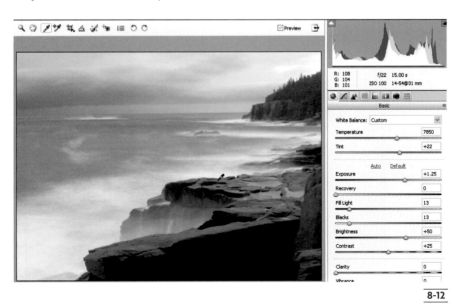

8-12

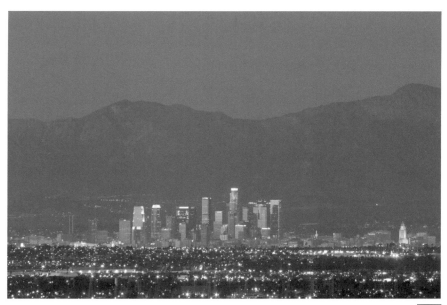

8-13

The photo has a serious adjustment problem. Haze in the sky weakens its contrast and tonal qualities. This haze-induced problem needs to be fixed as obviously haze can't be removed from the air at the time of exposure (and it is overemphasized by the camera). Otherwise the photo will never quite look right and colors will never reach their potential. In most cases, those tonalities must be adjusted first before critical work is done on the white balance. Here's how to adjust this photo with these concerns in mind:

> **Blacks.** This is the critical adjustment, not just for contrast and tones, but also for color, as you quickly see. Increase this setting until blacks begin to appear in the shadows at the bottom of the photo, as shown in figures 8-14 and 8-15. Immediately, a more dynamic dusk shot appears.

> **Fill Light.** Using a bit of Fill Light here gives more of a feeling of dusk rather than night, as shown in figure 8-16.

> **Exposure.** It's just about perfect in figure 8-17. Any increase of Exposure removes colors from the lights. Any decrease of Exposure only makes the photo dark. Recovery also has little beneficial effect on the image.

PRO TIP

Haze, whether it comes from fog, morning air, or smog, affects both the color and contrast in a photo. If the air is very hazy, don't try to over-adjust the white and black points through Exposure and Shadow. This can lead to an unnatural contrast for the conditions so that the photo looks harsh and unrealistic. Look for a balance that reflects the mood of the scene. Color is another story. Sometimes, you want to get rid of smog color completely, but on the other hand, a sunrise fog results in beautiful color that should be retained.

8-14

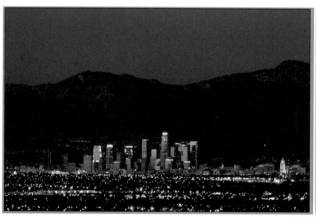
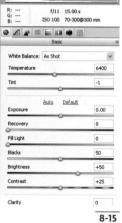

8-15

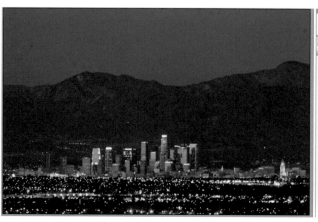
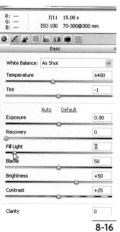

8-16

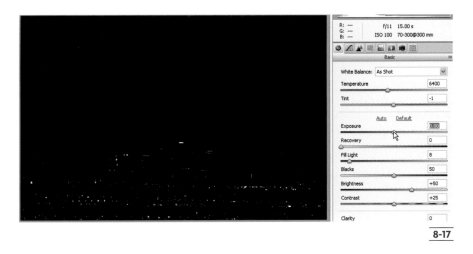

8-17

> **Tone Curve.** A livelier downtown and mountain tonality and color is achieved with the Tone Curve, as demonstrated in figure 8-18. The dark mid-tones need to be brightened slightly, which is done by setting the curve to Linear and then clicking about a third of the way up the curve from the bottom and dragging that point up. This makes the darkest tones a little too bright, so a second point is added slightly above the bottom of the tone curve and this point is pulled down. This movement of the curve down also makes the upper part of the curve rise, pivoting on the first point. This brightens up things like the buildings, which could be a problem in some photos and

would need to be corrected. In this example it looks good, so there is no reason to change the upper part of the curve.

> **Detail — Sharpening.** Enlarge the photo to 100%, and then hold down Alt/Option while moving the sharpness sliders to see the sharpening as it occurs, as shown in figure 8-19. (It shows Amount being moved.) I adjusted each control to give the optimum sharpness for the photo – Amount to affect the intensity, Radius to affect how the sharpened edges appeared (halos), Detail to affect the way the halos appeared, and Masking to limit sharpening to the buildings. You can see

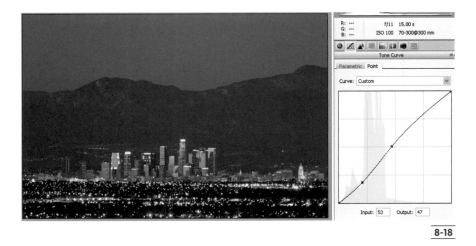

8-18

the effects of each slider best when the photo is at 100% and Alt/Option pressed. The actual amount of adjustment is always very subjective and depends on the subject and your needs for its sharpness (a building will be sharpened differently than a baby, for example). Be wary of over-sharpening. Over-sharpening was a real concern here because the edges of the bright lights have a strong, dark "halo" of sorts, as shown in figure 8-20 (the threshold screen for Radius). As I looked at how the sharpening worked, the dark halo seemed to have little effect on the image, however, and the sharpness looked good, as shown in figure 8-21, so I did not back off the adjustments.

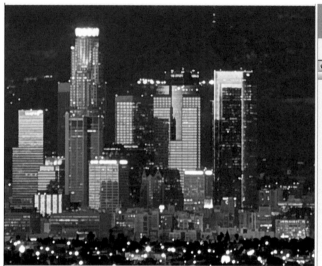
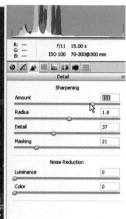

8-19

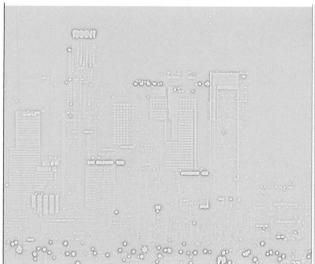

8-20

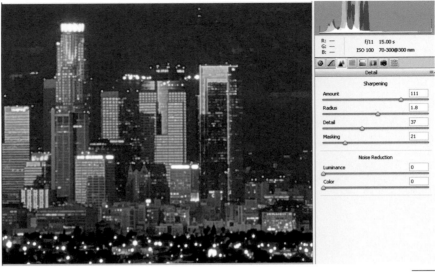

> **Detail — Noise Reduction.** There is a faint bit of noise in the sky. In a picture like this, I would avoid doing any big Luminance Smoothing (there is little color noise), because as Luminance Smoothing increases, details in the buildings may be affected. A little added smoothing can help, however, as shown in figure 8-22.

DUSK COLOR REVEALED

Once you've adjusted the tonalities, adjust the White Balance. This can have a great effect on a dusk photo. Figures 8-23 (Daylight), 8-24 (Shade), and 8-25 (Tungsten) show three radically different interpretations of color due to changes in white balance.

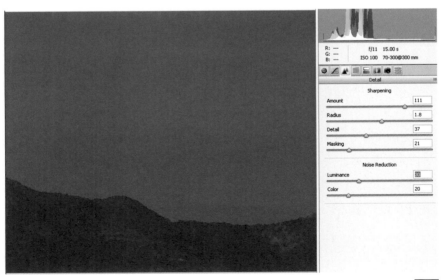

8-22

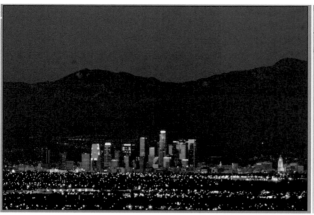

8-23

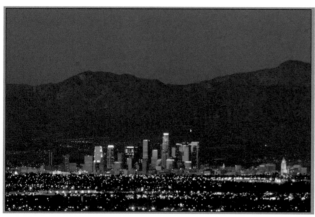

8-24

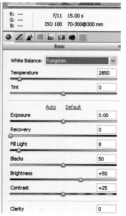

8-25

> **White Balance.** The As Shot setting looks good, as shown in figure 8-26. This is why setting your camera to shoot a specific white balance can really help your workflow. If you can bring a photo into Camera Raw looking good when the default As Shot is set, that means less time for you to make new choices or to figure out what the photo really should look like.

However, this type of shot really shows off how much control you have over the image in Camera Raw. By double-clicking the White Balance settings in Windows, you can then use your up- and down-arrow keys to move from one setting to another. If you work on a Mac, you must select each setting manually by opening the menu and clicking on each. Daylight is an interesting interpretation that makes the scene look more like a night shot. Cloudy warms it up, a little warmer than As Shot (which actually was Cloudy, but

Camera Raw's interpretation is slightly different), including adding a lot more magenta tint. Shade really warms it up, but so much so that it starts to look like pollution more than an attractive time after sunset. Tungsten and Fluorescent give a total night look, but they don't seem natural because of the reflected sky on the buildings. Flash is much like Daylight.

> **Temperature and Tint.** Using the Cloudy setting gives a Color Temperature setting of 6500. This is higher than the As Shot setting and offers a nice afterglow sort of color, except that it is too magenta. Here's where the tint comes in (minus is green, plus is magenta). By pulling it back from the +10 of the Camera Raw Cloudy setting, the tonalities and colors of the scene start to look more believable (the White Balance setting automatically changes to Custom). Going into the minus Tint settings (which adds green to counterbalance the magenta) gives the photo much better colors.

The White Balance tool is not of much use in a photo like this, shown in its final version in figure 8-27. Where are any good neutral tones that you can click? They are difficult to find. This photo does not need neutral tones to look natural. That would not reflect the lighting conditions.

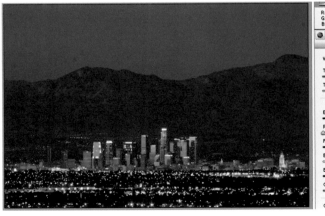
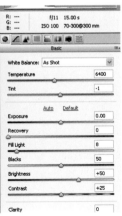

8-26

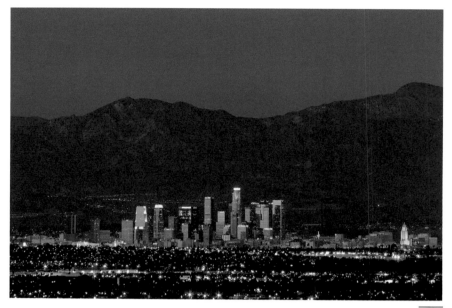

8-27

AQUARIUM GREENERY

In the image of people watching rays pass overhead at the Georgia Aquarium, shown in figure 8-28, the colors are difficult. These colors are not very attractive, although from a purely documentary viewpoint, this photo has accurate colors in terms of what the camera saw in the light (but not what the eye sees). The clear plastic walls and water in the pool are green. But no one sees this the same way the camera does — the eye-to-brain connection makes adjustments to give more natural-looking colors. By the way, if you get to Atlanta, Georgia, I highly recommend visiting this amazing aquarium.

Frankly, the photo's colors, real or not, just don't look right. They need to be adjusted. This is one case where the off-color is so strong that it can help to adjust it before making any tonal adjustments. This is important because the color is distracting. Adjusting blacks, whites, and midtones before the color is fixed can lead to poor judgments in making those changes. Here's how to do this:

1. Adjust the color with the White Balance tool. This is the type of photo where this tool really shines. There are always going to be some nice neutral tones to work with. By clicking around on the girl's white sweatshirt, the photo quickly gains better color, as shown in figures 8-29 and 8-30.

This example really demonstrates the power of Camera Raw and the White Balance tool. Most photos will not have this kind of color problem, but it is nice to know that the software can correct it.

PRO TIP

When shooting real-life scenes, it really helps to preset your camera and have it ready for action before you start photographing. Fumbling with the camera or just randomly shooting continuously in hopes of getting something usually won't get you the best shots. Know your camera. Be prepared so that you can just watch and wait for the action to develop.

173

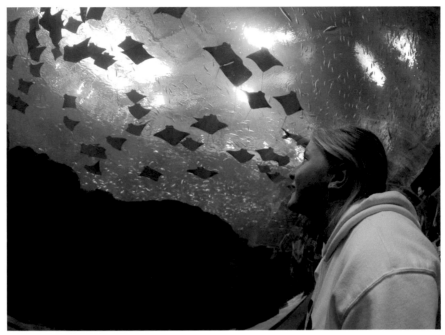

8-28

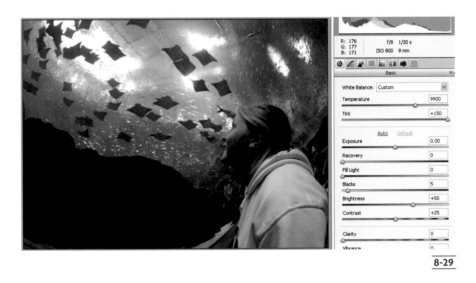

8-29

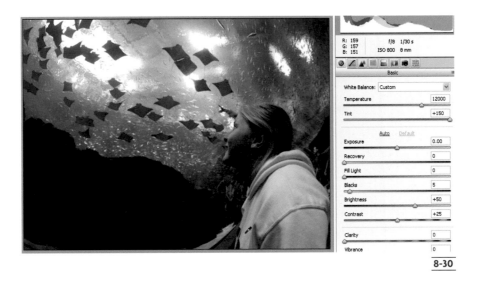

8-30

2. Adjust the Tint. Temperature increased significantly from the use of the White Balance tool, but the most dramatic change was in the Tint. The magenta component of the color soared to take out the green. It seems to be a bit too much, however, so it is worth backing it down somewhat, as shown in figure 8-31.

Now that the color has been corrected, the tonal adjustments can be made. This does not mean that the color work is done. As you properly adjust the tones in any photo of this nature, you are going to need to reevaluate color as you go. The key adjustments are as follows:

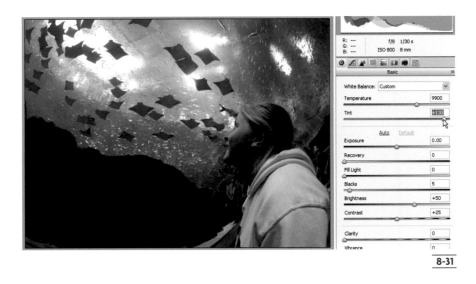

8-31

> **Blacks.** The dark area at the lower left doesn't have enough detail to make it worth using as anything other than a strong black contrast to the rest of the composition, as shown in figure 8-32. It is not pure black because of some noise in the area. I could have made it pure black, but I felt that caused problems elsewhere in dark areas.

> **Fill Light.** Adding Fill Light lifts some of the dark colors, as shown in figure 8-33. However, this much Fill Light also weakens the blacks, as shown in figure 8-34, so they needed some readjustment. This isn't always necessary; it always depends on the needs of the photo and how you intend to use it.

8-32

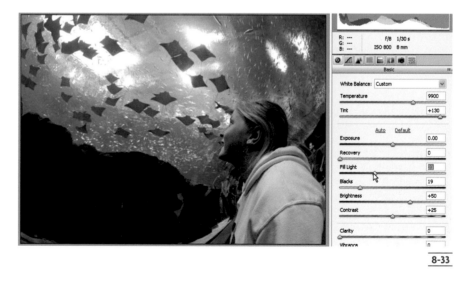

8-33

8

White Balance Decisions

8-34

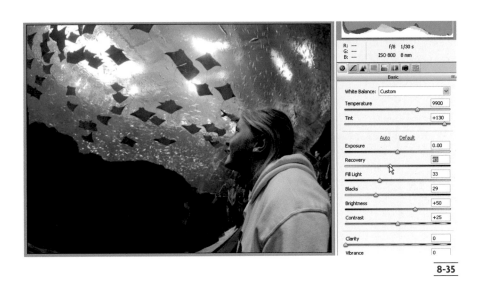

8-35

> **Exposure and Recovery.** The bright lights and the areas around them already pushed the highlights, so I didn't add anything there. However, I did find that increasing Recovery brought in some significant detail in the fish and water around the lights, as shown in figure 8-35.

> **Midtones.** The midtones need major adjustment at this point. This photo has many varied

midtones with many different gradations among them that work well with the Tone Curve, as shown in figure 8-36. You can see that most of the adjustment is in the Lights and Darks. These areas were definitely looking heavy. By raising up the middle of the curve, the midtones throughout the image are improved.

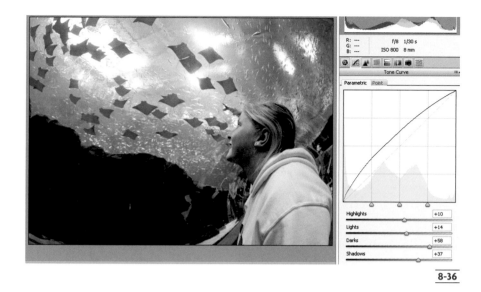

> **Color part II.** Now that you can see the tonal detail in the photo, it is worth checking color again. And there is a problem. The highly colored light filtered through the water gives very little strength to other colors. There is a weakness to the colors of the girl. This would take a lot of work in Photoshop to correct (you don't have the precision controls and masking capabilities in Camera Raw needed to do this). You don't simply have to throw out an image like this. The original color was a sickly green, but maybe giving the photo a different color cast, by trying a new white balance setting, would give a good interpretation to the photo. You can see what happens when Tungsten is chosen, as shown in figure 8-37. This is the great thing about working with Camera Raw — no adjustments are permanent.

The image looks too deeply blue now. After trying the Temperature and Tint sliders in a variety of combinations, the photo has a nice sense of being underwater, as shown in figure 8-38. To me, the color is less mucky and more magical than the image started with, plus the color is a color I chose and controlled, not a color the camera interpreted arbitrarily. You may or may not agree — color is very subjective, as you'll see in the next section. The point is that you have the flexibility to control and interpret color appropriate to your needs and the needs of your photo.

PRO TIP

When you are adjusting color sliders, especially Temperature and Tint, make big adjustments quickly. This will help you better see the changes and what works best for your photo. Avoid small, "tweaky" adjustments as they will mislead you.

Grabbed shots of interesting action in the world around you can have challenging color, as seen in this example. Often, the colors you have to deal with for

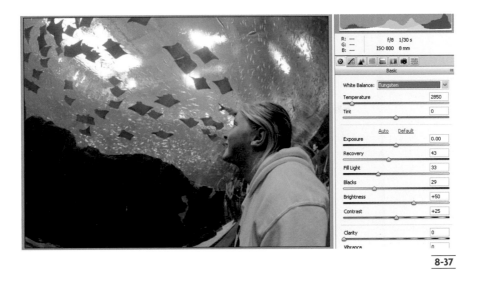

8-37

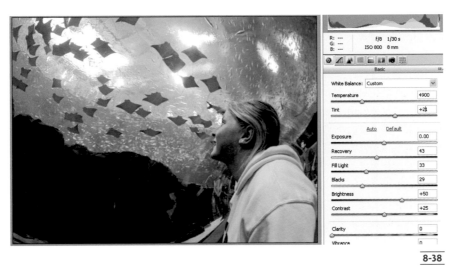

8-38

these types of shots do not record in ways that help the photo. However, it still helps to set the white balance the best you can. Then Camera Raw lets you get the colors right in the processing of the image, as shown in figure 8-39. There is much potential for this kind of photography, but many photojournalists simply accept what the sensor captures. That is often not appropriate or even accurate to the scene. The procedure shown for this example is a good one for this type of situation.

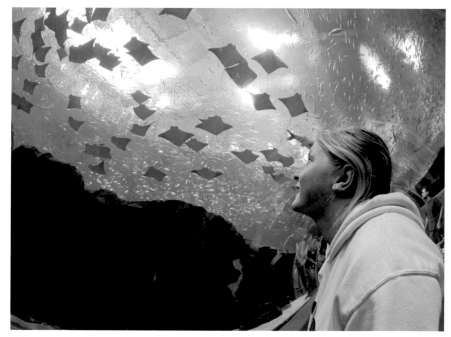

8-39

EVALUATING COLOR

What is the right color for your subject and scene? Ultimately, this is up to you and what you think is best for the photograph. However, there are some tips you can use to help you better decide just what is right or wrong about the color in an image.

KEY COLORS

In many photos, there are key colors that are critical to the subject or to the composition. These are colors that you and everyone else recognizes; therefore, if they are off in some way, everyone will believe the whole photograph is wrong, even if the rest of it is perfect. In figure 8-40, it is the color of the skin tone of the woman that makes the photograph read right, even though technically, the fluorescent lights in the background give an "off" color to it. You need to pay attention to such colors, whether they are the hue of

the sky or the color of skin. If these colors are technically recorded correctly yet do not look right, the rest of the photo will not look right, either. It is sometimes surprising how much influence a key color has over the image. If you hold your hand over that color, the rest of the photo often changes.

8-40

CRITICAL COLORS

For any pro shooting product photography, it is critical that certain colors of the product are adjusted properly. They may or may not be key colors, however; that depends on their dominance in the image. This is where the right exposure, light color, and white balance settings from the start help immensely. If any of these are off, the adjustment takes longer and often results in an unsatisfactory image overall. This is also where a calibrated monitor is absolutely critical — you don't want to be changing a color that is already biased by the monitor display.

You'll usually find it best to enlarge the image in the preview so that mainly the critical color (or colors) is displayed. It can also be very helpful to have either samples of the product or color available when working on your image in Camera Raw, but don't view them casually. Put them on a neutral background (gray or white, with no strong colors) that can be lit with a color-corrected, daylight-balanced light such as those from Osram.

8-41

MEMORY COLORS

There are certain colors that are always remembered in a certain way. Green grass, blue skies, skin colors, red apples, and more — each has an expected color based on what everyone remembers about it, such as the sky in figure 8-41, even if that memory isn't real-world accurate. (This is a little like key colors, but they don't always affect the entire photo like a key color does.) Even if color in a photograph is dead-on accurate, the photo will not look quite right if a memory color is off, even if that just means the subject has an unusual color. People will not believe it. If a color doesn't seem to read right to you, look closer and see if it is one of those memory colors that comes with its own expectations. If it is, try to adjust for it. Sometimes you can't get that color right in Camera Raw, and you have to wait until the image is in Photoshop.

COLORCASTS

Colorcasts can be good or bad for a photo. A *color-cast* is simply an overall color that gives a color to neutral tones and influences all colors in the photo. It can be left in the photo, removed, or modified depending on what you need from the image.

At sunrise or sunset, a photo looks normal with a warm colorcast, such as that shown in figure 8-42. That's what photographs of these times look like. You certainly don't want to remove that colorcast. But indoors, your eyes adapt to many lighting conditions, making colors look perfectly fine in ways that the camera won't. Colorcasts like the warmth of an incandescent light bulb might be welcome if they are not too strong, while a green cast from fluorescent bulbs is never wanted (unless you are going for some creative effect — visually, the human mind does not like green casts in a photo lit by fluorescent lights).

8-42

PRO TIP

Sometimes a problem colorcast is not obvious while you're processing the image in Camera Raw, yet it appears later when you're printing the photo. If you suspect a colorcast at all, it is helpful to correct it in Camera Raw. To find it, you can do two things: first, use the White Balance tool and click in the photo to see if colors improve (you'll see how the colorcast changes); second, increase the Saturation slider dramatically and see if an overall, undesired color shows up (move the slider back afterward).

Sometimes colorcasts seemingly just appear due to a variety of reasons, as shown in figure 8-43 and corrected in figure 8-44 (the latter is more accurate, but the first may be more interesting depending on your preferences). When they contaminate neutral tones inappropriately, then it is time to remove them. In a spring woods, for example, white flowers often have a greenish tint. Also, in low-light situations, you may find a magenta flavoring to colors that doesn't help them and needs to be removed.

WEAK COLOR

There are a number of factors that can cause color to appear weak:

> **Black adjustment.** If blacks are dark gray instead of black, colors suffer.

> **Low saturation.** Digital cameras record color differently than some films, so the RAW file may need a color boost.

> **Color interactions.** A very bright color in the image can strongly influence other colors and make them look weaker, as shown in figure 8-45. There is nothing you can do about this in Camera Raw. You have to make corrections later in Photoshop.

> **Color corruption.** A colorcast can corrupt the key colors, even if it is not an obvious colorcast.

COLOR INTERACTIONS

Colors do not act alone. They interact with each other. If you have the same red in two photos, one on a green background and one on a blue background, that red appears to be two different colors. This is also affected by tonalities — put the same color on black, then on white, and the change is dramatic, even though the color has not changed at all. Obviously,

8-43

8-44

8-45

CREATIVE COLORS

Of course, you can do anything you want to the image and create colors far beyond what you might normally use. This can be a good thing to try in order to create more interest in an important image that just isn't coming to life otherwise. You might, for example, use an indoor light setting, like Tungsten or Fluorescent, for an outdoor scene (like the one shown in figure 8-46) or a Cloudy setting for an indoor scene, just for the color effect that you get. Because you are doing all your adjustments in Camera Raw and will never replace the original RAW file, there is no quality loss doing this. There are no limits to the possibilities here, but I recommend you be careful and use this technique sparingly. On many images, it just looks like a mistake.

you can't change those interactions in Camera Raw, but it is important to be aware of this effect so that you can adjust the image accordingly, especially when dealing with critical or memory colors.

For example, you might enlarge the image so much in the preview that you are missing certain colors in it. Then you adjust the image to make the enlarged area look right, but when you go back to the whole photo, the colors now look off. This is why you always need to check color adjustments critically with the whole image, even if they all look right in the enlarged view. This is also why it is critical that the workspace around your computer has only neutral colors.

8-46

■ **It seems too complicated to shoot white balance presets in the camera. What if I just shoot Auto white balance? I can correct a lot of color in Camera Raw.**

You can do exactly that without affecting the quality of the image. It may mean, however, that you have more work to do in Camera Raw because of the additional changes you often need to make. By setting a specific white balance preset, you can change your angle, move around, and zoom in or out; and your colors are consistent, making that series of photos easier to adjust. With any dusk shot of a city like the one shown in this chapter, using a consistent preset white balance lets you actually see the changes in the light as the sun goes down and the city lights come on. Otherwise, the camera is likely to keep changing the colors so that when you do make adjustments in Camera Raw, you may miss some of the color changes that were there because the camera itself overcompensated.

What if I use black-and-white settings with my digital camera? Do I need to worry about color adjustments in Camera Raw?

Cameras that offer a black-and-white setting record just that, a black-and-white photo, but only in the JPEG file. The RAW file holds all the original color information from the sensor. The camera records information in the file that you shot in black-and-white, but Camera Raw does not recognize those settings for most cameras. (I actually don't know of any that it does recognize for black-and-white, but this is a constantly changing thing, so by the time you read this, it might.) If you want the black-and-white translation made by the camera (and some offer color filter settings that change black-and-white tonalities), you must either shoot RAW and JPEG at the same time (so you have both files) or use the camera manufacturer's RAW converter to recognize the choices. You can use Camera Raw to remove the color from the file, but that won't necessarily give you the same results you saw in the camera LCD.

Shooting RAW + JPEG is a great advantage when you use unique settings on a digital camera, such as black-and-white. This gives you the best of both because you get the black-and-white image you expected (from the JPEG), plus a complete RAW file that you can adjust for either color or black-and-white.

What if I just adjust the white balance first in a photograph? Why should I always do black, white, and midtones first?

You certainly can do white balance first. And in many cases, you'll get similar results. In addition, you should always do white balance first if the image comes into Camera Raw with the color way off.

I recommend doing the black, white, and midtones first because they can strongly affect color. Setting the black point in an image is especially critical and can have a big effect on how colors appear. Two things happen then: first, as the black point is set, all dark tones get a little darker, which makes many colors look a little richer; second, black sets off colors, and any bright color will look different in saturation when next to black.

THE NOISE PROBLEMS
NO ONE TALKS ABOUT

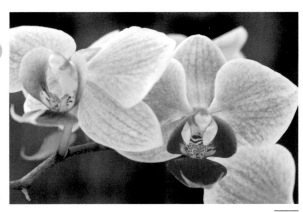

9-1

9-2

9-3

Noise is not a new issue with photographers. As I discuss in Chapter 2, it just had a different name in the past: grain. Grain and noise may come from different things, but visually, they are essentially the same — an artifact of the medium. (An artifact is something that comes into a photograph that doesn't exist in the world but is introduced into the image from the technology used to make the photo.) Noise and grain make an irregular, sand-like pattern over the photo that can range from difficult to see to annoyingly obvious.

Digital cameras today are truly technological marvels, and they promise to get even better in the future. Yet, there are limitations to the technology that can affect the final image. Sensors are limited in how they can capture tones and colors, plus how they can deal with noise. RAW is no magic bullet that solves those challenges, but they can be controlled by the right use of Camera Raw. It is interesting to me, though, that while the controls in Camera Raw that affect these things are usually mentioned in books and instruction about the program, the actual challenges to the photographer that come from these limitations are rarely discussed.

Noise is one of these challenges. I can tell you from personal experience that modern cameras have great noise-reduction circuits and even sensors with much lower noise characteristics, so noise is much reduced from a few years ago. But very important to note is that noise still exists and continues to be a critical issue for the photographer. Noise can be a big problem with any digital camera if exposure is not ideal, ISO settings are high, or you have to do major adjustments to a photo in the computer. Figure 9-1 shows what noise can do to a photograph, but it won't show up as strongly at the size used here, so details in figures 9-2 and 9-3 better illustrate what noise problems can look like.

How the image is processed in Camera Raw affects the noise in the final image. You have seen some basic approaches to working noise in Camera Raw in previous chapters. In this chapter, you see a very different approach compared to what I have discussed so far, or for that matter, in what is discussed in most books about Photoshop. You will start to understand what can and can't be done with noise, and why some of the most common approaches to noise reduction might not be best for your photograph.

PRO TIP

Noise is often more obvious in a print than on the computer screen. Once you have a photo you think you are going to like but have not finished all the processing in Photoshop, try making a print to check out noise problems as well as to get an overall view of the image as a print.

WHEN NOISE BECOMES A PROBLEM

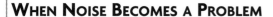

Noise becomes a problem when it distracts from the subject (see figure 9-4) and its detail (see figure 9-5). Sometimes noise can be an interesting creative effect that you can use to make a photo look older, or at least, give it an interesting texture, as shown in figure 9-6. (You can even add it in Photoshop, if desired.) But this is not something most photographers want in the majority of their photographs. However, it is important to note that in certain dramatic photos, especially news or sports photography, you might not notice noise at all because the subject is so strong that it overpowers any attention the viewer might put on the noise.

In photos of subjects such as people, flowers, landscapes, architecture, and so on, noise can definitely be a distraction to your subject and take away from

the appreciation of the photograph by a viewer. Noise can especially be a problem when big prints are made, where noise that you never saw on the computer monitor can appear. I find this is consistently an issue for anyone making prints. It is very easy to overlook certain patterns of noise on the monitor, especially if strong colors or graphic elements overpower it. That noise, unfortunately, appears all too well in the print.

The source of noise starts in the shooting due to several factors influenced by the electronics and digital elements of the camera. Processing an image in Camera Raw and Photoshop can reduce the appearance of noise, but making a noisy photo into a smooth-toned image is not easy. A smooth-toned image needs to be shot that way from the start. You can also increase noise in Camera Raw, if you are not careful in your processing, as you learn in this chapter.

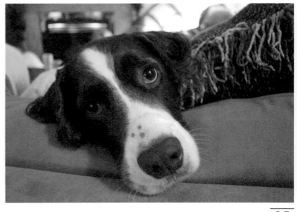
9-7

X-REF

For more about the sources of noise, see Chapter 2.

9-8

WATCHING FOR NOISE

The first step in controlling noise is to be aware that it exists and to look for it. For most images, that doesn't begin until well into the processing workflow when you go to the luminance and color noise controls in the Detail tab of Camera Raw. However, there are some things to watch for that can alert you to noise problems, as seen in figures 9-7, 9-8, and 9-9 (figure 9-7 is the full image; the others are details from it):

> **Dark areas.** Noise quickly appears in dark areas that are strongly adjusted to bring out detail in them, as shown in figure 9-8. Be careful about overprocessing dark areas. You may want to keep them dark (to minimize noise) or work on them in Photoshop (keep the file 16-bit for that) because you gain some more control then.

9-9

> **Underexposed photos.** My comments about dark areas can also apply to underexposed areas: noise can be a problem. You may need to process your image with more contrast so that the dark areas stay black (hiding noise).

> **Saturation.** The Saturation control in Camera Raw and Photoshop can increase the appearance of noise when you use it too strongly (another reason for being careful with this control). This control doesn't know the difference between broad colors that need changes and small details that don't (which is exactly what noise is). High saturation settings can especially intensify chromatic noise (color noise) and they may affect luminance noise as well.

> **Night photos.** Night photography has become extremely attractive for photographers now because of digital cameras. They allow you to get excellent results, as shown in figure 9-10, by using high ISO settings, white balance controls, and long exposures that you can check immediately with the LCD. The down side is that longer exposures with high ISO settings will increase noise. Many cameras have special menu settings for long exposure noise, but even then, you will notice a distinct increase in noise compared to daytime shots. That isn't always bad, as the public generally accepts some noise in night photos (because it is so common), but as digital cameras get better, that will likely change.

The solution to all of this is obvious: Shoot the photo the best you can in the first place, but that doesn't help much when the photo is in front of you in Camera Raw. At that point, you must deal with whatever noise you find. While you can't change the underlying noise, you can be alert when conditions (such as underexposure) might make noise more prevalent. Then you need to watch the image as you process it, being aware of changes in how strongly the noise begins to appear. When you suspect noise problems, enlarge the preview at times — you can

9-10

press Ctrl/⌘+0 to instantly return to the full image — so you can check for noise.

REDUCING NOISE IN CAMERA RAW

With a little experience, you begin to recognize when noise is more likely to appear in a photo. As you become more aware of noise issues, you can use the following key techniques in dealing with noise in Camera Raw:

> **Standard photos.** On many photos shot with newer digital SLR (single lens reflex) cameras, you do not notice much noise, as shown in figure 9-11. Check continuous tone areas such as sky or out-of-focus areas for any noise, as shown in figure 9-12, which is a detail of figure 9-11. A very slight pattern under high magnification is not really a problem (film always had that pattern

9-11

9-12

from grain), but if it seems a little high, you can always try the Luminance Smoothing adjustment in the Detail tab of Camera Raw (usually minor background noise in a standard, well-exposed digital photo is of the luminance type).

> **Moderate noise.** Higher ISO settings or slight underexposure may cause moderate noise in the image, as shown in figure 9-13 and its detail, figure 9-14. This can be reduced to a degree by using the Luminance Smoothing and/or the Color Noise Reduction sliders. You have to look at an enlarged portion of the image to see what effects these have.

> **High noise.** Unfortunately, when high noise appears in an image from the start (such as from a high ISO setting, as shown in figure 9-15 and its detail, figure 9-16, or a very underexposed photograph), compromises are involved to reduce it. The Luminance Smoothing and Color Noise Reduction sliders have some effect, but as you increase their strength, fine details in the photograph are also lost. Your best choice at this point is to adjust the image as well as you can and apply moderate noise reduction, but above all, do everything you can to not increase noise (not increasing noise is different from reducing it). After processing and opening the image in

9-13

9-14

Photoshop or saving it, you can then use noise-reduction software on it such as that built into Photoshop CS2 or an independent program such as Digital GEM, Noise Ninja, or Dfine.

> **Dark areas.** As you lighten areas that are too dark and noise starts looking bad, reduce that adjustment. Sometimes you must make a choice between putting up with some annoying noise if you must see the detail, or keeping the area dark to reduce the noise and lose the detail altogether. You can actually make the area blacker (this makes the photo look more contrasty), which removes or reduces the appearance of noise.

9-15

9-16

> **Saturation.** If you increase saturation, you may notice broad areas of color, such as sky, start to look grainy (sky is a common place for noise to show up with saturation changes). When this happens, back off the saturation adjustment.

WORKING TO CONTROL THE NOISE

In figure 9-17, you see a night shot of Big Ben and the Parliament building in London. This was shot with a moderate shutter speed of 1/20 second, but with an ISO of 400 using a digital SLR with a smaller sensor. The possibility of noise is high and with enlargement of the image, the noise becomes very obvious, as shown in figure 9-18. There is significant chromatic and luminance noise in the dark sky of the photo. There is actually very little noise in the bright parts of the photo, as shown in the detail in figure 9-19. This is typical of an image like this — noise will generally be less (or none) in bright well-exposed parts of an image. (Please note that this image is well-exposed, so what I mean by well-exposed parts of an image are the bright areas that are exposed to gain the best tones and colors; you can't do anything about the dark areas, the "underexposed" shadows, which is correct exposure for the scene.) Noise typically appears worst in the dark areas — that is one place to look for it initially. In addition, you might look for it in smooth areas of a photo, which in this photo also happens to be the dark sky.

9-17

9-18

9-19

The first thing to try here is the Detail tab to see what the noise reduction sliders can do. The new algorithms for the noise reduction feature with Camera Raw 4.x can make a difference. Enlarge the photo to 100% or more so you can see the noise clearly. The color or chromatic noise is strong so it is worth starting with that problem:

1. A good amount of color noise can be seen in the dark background near Big Ben, as shown in figure 9-20. A lot of color noise can be reduced here, but whenever you do such noise reduction, check the rest of the photo. High settings of Color Noise Reduction affect small color details in the photo. As this setting is increased, the color noise is

definitely reduced in a dark background, but some weird things can happen to the color detail in other areas as well. This may reduce the liveliness of the color there — not a good thing. So, I tend to be cautious with the Color slider, rarely dragging it to

a setting higher than 30, as shown in figure 9-21. This is a very subjective move — the amount varies depending on the photo and the amount of noise. It helps to check several areas of the photo as you make a final choice.

9-20

9-21

2. Luminance noise is quite obvious in the dark sky. Because adjusting Luminance also affects subject details, it helps to find something with detail as you do this. Big Ben has great detail in it as well as being right next to the sky's luminance noise. Increasing the slider setting to about 30 does a good job of reducing the noise somewhat without making the tower details look unnatural, as shown in figure 9-22. If you move the slider far to the right, as shown in figure 9-23, the photo seems duller and appears to lose focus, and the small tonal details of the lower part of the tower start to look like some sort of plastic. Little details in the photo disappear if you make such a move.

9-22

9-23

9

The Noise Problems No One Talks About

9-24

Again, this is highly subjective and totally dependent on the photo and what you need from it. Your level of acceptable noise may not match what I find acceptable, but if it meets your needs, that is okay. In addition, a photo with more fine detail that is dependent on a strong feeling of sharpness may not be able to handle a lot of Luminance Smoothing. On the other hand, a photo of clouds may be able to handle a great deal of smoothing because clouds don't have a lot of fine detail.

Looking deeper at noise

The workflow I just described — make normal adjustments, then check noise — works for most photos. However, it is worth taking a little deeper look at this image to see what else is affecting the noise and how that knowledge may lead to different choices in adjustment.

By turning off the noise reduction in the Detail tab for this photo, the noise returns with a vengeance. However, if you look at any of the buildings, the photo actually looks sharper and a little more detailed, as demonstrated by figures 9-24 (no noise reduction) and 9-25 (noise reduction). This is an optical illusion. A trick that experts who work with out-of-focus old photos use is to add some sharp noise to the photo to make it look sharper.

9-25

Another example comes from film. Tri-X is an old film technology that photographers have loved for a long time. Even when Kodak created newer films and threatened to remove Tri-X from the market, photographers still stuck to Tri-X. They loved its tonality even though it is a grainy film. Everyone printed it with the grain as sharp as possible, which gave the film a unique appeal and made it often appear sharper than it was.

This is why noise reduction is always a compromise. You can often smooth out noise quite strongly, but it comes at a cost of making the photo look less sharp and changing small tonalities and details.

But things other than noise reduction can help you deal with noise — adjustments that can be done either right from the start or later on when noise problems become more obvious. Sometimes these can be well worth trying because they have less effect on sharpness and details. This photo shows these effects when noise reduction in the Detail tab is turned off and it is adjusted differently in the Adjust tab.

Here are some things you can do to work with noise beyond just using the Noise Reduction settings:

1. If you have a very dark background, you can increase the Shadows slider setting a little to make the dark areas go quickly darker. This hides a lot of the color noise and some of the luminance noise. It definitely affects the darkest areas of the photo, increasing the overall contrast. This can be valuable in two ways: noise is reduced without affecting sharpness and the image gets more dramatic. In the Big Ben photo, the sky is too bright to do this effect.

2. The Tone Curve parametric sliders sometimes help because you can darken the darks and shadows somewhat separately.

3. Here is where some of the fancy capabilities of Curves (as known in Photoshop) come into play. The point Tone Curve can be limited in its

adjustment to ranges of tones. The darkest areas can be kept dark (to keep noise down) while the dark colors can be enhanced. Click on various sections of the curve to place additional control points. You can use them to pull up or down specific parts of the curve while not affecting other parts.

By clicking on a point in the bottom of the curve to anchor it and then clicking again in the lower part of the middle of the curve and dragging that part of the curve up (readjusting the original points, too), the dark areas get lighter without brightening the darkest parts of the photo with the noise, as shown in figure 9-26. The image looks more night-like and shows less noise than appeared in a more normal adjustment. This photo also needs a little tweaking to the upper part of the curve to brighten the light parts in a natural way.

Rather than trying to bring out all the dark detail, which just means more noise, working the image this way can give it more interesting tonal and color relationships, while at the same time, show less noise.

4. The Saturation slider has a strong affect on chromatic noise. This photo needs no extra saturation; if you added any, this would have an effect. You can actually see how the Saturation adjustment

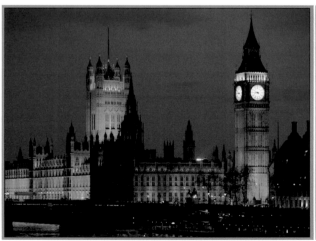

9-26

affects color noise if you magnify an area of the photo that has some noise, and then click and drag the Saturation slider way to the right, as demonstrated in figure 9-27 (Noise Reduction has been turned off so you can see this better in print). That color noise practically jumps out at you. Luminance noise is also increased because as color noise intensifies, the tonal differences that affect luminance noise also increase. When you increase the Saturation slider for a photo with noise challenges, watch color noise carefully.

READJUSTING THE IMAGE

Once you make your best noise adjustment using all the techniques I describe in the previous sections, it is very important to look at the whole image again and see if it needs any final adjustments. There is a tendency (and a real danger to good processing) to check the noise details in a magnified preview, see that they look okay, and then tell Camera Raw that you are done. You open the photo in Photoshop or save it, when you might be better off making some final tweaks to the photo in Camera Raw.

Here's how to check the image for final adjustments:

1. Set the Preview to show the whole photo (pressing Ctrl/⌘+0 is the easiest way to do this).

2. Step back visually and try to see the photo as a whole. It is really easy to only focus on the details you have just worked on. Force yourself to see the overall photo. Don't mess with the Tone Curve at this point if you have used it for the particular changes I describe earlier. Here is one place Brightness can be used to good effect.

Camera Raw Workflow

PRO TIP

Once you finish working an image that has noise challenges, be careful how you sharpen it in either Camera Raw or Photoshop. The Sharpening sliders of Detail and Masking in Camera Raw will definitely affect how noise appears in the photo. In Photoshop's Unsharp Mask, the Threshold setting affects how noise is sharpened. You may need to increase that setting to 6, or even as high as 10. Going much beyond that causes sharpness problems. The Threshold setting is very important for this purpose, which is why Photoshop CS3's Smart Sharpen tool is less useful when you're dealing with noise. Another way to handle noise is to selectively sharpen your photo in Photoshop. Make a copy of the image, sharpen the copy, and then hide it with a black layer mask. Paint in just the sharp parts of the photo with white on that layer mask so that only sharp things are actually sharpened.

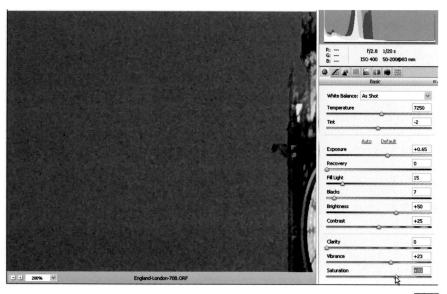

9-27

Q & A

What if I find the compromises are too much? Can I just leave the noise as is?

On some photos, you may need to do exactly that. The night photo in this chapter has a lot of fine detail. If your photo has that kind of detail, you may want to be very careful how much noise reduction you do. Also, as I mentioned, sometimes a bit of noise in the photo makes it look sharper. Don't overdue it, however, because a high degree of sharp noise is very distracting to the viewer unless you have a very special effect in mind.

When working with soft forms, such as clouds, or subjects that may have problems with noise, such as a traditional portrait, you can often increase the noise reduction settings quite a lot without harming the photo. They may even make the skin tones look smoother.

Noise is a very subjective thing. Fine-art photographer Robert Farber is famous for his images with deliberately enhanced grain and noise. On the other hand, you never see a bit of noise in the large-format landscapes of Jack Dykinga. Find where you and your subjects work best with noise.

What if I just used the Sharpening Amount slider to compensate for having to use the Luminance slider?

That line of thinking makes sense. After all, increasing the Luminance slider setting often makes the photo look a little softer, appearing a little less in focus. Adding in the Sharpening Amount control balances this a little.

The problem is that as the Luminance adjustment is increased, fine details start to blur, smear, and disappear. At that point, using sharpening won't help. In addition, it can actually mislead you into thinking that there is more detail in the photo than there really is because the preview looks sharper.

In many noise situations, you may be better off doing sharpening in Photoshop after you do your initial image processing in Camera Raw. You have much better control over that sharpening in the Unsharp Mask control, plus you can try some fine noise reduction software programs, such as Nik Software Dfine or Imagenomic Noiseware.

After applying a lot of noise reduction techniques to a photo, I notice it doesn't seem to have the same crispness and brilliance of other photos. Is that true?

This is a real danger of the noise reduction controls in the Detail tab. The crispness and brilliance of a photograph comes from tiny highlights that a lens resolves and the sensor captures. Unfortunately, those tiny highlights appear to Camera Raw as noise, so as you increase Luminance (mostly) and Color (to a lesser degree) Noise Reduction, these tiny highlights are dulled and blend into the photo. The result is that the whole photo loses a little of its crispness and brilliance. In some cases, the noise may just be too distracting and annoying, so you have no choice. You lose something as the noise is reduced. But in other photos, you may prefer leaving some noise so that other factors in the image, such as image brilliance and sharpness, are less affected.

By now you have a good idea of both how Camera Raw works and how to use it to process and interpret a variety of images shot under different conditions. The program also offers some special features that can be useful when needed, but most photographers will use them on a limited basis. Anyone can take advantage of these controls at any time, with any photo, but except for the new Retouch Tool, you won't need them in the everyday workflow.

In addition, Camera Raw and Photoshop allow for some batch processing, which means you can make adjustments to multiple files at the same time, as shown in figure 10-1. This, again, is not something every photographer will use, but it is important to understand what tools are available so you can use them when you do need them.

One thing that everyone can agree on about Photoshop is that it is a very powerful program with lots of features. There is a similar view of Camera Raw, though to a lesser degree.

Your photos will never need everything in the program. Master what you need. After all, Ansel Adams did all his great work with a limited repertoire of controls compared to what is available in Camera Raw (even if you restrict them to black and white). Then use a reference such as this book to help you with features you don't use as often.

SPECIAL TABS OF CAMERA RAW

So far in this book, two tabs in the adjustment window of Camera Raw have not been addressed: Lens Corrections and Camera Calibration (see figure 10-2). You learn how to use them now.

10-1

Special Features of Camera Raw

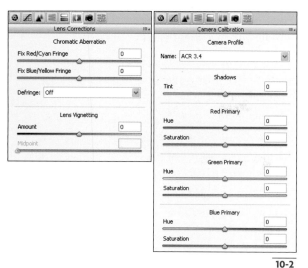

10-2

In addition, Lens Corrections has the Vignetting tool. Some lenses do not give an even illumination of the image area; the outer parts of the composition are usually darkened, as illustrated by figure 10-4 (which has been artificially exaggerated so you can see the effect). It is also possible, with certain lenses, to find the center of the image darkened. Darkening of the outer edges can be a problem with very wide-angle lenses and with lenses with extreme zoom ranges shot at wide focal lengths. It was also quite common with the old mirror telephoto lenses that are still around, but are much less popular than they used to be. The Vignetting tool removes that darkening when the slider is moved to the right.

Lens Corrections is a special tool that you can use to deal with some optical problems that a certain lens may have. Its very sophisticated processing capabilities allow you to remove color fringing (for example, in a magnified part of an image, as shown in figure 10-3) that sometimes occurs along the outside of an image due to a lower-quality lens or other optical issues (color aberrations). It increases the apparent sharpness of the lens and provides better color, especially in the outer regions of the photo.

10-4

10-3

PRO TIP

Many photographers are finding that they can also use the Vignetting control as a creative tool. Clicking and dragging the slider deliberately to the left darkens the outer parts of the image, adding emphasis to the subject and sometimes drama to the photo.

Camera Calibration can be a useful tool when you need it. The name Camera Calibration is misleading for most photographers because what it really does for them is selectively affect colors. (It was originally developed to create camera calibrations — I know of

few photographers who actually use it that way; you have to be pretty geeky to want to do that). It is a little hard to control compared to the HSL tab or other selective controls in Photoshop itself, but it does offer additional flexibility in color work inside Camera Raw that can be helpful when colors don't record as expected in relation to each other.

Fixing Lens Problems

The example photo used here is one that will quickly show problems with lens aberrations. Figure 10-5 is a shot of a low, wet area that had burned and had begun to resprout in southern California. Fires are a significant part of the ecology of much of southern California. They can be frightening and a threat to homes, but most of the plants growing here are adaptable and will regrow as long as fires don't repeat too often. The image is shot from within the wet area with an extreme wide-angle, full-frame fisheye lens. This produces a very different perspective. Color fringing, color that is not part of the subject, shows up on all the dark tree branches near the edges of the frame. Any time there is high contrast like this, there is the potential of lens aberrations, especially with extreme wide-angle lenses.

This photo has no fringing in the center (see figure 10-6) and some toward the outer edges, though you really have to magnify the image to see it. (It shows up as a green edge along the right side of the branches in figure 10-7.) I happen to really like the look of extreme wide-angles and especially full-frame fisheyes. I am willing to put up with occasional issues like this just to get the look. In many photos, this aberration will never be seen — it is the extreme contrast here that makes it show.

10-5

10-6

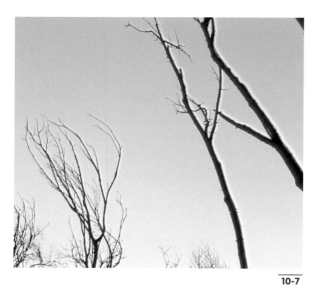

10-7

So to maximize such a lens, I always shoot in RAW because I can make corrections in Camera Raw and fix any problems. Some programs that have claimed to "fix" lens aberrations just mask them by changing the color fringing to a neutral color. Camera Raw goes beyond that and actually shifts pixels for the correction, shrinking the aberration while also fixing its color. It does quite a good job.

CORRECTING ABERRATIONS

Like all the other examples in this book, this photo follows the standard workflow. While the color fringing is strong, it really doesn't affect the overall adjustment of the photo, so it would not be considered a problem that was strong enough to make you want to fix it first. The exposure is good, so the core first steps are fairly straightforward and exactly what you have seen in the rest of the book: blacks, whites, midtones, colors, and so forth. All this has been done to this image already.

The next step is to go to the Lens Correction tab for some lens aberration correction. At this point, you must enlarge the image along some edge so you can see the aberrations, as shown in figure 10-8. This control is worthless if you don't do that. You must see what is there. How much to enlarge depends entirely on the size of the image file and the amount of aberration. You need to enlarge enough to see the color fringing from the lens aberrations. This image required an enlargement to 200% to see the aberrations.

Once you size the preview and find a good sample of color fringing, you are ready to go to work. Color fringing appears most strongly along contrasting edges, such as the small branches of the tree seen here. With this lens, it is quite strong and needs correction to make the photo look sharper as well as to remove odd colors along the sides of the subject.

In the Chromatic Aberration area of the Lens tab, you have two sliders: Fix Red/Cyan Fringe and Fix Blue/Yellow Fringe. Only one fringe type is present in

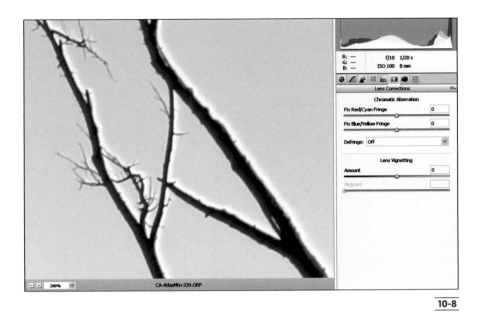

CA-AtlasMtn-339.ORF

10-8

this photo, so you don't need to adjust both. You may find that lenses you work with have only one type or the other, but some will have both. Move the slider until the color along the edge disappears (or at least isn't dominating the edge anymore), as shown in figure 10-9.

As you move the sliders, the color fringing lessens and the image actually shifts slightly to compensate for the colors. This shifting is quite a remarkable achievement by the computer engineers at Adobe because it does not affect everything in the photo. That said, it is a little like the Color Noise Reduction

10-9

Special Features of Camera Raw

10

tool in the Detail tab. You can affect small color details in the photo that are not part of the color-fringing problem, so only use as much as you need.

You will also note a Defringe option with a drop-down menu. This is sort of an automated way of getting rid of the color aberrations, but frankly, I have not found it works all that well. I just use the sliders.

PRO TIP

Once you have a basic correction for a specific lens, you can come back to that correction again and again. Make your adjustments, and then go to the drop-down menu accessed by the menu icon to the upper-right of the adjustments panel. There you will see a Save Settings choice. You can save the specific settings related to your lens to a file named for the lens. Then whenever you need to correct that lens again, you go to the same drop-down menu to Load Settings and load that specific settings file. Changes in focusing distance can affect the aberrations, so you may need to tweak the settings, but at least you have the basics. I cover more on these settings later in this chapter.

VIGNETTING ADJUSTMENTS

Vignetting, or darkening of the image toward the edges and corners, often exists in many lenses. Whether it is a problem or not depends entirely on the subject and your preferences. In many wide-angle images with sky (especially when you use extreme-range wide-to-tele zooms), for example, there is often definite darkening toward the edges of the frame. Some can be due to the change in sky tone as the scene goes farther from a very bright sky around the sun, as shown in figure 10-10, but that is a natural effect. At other angles to the sun, darkening of the sky is not so welcome.

The photo could be evened out ... or not. I happen to like the more dramatic look as is, but a little bit of lightening (moving the Lens Vignetting Amount slider to the right) brightens the corners, as shown in figure 10-11.

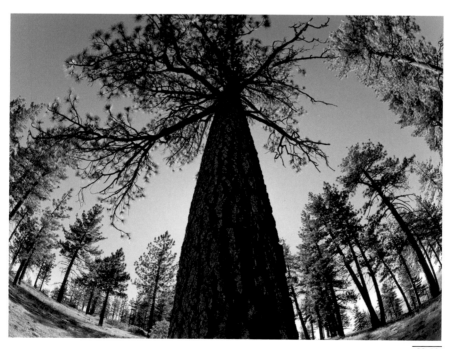

10-10

10-11

Once you move the Amount slider to either the plus or minus side of 0, a new adjustment becomes available below it, Midpoint, which may not be the most intuitive of names. It sort of implies that you can change the midpoint of the Lens Vignetting adjustment. You can't. What it does do is affect the spread of the change. Moving it to the right makes the circle of vignetting larger and more diffuse. Moving it to the left makes that circle smaller and more defined. This adjustment allows you to better match how a lens deals with vignetting problems.

It also allows you to creatively adjust vignetting for a specific effect. You usually do this to darken the edges of a photo, as shown in figure 10-12. This can be an important part of processing your image. It fills the role of "edge-darkening" in the traditional darkroom. Ansel Adams always talked about darkening the edges of a photo to keep the viewer's eye on the image, especially when it is a print. Be careful not to overdo this effect, but it can be helpful in tightening the appearance of and dramatizing your subject.

10-12

Using the Retouch Tool

The Retouch tool is brand new to version 4 of Camera Raw. While it is not quite as flexible as the Clone Stamp or the healing tools in Photoshop, it is a very easy-to-use tool with a minimum of settings, and it is non-destructive, like everything else in Camera Raw. You can clone or heal problems in a photo and that work is not permanent. You can always go back and change your mind and readjust the cloning or healing.

There is a difference between cloning and healing, and neither is arbitrarily better than the other. Cloning is the copying of a specific part of an image over to a new location, covering up what is underneath. Healing also copies a specific part of an image to a new location, but when it is at the new spot, it works to blend the copied image details with the underlying covered part of the photo. That sounds ideal, but in practice, you don't always want such blending to occur.

At the top of the Camera Raw interface, in the Toolbox toolbar, there is the Retouch tool between the Straighten tool and the Red-Eye tool, and when you click on it, two new options appear, Radius and Type, as seen in figure 10-13. Radius affects the size of the circle of change. (The Retouch tool is like a soft-edged-circle brush tool in Photoshop.) Type gives you two choices, Heal or Clone, as seen in figure 10-14.

10-13

10-14

Here's how to use the tool:

1. Magnify the image to the area with the problem that needs work, as shown in figure 10-15. In this photo, I was never really that happy with the moon in the photo. It wasn't big enough to really look good. It looked more like some odd piece of debris on the photo.

2. Click or click and drag over the problem. If you click, you get a healing or cloning, red-and-white circle the size that you set with the Radius slider, as shown in figure 10-16. If you click and drag, you get an expanding or contracting circle to fit the problem.

3. A green-and-white heal- or clone-from circle appears, as shown in figure 10-17, and the healing or cloning is applied.

4. Adjust the red-and-white circle size and position by clicking and dragging, and then move the green-and-white circle, doing these things to get a better healing or cloning. You can also change the type of "retouching" between Heal and Clone to see which does best.

5. To better see the change, click Show Overlay at the top right of the interface (shown in figure 10-18) off so the circles are hidden. Turn the circles back on by clicking again.

10-15

10-16

10-18

10-17

6. You can clear any cloning or healing circles by clicking on any one and pressing the Delete key. (You must enlarge your image in order to do this so that your cursor changes from a crosshair to a pointer when it goes over the retouch circle.) Clear all of them by clicking the Clear All button shown in figure 10-18.

USING THE RED EYE REMOVAL TOOL

You can use the Red Eye Removal tool, next to the Retouch tool, to fix the dreaded red-eye that occurs when a built-in flash is used in a dark room. In that situation, the flash reflects back off of the back of the person's eye, causing the pupil to turn red. It definitely gives the "devil-look" to your subject and is not flattering. Frankly, such light is not flattering either. You can get better shots without red-eye if you use an accessory flash or you have your subjects look at something bright before you take the picture.

Camera Raw's tool is a smart one. You simply select it and use your cursor to drag a box around the eye. Camera Raw then finds the pupil, selects, and darkens it, removing the red without affecting anything else. You do have Pupil Size and Darks sliders that can help you tweak the adjustment, but usually, you can just use whatever Camera Raw decides is right for the photo. Like I said, it is a pretty smart tool.

INFLUENCING COLOR CHANGES

The Camera Calibration tab is not particularly intuitive for photographers. You use it to calibrate adjustments for certain color biases or preferences (it

is even possible to have camera profiles; the default is Camera Raw or ACR). But frankly, few photographers will really use it that way. There just isn't the need except in special circumstances. It can, however, be very helpful in fixing problem color relationships in an image or for cleaning up color contamination in a color.

This set of adjustment controls changes how the basic RGB (red, green, blue) color scheme of the computer is mixed (the tab is shown in figure 10-19), almost like the Color Channel Mixer in Photoshop. (They really are different things, so the comparison is more for a point of reference than any true correlation between these two controls.) You can affect both the hue of each color as well as its saturation, but as you affect those things, the whole color mix changes, meaning that you can rarely adjust just one slider without making some counter adjustment elsewhere. One additional control, Shadow Tint, is also available, which adjusts along the green/magenta line, but mainly in the dark areas.

While this sort of mixing of colors is easy to do with the sliders available, actually using that mixing is not so easy. This is not an adjustment area most photographers typically use. If you have some very precise color issues that must be controlled, however, this can be one place to try so that the adjustments are done to the RAW file rather than to the adjusted file in Photoshop later. This can be critical with product photography where certain colors can be absolutely critical to a pro photographer's assignment.

But I have to be honest with you. With the addition of the new HSL tab, I almost never use the Camera Calibration controls. There really isn't much need to do so — you can do a lot with the workflow presented in this book without ever going to Camera Calibration. I recommend not cluttering your workflow with it unless you have some special need that it can satisfy.

10-19

PRO TIP

Something that I call the Extreme Technique can be very helpful in making any adjustment when you aren't quite sure of how the tool works. To me, it is the best way to use the Camera Calibration controls as most photographers won't be using them often. Move a slider to its extreme positions very quickly. This shows you instantly what the control will do to your image; that is, it tells you the direction to go and what the range of the adjustment offers you. Then you move the slider to the right spot based on how the image looks from that information.

Batch Processing

Batch processing is a way of applying the same changes to a group of image files. This is one of those features that some photographers will never use and others will use all the time. Batch renaming is the most common type of batch processing that nearly every photographer can benefit from. However, if you are a location shooter with lots of different subjects and light, you will not find batch processing as useful to your workflow because you mostly deal with each image in a unique way. The one-size-fits-all approach of batch processing won't work for those images (see figure 10-20). However, it is still worth learning how batch processing works because sooner or later, you will have a group of similar images where once you process the first one, you will want to process all the others the same way to save time and effort (see figure 10-21).

For studio photographers who have a distinctive look that covers many images and for any situations where the exposure and light is consistent, batch processing can be a real help to speed up the whole workflow process. You learn a number of techniques here for dealing with multiple images. Some are not technically batch processing, but they still give you the ability to make adjustments that affect multiple images.

PRO TIP

If you consistently need to quickly process a lot of similar images, you may be best served by going to Adobe Photoshop Lightroom. Lightroom is designed to make such processing easy and efficient. It uses similar processing controls to Camera Raw, so it is not a totally different system (though the interface looks very different). Syncing up adjustments among photos works quite well and is very fast to do.

10-20

10-21

SIMPLE BATCHING RENAMING

An easy and simple way to understand batch processing is to use Adobe Bridge controls to rename a set of RAW photos (it also will rename any other image file). It is a fairly simple process (the process is similar in the old Photoshop browser):

1. Select the files. Open Bridge associated with Photoshop CS3 (either in the File menu under Browse or by clicking the Bridge icon at the upper part of the Photoshop interface by Workspace). Select the files you want to name by going to the desired folder and then selecting them all or a specific group of them. Select All is in the Edit menu. You can label images in Bridge, too, and use Select Labeled, or you can Ctrl/⌘+click individual images to add them to the group (see figure 10-22).

2. Open Batch Rename. You open this dialog box from the Tools menu (see figure 10-23) or you can press Ctrl/⌘+Shift+R.

3. Select a Destination Folder. This part of the process offers you three options: Rename in same folder, Move to other folder, and Copy to other folder (see figure 10-24). Each option is important. If you select Rename in same folder, your chosen images get a new name and stay put. If you select Move to other folder, your images get a new name and are moved to an entirely different folder of your choice (which you choose by clicking Browse). If you select Copy to other folder, your photos gain the new name as they move to a new folder; the original files remain unchanged.

10-22

10-23

Destination Folder
○ Rename in same folder
◉ Move to other folder
○ Copy to other folder

[Browse...] Please select a destination folder...

Most photographers find the Rename in same folder option a simple and easy way to deal with renaming images; that usage is typical of changing names of a folder of images to reflect a specific shoot or location, for example. The Move to other folder option is useful when you select a group of images with a unique subject, for example, and you want to put them with a special name into their own folder. The Copy to other folder option is for obsessive photographers who never want to touch their original files ... just kidding. It is useful when you need separate and duplicate files with their own names for special uses; this is common for stock photography.

4. The New Filenames section, shown in figure 10-25, is a little confusing at first, but once you

understand the structure and how you want your photos named, it has its own logic. First, you need to decide how you want your files named. You can be as complex as you want. This batch tool lets you choose as many as ten separate naming boxes. Once you start using these boxes, a preview of your name choice appears in a preview at the bottom of the dialog box.

5. Create a new box by clicking plus to the right of the first box or remove a box by clicking minus. By default, Camera Raw gives you a whole lot of choices. Don't try to use them all. Pick and choose what works for you. If you shoot all RAW files (or if you did a shoot with all JPEG files), you can pretty much name your files however you want; so a simple choice might be Text, where you label the images with a name using a tool such as Sequence Number, which numbers your files consecutively starting with the number you want and uses the number of digits you select (see figure 10-26). This renaming tool will also keep your original file numbers if you select Current Filename, as shown in figure 10-27. This simply attaches that name to your text from the first box.

10-26

10-27

Each filename box has a drop-down menu, accessed by the down arrow, as shown in figure 10-28. Several choices are available — pick whatever helps you know what the images are. A preview of the changed names appears below these boxes.

10-28

6. In the additional boxes, you can add as much information in the text as you like. This can get unwieldy, but if you are shooting on assignment, this is a way to get a lot of information into the file name.

7. Select the Preserved filename option if you change the file names and you want a way to get back to the original.

8. Select a compatibility option when your photos need to go across platforms and you want to ensure the name is compatible.

9. Click Rename. All the files selected are renamed with the text specified.

GROUP PROCESSING

When Camera Raw was redesigned for Photoshop CS2, a totally new function was added: the ability to process multiple Raw files at once as a group, and this continues in CS3. In addition, Adobe engineers did a remarkable feat in allowing you to then process all of these images in the background while you work on a single image in Photoshop, something that was not possible before (you do need adequate processing power and RAM in your computer, however).

You start by selecting a group of images and opening them to Camera Raw (see figure 10-29). This gives

you a different look to Camera Raw — there is now a strip of images on the left of the image preview, as shown in figure 10-30. All of these images are not actually opened in Camera Raw. That would bog down your computer in a hurry. The image in the Preview is fully opened; the others are simply active in the sense that Camera Raw now recognizes them and can communicate with the files for processing information.

PRO TIP

If you want to process multiple RAW files in the background while working in Photoshop as described, you are going to need RAM and lots of it. Photoshop is a real RAM hog. If it can't get enough, it goes back and forth to your hard drive, so you will hear that drive grinding away, but working much slower than what the computer is capable of. Having a faster processor without a lot of RAM is meaningless because it will sit and wait idly while the image is moved back and forth to the hard drive as it is processed. One or more gigabytes of RAM has now become the minimum standard for Photoshop computers.

As you process the image shown in the Preview (and highlighted on the strip of images), you can apply that processing to all of the photos on the strip in several ways:

> **You can click on any one of the photos in the strip to bring it into the Preview so that it is the key photo to process.**

> **You can select multiple photos in the strip by Ctrl/⌘+clicking (including all by clicking Select All) so that any processing done to one image is then applied to all of them at the same time.** The first photo you select appears in the Preview.

> **You can also process one image separately however you like without selecting any others, and then select other unprocessed, multiple images, as shown in figure 10-31.** Nothing will happen at this point. Click Synchronize and you can apply any adjustments you made to the first photo to all of them.

10-29

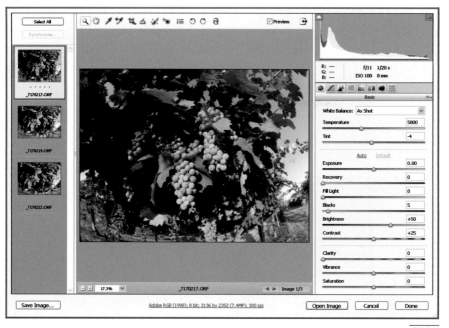

10-30

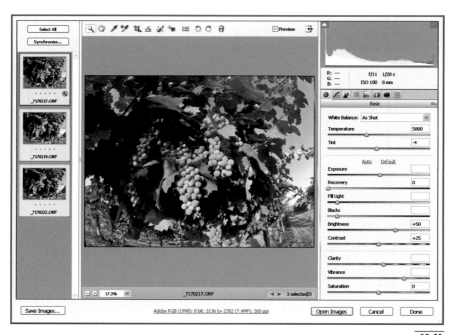

10-31

> **Synchronize is a very useful tool.** Once you click Synchronize, a dialog box appears asking what you want to synchronize. Often you want to only adjust a certain parameter or group of parameters consistently across a group of photos. You start by adjusting one photo as best you can, and then selecting a group of similar images and clicking Synchronize. You then get a list of things that can be synchronized among the photos, as shown in figure 10-32. Select whatever you need; deselect those you don't need. All of the selected photos will update appropriately. Click the down arrow to the right of the Synchronize box to access a drop-down menu that simplifies these choices.

conditions are consistent, so correcting the white balance for one applies to all. You fix the color with the White Balance adjustments for your preview image (and anything else needed), and then select the photos you need to also adjust for white balance. Click Synchronize, click the drop-down menu, and choose White Balance. All of the photos you selected will now be updated appropriately.

> **When your photos have been processed, a little symbol appears below the right corner of images in the strip.** The symbol is a little circle with adjustment sliders in it, as shown in figure 10-33.

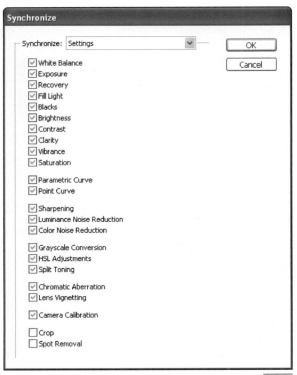

10-32

10-33

> **White Balance is a good example of a useful group-processing parameter.** It is not unusual to have a group of images that have unique Exposure or Shadow needs, but the light color

> Once you have allowed processing over multiple files or synchronized a group of images, you can then open that group (Open Images) or save them to a desired file format (Save Images) as shown in figure 10-34.

If you open your finished group of files in Photoshop, you have to wait for the processing to finish. Selecting Save processes the images and saves them to wherever you want (and allows you to rename the files, too). This processing and saving goes on in the background and you are free to work in Photoshop (although your computer may slow down considerably if it doesn't have enough RAM).

DUPLICATING PROCESSING: SAVING SETTINGS AND PRESETS

Another way of processing similar files in identical ways is to duplicate the processing for one file to use on others later. This is technically not batch processing in the sense that you are processing a batch of photo files at the same time. However, it is still a way of processing one photo in Camera Raw and then applying that work to others in a consistent way.

To do this you use Camera Raw's ability to save its processing instructions. First, open an image file that you can use as a master. A good example of when you might do this would be for studio work. You may have a consistent setup, for example, that you use for portraits. Or you might have a big shoot, such as a wedding, that has similar conditions and you don't want, or need, to process everything at once, so you process one typical photo as a master.

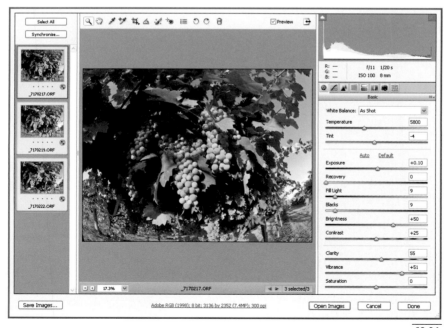

10-34

Here's how to process a photo as a master:

1. Open an image file that you can use as a master. It should have conditions typical of the group of images.

2. Adjust the master image as needed, as shown in figure 10-35.

3. Click the menu icon at the top-right corner of the adjustment panel. In the drop-down menu that appears, click Save Settings (see figure 10-36). The Save Settings dialog box opens, enabling you to save the settings of your adjustments to this photo (see figure 10-37). When you click Save, you will be able to name your saved settings — use a name that is appropriate to the subject type (for example, B&WSet1), the shoot (African Sculpture), or whatever else makes sense to you as a label. Normally, you would save to the Settings folder of Camera Raw, but you can save settings to another location so you can transport them to a different computer.

10-36

4. The Save Settings Subset choice in the drop-down menu is a variation of Save Settings. Save Settings saves all settings, while Save Settings Subset lets you choose what settings to save for reapplying later (see figure 10-38). This is like the Synchronize setting described in the section on multiple file processing. You could, for example, just save the settings for the Lens tab so you could reapply them every time you use a certain lens.

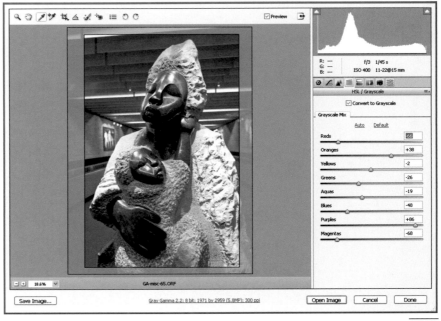

10-35

Whenever you open a new photo that can use the same settings used with your master photo, simply open the drop-down menu to the right of Settings and select Load Settings. You can then choose which settings you need, and Camera Raw instantly updates its corrections based on it. Of course, you can make further adjustments to that image to refine it, but that is the beauty of this system: it allows you to reuse the basic adjustment settings of a master photo.

You can also use the Presets tab in the adjustment panel. This is the far-right tab. Any settings that you save and name appear here, as shown in figure 10-39. This is a convenient place to find saved adjustments, which are now "presets" you can use again and again. There are also a number of photographers who are marketing special presets for certain types of work. Try Googling Camera Raw presets.

10-37

10-38

10-39

Q & A

■ **What happens if I have a lot of corrections to do to an image with the Retouch tool?**

That's really a good question. Because all the work is not actually applied to the image, it sits around as instructions. It can get a bit confusing seeing all the red/white and green/white circles for the tool. Plus, a lot of these can stress your computer's resources in terms of processing power and RAM.

I find that really sophisticated work dealing with problems that need retouching are best handled in Photoshop. It is nice to be able to have the added control over the tools in CS3, plus you can do the work on a layer for even more control.

How can I know if and when a lens has problems that need correcting?

This is a very good question because you don't want to arbitrarily make lens corrections to a file that doesn't need it. That, as I noted earlier, can cause problems with color details. There are some things to look for to help you decide what to do:

> **Lens quality.** While modern lenses are very, very good, there is no question that a low-priced, budget lens just will not match a high-end pro lens. The budget lens is more likely to have lens aberrations, so it can be worth looking for them, especially when the lens is shot wide open.

> **Zoom lenses.** These are also excellent today. However, many manufacturers have pushed the limits with them, and you can often find lens aberrations with the extreme-focal-length-range zooms, especially at the extremes of the range (for example, the widest and most telephoto focal lengths). Wide-angle ends of extreme zooms also tend to vignette, especially at wider apertures. Budget zooms can also have lens aberrations.

> **Contrasts at edges.** Magnify the image and examine strong contrasts of dark and light along the edges of the image. This is where you will typically see color fringing.

> **Skies.** Watch skies and other flat areas of tone where vignetting will appear in a hurry.

If you are concerned about any lens, it is worth doing some tests. Try different f-stops; with zooms, try different focal lengths, especially maximums. Then look at details along the edges of the image.

I know that once I process a RAW file, Camera Raw keeps processing information with that file so that it will be opened the same way each time. Can I move that processing information with the RAW file if I put it into a new folder or to a new location?

Absolutely. If you've spent some time processing images, and particularly if you have worked a whole group, you will want to be sure that work is kept with them. To do that, you need to keep the XMP file with its parent – the XMP file is a small file of processing instructions that is saved by Camera Raw with your original file. On your hard drive where you keep your images, you will discover that a new little file appears next to your image file in its folder whenever you adjust an image file for the first time (after that, the XMP files will just be updated).

When you move or copy your images to a new place, make sure you move or copy the XMP files as well.

MAKING CAMERA RAW WORK HARDER FOR YOU

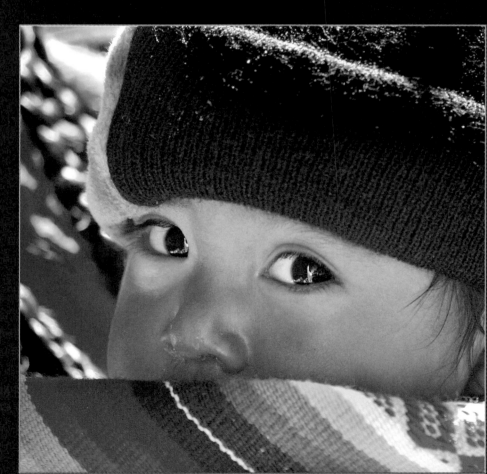

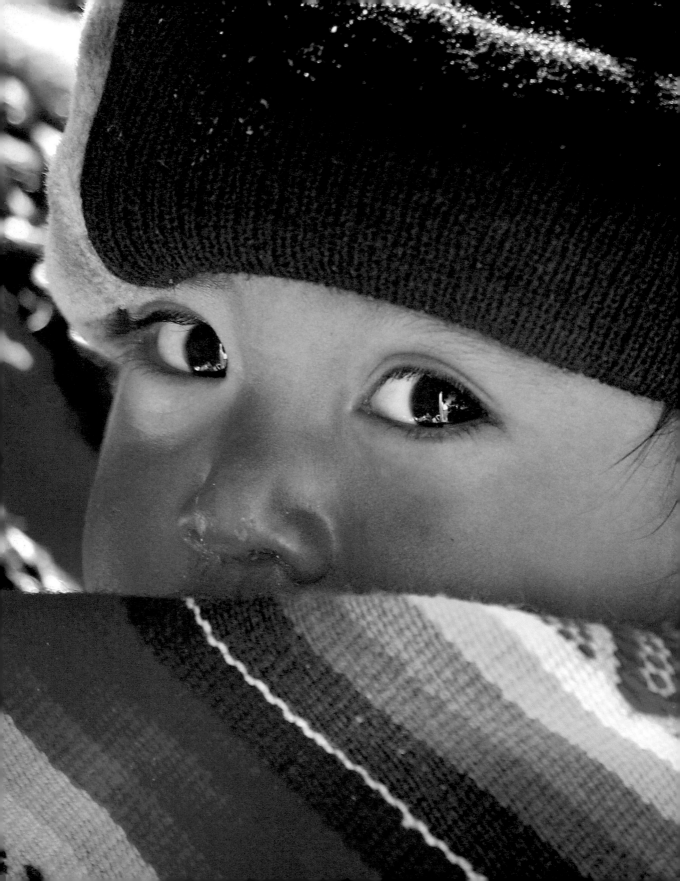

TOUGH DECISIONS

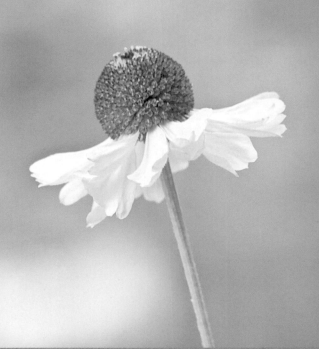

Wouldn't it be great if every photo had a perfect range of tonalities and colors that you could quickly and easily adjust in Camera Raw? Unfortunately, the real world doesn't offer that possibility. Some scenes are dark; others are light. Lighting is uneven; subjects and backgrounds don't match, and so on.

Scenes that do not have a perfect range of tonalities and colors may force you to make some tough decisions on processing in Camera Raw. There are a lot of classes and books about Photoshop that discuss important general image processing and working with problem images, but tough decisions are rarely addressed. Yet, every serious photographer faces them sooner or later.

This chapter gives you more insight on working with Camera Raw while offering some advice on making tough decisions about challenging images. Learning to use Camera Raw to its potential is not about learning all the sliders and adjustment controls. You already know them all by this point in this book. To truly master Camera Raw (and this applies to Photoshop, too), you need to learn to read photos and be able to make the right decisions on how to adjust them. There are three images shown in this chapter — a photo with soft and subtle colors, a high-contrast image shot at dawn and a night shot with totally artificial lighting. Remember that there is no absolute right decision, because any adjustment to an image is always based on your particular style, preferences, and use of the photo.

Soft Colors

Photography has the potential to show all sorts of interpretations of the world. The photo in figure 11-1 is a soft look at a sneezeweed flower in Yosemite National Park. (This is the final, adjusted photo.) This soft, shallow depth-of-field shot is a highly photographic way of seeing. Such an image does not exist for human vision. Yet, it is an interesting and effective way of shooting certain subjects, from flowers to people.

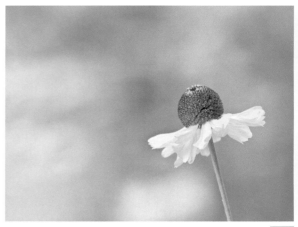

11-1

I took the image along the edge of a meadow high in Yosemite. These meadows are beautiful places, but one has to be careful not to trample all over them. They can get a bit mosquito-ridden at times, but in the summer when these meadows are in bloom, spending some time in and around them is well worth it.

I deliberately shot the photo in figure 11-1 for the effect. The area I was in was so filled with yellow flowers that I wanted to give a visual impression of all that color. The photographic technique for this soft effect is fairly simple:

> **Shoot with limited depth of field using a wide f-stop and a telephoto lens.** This particular photo was captured at 200mm of a 50-200mm zoom lens, shot wide open at f/2.8. This was shot with a Four Thirds format digital camera, which gives a very different effect with a given focal length compared to a 35mm: the 200mm of the lens acted more like a 400mm lens on a 35mm camera.

> **Shoot deliberately through foreground and background elements.** In this case, I moved the camera until I could shoot through flowers and so that flowers would also be behind the subject; but the main blossom is clearly seen and sharp, as emphasized in the cropped detail shown in figure 11-2. It helps to use manual focus and be careful of your focus point.

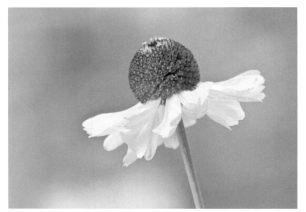
11-2

PRO TIP

Your camera records exposure information for each shot in the metadata (information about the file) kept in the image file. With many lenses, the camera also records focal length. This can be a great way to check how you made a particular shot. Camera Raw does not offer a way to access this metadata; however, the Adobe Bridge does (the old Photoshop CS browser does, too).

No harsh contrasts

If this photo starts looking too harsh, the soft feel of the colors is quickly lost. If it were simply processed by the numbers, so to speak, based on what I discussed in earlier parts of this book, that is exactly what would happen. Here's how that would work:

1. Standard procedure is to press Alt/Option while clicking and dragging the Shadows slider to set blacks, as shown in figure 11-3.

2. Continuing the normal way of working an image, press Alt/Option while clicking and dragging the Exposure slider to set the highlight level, as shown in figure 11-4.

3. Once the brightest and darkest parts of the photo are determined, check the midtones. In this image, they could go darker (see figure 11-5).

11-3

11-4

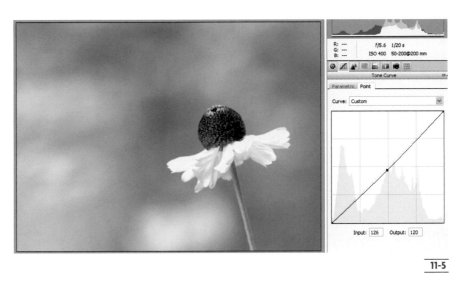

11-5

How a soft image like this is exposed in the camera can be a very important issue. Often, soft colors are attractive because they are light in tone. Dark colors never really look soft and don't make this effect work its best. An overall light-toned subject (including the soft, out-of-focus colors) is often underexposed if the camera meter is used without interpretation. That can mean less quality to the soft colors when they're adjusted in Camera Raw.

Basic choices have been made and the result in figure 11-6 is certainly a snappier image than the original. It is okay, but it really doesn't support the original intent. Such adjustments certainly are acceptable in many applications, but they really aren't what is needed in this case. In fact, many folks do not like the overly-juiced colors of images like this because they have been overdone a bit in nature photography, especially when Velvia film was so popular.

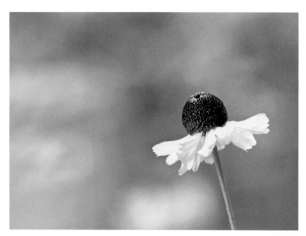

11-6

The original shot as it first came into Camera Raw was also okay, but rather flat, as shown in figure 11-7. The image needs something in between this juiced-up version from standard adjustments and the original capture from the camera.

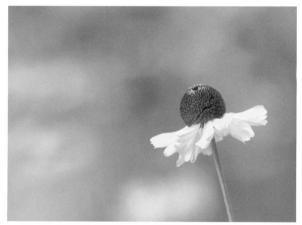

11-7

ADJUSTING WITH SOFT IN MIND

This photo really looks its best when it shows off the softness that the shooting technique captures. To do this, take a more studied approach to the standard adjustments:

1. Adjusting Shadows is tricky. Generally, you want some sort of dark areas in a photo (even if they are very small) for contrast and color. This does not work for this photo. Increasing the Shadows setting slightly does make the photo a little richer, but too much of an increase and it quickly becomes harsh. The Alt/Option and threshold technique helps you visualize where the darker areas are, but on a shot like this, however, you need to adjust the Shadows slider purely by the way the image looks in the preview, shown in figure 11-8. It can be helpful to check the thresholds, as shown in figure 11-9, to be sure you have something that is strong in the threshold areas (that is, the threshold screen is not pure white). In this photo, the red and green channels are maxing out in some areas (the yellow and green of the photo).

2. Fill Light can be very helpful in a soft photo by helping bring up colors in dark areas, as seen in figure 11-10.

3. If you press Alt/Option to adjust Exposure to its normal place where the highlight threshold appears, the image is too harsh. This image has a lot of bright areas in the yellows, so an effective way of dealing with this is to play with the Exposure and Recovery, as shown in figure 11-11. I used Recovery to make the bright yellow color look better, and then brightened the whole thing with Exposure. In doing that, I found the overall image a little flat, so I increased the Blacks a little. This is all shown in figure 11-11. It is misleading to show specific steps here as you must pay attention to the needs of your photo. In photos like this one, such needs are unique and variable. A alternate way of starting this step is to press and hold Alt/Option with Exposure and click and drag the slider until the threshold is reached; then back it off a bit.

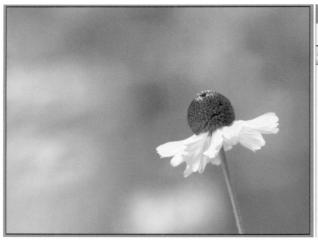

11-8

11-9

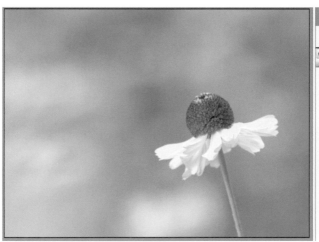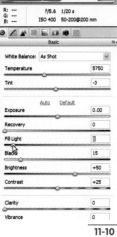

11-10

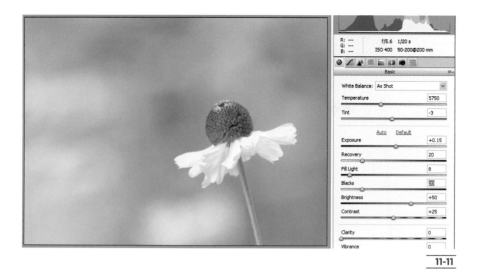

11-11

4. Because subtle tonalities are a real key to the soft-
ness of this photo, the Tone Curve is a good way
to deal with midtones. The Medium Contrast set-
ting doesn't actually look too bad, as shown in
figure 11-12, but it could be improved (the
brighter areas need more brightness). It does,
however, point to a direction of adjustment,
namely darker dark tones and brighter light tones
(this is not the same as blacks and highlights, but
refers to dark and light gray tones that are very
important to the photo). By placing two points on
the Linear Curve setting (which changes it to
Custom), one at the bottom quarter intersection to
anchor the dark tones and one in the upper-third
quarter to lighten the mid- and brighter tones, the
image can quickly be brightened and the contrast
boosted slightly without hurting the soft colors
(see figure 11-13).

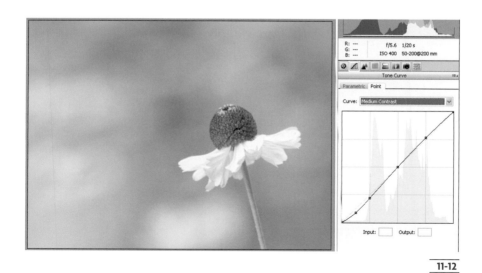

11-12

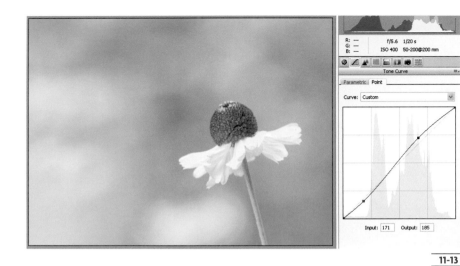

11-13

PRO TIP

It is important to remember that with the Saturation slider, a little can go a long way in most photos. Oversaturated colors often lose tonality and can look garish. Oversaturation can be a sure sign that an image has been Photoshopped (or perhaps, over-Photoshopped).

COLOR ENHANCEMENT

Overall, this photo has strong color after adjusting tonalities. On one hand, it seems to have a little too much yellow. (You can even see this in the histogram that is very strongly yellow to the middle and right side.) One interpretation might be to adjust that. Yet, this photo really is about yellow, so that might not be the best.

One adjustment to the color that isn't recommended is to use Saturation — that is too heavy-handed for a photo like this. Yet, I have seen too many photos such as this look garish because a photographer wanted to make it more like Velvia and so increased the Saturation slider.

At this point, the photo could be used as is, or other interpretations could be made. Here are some ideas:

1. Try different White Balance settings, such as those shown in figures 11-14 (Cloudy) and figure 11-15 (Auto). Auto often ruins the color (in my opinion), but Cloudy adds an interesting warmth and glow to the shot. It really begins to look like yellow flowers on a warm summer day.

2. Increasing Clarity pops the sharp flower a bit from its surroundings, as shown in figure 11-16, plus it enhances the tones and color of the central dark part of the blossom (the disk flowers of this compound flower).

3. This photo has so much color in it that increasing either Vibrance or Saturation can quickly result in some ugly overkill.

THE DETAIL TAB

There really isn't much left to do with this photo other than sharpen it and check for noise. I sharpened the image with the great new Sharpening sliders in Camera Raw, described in Chapters 6 and 10 and shown in figure 11-17.

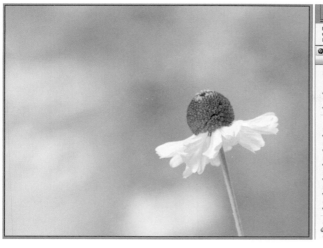

11-14

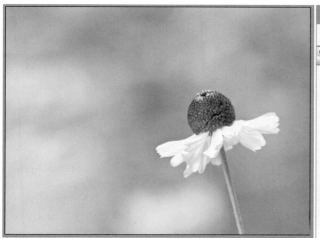

11-15

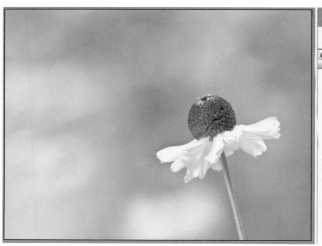

11-16

11-17

Photos like this have so much soft, out-of-focus areas that noise can be a real problem. Enlarging the photo preview to 200%, as shown in figure 11-18, reveals that there is a little noise in the image. Some noise reduction helps, as shown in figure 11-19. Most of the noise is luminance noise, so the Luminance slider is the one to use.

On first glance at the photo, you might think that Color Noise Reduction does very little on such an image. Overall, that is true. However, when the fine parts of the flower are enlarged, the fine color on the disk florets (the brown part) is damaged when you drag the Color slider to the right. No Color Noise Reduction should be applied to this photo. It is

11-18

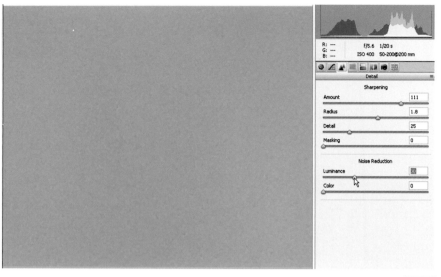

11-19

important to check multiple points in your photograph as you adjust the Color Noise Reduction slider. You don't want to gain noise reduction in one area at the cost of losing important color details in another.

The final image has excellent color yet the soft effect is still obvious, as shown in figure 11-20.

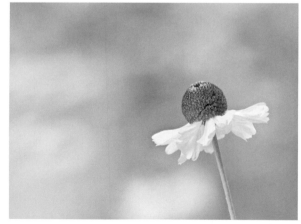

11-20

BACKLIT CONTRAST

Any image with high contrast such as that from backlight conditions always challenges you when you're working in Camera Raw. Camera Raw offers many choices, but the contrast of the image limits what you can and can't use, especially if you want a realistic photo. One problem is that Camera Raw can only adjust the whole photo. Sometimes high-contrast images need special work in Photoshop where you can control the adjustment of small areas of the photo separately from each other. If your image needs a lot of adjustment, it can help to bring it into Photoshop from Camera Raw as a 16-bit file.

That said, Camera Raw offers quite a bit of capability with a contrasty image, such as figure 11-21 taken in a swamp in the Everglades wetlands southeast of Lake Okeechobee, Florida, shot toward the rising sun. This figure shows the unadjusted image straight from Camera Raw. I also used this photo in the first edition of Adobe Camera Raw for Digital Photographers Only,

which makes a very interesting comparison. The older form of Camera Raw did not have the capabilities for dealing with dark and light tonalities that the latest Camera Raw has. This tremendously influences what you can do and how you can do it with such a photo.

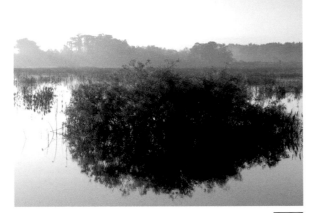

11-21

This image is bright because the sun has just risen and should retain that feeling of brightness. Yet the shrub in the foreground is rather dark, and the overall contrast seems a bit harsh for the humid atmosphere of a swamp in the early morning. You cannot change this at the point of exposure. More exposure would totally blow the sky out; less exposure would give the shrub even less color.

PRO TIP

In harsh, backlight conditions, one way to get a better tonal range for Camera Raw is to use a flash. Fill flash used to be a real hit-or-miss proposition, but now you have cameras designed to compute the right amount of flash automatically and can use the LCD review to check the shot right away. Bigger, accessory flash units offer more fill capabilities than a built-in flash unless you are very close to the subject; and some photographers such as Frans Lanting and David Muench even use flash on images like this one.

CORE DECISIONS

As I stress throughout this book, it always helps to follow a consistent workflow when working an image. This automates the process and gets you to think less about Camera Raw and more about the photograph. The photograph and your interpretation of it should always color your decisions on how to adjust it, not arbitrary rules about processing a photo that are sometimes given. Here's one way of interpreting this high-contrast photo:

1. Moisture in the air makes the shadows a little weak. Using Alt/Option and the Blacks slider, the shadows can be strengthened by bringing them up just a bit to encourage some blacks, as shown in figure 11-22.

2. Now here's where Camera Raw's new controls help a lot. The Fill Light slider really opens up the shadows of the foreground bush, as shown in figure 11-23. With such a large increase in Fill Light, I did find I needed to bump up the blacks slightly, too.

3. As you've seen throughout this book, the Exposure slider is typically used next and teamed with Alt/Option. In this case, however, the photo comes into Camera Raw with a lot of brightness at the upper left. This is a good exposure because there is adequate detail in the dark areas, but the highlights need to be toned down.

As the slider is dragged way to the left, some clouds in the bright area appear in the top left of the image, but this actually occurs beyond the threshold point shown with the Alt/Option key (the threshold shows as black). That's okay — to a degree. However, the feeling of brightness is lost and that bright area appears a bit flat and gray if the Exposure slider is dragged too far to the left, even though some clouds in the bright area show up more, as shown in figure 11-24.

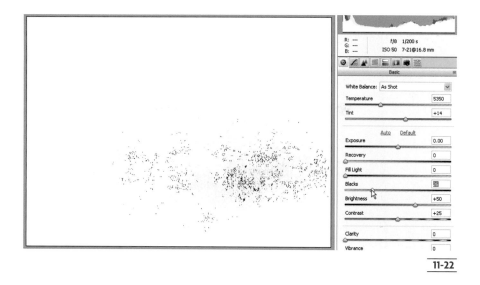

11-22

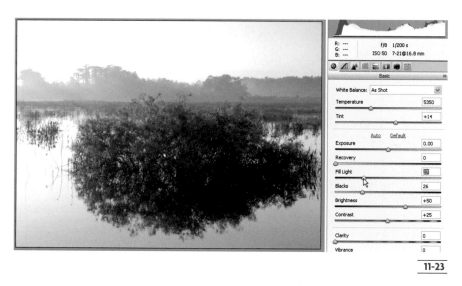

11-23

This is an important point. I don't believe in making a photo serve some arbitrary standards that aren't necessarily appropriate to the needs of the photo itself (it is interesting that the automatic choice for Exposure makes it even grayer than figure 11-24). This photo needs brightness where the sun is rising. That's a normal way you see

such an area. If the brightness is arbitrarily toned down just so you can see the clouds, you have to ask, so what? Does that really help the photo? In this case, I don't think so, so I like what is happening in figure 11-25. Note how much airier the background atmosphere looks.

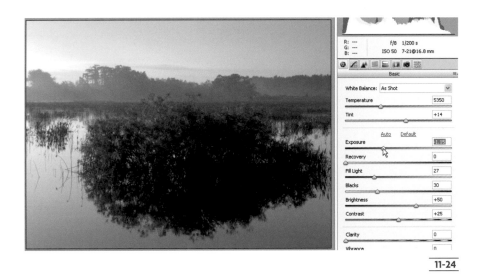

11-24

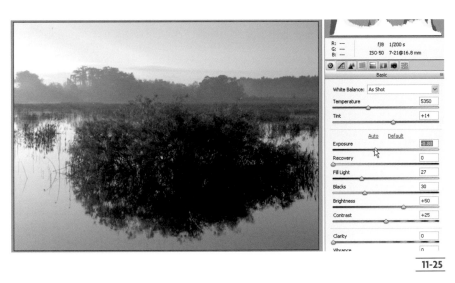

11-25

▌ ▌ PRO TIP ▌ ▌ ▌

The numbers available in Camera Raw can help in photos like this. For many situations, I feel they take you away from the real photograph and make the process too mathematic and arbitrary. However, this photo does point out a situation where the numbers can help, such as very bright or dark areas. Check the numbers for RGB at the top right of the interface when your cursor is over a part of the image (in figure 11-24, it was over the brightest part of the sunrise at the top left). White happens when all three numbers approach 255; black when all three numbers approach 0. In figure 11-24, the brightest part of the photo is not pure white (the numbers are in the low 240s).

4. The Recovery slider can now help with the highlights and influence the final setting for Exposure, as shown in figure 11-26. Recovery works great with images like this that have very bright areas yet still have some detail there that can be recovered. There are some nice, subtle details in the early morning fog that are showing up nicely because of the use of both of these sliders, as shown in figure 11-27.

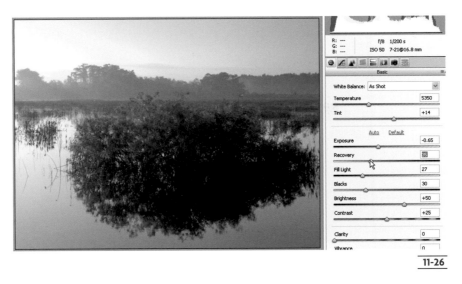

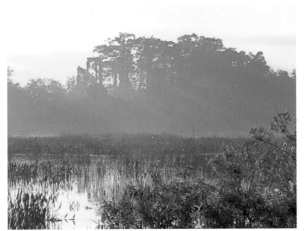

11-26

11-27

5. The subtle tones and extreme contrast of this photo really need the Tone Curve (see figure 11-28). Working with parametric sliders allows some significant changes: Highlights are dropped slightly while Lights are brightened. This gives some nice tonality in the brighter areas by lifting the bright areas to give that feeling of morning yet keeping the very bright areas depressed in tone. In addition, a significant brightening of the Darks helps, while Shadows are kept as is. By using the curve to selectively affect different tonalities, the photo now starts showing some of the atmosphere that one expects from a swamp at dawn.

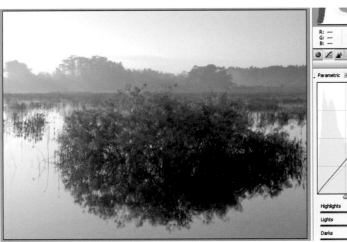

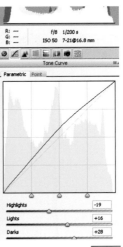

11-28

6. Clarity does an interesting thing to this photo. You would expect it to affect the midtones of the vegetation, but that is not where it really boosts the photo. It does some interesting things to the edge of the tree line in the background, making it and the low cloud more distinct, as shown in figure 11-29.

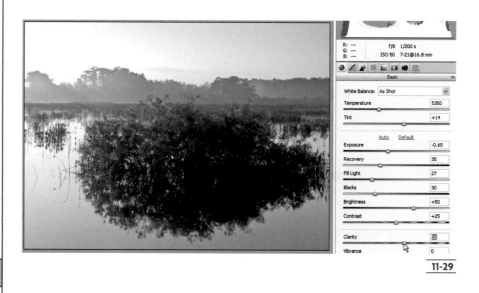

11-29

COLOR ENHANCEMENT

At this point, the image looks good, but the color is a little weak. Sunrise and sunset are definitely enhanced by a warm interpretation of the scene. This has become the way such conditions are seen in photographs (because traditionally, a color film balanced to be neutral in the middle of the day was used, making the sunrise or sunset far warmer than seen by the human eye). A real documentation of a sunrise or sunset often seems false to most viewers. To give this photo a more traditional sunrise feel, it needs some more warmth and even more color overall.

1. This is a perfect photo to click down the choices of the White Balance setting menu from top to bottom to see what the different choices offer the image. The indoor settings are way too blue and Daylight seems at first a bit wimpy. Cloudy and Shade add quite a bit of warmth to the scene. For me, Cloudy worked best when used alone, which is demonstrated in figure 11-30. This immediately evokes a strong feeling of sunrise in the Everglades, yet this is also highly subjective. I also saw potential in the Daylight setting now that Vibrance is part of Camera Raw.

2. The Daylight setting just slightly boosts the warmth at the back of the image, yet keeps the cool tones in the water. Vibrance is perfect for increasing the intensity of those colors, as shown in figure 11-31. It can be used at fairly high settings for a shot of this type. Saturation does a little at lower amounts for this image but starts making colors look mucky at higher settings. Vibrance works far better. I could use the HSL tab to try to adjust individual colors, but I don't think this photo needs that.

3. As I look at the photo, I start to feel that more color in the foreground bush would be helpful, so increasing Fill Light helps, as shown in figure 11-32. This also adds to the feeling of a soft light at dawn.

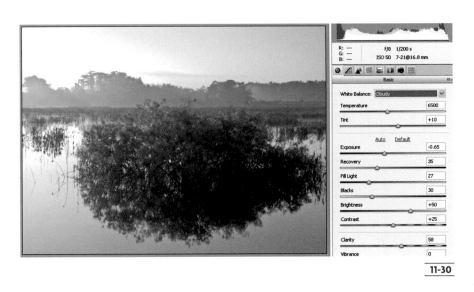

11-30

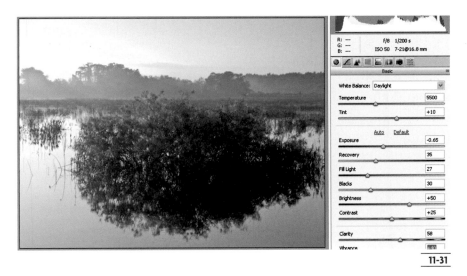

11-31

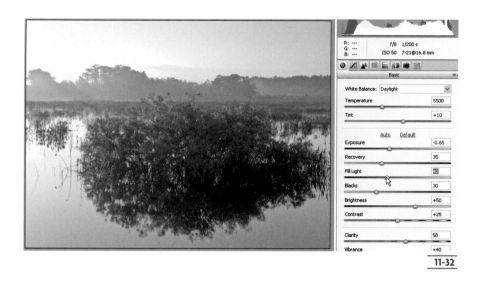

11-32

Once the image is in Photoshop, I am tempted to add some color to the sky, especially the top-left corner, to bring it down in tone a bit, and I would probably increase the blue content of the water in the lower right (a very natural look). Both of these are selective, small area adjustments that you cannot do in Camera Raw (blue in HSL does not give the strength to the water I am talking about, so other techniques would be needed).

Overall, however, the photo now has a nice feel to it, as shown in figure 11-33 (which has had sharpening and noise reduction applied from the Detail tab). There is color in the leaves in the foreground bush, plus there are some nice tonalities in the humid air around the trees in the background.

If you have access to the first edition of Adobe Camera Raw for Digital Photographers Only, you will see a different interpretation of this same scene. Ansel Adams used to talk about this. As a photographer, you change and change how you see things. This affects your interpretation of a scene. In addition, new tools, such as Fill

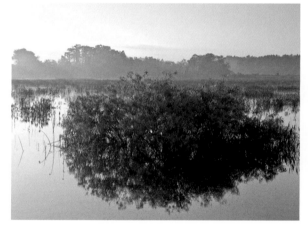

11-33

Light and Recovery, offer new opportunities for interpretation. You should be careful, however, of using new tools just to use them, without paying attention to what the tools are doing to the overall image. This was a problem when Adobe first came out with the Shadow/Highlight tool in Photoshop, and everyone started using it, amazed, yet blinded by its capabilities, often creating open shadows, but unattractive photographs.

PRO TIP

Digital cameras are great for shooting night scenes. Night shots used to be difficult with film because of *reciprocity failure* (a change in light sensitivity of the film as long exposures are used) and because exposure was so hard to judge. With a digital camera, you can freely take pictures, check the exposure immediately, and then adjust as needed. In addition, you can play with white balance settings to gain a color interpretation that seems reasonable and still change that later in Camera Raw if needed.

NOT THE NORMAL LIGHT

When the light on your subject is not the normal daylight or indoors lighting, you are faced with some interesting choices as to how to deal with the subject. Do you try to make it look like its real colors (if you remember what they are)? Do you try to make it look natural (which can be something entirely different than the real colors)? Or do you go for an unexpected interpretation that is far from an accurate rendition of the scene?

Figure 11-34 is the unadjusted shot of a plaza in San Jose, California (actually right across the street from the Adobe headquarters), an image that would be fairly flat and ordinary during the day. At night, it comes alive, yet what colors are real or natural? Or should it have a completely different rendition than the camera captures? I lean toward a natural look for this scene. Camera Raw interprets how the camera recorded the image as a bit warm, so that should be adjusted. But tonalities are all over the place in this image, which gives me the opportunity to make some very distinct choices when I adjust them.

COLOR OR TONALITIES FIRST?

In this photo, a different workflow approach may be warranted because of the color, but before you start to work on a photo like this it is important to understand how viewers perceive it. Generally, people like to see some warmth in the light from night photos. Whether that is realistic or not isn't the issue. People are used to seeing photographs taken at night with film that has imperfect color balance. For a variety of reasons having to do with film types and color temperature of lights, traditional color films recorded nighttime scenes with an amber or red-yellow bias, even though the human eye sees the same scene in a more neutral manner. So people expect a color night photograph to look somewhat warm and consider it unrealistic if it is not, even though it can be corrected to a neutral condition in Camera Raw or Photoshop itself.

In figures 11-34, 11-35, and 11-36, you can see three different interpretations of the color in this scene:

> **Figure 11-34.** While the color in this night photo is okay as interpreted by Camera Raw from the camera settings, it seems a little too warm. The bear statue is especially a bit yellow.

> **Figure 11-35.** You can see that although this more neutral image is probably closer to what the eye sees, it does not look as realistic as the others. Most people would consider it a bit cold compared to the two other images. Still, it is a valid interpretation of the scene, and there may be situations where it is required.

> **Figure 11-36.** This is the interpretation I like. It keeps some warmth, yet has a more naturalistic feel to the night.

There is no right way to deal with the color in this image. Any photo similar to this with mixed, artificial light requires you to experiment a bit and see what you like. Because color is so variable in such an image, it is a good idea to deal with color first in the workflow. Color is affected by further adjustments, so I like to deal with really odd or off-color first so that I am not bothered or distracted by it as I continue to process the image. Here's how I determined the color to get to figure 11-36:

11-34

11-35

11-36

1. A quick way of fixing colorcasts like this one is to use the White Balance settings. Because this is night with tungsten lighting, that is certainly a logical choice. Tungsten does indeed take out the warm color, as shown in figure 11-37, making the whites and grays of the scene fairly neutral, although it is too neutral with too much blue for my taste.

Note that the neutral tones are different in color (compare the statue with the water fountain, for example). That is because tungsten and other artificial lights do not have a consistent color temperature (unless you supply lights designed for photography). Wattage and variations in manufacture change that. This is one reason why you can never get a perfectly neutral scene in a photo like this, which has different light sources. (If you wanted to do that, you'd have to go into Photoshop and adjust the areas individually.)

2. The little gray eyedropper, the White Balance tool, works quite well in any photo where you can easily find neutral tones, as shown in figure 11-38. In this night scene, the bear statue and the fountain both have neutral tones, and clicking on different places with the White Balance tool actually gives quite a range of results. That's normal because different parts of the statue are exposed to different lights, for example. Sometimes by just clicking around, you can get a perfect color. When you try this on your photo, some of the adjustments look good compared to others, so note where the Temperature and Tint sliders end up with the adjustments you like.

3. Because neither the White Balance settings nor the White Balance tool provided exactly what I wanted, I decided to adjust the Temperature and

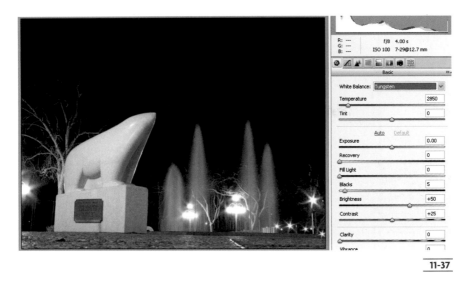

11-37

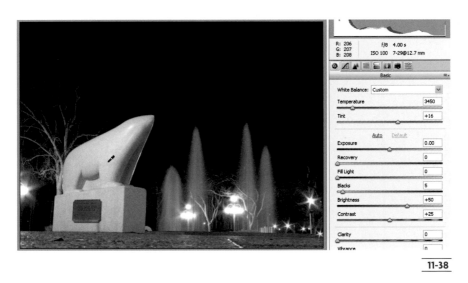

11-38

Tint sliders manually. The notes I made about the Temperature and Tint slider numbers in Step 2 gave me a starting point. I knew I didn't want the high number used for the original Camera Raw interpretation of this photo of 5500 for Temperature. I didn't like the numbers below 3000 for Temperature that came from the White

Balance tool, but I did like some of those around 3500 with Tint adjusted toward magenta. So I tried around 4400 for Temperature and Tint at 8 (see figure 11-39). This gave it a nice night feeling without looking too yellow or amber. (I did try some other interpretations, yet came back to the same settings I used for this image in the original book.)

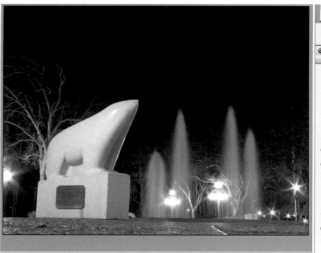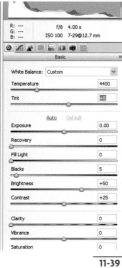

11-39

NIGHT TONE INTERPRETATION

The night sky is important to this composition as it defines the time of day and accents the lights. Seeing a hint of trees in the sky also seems to help, though how much is debatable. When looking to interpret a photo, you often have to make compromises. To get a very dark sky may mean losing some of the highest parts of the trees, yet that darkness may be more important to the scene than an arbitrary capture of the twigs just because Camera Raw can bring them out.

Another thing to consider here are the bright lights. The lights are overexposed, but that's pretty much normal for night shots. You can tone them down a bit in Camera Raw or they can be exposed for their detail, but you have to ask why? I'm not sure what that would accomplish other than underexposing important parts of the image. Pure white, bright highlights in lights is an accepted way to see night lights in a photo.

Some people wonder about the star patterns on the lights, as shown in the detail (see figure 11-40). This is not from a filter. This is a diffraction pattern along the diaphragm blades of the iris of the lens. As you stop a lens down to its smaller apertures, the opening for light gets smaller and bright highlights diffract as they pass that opening. A pattern is created that is related to the actual shape of the diaphragm. This particular shot was made with an advanced compact camera that has a very small lens to begin with, which makes even moderate apertures act this way.

11-40

ADJUSTING FOR THE NIGHT

This photo could be made brighter or darker, and frankly, who would know that either condition wasn't an accurate rendition of the scene? Probably both would be! Still, a night photo should be tuned to keep its feeling of night, and here's how I adjusted this one:

1. To get the feeling for the night sky for this composition, the workflow changes again and I begin with the Shadows slider. I really feel the night sky needs to be black, and easily do this by pressing and holding Alt/Option while clicking and dragging the slider to the right, as shown in figure 11-41. The pure black part of the sky does not go all the way down to the trees and fountain. That is important. Having a dark tone there with a slight color to it gives some atmosphere to the night.

2. There isn't much that you can (or should) do to the bright lights. There is a bright highlight on the statue that I could tone down a bit with the Exposure slider, but that really doesn't add a lot to the photo.

3. The midtones important to this photo are the grays of the statue and water, plus the darker tones of the tree branches. These are all affected nicely by the Parametric Tone Curve, as shown in figure 11-42. I increased the Shadows and Darks sliders a good amount to bring up tonality in those areas. In the upper sliders, however, my adjustments might not be expected. I lowered Lights slightly and increased Highlights. The reason for this is that I did not want to affect the bright areas too much, yet I thought a little more contrast might help there. That contrast comes from moving the sliders like this, making a lower one have a minus setting while the next higher one has a plus setting.

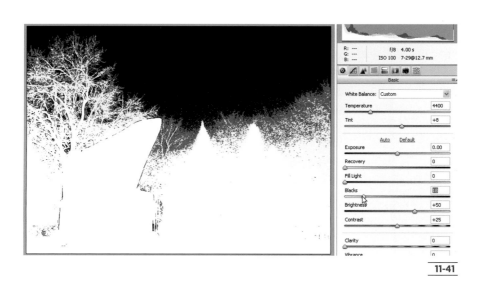

11-41

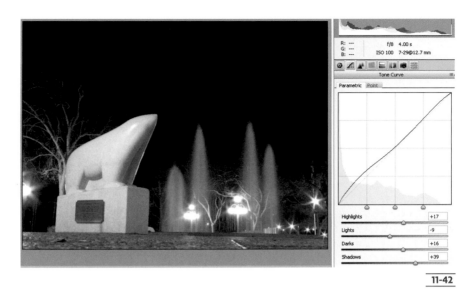

11-42

CROP FOR EVALUATION

At this point, the photo looks good, but it seems a bit spacey; that is, it could be cropped. This is a fairly large image file (from a 7.1-megapixel camera), so a bit of cropping won't hurt it much. I am a firm believer in always trying to fill your camera's image area with important elements in your composition. This does two things: it ensures you have maximum quality to work with from your camera file (you paid for that sensor, so why not use it!), and it forces you to really look at all parts of your composition while you are with the subject. It is very frustrating to be working on a photo in the computer and tell yourself, "If only I ..." But when a photo needs cropping, do it! A strong image is more important than some artificial statement ("I never crop my photos.") that no one cares about except the pretentious photographer.

This image has too much space at the top for me, and the light that sits on the left side of the photo is a little distracting because of its placement. Because Camera Raw allows cropping now, why not do it? Actually, some Photoshop pros feel it is better to crop later, in Photoshop. As far as quality goes, there is no difference between either approach. In addition, any crop in Camera Raw is not permanent. If I need to crop, I

often crop an image early in the process (at least a rough crop), such as in Camera Raw, so that I can remove annoying elements (they are actually just subdued in the Camera Raw interface) that might be distracting as I adjust the image.

You crop your image with the Crop tool. Simply use it like a cursor — click and drag the cropped area to a rough size, as shown in figure 11-43. Then tweak this adjustment by moving the sides in and out. You can also rotate the whole cropped area if the photo is crooked.

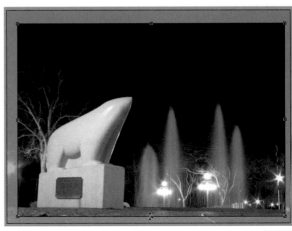

11-43

Once you make the crop, you still see the rest of the photo, though it is grayed out. It would be nice if you could now give a simple command (such as Ctrl/+0) to see the cropped area filling the preview window, but Adobe has not provided that yet. (Actually, Ctrl+0 still gives you the whole image, even that which is being cropped, which is a bit silly as this makes the active photo smaller.) I find it helpful to use the Zoom tool to outline the active, cropped area of the photo.

PRO TIP

You may notice that the Crop tool has a little triangle at its lower-right side. This means it has a flyout menu if you click on the tool and hold the mouse button down. You now have a choice of cropping ratios. This is very helpful if you need a specific size. The Crop tool gives you the specific ratio you pick, allowing you to very carefully place the crop over the elements in the image. The numbers, however, are a bit cryptic: 1 to 1 is square, 2 to 3 is the same as 35mm, 3 to 4 is approximately television size, 4 to 5 is perfect for making an 8 x 10, and 5 to 7 is the same as 5 x 7 or 10 x 14, which now makes it close to full preview size.

NIGHT NOISE

The bear and fountain scene was shot with a relatively low ISO setting of 100. I often use such settings because of the lower noise they offer, especially when I can support the camera with a tripod or other support. (I used a small beanbag here.) This can be especially important with night photos, as longer exposures tend to increase noise. In addition, because I took this shot with a small digital camera, noise also increases. So keeping noise lower by using a lower ISO setting helps.

There is noise in this photo, so working in the Detail tab is the next step:

1. Sharpening affects noise, so generally, I do that first, as shown in figure 11-44 (if I am going to sharpen within Camera Raw; if I were using a different noise reduction software, I would sharpen after that in Photoshop). Detail and Masking can have a big effect on how noise appears. Sometimes I readjust them after adjusting Noise Reduction.

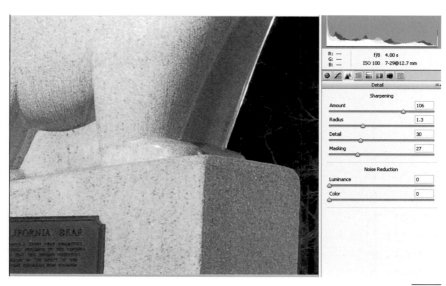

11-44

2. How to reduce color noise is one of the first things to look for in a night photo, and there is almost always chromatic or color noise in a photo like this. However, setting this control too high adversely affects some of the small features of the trees. A little reduction of color noise helps the fountains, so setting the slider to 10 helps without hurting the trees (see figure 11-45).

3. There is enough noise that increasing the Luminance Smoothing slider setting helps. A setting of about 35 works to reduce noise in the water without hurting the trees or the grain texture of the granite used for the statue (see figure 11-46).

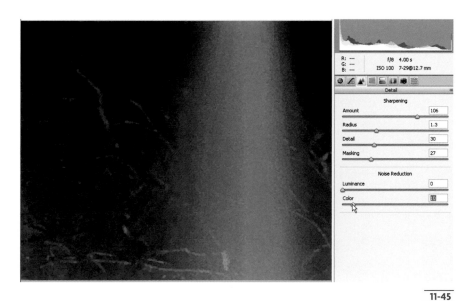

11-45

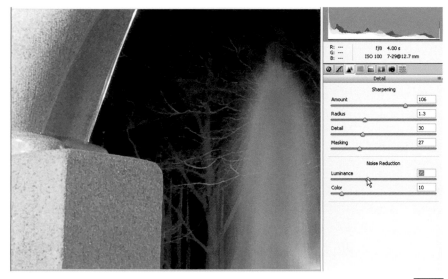

11-46

FINAL CHECK

Again, it is important to do a final check of the photo in full size in the preview. All of the adjustments you make to a photo can affect each other. You can't expect that one adjustment remains the same as you make others.

In this photo, the overall photo looks good (see figure 11-47). Is it perfect? Absolutely... for me. You may feel it needs more of this or that, less of something else. That's fine. A photo like this is open for a lot of interpretation — that's one thing that makes night photography fun!

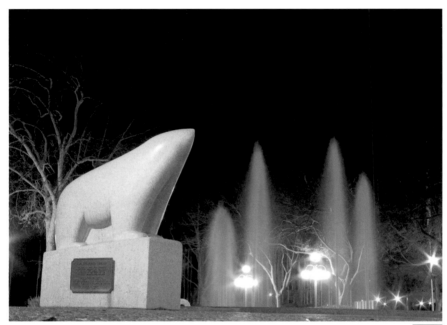

11-47

■ **What if I really do want to adjust colors in different ways in the same photo? If I want to get the best tonalities possible for those colors, I know I need to use Camera Raw, but it won't allow separate adjustments.**

That is absolutely correct. Camera Raw is an overall or global adjustment tool. It is not designed to adjust parts of a photo differently. However, the new HSL tab does give you some control over specific colors and you can always try that. But if you have a very specific area of color that needs adjusting, you can try a special technique, which I explain fully in Chapter 13, on double processing for exposure. (This is a favorite technique of mine and I use it often.)

Briefly, this is what you do: First, process the photo the best you can for the color of one area, and then open that image in Photoshop. Save it as a Photoshop file. Then reopen the image in Camera Raw again and process for the color of the area that needs a different adjustment. Open that into Photoshop and save it as another Photoshop file. Now, drag one image onto the other (use the Move tool and press and hold Shift to align both photos). Next, hide the top image with a black-filled layer mask and paint in its color with a white paintbrush.

A photo with harsh contrast sometimes seems like it needs two completely opposed ways of processing in Camera Raw, but that isn't possible. How can I cope with such differences?

This can be a real challenge, especially with backlit conditions. To start, it is best to carefully choose your Exposure and Shadows slider points, along with Recovery and Fill Light. Be sure you are keeping the detail you want in the highlights and shadows. Then almost always, you want to use the Tone Curve for further adjustment. Set the curve to the Parametric setting, and then start changing different parts of the curve to adjust the image. Play with this a bit. Don't be afraid to just try the sliders and see what they do. You can always undo any of them by double-clicking on the slider itself.

You have to really watch your tonalities as you do this. It is too easy to get a technically-adjusted photo (meaning you have pulled in the highlights and shadows as best as possible) but an aesthetically dull shot because the midtones are just too flat. If this starts to be a problem, you need to do the two-image adjustment process, as I describe previously and in Chapter 13. This allows you to carefully adjust your photo to get the most from both the bright and dark areas.

BLACK-AND-WHITE PROCESSING

Black-and-white photography has made an amazing comeback. Not all that long ago, it was considered by some to be "average" and even "cheap," yet now it is often considered elegant and sophisticated. Of course, at one time, black-and-white photos were the only photos. You couldn't do color a hundred years ago. But then as magazines and other publications began to use more and more color through the 1970s and 1980s, black-and-white started getting a poor reputation. Those images were the ones done on the cheap paper, while color got all the glory.

By the 1990s, I don't think any of us in the industry could have predicted how black-and-white would not only survive, but also gain a whole new reputation by the 2000s. Twenty years ago, someone would have seen a black-and-white print and said, "Oh, black-and-white ... don't you have any color?" Now it is, "Oh, black-and-white! How cool!"

Camera Raw now offers a much improved way of converting color to black-and-white, as shown in figures 12-1 and 12-2. You have far more control. While some people recommended using the old Camera Raw for black-and-white, it was not a very photographic tool. Now it is. You can convert color images quite effectively by targeting selected colors to change into specific tones of gray. That specific color-to-gray conversion is what allows photographers to create truly excellent black-and-white photographs.

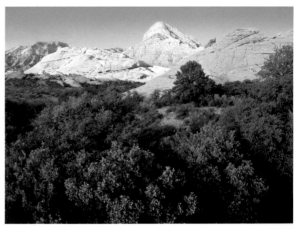

12-2

CAMERA RAW OR PHOTOSHOP FOR BLACK-AND-WHITE

Photoshop CS3 introduced two new ways of getting excellent black-and-white photos — the new grayscale part of Camera Raw, shown in figure 12-3, and a new black-and-white conversion adjustment, shown in figure 12-4. Both methods of converting to black-and-white work, and they work very well. There are important differences, however, and because of these differences, I cover how to use both.

The Camera Raw conversion uses the ultimate in data from the sensor. It potentially can give you the best tonal range in the black-and-white, especially in bright and dark areas. Plus, it allows strong change in tonalities without creating banding or other tonal problems.

The new Black-and-White adjustment in Photoshop doesn't offer quite the range of tonal values, though it is very good when used with 16-bit. However, one thing it does offer is click-and-drag adjustment (I suspect this will appear in Camera Raw in the not-too-distant future). With this, when you click on a tone in the photograph with the cursor, Photoshop identifies the color underneath the black-and-white tones. Then you move the cursor to the right to make that tone lighter (based on the color) and to the left to make it darker.

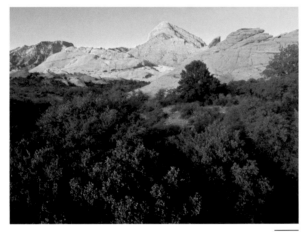

12-1

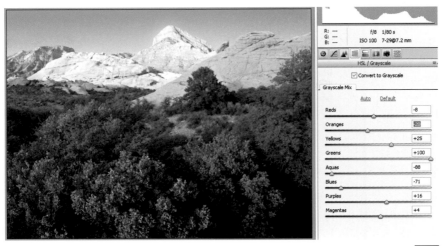

12-3

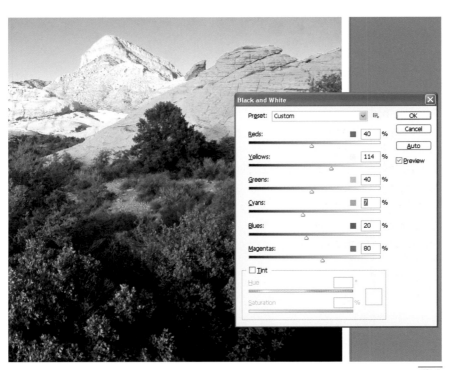

12-4

This choice is not an easy one to make. You may be able to get that higher quality from the RAW conversion, yet the Photoshop Black-and-White control is more intuitive. If you are really interested in black-and-white, I suggest you try, and learn, both, as they will both prove useful. Many of the ideas in this chapter apply to both types of conversion.

CAMERA RAW DOES BLACK-AND-WHITE RIGHT

Absolutely critical to a good black-and-white photo is how each color is translated to a tone of black, white, or gray. There is no automatic right way a color changes to a grayscale tone simply because black-and-white does not exist for people except in a photograph (or similar medium). A red could be light gray, medium gray, or dark gray, as shown in figures 12-5, 12-6, 12-7, and 12-8, and so could a green, blue, or most other hues. So how that color appears when translated to gray is totally an interpretation.

This is why many simple grayscale or black-and-white adjustments have been unsatisfying to the photographer. Black-and-white had such potential, yet such adjustments have showed little of that potential — they've treated all colors the same, so that a red is

PRO TIP

Watch out for noise as you make extreme changes in brightness or darkness of a given tone. The black-and-white or grayscale controls are very specific, which is great in defining tonality in a photograph, but that also means they read noise very specifically, too, so that it will often become intensified. Either back off the adjustment or use a noise-reduction adjustment or software.

12-5

12-6

12-7

12-8

always a certain tone, a blue another tone, and so forth. Without being able to change those tones as they relate to a specific color, you really are very limited in what you can do in black-and-white.

Camera Raw used to just do the simple grayscale adjustment. It is true you could make some adjustments to colors in the Camera Calibration tab and with the white balance that would affect the black-and-white image. But this was hardly the real black-and-white capability that a photographer really needs. Now you have the controls needed to actually affect how a color appears in a black-and-white image. As shown in figure 12-9, the HSL/Grayscale tab (fourth from the left) gives a set of color sliders that specifically work to make that color lighter or darker in a photo. You first check Convert to Grayscale and you get the settings shown in 12-9. They may or may not work with your photo.

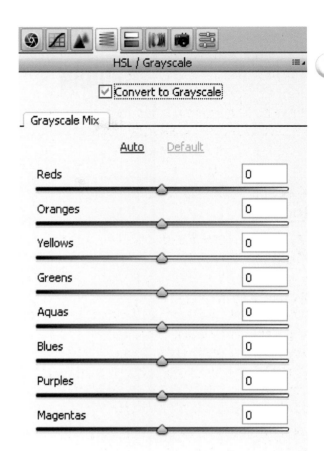

12-9

Terminology

You will see black-and-white called several things: grayscale, monochrome, and of course, black-and-white. Grayscale is pretty much a computer thing — you will rarely (if ever) see the term used in classic books about black-and-white photography. From a quick check of the Ansel Adams books, grayscale never appears, though a gray scale, referring to how exposure is made, is in the books (and it is totally different). Monochrome tends to be used by the art crowd. Somehow it seems more elite and high-brow, I guess, than black-and-white (and it never appeared in the traditional black-and-white photographers' texts as far as I can tell). I tend mainly to use black-and-white because my education is as a photographer who actually worked in the black-and-white darkroom (no one ever refers to a grayscale or monochrome darkroom), and because it is a photographic term with a history of strong connotation and meaning.

But remember, there is no cost to experiment and try different sliders to see what happens. The color becomes a dark gray when the appropriate slider is moved to the left and a light gray when moved to the right.

In the sequence of images of the fern leaf with dew on it, shown in figures 12-10, 12-11, and 12-12, you can see exactly how this happens. It is very green. As the green slider is moved, that green changes in tone, as shown in figures 12-11 and 12-12. No other adjustments have been made for these two photos.

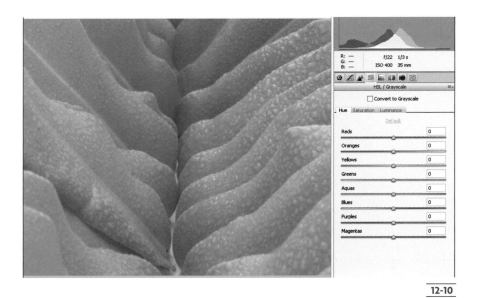

12-10

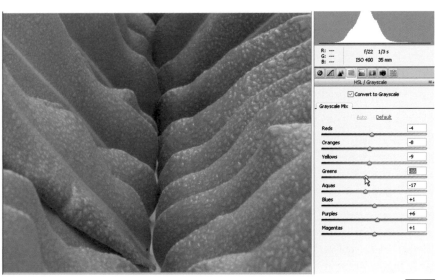

12-11

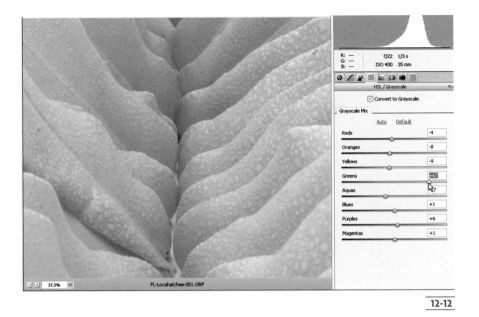

12-12

How to Think Black-and-White

A mistake that neophyte black-and-white photographers often make is thinking that black-and-white is simply about changing a color photo to grayscale in the computer. The color is gone and a black-and-white image does appear in its place. Good black-and-white, however, is not about the absence of color. It is about tonalities and how they interact and interplay with each other as tones of white, black, and gray.

You can convert any color image to black-and-white, but some simply will never convert well because the photo is really about color that can't be shown in black-and-white. A good black-and-white photo comes from critically looking at a scene or a digital file to think about how it might look when the color is changed to black-and-white. I know that this idea of thinking about how colors might translate is not easy at first, but it does come with practice. In addition, good black-and-white generally requires attention to light and how the light makes picture elements separate from each other.

One way that can help you visualize is to use a digital camera with black-and-white capabilities. Try shooting different scenes with varied dominant colors and see what they look like in the LCD. If the camera allows shooting black-and-white as if shot with different filters, you can try them, too, to see the effect. This is a great use for a little pocket digital camera — it becomes a note-taker, a sketchbook, a way of testing ideas simply and unobtrusively.

NOTE

If you try experimenting with shooting black-and-white in-camera with RAW and no JPEG files, you will not see any black-and-white effects in Camera Raw. In-camera black-and-white is applied to JPEG files, and only exists as instructions in the metadata for the RAW files. Camera Raw does not recognize those instructions — the camera manufacturer's RAW conversion software does.

As you shoot a scene that you would like to make black-and-white, or you are looking for digital images already shot that would make good black-and-white photos, there are some things that you can keep in mind to help you. These are not rules, but simply ideas that should help you find better black-and-white photos. You may find photos that you really like that don't fit these ideas, and that's fine. These are simply starters for photographers who want to get good-looking grayscale images from Camera Raw:

> **Look for photos and scenes with good color contrasts.** When the colors contrast, it is easy to make them contrast as black-and-white tones, too.

12-13

> **Look for contrast in the light.** A color photo can be beautiful in a soft, gentle light that gives gentle, pleasing colors. In black-and-white, that color is gone and the softness usually translates poorly to black-and-white.

> **Look for separation in the brightness of tones.** You need to gain some separation in shades of gray and variation in brightness of tones will help do that.

Looking for picture elements that will help black-and-white images is one thing, but another thing you need to consider are problems with a scene that could give poor black-and-white photos:

12-14

> **Avoid low-contrast images with subtle, soft colors.** A photo like that in figure 12-13 is pretty for its color, but usually gives a mediocre black-and-white version, as shown in figure 12-14.

> **Search for contrasts in the tones.** If you can get tonalities that already are darker and lighter than each other, you will get a photo that has those same contrasts in black-and-white.

> **Learn to see colors as tones or potential tones of gray.** In other words, don't be distracted by the colors if your goal is black-and-white, as shown in figures 12-15 and 12-16.

12-15

> **Look for working light.** Be aware of light that highlights and separates your subject from the background. Watch for light that skims the surface of a scene and offers great textures. Always be looking for light that does much more than simply illuminate a scene and its colors.

Shooting for Black-and-White

If you really want the best in black-and-white photos, it can help to shoot specifically with black-and-white in mind. This does not necessarily mean shooting with a black-and-white setting on your camera, but it does mean shooting with a black-and-white mindset. You need to start seeing black-and-white possibilities in the world as you shoot. This guarantees that your black-and-white photos will be solid no matter how you process them.

Frankly, this means taking a lot of photos and seeing how they come out as black-and-white. As I mentioned previously, using a camera that allows you to take black-and-white photos directly can be very helpful. This trains you to see what happens to the light and color of a scene as it changes from color (what you see) to black-and-white (what appears in the LCD review).

I could include a lot of images like the ones shown in figures 12-17 and 12-18, but this would limit you to seeing only what I saw. Your subjects, locations, light, and colors will be different. You need to see what happens to them with your shooting likes and dislikes.

12-17

12-18

The traditional black-and-white photographers such as Ansel Adams and W. Eugene Smith had to shoot black-and-white with black-and-white film. There was no good way of converting to black-and-white from color. Though this is the way the photographers

worked out of necessity, some folks today would have you photograph in black-and-white, period, even if that means shooting with black-and-white film. While there is certainly nothing wrong with that, why not use the capabilities of the computer to gain more from your black-and-white work? You can get a lot out of an image if you shoot RAW and process in Camera Raw.

By shooting with the idea that you are going to convert your color later to black-and-white, you gain two significant benefits:

> **You have an infinite choice of how colors are translated into black-and-white tones**. If you shoot black-and-white from the start, you are limited to what is captured at that point. Even though you can use filters to affect the look of the tonalities (a red filter makes reds lighter compared to blues, for example), you still are limited to the filters you have, and you are locked into a single choice. Converting in the computer is like having an infinite number of black-and-white filters.

> **You can do something that no one can do when shooting black-and-white from the start — do more than one color translation on the same photo (this would be like a traditional black-and-white shooter using two filters at the same time).** Doing more than one color translation on the same photo uses the same techniques as I describe in Chapter 13. Basically, you make one translation of a scene for one part of a photograph, such as the sky shown in figure 12-19, and then you make another translation specifically for another part, such as the Parliament building shown in figure 12-20. You then combine the two photos in Photoshop, as seen in figure 12-21.

CONVERTING TO GRAYSCALE

To convert an image to grayscale in Camera Raw is seemingly simple: You just click the Convert to Grayscale checkbox. However, there is a lot more than

12-19

12-20

12-21

that involved if you want to get great results. I don't want to give the impression that black-and-white is difficult or that you should be an expert photographer to try it. That's nonsense — anyone can have great results with black-and-white. However, if you want the best from your photos when they are translated to black-and-white, you have to think a little about how you make the conversion to grayscale. Here is a workflow that you can use to get a better black-and-white conversion:

1. Adjust your photo for blacks, whites, and mid-tones first. You need to start with a good image before translating it to grayscale, as shown in figure 12-22.

2. Try over-adjusting Vibrance, as shown in figure 12-23, as this increases the differences in the colors. I tend to avoid doing that with Saturation as it often causes colors to block up, losing detail in the color, which results in lost grayscale detail, too.

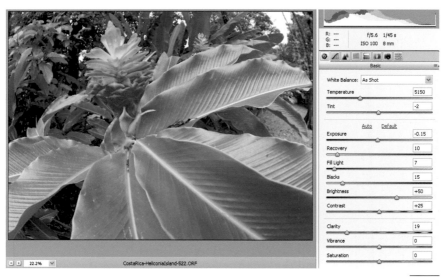

12-22

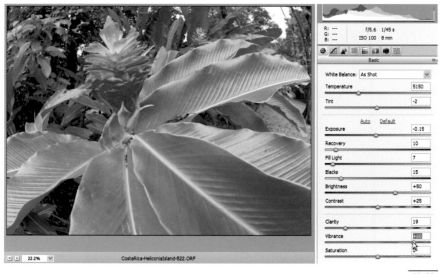

12-23

3. Go to the HSL/Grayscale tab and click the Convert to Grayscale checkbox, as shown in figure 12-24. This is an auto conversion that Adobe engineers set up. It may work, but often it does not, as figure 12-24 demonstrates. The reddish flowers and green leaves are tremendously different in color, but here they look too much the same. As a black-and-white image it now looks rather muddy, a term often used in black-and-white photography to refer to midtones that don't separate.

4. Use the color sliders to change the tonalities of the colors as translated into grayscale. If you aren't sure of a color, just try one and see what happens. Try different interpretations, such as the ones shown in figures 12-25 and 12-26, to see what you like best.

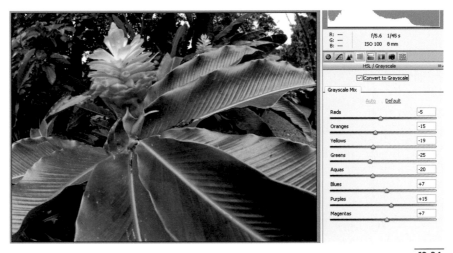

12-24

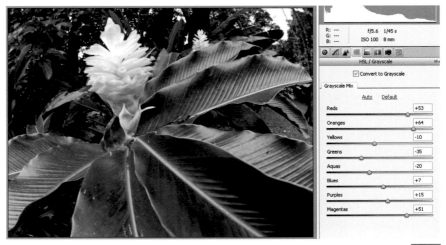

12-25

5. Check the image and see if it needs additional adjustment with other controls. The Tone Curve is especially helpful at this point to tweak how the midtones work together, as shown in figure 12-27. You are working toward a rich mix of tonalities.

6. Adjust the underlying colors for hue and saturation to affect how they translate to black-and-white.

7. Try some edge burning to make the photo look a little richer and to keep the viewer's eyes in the photo. You can do this in Photoshop, but you can also use the Lens Corrections tab to darken the edges as described in Chapter 10 and shown in figure 12-28.

8. Finish the photo as you usually would with the Detail tab. The final photo is shown in figure 12-29. This is a dark, somewhat dramatic interpretation of the flower and leaves. Other interpretations are indeed possible.

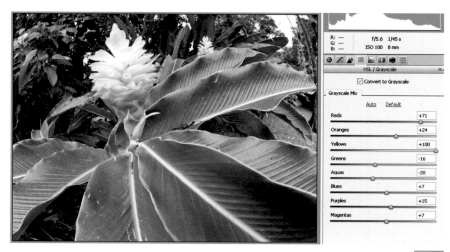

12-26

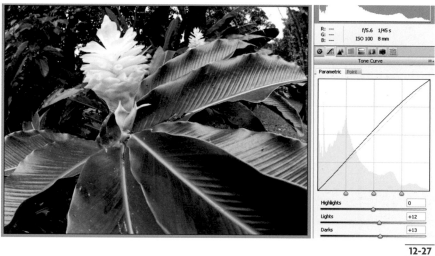

12-27

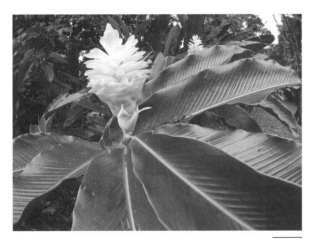

12-29

NOTE

You may notice that I suggest quite often trying sliders to see what happens. When you are new to making adjustments, it can really be a time to play and experiment to see what you can get from your photo. After a while, you start to learn certain things about how the colors act when changed to grays.

There is no arbitrary setting of the color sliders in the grayscale conversion that always works. You must look at each photo in terms of the colors in it and how they relate to each other as the image changes to tones of gray.

Don't be afraid of making very aggressive changes with the sliders. You can't hurt anything at this point. See what happens and what you like and dislike. Back off the sliders if the image starts looking too harsh. And, if you can't remember which colors are which, just click Convert to Grayscale on and off. That immediately shows you the colors and you can compare the color with the tone of gray that appears as you click on and off. Then you can try certain sliders to see what happens.

PRO TIP

When making your adjustments to grayscale, try moving the sliders large distances along the scale, both left and right. See what happens. You have nothing to lose. You can reset any slider at any time by double-clicking the slider.

OPTIMUM USE OF COLOR SLIDERS

As you've just seen, converting a color image to black-and-white is about interpretation. Should a red be light or dark? How about a green? The blues?

However, Camera Raw's black-and-white is not like traditional black-and-white in terms of colors. When Ansel Adams shot a scene with a red filter, for example, the red flowers would get lighter and the sky (blues) darker. In Camera Raw, when you use the Reds slider, reds get lighter, but there is no effect on any other color, blue or otherwise. This can be a little counterintuitive to a traditional black-and-white photographer, but on the other hand, it gives you wonderful control over the image. You can now use the sliders to affect only the color that is being adjusted and not others. So you can get surprising results when you move different colors back and forth ... surprising and terrific results, too! So don't be afraid to experiment.

USING SPLIT TONING

The tab directly to the right of HSL/Grayscale is Split Toning. This allows you to add color to highlights and shadows for some very nice effects in black-and-white. Traditionally, black-and-white photography often had some color in it, such as sepia or selenium tones (warm or cool, respectively). In the publication printing industry, colors were often added to a black-and-white photo differently in the dark and light areas to create duotones and other effects that gave the photo a stronger presence on the page.

PRO TIP

You can also use Split Toning with color images, following the same instructions for black-and-white, though you have to be very careful how you use the Saturation slider. I don't use it this way a lot, though some photographers do, while keeping the saturation very low.

Here's how to use Split Toning:

1. Increase the Saturation slider for Highlights enough so you can really see the color. I would suggest around 40%, as shown in figure 12-30. You do not keep this number; you are only using it to see and adjust the actual color.

2. Adjust the Hue slider for Highlights until you get a color you like. A very nice effect comes from using a warm tone for highlights, as shown in figure 12-31.

3. Increase the Saturation slider for Shadows now so you can see the color.

4. Adjust the Hue slider for Shadows until you get a color you like. A very nice effect comes from using a cool tone for shadows that contrast with warm highlights, as shown in figure 12-32. This is not the final image — the saturation is too high in both areas.

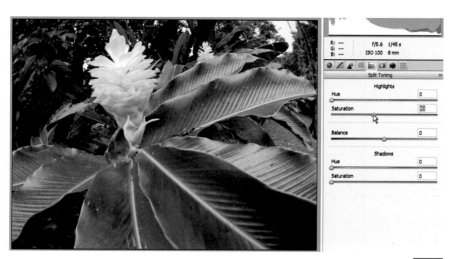

12-30

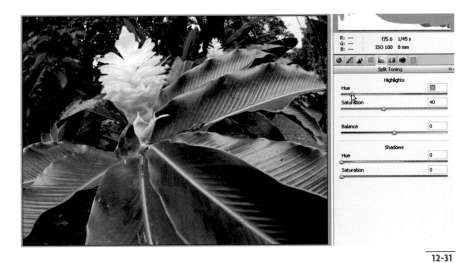

12-31

12-32

5. Decrease the Saturation sliders for both Highlights and Shadows until you get the colors you like in your photo, as shown in figure 12-33. This is extremely subjective and depends on what you like in these colors and how the final image is to be used.

6. Move the middle slider, Balance, which changes the balance of the colors acting on the shadows and highlights. Moving it to the right favors the highlight color over more of the photo. Moving it to the left favors more of the shadow color.

Split toning can give a very classy look to a black-and-white photo, as shown in figure 12-34. Be careful not to overdo it, though, as then the image can look garish.

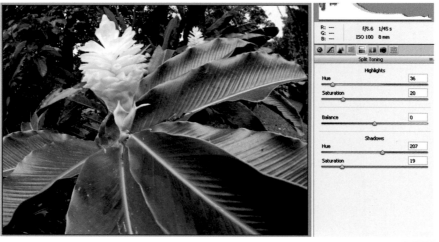

12-33

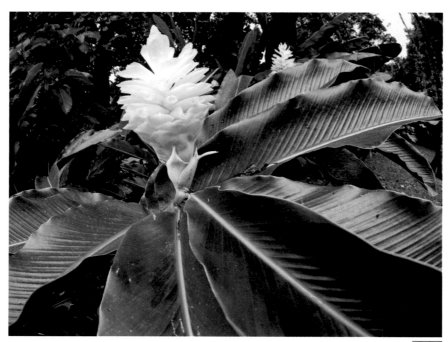

12-34

■ **I like really contrasty black-and-white photos. Why can't I simply take the standard grayscale image and make it more contrasty using the Tone Curve?**

You could do that, but you'll often run into a problem because the colors haven't given you the best tones to work with. For really contrasty images, for example, Ansel Adams used to photograph a landscape with a red filter over the lens. This would make the skies dark, the clouds light, and many things on the ground lighter, too. Trees would go dark. This would then allow him to really make a contrasty image when he got into the darkroom.

When making a strong black-and-white photo, which would include a high-contrast image, you are always best served by getting as much contrast as possible first from changing the translation of colors into gray tones. You can also increase the separation of colors by tweaking the Vibrance slider, as well as changing individual colors in the HSL/Grayscale tab using all three sliders: Hue, Saturation, and Luminance. This can give you some really dramatic results.

Just like in color, a black-and-white photo with harsh contrast sometimes seems like it needs two completely opposed ways of processing in Camera Raw, but that isn't possible. Should I deal with it the same way, using two processing stages?

You can, and that sometimes is the best thing to do. However, black-and-white really is different aesthetically from color, so you won't necessarily make adjustments the same way. As you start with the color image, it is best to carefully choose your Exposure and Shadows slider points, then how you use the Tone Curve. Then, revisit them after making your conversion to grayscale. You will often find you need to readjust the Fill Light slider, especially, and then perhaps some of the Recovery slider. It is worth playing around a bit with them. Then go to the Tone Curve. This can be an excellent tool for getting more from your black-and-white photos.

And, as you do for color, you have to really watch your tonalities as you do this. I have seen this happen in the darkroom, too — photographers get so focused on getting more tonal detail out of dark areas, for example, that the photo starts looking very dull. The midtones look muddy. You need to constantly look at what is happening to the whole photo.

DOUBLE PROCESSING FOR EXPOSURE

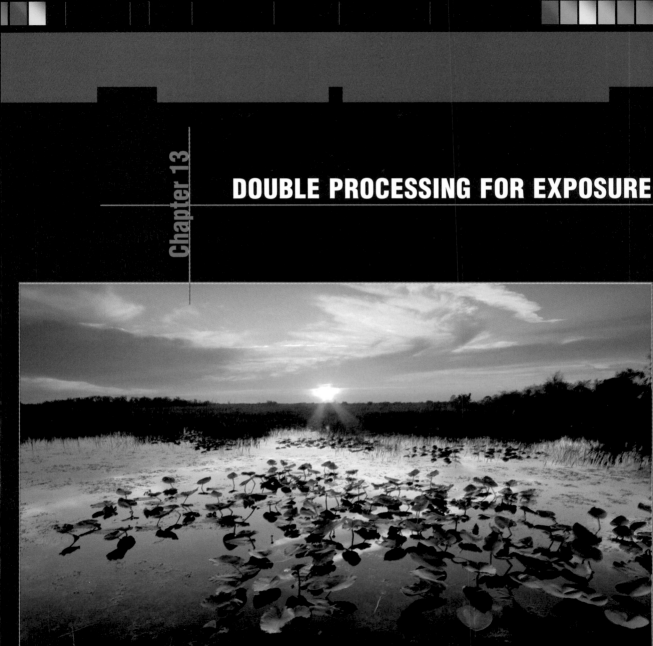

You have now learned the secrets of Camera Raw. Using its power is not so much about knowing all the controls as it is about being able to interpret their use for a particular photo. After all, Camera Raw has a fraction of the controls that Photoshop itself has. Using Camera Raw takes practice and work on many varied photos, sometimes even trying different processing techniques on the same image file just to see how the image can be affected.

In this chapter, you learn a technique that requires you to process the same image file in two different ways to achieve a very specific effect. You may have noticed when working on photos in Camera Raw that as you work on optimum adjustment, one set of tonalities is not optimum for something else. This is especially true when you try to make the most of dark parts of certain photos compared to the highlights.

Yet, RAW files hold a great deal of very useable detail in those dark areas, as shown in the example in figures 13-1 and 13-2, where figure 13-2 is an opened-up version of figure 13-1. One very real advantage of shooting RAW is that you can capture better shadows and highlights than you can when shooting JPEG. You need a way of getting the most from both. That can be difficult when you have a scene with a big tonal range of important details. With film, you have to be satisfied with a specific and unique result from the exposure used for a single frame. With slide film, for example, you expose for the highlights and hope for the best in the shadows. In bright light, that often results in a dramatic photo to be sure, but one with good highlights and no shadow detail.

But now you don't have to accept that. You can go beyond the limitations of standard exposure and JPEG processing to gain images with tonal ranges truer to what you saw in the first place. It is interesting to me that some so-called purists claim the processing described in this chapter is false, that it somehow distorts reality. That is truly a lot of nonsense. The great black-and-white photographers would frequently process their images differently because of different

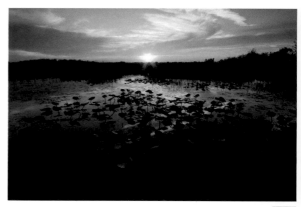

13-1

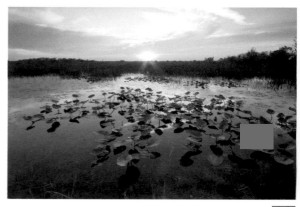

13-2

subject conditions. Just like their darkroom work, the processing you learn here actually reveals reality. In some cases, such processing might be considered the "truth," because it really does allow you to come closer to what can really been seen rather than what was arbitrarily revealed by the technology.

PRO TIP

Exposure is still important, even when you're doing a double-processed image. If a photo is much overexposed, then adjusting the bright areas is a challenge requiring more work at the least, and a bad compromise at worst. If a photo is much underexposed, adjusting the dark areas may also add work, but even worse, noise becomes much more prominent and colors will be weak.

ONE SIZE MAY NOT FIT ALL

Standard processing of RAW files works most of the time. Double-processing an image, as I describe in this chapter, increases the work involved for a photo and, therefore, changes your workflow. That may simply not be acceptable for many photographers. No wedding photographer, for example, is going to double-process all of the shots from a wedding.

However, there is no question that trying to force every image into the mold where you do everything once with the controls that Camera Raw offers compromises some images. One-size processing won't fit every photo. Even a wedding photographer finds it helpful at times to process that one key photo from the wedding, to bring out details in both the bride's white dress and the groom's dark tux that cannot be revealed in any other way.

Camera Raw doesn't give you the ability to control one part of a photo differently from another. As you adjust dark areas, light areas are affected. The best adjustment of the bright parts of a photo may give you the ability to only make a mediocre adjustment of mid- to dark tones. Figure 13-3 demonstrates how much you can get from an image in different tonal areas by using all the features of Camera Raw. Although the image isn't bad, it could still be better.

13-3

One might ask, "Why bother?" It is so much easier to focus on really important parts of the photo and process for them independently so they look their best compared to doing a lot of work trying to beat the system and processing the image only once. And when bright areas and dark areas really do require different thought, rarely does it happen that both look their best when forced into being adjusted simultaneously.

So what to do? Process the image twice: once to optimize the highlights, and once to get the most from shadows. Then put the two photos together in Photoshop. You learn to do all of this in this chapter.

BRIGHT SKY, DARK GROUND

One major type of shot that cries out for double processing is a scene with a bright sky and dark ground. In the photo of sunset in the upper reaches of the Everglades drainage in Loxahatchee National Wildlife Refuge, the color in the sky and clouds looks great. As I stood by the water, I knew I wanted the water and the plants with their reflections in the composition, but I also knew that the camera sensor could not handle the full range of brightness that my eye was seeing.

A three-stop graduated neutral density filter helped with the exposure by knocking down the brightness of the sky considerably. At this point, the sky and ground at least recorded with detail that could be used. This gave an unprocessed result that looked a lot like what you would have achieved with slide film (see figure 13-4). Most people actually expect a scene like this to look similar in a photograph, even though that is not really how it looks to the eye. But to get an image with a range of tonalities more representative of what I actually saw demands RAW to better dig the darkest and brightest tones out of the recorded image file.

This photo presents a significant challenge facing digital photographers working today. Most people expect certain images to appear a certain way regardless of what the original scene looked like. The predominance of Fujichrome Velvia film, which has been used by

13-4

With digital and with the double-processing technique, you can get a sunset with colors that people expect and more tonality than most viewers think such a scene has, according to what they have seen in photographs before. This is in spite of the fact that the film simply was not able to capture the range of detail that the eye saw. So sometimes you can adjust an image correctly for what was in the scene, yet the viewer will find it unnatural, not because it is really unnatural, but because it doesn't look like what they think a photo of such a scene should look like.

BRINGING OUT THE SCENE

Double processing works on the principle of creating two image files from Camera Raw. The files have different colors and tonality based on processing for specific parts of the images, which are then combined in Photoshop. The result is that you don't have to try to make the whole image perfect by using all of the adjustments possible in a single processing. Double processing is a way to get around the limitation that Camera Raw only allows overall, global adjustments of an image and cannot treat only selected areas.

professional nature photographers for the past 20 years, created a look that now defines expectations of what a nature photograph should look like.

An easily understood example of this is a sunset. Sunset light is not anywhere near balanced to the daylight film with which it has been traditionally shot. Velvia records a far warmer, much richer color than is seen in reality. When shot with a digital camera, a sunset depends on the white balance. You can actually remove the color by using a tungsten balance, which neutralizes much of the sunset color altogether (see figure 13-5). Auto white balance usually gives sunset a warm, but weaker coloration. It usually looks more like what people expect if it is shot with daylight or cloudy white balance.

For this photo, it is possible to adjust the image once for the sky (see figure 13-6), and then open that version into Photoshop. The RAW file is opened a second time and readjusted for the plants and water at the bottom (see figure 13-7), and then that photo is opened into Photoshop, too. Of course, you can try to make adjustments for both at once by using the Tone Curve (along with the other adjustments), but I guarantee the results on this type of image: You gain the desired tonal range but at the cost of more work, frustration with tones and colors not working together, and a flatter look to the image.

Double processing is a little tricky at first. You have to force yourself to only look at the specific parts of the photo you are adjusting for each processing and not be distracted by another part of the photo that might begin to look really bad from this adjustment. In this photo, for example, when adjusting the sky, you have

13-5

13-6

13-7

to ignore the lower part of the photo. Then when the photo is adjusted a second time for the lower part of the image, you must ignore the sky. Sometimes photographers have trouble ignoring the other part of the photo until they have experimented with a few double-processed photos.

PROCESSING THE BRIGHT AREAS

In the double-processing technique, it is usually best to start with the most straightforward adjustments. In other words, look at the photo and see what part of it you can adjust quickly and easily. On this photo, it is the sky because it has good exposure and color. This is really a critical part of the image, too, as color and contrast in the sunset itself always influence the rest of the photo.

The sky then needs to be adjusted for itself only, ignoring what happens in the rest of the photo. You still need to follow a standard Camera Raw workflow, this time focusing on the sky.

1. Bring the brightest areas down in value. The area around the sun is still a bit bright from the original exposure, so by using the Alt/Option threshold command and looking at the Preview, I brought the brightest areas of the sky down a bit in value (see figure 13-8). I also added some Recovery adjustment, which affected the bright area directly around the sun.

2. Lessen the Blacks adjustment. Most of the photo has more than enough black from the bottom of the image, so the Blacks adjustment does not need to be stronger (go to the right). There is no reason for a pure black in the sky, so minimal change of shadows is needed. Having a little of the Blacks adjustment (in other words, not all the way to the left) gives more strength to the darkest parts of the sky, as shown in figure 13-9. Bringing up the Fill Light a little also helps the clouds.

3. Adjust the Tone Curve. Skies with a lot of variation in tonality like this one do quite well with the Tone Curve, as shown in figure 13-10. This allows some tweaking of contrast so certain parts of the sky brighten, while others darken for more drama.

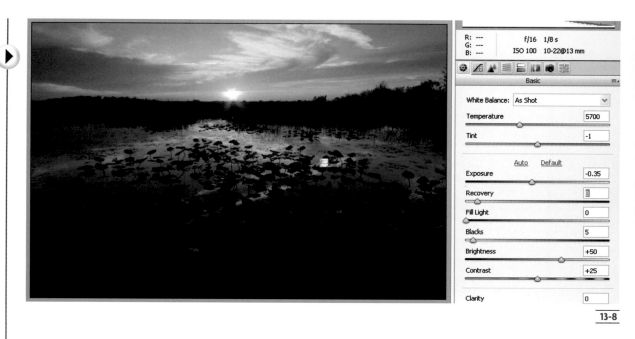

R: ---
G: ---
B: ---

f/16 1/8 s
ISO 100 10-22@13 mm

Basic

White Balance:	As Shot	
Temperature		5700
Tint		-1

Auto Default

Exposure		-0.35
Recovery		3
Fill Light		0
Blacks		5
Brightness		+50
Contrast		+25
Clarity		0

13-8

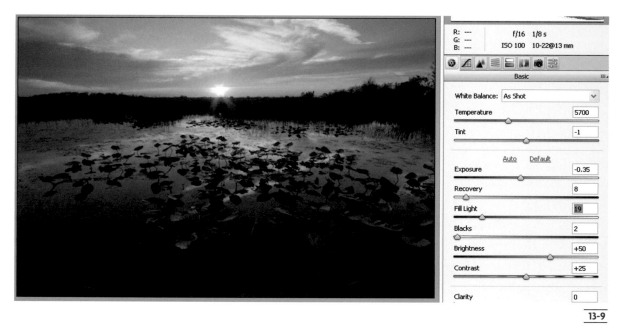

R: ---
G: ---
B: ---

f/16 1/8 s
ISO 100 10-22@13 mm

Basic

White Balance:	As Shot	
Temperature		5700
Tint		-1

Auto Default

Exposure		-0.35
Recovery		8
Fill Light		19
Blacks		2
Brightness		+50
Contrast		+25
Clarity		0

13-9

4. This is a good time to check Clarity and Vibrance. Clarity doesn't do much to this sky and Vibrance kicks up the color a little, as shown in figure 13-11. At this point, you can see immediately that although the sky is looking great, the rest of the image still doesn't have the best color and tonality. This is the point at which photographers can panic and try to adjust the rest of the photo. Don't! This is exactly as the photo should look at this point.

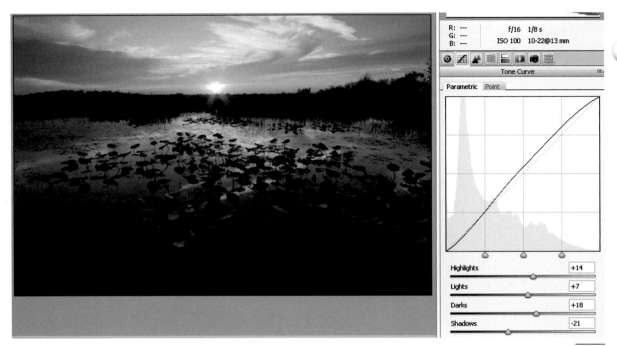

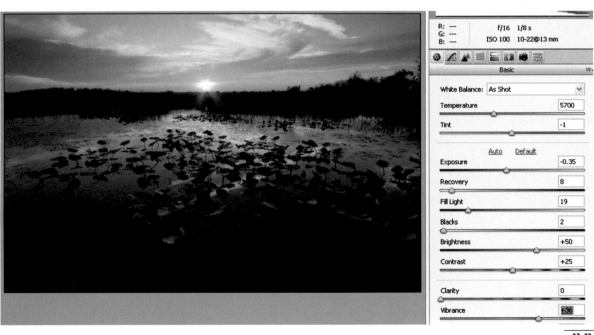

5. Increase the Temperature slider of the White Balance settings. This is a good way to add some color to the sunset as shown in figure 13-12. This method can make for a very richly colored sunset, but if you go too far, it can be hard to balance this part of the image with the rest of the photo when the lower part is processed.

This photo in this example is very clean in the sky and needs no adjustment in the Detail tab beyond the defaults for sharpening and keeping Noise Reduction to 0 (see figure 13-13). Once you have gone through these steps, open this processed sky image into Photoshop and save it (see figure 13-14) with a name that relates to the processing.

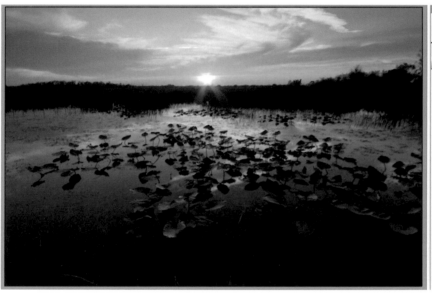

13-12

13-13

13-14

PROCESSING THE DARK AREAS

The lower portion of this photo is dark, but it has a lot of detail that can be brought out. When double processing, I like to go back to what the image looked like before the sky was processed. You do this by using the drop-down menu for the Adjustment panel and choosing Camera Raw Defaults, as shown in figure 13-15. You can just pick up adjustments where you left off with the first processing of the image, but I find that confusing. In that case, you are adjusting your adjustments, rather than starting fresh.

This particular photo allowed me to use the Preview area to look only at the lower part of the photo and hide the sky. By magnifying the photo slightly and then moving it up within the Preview space, the sky disappears from view, as demonstrated by figure 13-16. Not all photos will work this way as this magnification hides details on the sides of the image, too. If those details are important to the adjustment, then you have a problem. But many times this magnification can help you from being distracted by the sky.

Here's how to work the image to get the most from the dark areas:

1. Because this part of the photo already is in the shadows and has several black areas, you could leave it as is. I decided to increase Blacks slightly to give the leaf shadows strength (see figure 13-17). I did not want to open up this lower part of the image so much that it looked like a daylight photo. This would never look right against the sunset. However, using fill light to brighten the dark areas did help, as shown in figure 13-18.

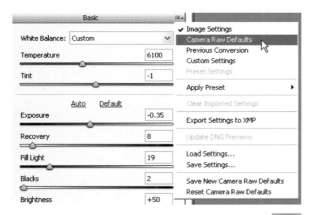

13-15

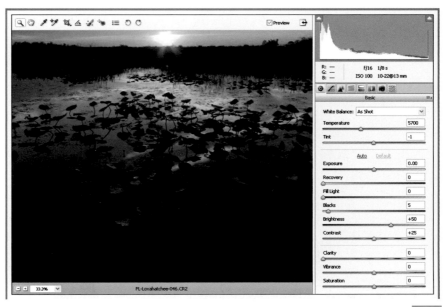

13-16

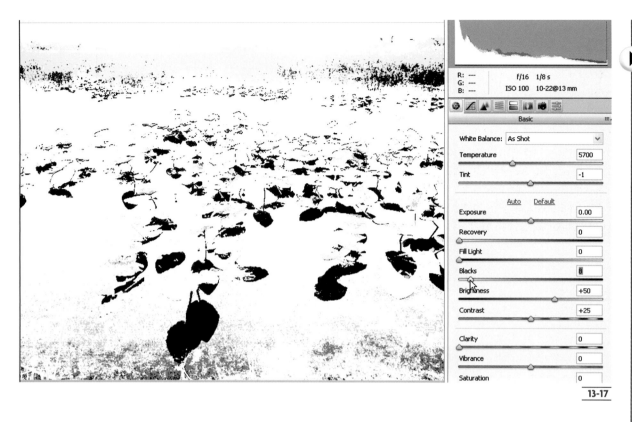

13-17

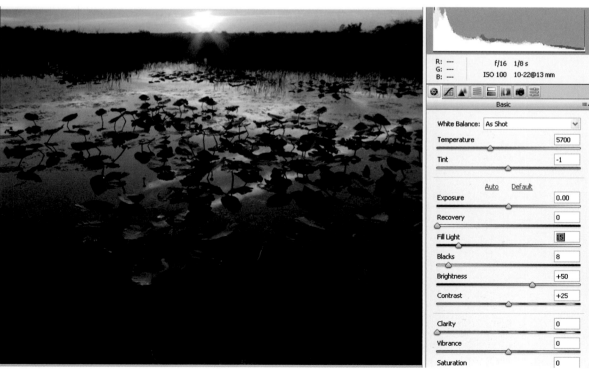

13-18

2. Freed from the demands of the bright sky, the watery landscape can be lifted in its highlights by Exposure quite a bit, as shown in figure 13-19. I would avoid trying to go too far with the Exposure setting because this is, in fact, the dark part of the photo. You want to make it brighter, but not so much that it competes with the sky.

3. The Tone Curve really helps with double processing, as shown in figure 13-20. Most double-processed photos deal with limited tonal ranges in each adjusted version of the image (because you usually are working with mainly the dark or mainly the light tones for each version). The Tone Curve enables you to work that tonal range with

more control. This often requires multiple points on the curve. You do have to be careful, however, that one area of the curve is not so over-processed that it makes the image look odd, even posterized. Watch how tones blend into each other. Very steep changes to the Tone Curve can result in such problems.

One problem that can occur as you process a part of the image with limited tonal range is that the gradations of tone can begin to tear, leaving you with odd tonal transitions. Increased noise can also be revealed from strong processing. Be aware of these possibilities — you may have to temper some of your processing.

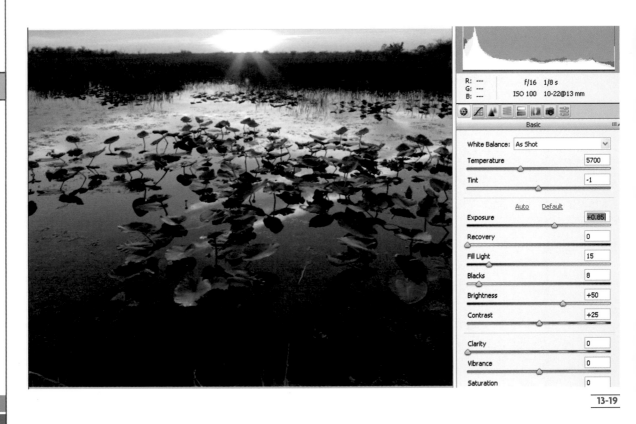

13-19

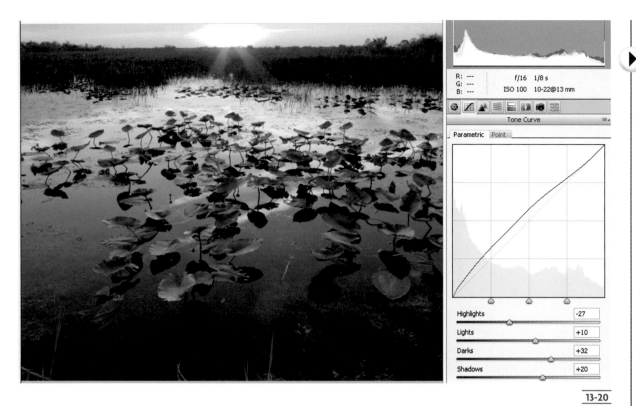

R: ---	f/16 1/8 s
G: ---	ISO 100 10-22@13 mm
B: ---	

Tone Curve

Parametric | Point

Highlights	-27
Lights	+10
Darks	+32
Shadows	+20

13-20

4. There is a big flare spot in the photo that could be removed now (you can see it at the bottom of figure 13-20). Because it is in a dark area without much detail, the Clone Retouch Tool works well as shown in figure 13-21.

5. Saturation can often be boosted a lot in dark parts of an image because the color was originally captured weaker than it actually was (dark areas will do that). In this photo, the water and plant leaves look better with more saturation (see figure 13-22). Vibrance also worked, but not as well in this photo.

I decided to leave the White Balance section as is. I liked the color of the water reflecting the blue sky. It gives the color in the photo a cold and warm contrast. Increasing the Temperature setting gives the photo more sunset atmosphere, but then you lose the cool blues at the bottom of the image.

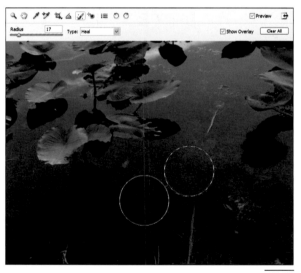

Radius	17	Type: Heal	

Preview

Show Overlay Clear All

13-21

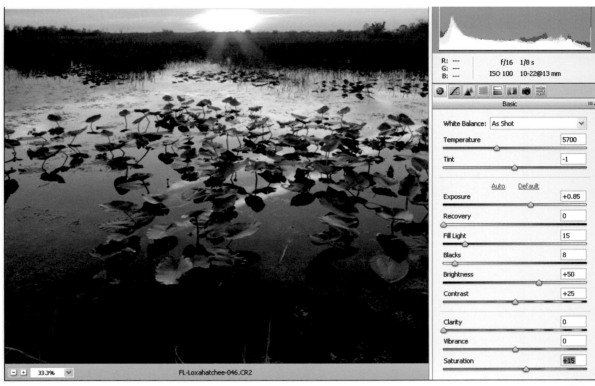

13-22

6. All this adjustment of dark parts of a photo begins
 to show noise that is normally not seen, but is
 evident in figure 13-23. Both color and luminance
 noise appear so that some adjustment of the
 Detail tab is needed. There really aren't a lot of
 fine details in this watery part of the photo, so
 both the Luminance Smoothing and Color Noise
 Reduction sliders can be used fairly aggressively.
 Most of the noise is cleaned up quite well with
 Luminance Smoothing set at about 40 and Color
 Noise Reduction at about 25, as demonstrated in
 figure 13-24. I am not adding any sharpening
 beyond the default here because of the work that I
 will do in Photoshop.

7. Open this processed sky image into Photoshop
 and save it.

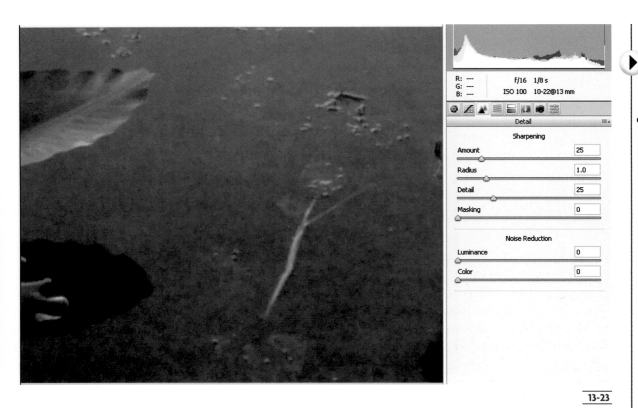

13-23

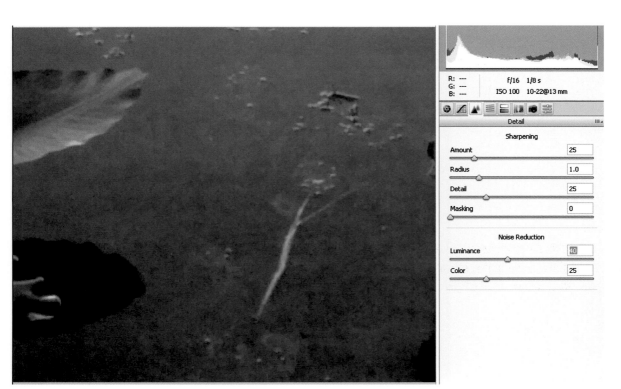

13-24

THE MERGING PROCESS

At this point there are two distinctly different images open in Photoshop: a dark one that was processed for the sky and a light one that was processed for the water and plants, as shown in figure13-25. Although they look okay, neither one looks great overall. The important thing is that there are now two images optimally processed for specific parts of the photos. Any overall processing, as you have seen, leads to a compromise that doesn't truly make the most of the scene.

Now the two versions have to be brought together into one final image, which is truly a magical moment. It's magic to me because now I can see in the photo something much closer to what I originally saw when I made the photograph. It is like seeing the image become real in the developing tray in the traditional darkroom. And it truly reveals the power of digital and shooting RAW.

The process is simple in concept: You move one photo on top of the other (automatically making it a layer), and then remove the bad parts of the top photo to reveal the better processing of those parts in the bottom image. Because both images came from the same file, they line up exactly. But which photo goes on top? There is no right or wrong way to do that. It depends heavily on the photo. And sometimes you guess wrong, which is really no big deal: You have your two images processed and saved, so you just move the other one on top.

As you gain experience using this technique, you learn to judge which photo should be on top. Here are two things to consider:

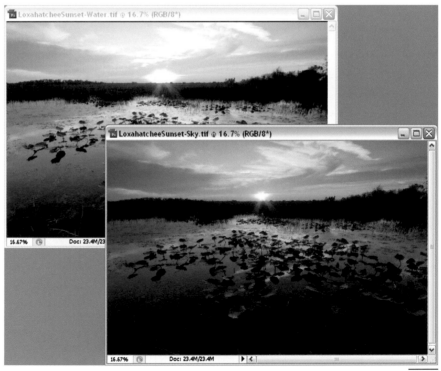

LoxahatcheeSunset-Water.tif @ 16.7% (RGB/8*)

16.67% Doc: 23.4M/23

LoxahatcheeSunset-Sky.tif @ 16.7% (RGB/8*)

16.67% Doc: 23.4M/23.4M

13-25

> **You will be removing parts of the top layer to reveal better-adjusted areas from the bottom layer.** The photo that needs the least amount of area removal often is best on top.

> **Because the top photo is on its own layer and the bottom image is on the background, the top photo can be further tweaked by adjusting the Opacity of the layer.** That implies that the photo with the overall best adjustment goes on the bottom.

PUTTING TWO IMAGES INTO ONE

In this scene, the sunset-adjusted photo has an excellent sky. It's hard to say if the water-and-plant-adjusted image balances the sky as is when it is added to the sky photo, meaning that the darker image may need some Opacity adjustment to its layer to balance it. This thought process is useful for any image as it helps you decide which image needs to be on top in a layer. This won't be obvious when you first start using this way of working an image, but you'll learn it as you go. Here's how to put these two images together:

1. Line up the images. Move the two photos enough apart on your Photoshop workspace that you can easily see both the top photo and much of the image under it. You may need to reduce the viewing sizes of the photos to do this. Make the photo you think should be on top the active image (which makes it on top visually on the workspace), as shown in figure 13-26.

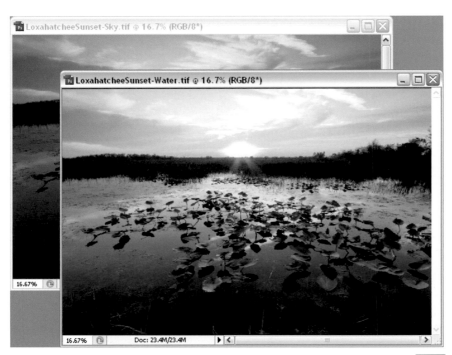

13-26

2. Select the Move tool in the tool palette. Click anywhere on the active photo, press and hold Shift without moving anything else, and then drag the active photo on top of the bottom image. Holding Shift during this movement makes the two images line up exactly.

It is very important that you move your cursor completely onto the bottom image so that the cursor icon changes to a white cursor with a little box and a plus sign (see figure 13-27). Then release your mouse button and Shift in that order. If you do not move your cursor far enough, an error message that indicates that Photoshop "Could not complete your request because the layer is locked" appears. That only means you did not drag the image far enough.

If you release Shift before you release your mouse button, the top photo's position moves, and it does not line up with the bottom photo. You can check to see if the two photos are lined up correctly by turning on and off the top layer (check

the eye icon); they should change in brightness, not in position.

3. Add a layer mask to the top layer, the photo you just dragged, as demonstrated in figure 13-28. You can do this through the Layer Mask icon at the bottom left of the Layers palette or through the Layer menu.

4. Remove the bad parts of the top photo. In a layer mask, black hides the layer and white reveals it, so as long as you are in the layer mask (the Layer palette shows which is active), you can paint the top photo out (black) or in (white). Use a big, soft brush to make this painting in or out blend well, as shown in figure 13-29.

This photo offers another possibility for removing the bad parts of the photo, a gradient in the layer mask using the Gradient Tool (be sure the Linear Gradient is chosen in the tool Options bar as well as the first blend of foreground to background colors or the third blend of black to white). By

LoxahatcheeSunset-Sky.tif @ 16.7% (RGB/8*)

LoxahatcheeSunset-Water.tif @ 16.7% (RGB/8*)

16.67%

16.67% Doc: 23.4M/23.4M

13-27

setting the foreground/background colors on the Tools palette to black on top and white below, you can use the Gradient tool to start with black (to remove that part of the photo) and gradate to white (to keep another part of the top image) wherever you click again. A gradient blend occurs between those two click points. On this photo, clicking near the sun and pulling down the blending line to just below the horizon, creates a blend that works well right along the horizon, as shown in figure 13-30.

13-28

13-29

The image window title bar reads: LoxahatcheeSunset-Sky.tif @ 16.7% (Layer 1, Layer Mask/8)

13-30

You may have to try this gradient multiple times. Where the blend occurs and how big the blend is has a huge effect on the photo, and every photo is different as to what is best. Some need a very narrow blend, while some demand a blend halfway across the photo.

5. Refine the differences. Use a smaller brush, still soft, to paint around smaller areas that did not blend properly in the overall changes. In this photo, for example, I did some extra work through the trees to bring them out a little.

6. Tune the top layer. Often the top photo can be made to balance the bottom better by turning down the top photo somewhat, by using the Opacity control of the top layer, as shown in figure 13-31.

7. Tweak as needed. At this point, you can do further work to the image by controlling and isolating changes to the layers. You might add an Adjustment Layer for the bottom photo and another one grouped with the top layer alone. You use these to make the top and bottom layers blend better. I added a Curves adjustment layer grouped with the top, darker version, just to lighten it a little further, as shown in figure 13-32.

8. Save the file. I typically flatten the photo now, and then sharpen and save it as a new file. Because I have already saved the two processed photos, I feel little need to save a Photoshop layered file for the whole image. If you have to make a lot of small changes, for example, painting in and out lots of isolated areas across the photo, then it is a good idea to save a whole layered file that you can go back to and readjust if needed.

PRO TIP

You can deal with the top photo without a layer mask if you are not comfortable with layer masks yet. (I say, yet, because they are an extremely valuable tool for the photographer using Photoshop.) You then use your Eraser tool from the tool bar and your Undo controls. Pick a big, soft brush for the eraser and just erase the parts of your top photo you don't need. Use the Undo command or the History palette to back up if you go too far.

13-31

13-32

Compare again the single-processed and double-processed files in figures 13-33 and 13-34, respectively. There is quite a difference! Figure 13-34 is considerably livelier and, I believe, closer to the real-world experience of that sunset. You may also notice that I removed a little bit of orange flare at the bottom of the image using a layer to copy the area and adjust its color to match, and then used the Clone tool to blend.

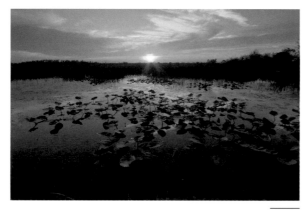

13-33

SMALL AREA CHANGES

Not all photos needing double processing will have the areas of difference so clearly defined as in this landscape example. The little jumping spider in figure 13-35 is a good subject to show off the power of double processing in an image that needs the work, but only for small areas.

The backlight in the image direct from RAW without processing makes for some interesting sparkle in the sand around the critter, plus it offers nice three-dimensional modeling of the animal and a good shadow for an interesting compositional element. However, that backlight also severely underlights the front of the spider so it is difficult to see the interesting features of its head.

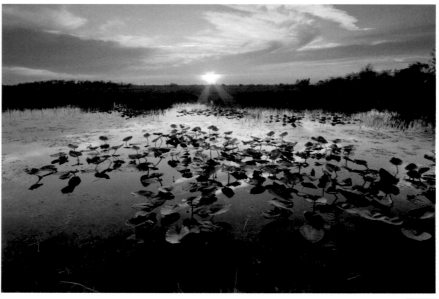

13-34

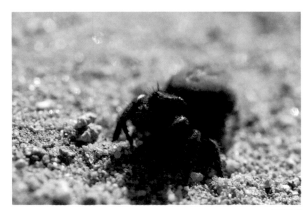

13-35

possibility that would allow both the drama and life of the backlight as well as detail in the shadowed face of the spider.

You might ask, why not use the Shadow/Highlight adjustment tool in Photoshop? Simple — control. With the double-processing technique I don't simply brighten the shadows or darken the highlights, as in Shadow/Highlight (though it does those things well). With this technique I can specifically process an image version that absolutely favors the highlights, even to the extent of ignoring shadows, and then I can process a second version that does the opposite and totally favors the shadows. Then, on top of that, I can selectively decide where to emphasize the highlights and shadows in the final image because of the way I blend the two photos together.

PROCESS FOR THE MAIN PHOTO

The spider photo is an excellent example of how to deal with processing a shot that needs a small area adjusted totally differently than most of the image. First, it is always best to do the easiest adjustments first, and that would be making the main photo look its best.

1. Because the dark areas of the subject will be adjusted again just for those tonalities, the overall image can afford a slight increase in the Blacks slider. This deepens some of the sand shadows, as shown in the threshold screen (Alt/Option) in figure 13-36.

2. I added a bit of Fill Light to lift the tonal values of some of the darkest tones, as shown in figure 13-37.

3. Do both a visual check of the image and use Alt/Option to see the highlight threshold with Exposure; these show a well-exposed image. There is no point to making the highlights brighter.

4. The Tone Curve helps the overall photos, as shown in figure 13-38, but the spider face looks worse.

PRO TIP

Brilliant Photoshop expert Jack Davis likes to blend image layers together using Layer Styles Blending Options. This allows you to blend the two versions of your processed photo in a different way. You can experiment with this by choosing Layer ➪ Layer Style ➪ Blending Options. Then you use the sliders at the bottom (Blend If). Choose Gray and move the top sliders back and forth to see how the two versions blend together. You can split the sliders for more control by pressing and holding Alt/Option and dragging a slider apart. I tend to favor the layer mask and painting parts of the image in or out as needed because I like the control this offers as to where my changes appear in the photo.

Backlighting is a real problem with shooting existing light on many subjects. The light is great overall, but causes problems with details that need to be revealed. Flash might help, but it can also overpower the scene when it's this close, and it means you have to carry along a big flash. A reflector can help, but sometimes subjects, such as this little guy, have no reason to wait around while you set a reflector. The result in the past would have most likely been one of two things: tolerance of the lighting conditions so the subject could be captured on film or an image tossed to the round file when it got back from the lab.

This shot was made with RAW so that would not be necessary. I knew double processing was a real

293

5. Color doesn't look too bad using the As Shot setting, so it can be left as is at first. Saturation and Vibrance really don't help this image.

6. Detail in the image is very clean and needs no noise correction. Sharpening should be applied later in this process.

7. Adding a Vignette to the image from the Lens Corrections tab does add a nice effect, darkening the outside edges, as shown in figure 13-39.

8. Open the processed image into Photoshop and save it.

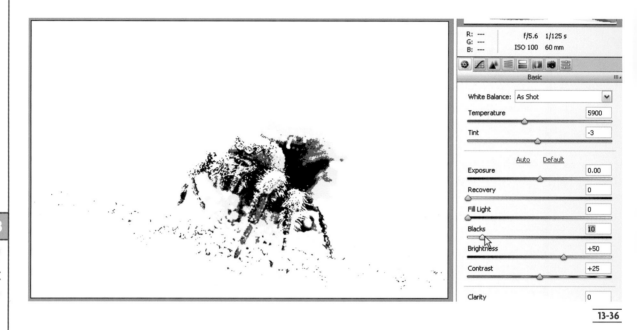

13-36

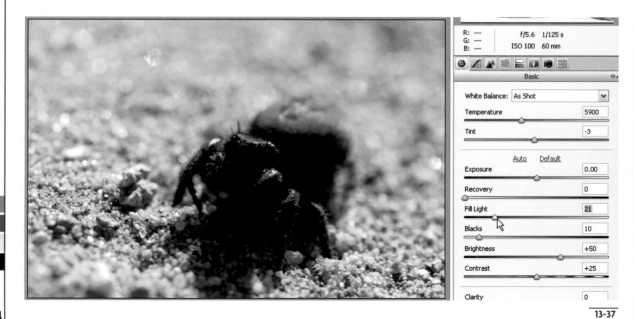

13-37

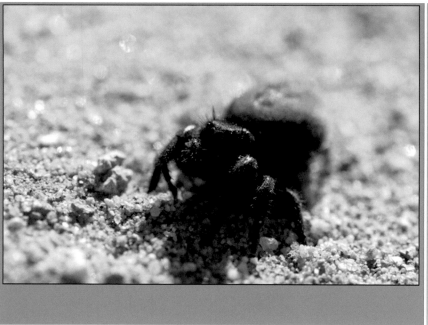

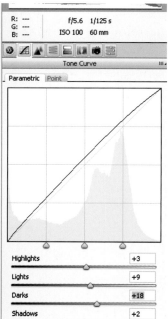

13-38

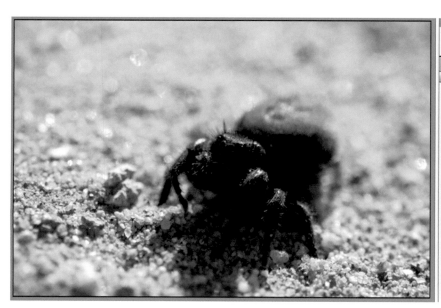

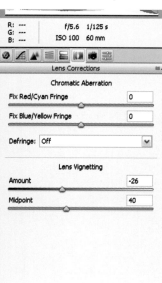

13-39

PROCESS FOR THE DETAIL

Now the dark side of the spider has to be developed (apologies to George Lucas). Once again the image is put back to the Camera Raw Defaults, and then processed for the dark face. Enlarging and moving the photo in the Preview doesn't help much to minimize distractions in this image. You just have to accept that most of the photo will look bad as the dark detail is adjusted.

1. The Blacks control could be moved to the left slightly to make the blacks lighter, but mainly, fill light really needs a strong adjustment, as shown in figure 13-40. Some people might find this image acceptable. I think it has lost some of its daylight intensity and mood. But that is okay for this processing.

2. Using the Alt/Option technique for Exposure doesn't help much for processing the dark part of this photo. I just used Exposure a little to lighten the dark areas a bit. You could actually skip the Exposure step, but I like to use it because it strengthens the bright areas of the dark part of the image.

3. For the midtones, the Tone Curve is a huge help for dark areas like this. By using the parametric sliders carefully, the dark face of the spider really starts to light up (see figure 13-41). I did keep the Shadow slider low so that the blacks didn't turn gray. The rest of the photo gets way too bright, but that doesn't matter.

4. Color looks fine with the As Shot setting, as does Vibrance and Saturation. There isn't much color here to worry about except shades of dark gray.

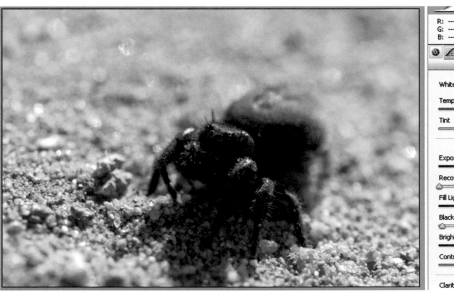
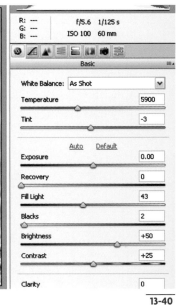

13-40

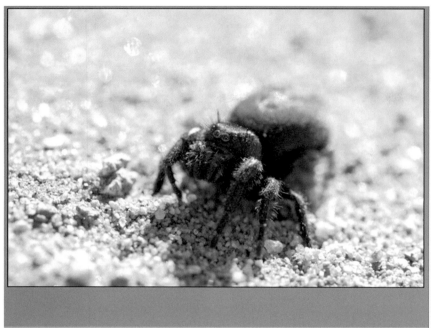

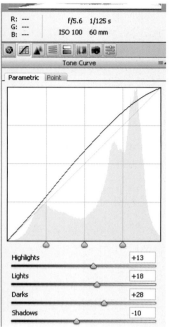

13-41

5. All of this major dark-area processing has once again made both color and luminance noise appear, shown in figure 13-42. There is some fine hair detail on the spider that affects how much noise adjustment can be made. Still, the photo can definitely use some noise suppression. A

setting of about 30 seems to work for Luminance Smoothing and doesn't kill the hairs. Color Noise Reduction does not need a lot, maybe 15 or so (see figure 13-43).

6. Open the processed image into Photoshop and save it.

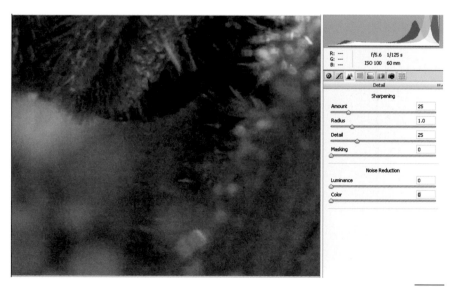

13-42

13-43

PUT THEM TOGETHER AGAIN

When doing photos like this, it is often most helpful to put the main photo, the one that has the best overall processing, on the bottom. This allows the detail photo to be blended in more easily because you can use Opacity controls to adjust how much of it is used.

This presents a challenge, however, because the two processed images have the important details in a variety of areas. Here's how to deal with this:

1. As in the previous example, drag and drop the lighter, detail image onto the main photo by using the Move tool and pressing and holding Shift as you move the photo from one file to the other.

2. Add a layer mask to the top layer, and then hide it (in essence, removing it all) by filling the layer mask with black (choose Edit ⇨ Fill). You can actually add a black layer mask through the Layer menu (choose Layer ⇨ Layer Mask ⇨ Hide All) or by Alt/Option+clicking the layer mask icon at the bottom of the Layer palette. Figure 13-44 shows the image plus layer palette showing the black layer mask.

3. Paint in the detail. Here's where you can have a lot of fun. How much do you want to see of the specially processed detail? You paint that in with white on the layer mask wherever you want it. Use a soft-edged brush in a variety of sizes to bring in the details. If it starts to look overdone, change the brush to black and paint it back. You can even vary the opacity of the brush to help blend the two layers even more. This takes a bit of playing to make everything look right, as shown in figure 13-45. I pushed the lighting a bit under the spider so that the shadow is now technically uneven, but that was the only way to make the legs show up. I used as large a soft brush as I could there to make it blend.

You can actually select the darkest areas of the bottom photo with the Color Range tool in the Select menu and then fill that selection in the layer mask with white to reveal the dark details. This sometimes works, but often I prefer to paint in and out the details I need for very precise control. There is now a lot more detail in the dark part of the spider, yet the overall photo has not been compromised in tonality or color.

13-44

13-45

4. More detail in the dark areas can be pulled out of this spider. Change the blending mode of the top layer to Screen (modes are at the top left of the Layer palette), as shown in figure 13-46. This immediately lightens the details even more. They get too bright, but are easily toned down with the Opacity control.

5. Flatten, sharpen, and save. You can now merge the two layers, sharpen the photo, and save it.

You may also want to save an unsharpened version that can be later resized as needed, and then sharpened to that specific size.

Check out the final, double-processed image shown in figure 13-47. This is an image that brings this little spider to life! The double-processed file allows the shadow area to have its own, more snappy adjustment compared to the rest of the image so the face is more visible.

13-46

13-47

DOUBLE PROCESSING FOR COLOR AND TONAL RANGE TECHNIQUES

This double-processing technique works on more than tonal range challenges. You can use it with color problems. For example, you might have a scene with two different lights on it, and they are distracting. This might be an indoor scene with fluorescent lights in the center of the room and incandescent lights along the outer edges. The two colors do not look right together and cannot be adjusted in one pass through Camera Raw.

The answer is to do two passes. Process the image once the best you can and balance one color, ignoring the other. Then do the second processing to balance the other color. Now put the two images together just as you would do with exposure differences. This may take a little more work in painting in and out the different colors using a layer mask, but it works.

All of this is well and good if you have photographed a scene that fits within the dynamic range of the sensor. The world holds subjects that have tonal ranges from dark to white that go beyond what the sensor can handle. The human eye can see that range, but the sensor cannot. If you wanted to photograph that scene in the past, you had severe limitations as to what you could do:

> **You could have created an image that favored the highlights and let the shadows go to impenetrable black (see figure 13-48).**

> **You could have created an image that favored the shadows and let the highlights go to blinding white (see figure 13-49).**

> **You could have tried some dramatic filtration if the filters fit the scene.**

> **You could have tried a flash if the dark area was small enough.**

> **You could have said, "Just forget it," and moved on to more profitable images.**

13-48

13-49

With digital, you have another option. Take more than one exposure of the scene, one for the highlights and one for the shadows, for example, and then process them separately in Camera Raw to get the most from each. Bring the two images together in Photoshop for a new image that represents the original scene better

than any single shot ever could. In addition, you almost never have problems with noise because each shot is exposed to optimally capture highlights and shadows.

It is interesting that Photoshop CS2 introduced a new feature (continued in CS3), Merge to HDR (high dynamic range), which mathematically merges multiple exposures into one image with a huge dynamic range. This offers some new and interesting possibilities for the photographer, but it has a serious limitation. It merges everything into the whole image area. You have no ability to separately control how a dark area is processed compared to a bright area. The techniques described in this chapter give you more ability to make the photo communicate better as well as give you more creative capabilities. But HDR is still new and may prove to be very valuable as everyone learns more how to get the most from it.

TWO-SHOT PROCESSING

Two-shot processing is exactly that: You take two shots of a scene with two different exposures. Next, you process each separately to get the most from each file (see figures 13-50 and 13-51). Then you bring them together to merge the best of both (see figure 13-52).

13-51

13-52

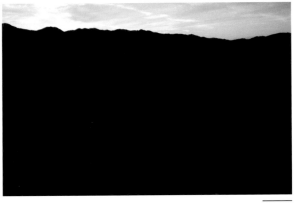

13-50

You can do this technique with multiple shots and bring them all together into one image, but most of the time, that is more an exercise in technique than any real benefit to the average photographer. I always try to balance workflow needs with technique. I am less interested in something that is going to take more time without a commensurate benefit.

Although I have done this without a tripod, it is much easier with a tripod. A solid tripod allows you to shoot two consecutive images without the camera moving in between shots. That results in two images that line up perfectly in the computer, or at least they line up with minimal work. The procedure is fairly simple:

Double Processing for Exposure

1. Lock down your camera on the correct composition.

2. Make one photograph that favors the highlights in exposure.

3. Make a second photograph that favors the dark parts of the exposure (or an important color or any other critical element of the image).

4. Use manual focus to be sure focus doesn't change between shots.

In the scene used in the next processing example, I came over some rocks near Point Dume in Malibu, California, to find this intense green algae on the big boulders at the ocean's edge (figure 13-53 is the final, processed shot). It really was intense and overpowered any other impression. But in looking at the scene, I knew there was no way that an optimum exposure for the green of the algae would also give me anything but overexposed junk in the bright water above it. I wanted both, as that seemed to make the scene complete. The only way to accomplish this was with the two-exposure technique.

13-53

PRO TIP

One way of doing this technique quickly and easily is to use the auto bracketing function of your camera. Set it to do an auto bracket of a full stop between shots. That way, you set the camera to continuous shooting, press the shutter release, and the camera automatically takes three exposures. There will then be two shots two f-stops apart; you can discard the middle exposure. If the scene needs a greater range, set the auto bracket for a greater difference. You may find you need to do some exposure compensation before auto bracketing, too. The advantage of using auto bracket is that you don't have to move anything on the camera between shots.

INTO CAMERA RAW

When you have two images of the same scene of different exposures (see figures 13-54 and 13-55), Camera Raw gives you the advantage of the best in processing so that you can really get the most from each exposure. I'll quickly go through this to optimize both images. The lighter image needs to be processed to get the most from the green rocks:

1. Ignore the overexposed water and sky at the top of the image to get a good highlight brightness in the green. It does not have to have any pure white, but Exposure is used to lift the brightest spots.

13-54

13-55

2. This is a bright, sunny day with dark shadows. The shadows can be made richer and blacker, which actually make the green show up more strongly (see figure 13-56).

3. The Tone Curve works well to give some definition and richness to the color (see figure 13-57).

4. There is no question that the color saturation needs to be kicked up. This color was really intense in real life. You have to be wary of using the Saturation slider on intense colors like this, however, because you can block up details if you move it too far to the right. I made no change there, but instead I used Vibrance for a nice increase in richness for the green, as shown in figure 13-58. I also increased Clarity, which makes the green detail look better.

R: ---
G: ---
B: ---

f/11 1/20 s
ISO 100 16-35@16 mm

Basic

White Balance: As Shot

Temperature 5900

Tint -3

Auto Default

Exposure 0.00

Recovery 0

Fill Light 0

Blacks 14

Brightness +50

Contrast +25

Clarity 0

Vibrance 0

13-56

R: ---
G: ---
B: ---

f/11 1/20 s
ISO 100 16-35@16 mm

Tone Curve

Parametric Point

Highlights -13

Lights +8

Darks +41

Shadows -14

13-57

PtDume 03-05-9328.CR2

R: ---
G: ---
B: ---

f/11 1/20 s
ISO 100 16-35@16 mm

Basic

White Balance: As Shot

Temperature 5900

Tint -3

Auto Default

Exposure 0.00

Recovery 0

Fill Light 0

Blacks 18

Brightness +50

Contrast +25

Clarity 30

Vibrance +33

Saturation 0

13-58

5. The image is very clean. There is no reason to do anything with noise reduction.

6. Open the processed image into Photoshop and save it.

This processed-light exposure really looks terrible in the water and sky areas, as shown in figure 13-59. Even if you tried, you would not be able to get good surf detail out of this RAW file.

13-59

But that is why I took a second exposure. Next, I adjusted the darker photo to favor the water and sky:

1. I like the effect of moving the Blacks slider to the right a bit to make the rocks dark and dramatic in the upper part of the photo (see figure 13-60).

2. I used a combination of Exposure and Recovery to deal with the white waves, toning them down (see figure 13-61). I did not want the bright water to overpower the green of the rocks in any way. A by-the-rules processing of this file makes the water too bright for the scene. When I was there, the green truly visually overpowered the water, so to make the water overpower the green would do a disservice to the real landscape.

3. The Tone Curve does a nice job with the water and sky. I used the parametric sliders to give a little contrast to the wave area and to open up some dark areas slightly, as shown in figure 13-62.

4. Adding some Vibrance boosts the color of the sky and the sand in the small beach area. I felt that gave some color richness that would balance the green rocks.

5. Because each exposure is shot to optimize a certain part of the scene, noise should always be minimal. No noise reduction was needed here.

6. Open the processed image into Photoshop and save it.

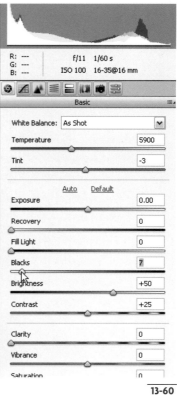

13-60

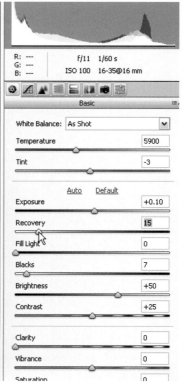

13-61

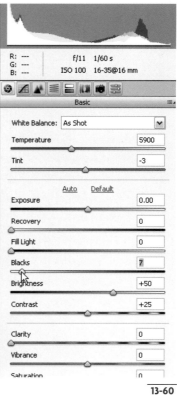

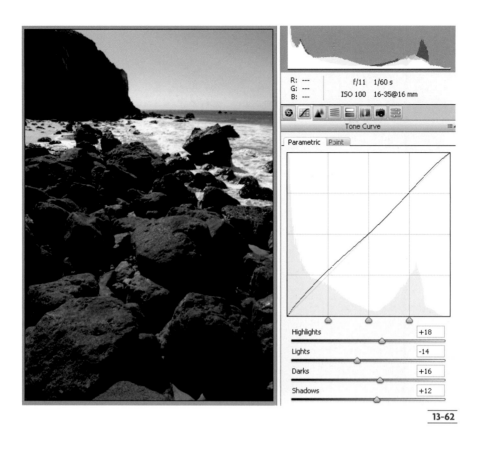

13-62

This processed dark exposure now looks terrible in the rock and algae areas, as shown in figure 13-63. Even if you tried, you would not be able to get the best green color out of this RAW file. If you have seen my first edition of *Adobe Camera Raw For Digital*

Photographers Only (Wiley, 2005), you may have noticed that I did not process this file exactly the same way in this updated book. That brings up a very good point — time, your own inclinations, and new software controls will affect how you make adjustments.

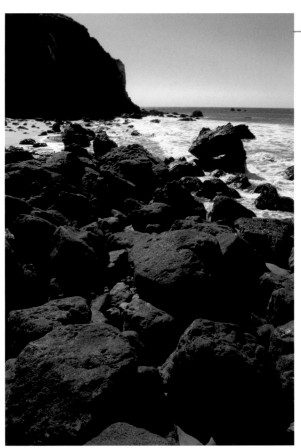

13-63

MAKING THE PHOTO WORK

The rest of the process is based on the same technique used in the combinations of two photos described earlier in this chapter. It is very important to note, however, that this is not an arbitrary, absolute process. It is totally flexible and should always be adapted to both the images you are working with and the interpretation of those images.

Any processing you do of a photo is always an interpretation of the original image. It can be an interpretation based on reality or something entirely different. Ansel Adams used to compare this to music. The negative was the score, the unrealized notations of sound, while the print was the performance of that score. This definitely applies to a RAW file; it can also be compared to the score, while the finished image coming from Camera Raw and Photoshop is the performance.

Here's how these two rocky shoreline images could be interpreted:

1. First, the images have to be put together. It seems appropriate to reveal the green into the darker image. This is done by dragging the brighter image onto the dark version, as shown in figure 13-64.

2. Add layer mask to the light layer, but use a black-filled mask to hide the layer's effects (choose Layer⇨Layer Mask⇨Hide All), as shown in figure 13-65.

13-64

PRO TIP

It might seem like a dark image should go on top (it would if you were only erasing parts of it to reveal the color underneath). But with the bright color as a layer on top, you can always reduce that layer in intensity by using the Opacity slider. You can then reveal a layer gradually by adding a layer mask filled with black and painting white to gradually show it.

13-65

3. Paint in the areas needed. Use a large, soft brush
to paint in white onto the layer mask. This gradu-
ally blends in the green from the top layer. You
can paint in whatever you want. I tried to be fairly
selective and limit my painting to the green parts
of the rocks, as seen in progress in figure 13-66.

13-66

4. Refine the layer mask. Change your brush size and go back and forth between white and black to refine what is seen and not seen in the top layer. This is where the interpretation of the scene gains strong importance. Work quickly; don't think too much about it, but enlarge the image as needed to deal with smaller details, as shown in figure

13-67. You can quickly change your brush back and forth from black to white by pressing X. You can also change the intensity of the painting by altering the opacity setting of the brush. For example, I found the green in the center of the rocks to be a bit bright, so I toned it down with a 10 percent setting of a black brush.

13-67

5. Check the overall relationship between the layers. In this case, I felt the green algae layer was a little out of balance compared to the darker, surf layer, so I brought down the opacity to 90 percent. Another possibility would be to put a Curves layer in between these layers to adjust the bottom layer without affecting the top.

6. Flatten, sharpen, and save. You can now merge the two layers, sharpen the photo, and save it. You may also want to save an unsharpened version that you can later resize as needed, then sharpen to that specific size.

This photo now looks like the green algae is spotlighted, as demonstrated by figure 13-68, but truly, this is exactly how it appeared to me. The water has excellent detail, as does the green algae on the rocks. The background cliff looked good to me dark, so I left it. However, it could have been lightened with the rocks by painting it in from the light layer.

I have to admit I exaggerated a bit in the first book saying, "There is no way that you can get the richness of color in the green as well as the dark, dramatic rocks and detailed surf by shooting only one exposure of this scene." That might be possible with really

careful technique and a lot of work in Photoshop. And that is exactly my point. I have no interest in doing lots of work in Photoshop if I can get a better image more simply. Shooting two exposures of the same scene offers the possibility of really showing off high-contrast scenes as they appear, where they're not reduced in intensity or lack increased grain and contrast due to the limitations of the medium.

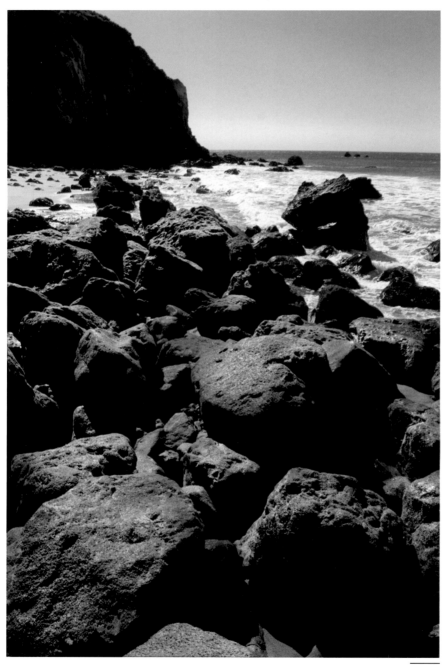

13-68

■ **What if the two image versions I process for the double-processing technique have some parts that aren't quite their best, even though most of the image works right?**

This can happen. Camera Raw can only deal with the overall image. Even when you are processing an image twice, you can find that such processing still doesn't make everything look right. You have a few choices:

> **Process the image again for a third version and combine that with the other two in Photoshop.**

> **Process only two versions, but keep both in 16-bit and do some selective tweaking of the layers in Photoshop.** This is easy to do by using an adjustment layer and a layer mask to control where the small adjustments occur.

> **Process only two versions, but use 8-bit and do some selective tweaking of the layers in Photoshop.** This offers a little less control, but 16-bit can have a memory penalty (it uses RAM in a hurry). For many images, 8-bit is fine, and still offers excellent control with an adjustment layer, but doesn't cause memory problems.

You mention processing the image for a third version. I believe that works for exposures, too, and you can get an even greater tonal range with three exposures. What do you have to watch out for when putting more layers together?

You are absolutely right: You can use three exposures of a scene — even more if you are so inclined to deal with very large brightness ranges. This is essentially what is automated in the new HDR tool, but that tool gives you none of the control that you have seen in this chapter.

You do put your three (or more) versions of your scene together into one image with layers (dragging and dropping just as with two images). Now it becomes a little like the 3-D chess they played on *Star Trek*: as you paint in and out one layer, and then another, they start interacting with each other. It can be done, but it can also be a lot of work.

It seems that as you adjust an image one way in Camera Raw to be used with another adjusted version of the same image, it would be good to see both. Can you do that?

At this time, not really. You can do a work-around with the two-exposure technique by bringing the two different exposures into Camera Raw at the same time, as I describe in group processing in Chapter 10. You can then click back and forth between them as they are adjusted. That will reveal the images in the Preview and show how they are different.

But you cannot do the same with double processing of the same image, though there is also a work-around, but it is a little awkward. It so happens that once you open Photoshop and go to Camera Raw, Photoshop sits in the background, unusable by you, but still there. If you process your first adjusted version and open it into Photoshop, it will also sit there. Now when you have Camera Raw opened, you can grab the top of its interface and move the whole thing, even until you reveal the first version now in Photoshop. This actually works quite well if you have two monitors. You can make needed comparisons, and then move the Camera Raw interface back into place so you can access all of its controls.

POST CAMERA RAW PROCESSING

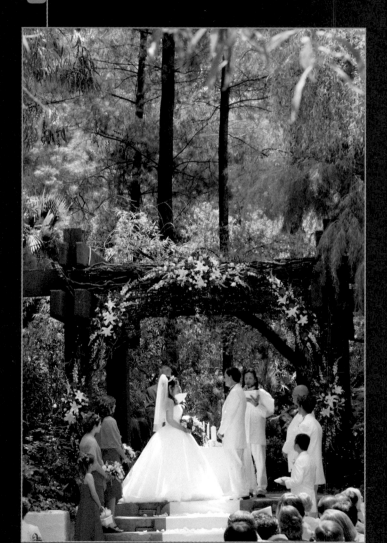

In past versions of Camera Raw, you were not done with the photo once you finished processing in Camera Raw. Camera Raw was a step on the route to a final image, though admittedly an important step. With the latest versions, you can actually complete an image with the program and save it without going to Photoshop. The additional controls, such as sharpening, the Retouch tool, individual color adjustment in HSL (Hue/Saturation/Luminance), and so on, make Camera Raw a very complete image-processing program.

Yet, there are some very good reasons to continue on with your processing in Photoshop. These include

> Camera Raw cannot selectively process areas of an image as you have seen throughout this book.

> Because you will always resize and sharpen an image for the best quality when the photo is needed for different purposes, you do this in Photoshop, not Camera Raw.

> Some things are better done in Photoshop (or even other programs), such as masking areas to adjust one part of an image without affecting another.

> Some of the strongest adjustments for tonal balancing, eye-control (how an image is adjusted to affect how a viewer sees it), composition enhancement, and more, are best done in Photoshop.

The image shown in figure 14-1 is processed overall in Camera Raw; figure 14-2 has been adjusted for specific or local areas in Photoshop.

14-1

14-2

You can find many excellent books on every nook and cranny of the inner workings of Photoshop, so this chapter on post Camera Raw processing is not meant to compete with any of them. But finishing a book on Camera Raw without a discussion of the interpretation of that file in Photoshop seems a serious omission. That is part of the process, especially for me, and to leave it out would leave the whole workflow discussion incomplete.

I have no intention of offering every possibility for post Camera Raw processing. I want to leave you with some ideas and ways of thinking about that stage of image work. I have found them very useful and helpful to me and offer them to you in the hope that you may also find them helpful and useful.

PRO TIP

Black-and-white darkroom books are good places to find ideas on how to work on photographs in Photoshop. Ignore the parts about chemicals and enlargers. Pay attention to the discussions about how to control and interpret the brightness and contrast of an image and the recommendations the author makes about dodging and burning (brightening and darkening local areas) to enhance the image.

ANSEL ADAMS AND IMAGE PROCESSING

I consider Ansel Adams and his classic books, *The Negative* and *The Print,* to be very important for the digital photographer. As a Camera Raw and Photoshop user, you are not going to need to read these books from cover to cover for great tips. Much of the books cover such things as darkroom chemicals and how to process film and prints differently — not much use for the digital darkroom.

However, what Adams offers is his analysis of his photographs — why he shot something a certain way, how he printed it in the darkroom, what was dodged,

what was burned, how he use contrast, and so on — are all things you can apply to the photograph in Camera Raw and Photoshop.

Adams, as you probably know, would spend days on a photograph in his darkroom getting it right. He used a lot of that time to experiment, process the prints, dry them, examine them carefully, then make changes, and start the process over. In Photoshop, you can do in minutes much of what would have taken him hours.

PRO TIP

A number of aspects of how Adams' work applies to Photoshop are covered in my book, *The Outdoor Photographer Landscape and Nature Photography with Photoshop CS2.*

His books bring up a very interesting approach to Photoshop, too, believe it or not. Consider that all that work in the darkroom was based on a very limited set of actions: Adams could make an image lighter or darker, give it more or less contrast, and then he could control local or limited parts of the image in those ways as well. Yet with that limited set of actions, Adams created wonderful images.

The point is that you don't have to know everything about Photoshop in order to use it well. Thinking about how to interpret your photo plus using a core set of tools to do that interpretation is far more important. It is the application of Photoshop tools rather than the number of tools you know that will make your image better. Knowing certain Photoshop tools can be useful when you have specific needs, and many of the tools make the work easier, but few photographers need to know everything about Photoshop in order to use it well.

What's a good image, anyway?

As you may guess from what I've said in earlier chapters, I am not one for absolute answers about photography. One thing I certainly don't believe is that a good image can be contained by arbitrary definitions. As soon as someone says a photo should be this or that, be wary — even if it comes from an author telling you about Camera Raw! Some of the interpretations you have seen in this book might indeed be interpreted differently by you and result in perfectly good images none the less. And if you compare some of the photos that I used in this updated book with those in my original book, you will see I have even interpreted some images differently because I've been working with new tools, and frankly, been in a different frame of mind that day.

One thing I will particularly warn you about is what I call the tyranny of matching the monitor. I have seen a lot of photographers work too hard to match what they saw on the monitor for a print, getting the print close to that representation, and then being very proud of how good that print was. There are several things wrong with that idea:

> **Monitor calibration (very important) is to make your image processing consistent and predictable, which will make your prints better, but is not designed to make them match the monitor.**

> **Monitors and prints have different color gamuts — one holds glowing colors, the other pigmented reflective colors.**

> **Monitors and prints are designed for entirely different viewing experiences.** So far, few people hang their computer monitors on the wall the way a print is hung!

> **People respond very differently to monitors and prints.**

> **A print should stand on its own.** No one is going to ask you to turn on your monitor to see if it matches it.

An image that looks good on the computer and is matched well in the print might not be the best print because of all of these reasons. The brilliant black-and-white photographer and master printer John Sexton once told me that one problem he saw with a lot of digital prints is that the photographer tried to do it all in one print and didn't make prints that could be evaluated as prints early enough in the process. He felt the printing process, even from a computer, demanded making prints, looking at them as prints, and then making changes to make them better prints, not simply getting the best image on the monitor and then making a print.

So what is a good print or image of any type? I believe a good image is a photograph that you like, does what you expect of it in terms of color and composition, communicates your intent, does not get in the way of why you took the photo, and has some impact on the viewer. A good photograph is not necessarily something that everyone likes as people don't always share the same taste. I can guarantee you that even though I like the spider photograph in Chapter 13, there are a lot of people who will never like it, no matter how much I work on it.

PRO TIP

Expect your evaluation of an image to evolve as you work it. For example, when you darken one part of the image, you may find a totally separate area changes in how it appears for color. Or as you deal with the balance of tonalities, you may discover the overall image starts looking too light or too dark and that has to be compensated for. In reading Ansel Adams's work, you can see that this is exactly how he worked, too, though he took a lot longer to do it because of chemical processing times.

Expressing what you want

Back to Ansel Adams for a moment. In his book, *The Print*, he says, "Exposure and development of the negative follow technical patterns selected to achieve

the qualities desired in the final print ..." — in other words, paying attention to exposure and key technical aspects of the image (such as blacks in the shadows and details in the highlights) comes first as you've seen throughout this book. He continues, "... and the print itself is somewhat of an interpretation, a performance of the photographic idea." In other words, you the photographer take that exposure and technique to create or "perform" an image that interprets or expresses something important to you. Figures 14-3, 14-4, and 14-5 show three different expressions of the same image, different versions that cannot be made from Camera Raw alone.

How do you evaluate an image for interpretation? That is certainly up to the individual, but here are some things to consider:

> **Balance.** How are tones balanced in the image? This was a basic consideration of the black-and-white darkroom worker. In the past, you would never see a composition that favored the subject graphically but emphasized something else based on tonalities. Yet, that is all too common, even among news photography that should balance tones so the news is communicated clearly.

> **Composition.** Can you adjust colors or tones to emphasize your composition?

> **Mood.** What kind of a mood do you think your scene expresses? Can you use darker or lighter tonalities to emphasize that?

> **Color interactions.** While it is true that you can totally change colors in Photoshop, for most photographers, that is an exercise, not something they really need. I am talking more about how the subject and scene colors react with each other. For example, for a sunset-lit scene, the shadows might be intensified in their blue component and the highlights in their yellow/red component so the scene's colors look richer. In another example, a brightly colored background might be desaturated slightly so that it doesn't compete with the subject.

14-3

14-4

14-5

> **Eye-control.** Adams talked a lot about this. Photographs are always visually flatter than the scene because they are two-dimensional compared to three-dimensional reality. This results in two things: The eye tends to go off the edges of the photo, and the eye wanders the imaged scene more than in real life. In the first case, the answer is the traditional darkening of the edges (especially brighter edges) of a black-and-white print (this can easily be applied to images in Photoshop). In the second, the answer is selective lightening and darkening of photo elements to better express the scene to the viewer.

INTERPRETING AN IMAGE

The photo shown in figure 14-6 is from some friends' beautiful outdoor wedding and is processed as far as possible in Camera Raw. You've seen all the steps throughout the book, so I won't show all that again as there is nothing unique about processing this particular image. As it stands, it looks good in figure 14-6, and it is perfectly usable in many applications. It has good tonalities from dark to light, and the color looks right. But now you'll see how this can be made a more expressive and richer image.

My process is simple in its use, but requires thought in its application to specific images. I use mainly adjustment layers to control specific tonalities and colors in the image, keeping each specific change to the image isolated to its own adjustment layer as demonstrated in figure 14-7. This allows a huge amount of control. Consider this: As one part of the photo is changed, that change often affects another part of the image, so to bring them back in balance, a compensating adjustment is needed. If that compensation is just a resetting of an adjustment layer, you have no image quality loss, and you can always go back to original pixels (adjustment layers do not change the original pixels).

Also, the process is always an evolving one because one change will affect another. As you work one part

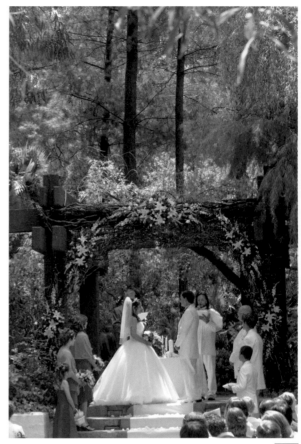

14-6

of an image, you might realize that another part needs some work, too. This does not have to be a chore. Adjustment layers with their layer masks and settable opacity levels let you do this very quickly. You can quickly control where the adjustment appears in the image by painting black or white in or out of the layer mask (as I demonstrate in Chapter 13). This is far, far faster and easier than using a selection tool to carefully isolate parts of a photo and adjusting each selection separately (whether on a layer or not). Selection tools can help in using layer masks, but whenever I can avoid using them, I do, because they can take so much time to deal with.

For the wedding image, I noted several things right away. The top of the photo is brighter than the bottom. While the white clothes of the wedding party

14-7

attract the eye, the composition is not served by that tonal difference. The eye definitely wants to wander up into the trees. Not a bad thing, necessarily, if you want a photo that emphasizes the setting over the wedding party, but I wanted to interpret this image so as to emphasize the wedding party as part of the setting.

Sometimes I add a Levels adjustment layer just to check to be sure where my blacks and whites appear in the photo. Checking black and white areas of a photo is part of the process of using Camera Raw, but once you go beyond that initial work, you may decide you want another interpretation of the photo's blacks, for example, when you see it open in Photoshop (that may seem odd, but the interfaces are very different and can influence how you see a photo). I didn't feel this was needed here.

This is how I proceeded:

1. Tone down the top. The first thing is to add a Brightness/Contrast layer (if you stopped reading in shock, check the previous Pro Tip), as shown in figure 14-8. The top of the image needs to be darkened, so you make a guess at how much to darken by moving the Brightness slider to the left (you can adjust this easily and quickly if your guess is wrong). The whole photo goes dark.

2. Next, the bottom of the photo needs to have that adjustment removed by use of the layer mask. The gradient tool is ideal for this. By having the tool go black to white (foreground/background colors), the cursor can be clicked at the top of the arbor and dragged up into the trees above. A longer drag blends the tones more and is often needed. This immediately helps balance the photo better (see figure 14-9).

14-8

14-9

3. Tone down bright areas. There are some bright areas that need additional toning down as they stand out too much from the first adjustment. These are in the top of the image, such as the backlit leaves above the arbor, but also include hot spots of brightness throughout the image. Again, a Brightness/Contrast layer is added and used to darken the image. The best way to deal with small areas of adjustment like this is to fill the layer mask with black (choose Edit⇨Fill⇨Black; this hides its effect) and then paint in the effect with white only where needed. I vary the Opacity of the brush to vary the strength of the effect. For example, the leaves above the arbor get 100 percent but the light area of trees a little above it gets a much reduced amount. The layer mask is really getting a workout and starts to look like a star field, as shown in figure 14-10.

4. Make readjustments. Being able to readjust on the fly makes this so much easier than the process Ansel Adams had to follow. He would make a change to his image during the exposure of the print, and then have to process the whole thing for many minutes to evaluate the results. You can make a change and instantly see the effect. The toning down of bright areas in Steps 1, 2, and 3 helped those areas and balanced the photo better. But it seems that the whole photo lost a little of its feeling of brightness. This is not something that is easy to predict when processing an image in Camera Raw. You have to see how the various changes interact with each other. So I added a Curves adjustment layer and opened up the image until it looked better, as shown in figure 14-11.

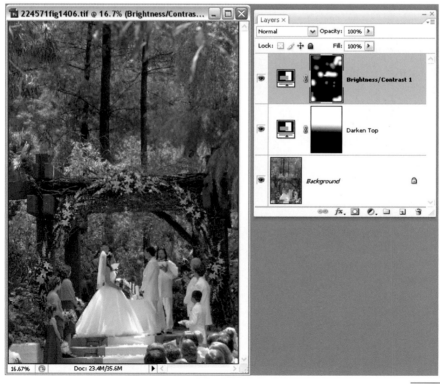

14-10

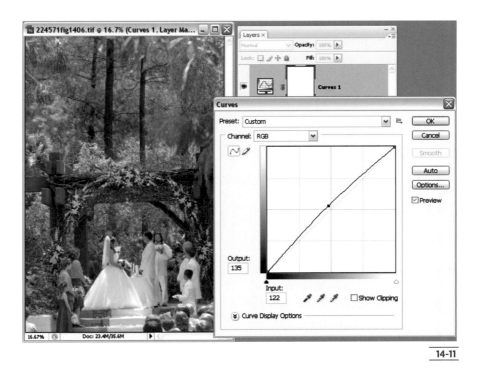

14-11

5. Brighten the arbor flowers. The arbor flowers are quite nice and deserve some more attention. First, I added a Curves adjustment layer to brighten the area. I find Curves works better for lightening an area because Brightness/Contrast-lightened areas often appear to have weak-looking contrast. The layer mask is filled with black and the effect painted in only where desired along the route of the flowers, shown in figure 14-12. You will need to constantly change the size of your brush as you do this type of work. I use the bracket keys to the right of the P on the keyboard. Press [to make the brush smaller; press] to make it bigger. In addition, it is helpful to go back and forth between white and black to paint affected areas in and out. Press X to change the foreground or background colors instantly.

6. I was still not completely satisfied with the flowers on the arbor. I felt the top blended too much with the background, so I decided a little traditional Ansel Adams-style burning in or darkening of the leaves above would help. In this case, I needed to drop the brightness without hurting the feeling of bright leaves. I added a Levels adjustment layer and clicked okay without changing anything. (I could have used any adjustment layer for this effect.) The mode for the layer is changed to Multiply, which darkens everything, so the layer mask is filled with black, and once again, the effect painted in with white over the leaves just above the top flowers, as shown in figure 14-13.

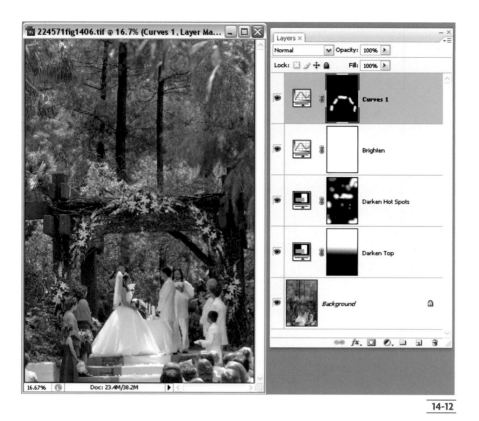

14-12

7. Readjust. At this point, the arbor below the flowers looks too light. Go back to the first darkening adjustment layer to paint in that darkness in the arbor so that it is balanced with the latest adjustments (see figure 14-14). You can see this way of working an image in Photoshop is a continual balancing process. It takes much longer to describe here than to actually do it. With a little practice, you will find this goes very fast.

8. Highlight the subject. Be sure the subject — the bride and groom — stand out from the crowd, so to speak. If the photo has been properly adjusted to this point, then lightening the subject is the wrong thing to do. To make the bride and groom stand out, other areas must be toned down, such as the bridal party around them. This time, I use a Curves adjustment layer rather than Brightness/Contrast. I

did this because I wanted more control. I wanted to be sure the colors of the bridesmaids' dresses did not get muddy, for example, which Brightness/Contrast can do. The layer mask is once again filled with black to turn off its effect, and then white painted in to add darkness only to those areas that need it (see figure 14-15). The brush is a large one (as shown by the circle) — a large, soft brush gives a nice blended edge to the brush strokes. You might ask why not go back to the first darkening Brightness/Contrast layer to do this darkening? My answer, as you may have guessed from most of this book, is control. I want to control these areas totally separately and be able to make adjustments to the layer independent of any other layer, as well as be able to use exactly the right type of layer for each adjustment.

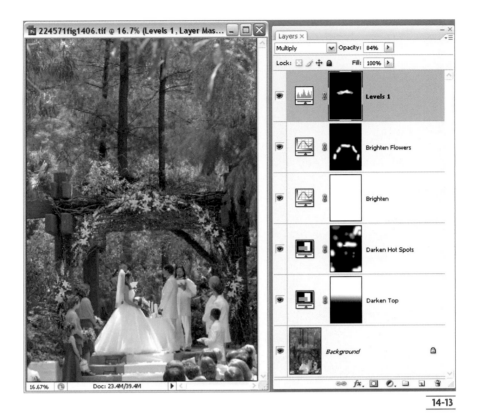

14-13

14-14

14-15

9. Darken the bottom corners of the photo, which are still a little bright; they are important to the composition because they show there were people at this wedding. Again, the Brightness/Contrast adjustment layer comes out for a little darkening work. This time, I moved the Brightness slider to the left to darken the photo as well as the Contrast slider to the left to lower the contrast (darkening an area and reducing its contrast is a common painter's technique to reduce emphasis on an area). The astute Photoshop user will note that something similar to this is also possible with Curves, but the amount of work needed for the same effect is increased, and I am never in favor of more work for the same results.

Once again, the layer mask is filled with black and the darkened corners painted in with white (see figure 14-16).

10. Brighten the faces. Overall, the image has come much closer to the photograph I saw when I made it. However, in looking closely, I noticed the bride, groom, and the man speaking had darker faces than needed. There are a lot of ways to fix that. Selecting the faces, however, is not a workflow I would recommend. Using a layer of gray set to overlay and painting dark or light to dodge and burn is an option, but it is too heavy-handed for good face tones in this photo, in my opinion. So I went with a Curves adjustment layer. I found the actual point on the curve where the faces were



14-16

by pressing and holding Ctrl/⌘ and clicking on the face, as shown in figure 14-17. This sets a control point on the curve that corresponds exactly to that point. I lifted that point to brighten the faces and brought down the lower part of the curve to keep contrast strong. The whole photo looks ugly with that adjustment, but a quick fill of black turns it off, and then a small white paintbrush brings it in on the faces, as shown in figure 14-18. The cool thing about this technique is that you don't need to spend a lot of time outlining the faces as long as the brush is soft. You just paint, and if it is off a little, change the brush to black, reduce its size, and fix it.

Compare the photos now as before, figure 14-19, and after, figure 14-20, and you see a distinctive change in emphasis. Nothing has changed in the original scene. No truths were manipulated, no falsities added. In fact, I would argue that the image is now truer to the original scene as perceived by the participants as the final shot truly gives emphasis within the frame to how one would really view such a scene. Notice how the eye goes quickly to the bride and groom in that shot compared to the before image. The camera's interpretation is a rather artificial and flat version that is its own way of capturing the world, but not necessarily more real than what we see.

14-17

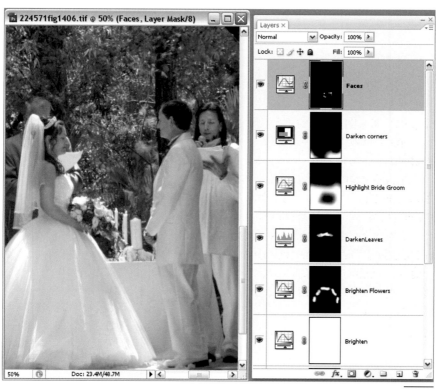

14-18

14-19

14-20

SHARPENING

Again, this book is not a complete guide to Photoshop, but because I did not use the sharpening in Camera Raw for this photo (it needed so many adjustments in Photoshop), I need to at least wrap up the sharpening discussion here so the process is complete. If you want a more detailed discussion of sharpening, you can find that in most Photoshop books. The bottom line is that you need to do some sharpening of your digital images, whether that is in Camera Raw or Photoshop. You may already know this, but because it is still a big misconception by many photographers, sharpening the processed photo is not about making an unsharp photo sharp but only about bringing out the inherent sharpness of the original image as captured by your camera and

lens. The name of the key sharpening tool, Unsharp Mask, confuses the issue (although the name actually comes from a true process for sharpening that was commonly used by the printing industry).

There are two key parts to sharpening:

> **Size your image to its usage (see figure 14-21).**

> **Use Unsharp Mask as your sharpening tool (see figure 14-22).**

Unsharp Mask has three controls for sharpening: Amount, Radius, and Threshold. There are a huge range of ways that photographers use these controls, and some folks are quite passionate about a particular recipe. However, what works great for one photographer's work, may or may not work equally well for yours. I will give you some numbers that work for me, and you can try them to see how they perform for your images.

Unsharp Mask looks for contrasting edges in an image and adjusts them to increase the appearance of sharpness. Amount is the intensity of the sharpening

on that edge; Radius is how far Photoshop will look for edge differences; and Threshold tells Photoshop at what point to start changing those edges. Any recipe for these controls is always based on numbers for all three because you can't adjust one without affecting the others.

I tend to prefer an Amount typically between 130 and 180 percent depending on the detail in the image (which is also affected by the size of the photo — small photos will get even less). Except for very small photos, I usually choose a Radius between 1 and 2 pixels. Radius is strongly affected by the file size of the image. For file sizes (opened in Photoshop; the flattened size, not the layer size) of approximately 10 to 20 megabytes, I commonly use something between 1 and 1.5 pixels. For larger files, I will go up to 2, but rarely higher.

14-21

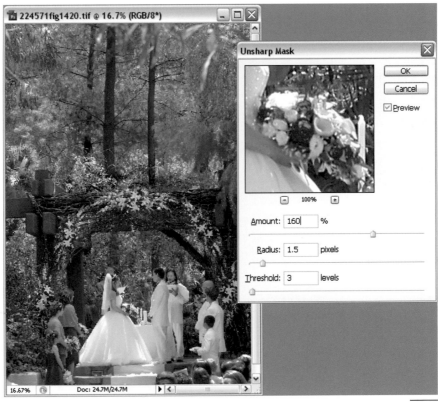

14-22

You can consider the Threshold the noise-sharpening control. With more noise, more Threshold is needed, up to about 10 to 12 (more than that and you will have some real sharpening challenges). As Threshold increases, you will usually need to increase the Amount, too. For most digital camera shots with low noise, I typically choose a Threshold between 0 and 3. The best way to see this is to click your cursor on an area without much detail, such as the sky, and see what noise shows up in the Unsharp Mask preview image. With moderate noise, a Threshold from 4 to 6 or so often works. For high noise, you may need to go as high as 12. If that is still a problem, then you may want to consider some noise-reduction software.

One easy way of getting great sharpening results without having to deal with all of these choices is to use the plug-in from Nik Software called Nik Sharpener Pro (see figure 14-23). This is a very intuitive sharpening tool that allows you to choose how large the image will be, how it will be used, on what type of paper, and so forth, as well as how strong you like to sharpen. In the latest version, it even lets you control how sharpening affects different tones and colors in the image, which can be a great benefit for dealing with noise.

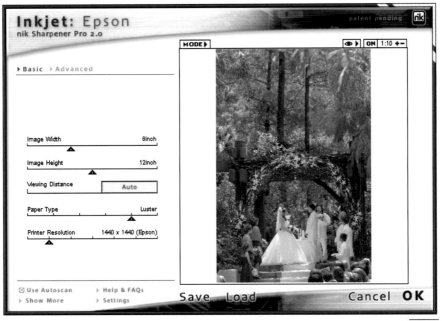

14-23

■ **I like lighter images, it seems, more so than many people. What if I always process an image to make it lighter? What problems will I have?**

Photography is such a great way to express how you relate to the world, which includes how you relate to photos. There is no arbitrary rule that photos have to be processed a certain way. It is true that some types of processing will affect an image in such a way as to change its meaning or how it might be used, but if it works for you, go for it.

The one thing I would recommend, however, is that you do these adjustments to layers and save an image as a layered Photoshop file (.psd) for a master file that you can always go back to. This way if you decide your lighter interpretation of the image is not exactly as you want, you can easily reopen that master file and readjust it.

Some photographers use the original RAW file as this master. I think the original RAW file should be kept as the ultimate, revisable original, but I like to keep the Photoshop file with layers that represent my last interpretation of the image as a master. That is a lot easier and faster to open and just tweak an adjustment layer for a specific purpose.

I notice that Photoshop has a Smart Sharpen tool. Why don't you use that instead of Unsharp Mask?

I could, I suppose, say you can't teach old dogs new tricks, and once you learn Unsharp Mask, you never want to go back, but that wouldn't be true. I was really rooting for Smart Sharpen when I first saw it, and it may eventually prove very useful to the photographer. This tool does an excellent job of sharpening. It does some very nice things to edges without causing sharpening halos as easily as Unsharp Mask and makes images gain more sharpness quite easily.

I would love it except for one thing: The engineers left off the Threshold control. Smart Sharpen sharpens noise too much for my taste. Because of that, I don't find it as useful for sharpening digital camera images as I do Unsharp Mask. The Threshold control, in my experience, is a key control in affecting how noise appears in the image. That said, if you have little problem with noise in a given image, or with one of the latest digital SLRs, you may find Smart Sharpen is a better tool for you.

What if I sharpened the image in Camera Raw? Do I still use Unsharp Mask in Photoshop?

In most cases, if you do any sharpening early in the process, whether it is in Camera Raw or in the camera, you will do less or no sharpening in Photoshop with Unsharp Mask. This is dependent on how much sharpening was done before. The more sharpening you do early, the less likely you will want to sharpen later. While how much sharpening you need and like is definitely a very personal thing, sharpening on top of sharpening can cause problems with image artifacts such as noise and edge haloing.

Most non-pro digital cameras, both SLR and non-SLR, tend to apply some sharpening to the image by default that shows up in JPEG files (many cameras will allow you to turn that off or down). That sharpening is not applied to RAW files, although it may be applied by the camera manufacturer's RAW processing software (you can turn it off if it does). This is a real advantage to shooting RAW because you can always control when and how you sharpen an image.

ALTERNATIVES TO CAMERA RAW

Adobe Camera Raw is a popular and convenient way of converting and processing RAW files because of its connection to Photoshop. Most other RAW conversions and adjustments must be made in separate, stand-alone programs whose interfaces are not the same as Photoshop. Although many features are similar, there is not that congruence of programs.

There are certain purposes, however, when other methods of converting and processing RAW files can be very useful. It is worth knowing a little about them. While I have seen all of the programs described next demonstrated and I have had hands-on experience with many, I simply don't use all of the cameras that would be needed in order to use all of these programs. Most are specific to one camera manufacturer; if you don't use a camera from that company, you cannot use a program specific to it. This group does not include every little program that can convert a RAW file, but all of those listed are available in both Windows and Mac versions and include the major programs available today.

I have spoken to all of the manufacturers so that I can fairly report on all of them. Obviously, I can't give you in-depth instruction on each program, but then, that's not the purpose of this book. However, because you may have use for some of the unique characteristics of these RAW programs, it is worth presenting an overview of them.

WHY USE OTHER PROGRAMS?

Why would you even consider using another RAW conversion and adjustment program if Camera Raw does such a good job? It is entirely possible that you never will need to consider any other program than Camera Raw, but here are some reasons why you might:

> **Image quality.** The engineers at Adobe do a great job of putting together algorithms to get the most from a RAW file in Camera Raw. Yet, it is true that

the very, very best in quality comes from the manufacturer's own RAW program (though it's not necessarily the best in software interfaces — Japanese camera companies, for example, are not known for software design expertise). This makes sense because the manufacturer built the RAW file in the first place, so whose software should be better able to process it? The difference, however, is generally not great and requires a lot of file magnification to see it. Is it worth it? This is really up to you.

> **Color.** Camera Raw does a great job of building a color image from the RAW file data, but it is still Adobe's interpretation of what the color palette of the image should be. There is no such thing as color management when you're looking at translating a RAW file into a color file simply because the manufacturer has its own proprietary standards. Some photographers like the color better that results from the manufacturer's RAW converter or an independent converter.

> **More controls.** Camera Raw has a fairly simple interface. While I appreciate this simplicity, there are some photographers who want more controls than Camera Raw offers. There are even some color controls that offer more possibilities, in a more intuitive interface, than Camera Raw.

> **Unique features.** Almost all manufacturers build certain information into the metadata of the RAW file that tells their converter how to deal with that file, information that Camera Raw has to interpret in its own way (and sometimes can't even read). This may be as simple as certain white-balance information to as complex as unique tone curve interpretations built into the camera. In fact, at one time Nikon encrypted the white-balance information in their RAW files, which meant that Camera Raw could only do an approximation of the white balance set by the camera (auto or preset).

> **More and easier batch processing capabilities.**
> Many RAW converters allow you to do batch processing more completely and more easily than you can in Camera Raw.

This appendix summarizes the key features of the main RAW converters on the market at the time the book was written. Each has its advantages and every one has its champions. They all include basic functions such as exposure and color adjustments, as well as browser capabilities. This appendix starts with the camera manufacturers' RAW programs, in alphabetical order, and then goes to the independent software, also in alphabetical order.

ADOBE PHOTOSHOP LIGHTROOM OR APPLE APERTURE VERSUS CAMERA RAW

Okay, so Aperture and Lightroom are not pure RAW converters. But they are very important RAW programs. Camera Raw and Lightroom have some things in common in that they share the basic RAW conversion engine and many of the controls. Lightroom and Aperture, however, are totally new programs, designed from the ground up for photographers.

> **NOTE**
>
> For more on Lightroom, you can check out my book, *Adobe Photoshop Lightroom for Digital Photographers Only*, also from Wiley.

LIGHTROOM

Lightroom is Adobe's first program designed specifically for photographers from the beginning. While originally made to make an efficient RAW workflow, Lightroom now lets you work on lots of images in JPEG, TIFF, PSD, and of course, RAW, quickly and efficiently. It has a totally different interface than either Photoshop or Elements, but the layout is very simple and easy to understand. It is based on modules that

hold the processing tools for a specific type of work: Library, Develop, Slideshow, Print, and Web. The Library module s a very powerful photo-organizing and editing tool. With it, you can quickly sort, keyword, add metadata, remove photos, and so on. The Develop module is like a more powerful Camera Raw. It even includes a magic button that turns your cursor into an adjustment tool for tonalities and colors — you simply click on the photo, on the tone or color you want to adjust, and drag to make the adjustment. Lightroom finds the right tone or color to change for you. This makes some adjustments happen very fast. Slideshow is limited to presentation sort of shows because audio cannot be exported with them. Print puts all the printing controls in one place, and Web makes it very easy for photographers to do Web galleries. It is moderately priced, though of course compared to Camera Raw, it is quite a bit more expensive as Camera Raw comes with Photoshop for free.

APERTURE

Aperture is Apple's first program geared directly toward photographers. The Mac has been popular among professional photographers for a long time, so Aperture is designed to help them better work with photos on the computer — on a Mac, of course! (Aperture is only available for Mac, and it works best on a Mac-Intel system with a speedy processor and at least 2 GB of RAM.) While similar in many ways to Lightroom, Aperture definitely has a different, very Apple-like personality. It is optimized to handle RAW files as easily as JPEGs, but it work with JPEGs and TIFFs as well. Like Lightroom, Aperture was designed to work with a lot of images typical of a pro or advanced amateur's work and includes some very powerful photo management tools. One really amazing feature is a virtual light table. With it, you can sort images into piles just as if you were working with real slides, and these piles automatically form groups for the photos. When you want to compare images, the loupe feature makes it very easy to quickly examine many images, efficiently making informed decisions

about their quality. The program is a full-featured RAW processing program, too, though I don't find it as strong as either Camera Raw or Lightroom. Aperture also includes some very good output options, including slideshows, Web galleries, photo books, and more. It is priced the same as Lightroom.

CAMERA-SPECIFIC RAW CONVERTERS

Camera-specific RAW converters include the programs that come from the camera manufacturers that are made to work with their cameras' RAW files and only those RAW files. Some manufacturers have more than one program, a simple one that does basic conversion plus a more complex program that includes many of the controls in Camera Raw.

CANON ZOOMBROWSER EX AND DIGITAL PHOTO PROFESSIONAL

Canon upgraded its RAW file format and came out with a new RAW software program when it introduced its Mark II series of cameras. Frankly, it really needed to do that. Even Canon admitted its EOS File Utility program left a lot to be desired (for a time this was the only Canon software that opened and converted Canon RAW files). Digital Photo Professional (DPP) was developed to bring Canon RAW file processing up to speed with the rest of the digital world and was introduced with the EOS-1D Mark II camera.

Today, Canon includes basic RAW conversion features in its ZoomBrowser EX as well as the advanced controls in DPP. While ZoomBrowser EX is a good browser program for RAW and JPEG files and offers RAW conversion capabilities that use Canon's own proprietary algorithms, in reality, that is about it. The program acts like simple point-and-shoot camera software with very little control. For serious processing of RAW files, it really doesn't offer the photographer a lot.

With Canon's .CR2 RAW files and DPP, you have a full range of RAW adjustments. DPP was developed totally in response to photographers who wanted a better RAW processor from the manufacturer. It was

built totally from scratch and even allows processing of JPEG files.

DPP is designed for more speed, and has traditionally been faster than Camera Raw, though I am not sure the difference is really significant anymore. The program is designed for the pro and its interface shows that. It includes a whole range of valuable controls, including tone curves, exposure compensation, white balance, dynamic range, brightness, contrast, color saturation, ICC Profile embedding, and more. The program can even save adjustments to a file (like Camera Raw) that can then be loaded and applied to other RAW files. DPP also has a great feature that Adobe should consider using: a comparison mode that allows original and edited images to be seen side by side or in a split image (this is, is fact, actually now available in Lightroom).

Another feature that I like is the very intuitive and flexible color wheel for color balance adjustments. DPP also offers a cropping tool (as Camera Raw does), CMYK printer simulation (which very few other programs of this type do), batch conversion, and much more. Its batch conversion allows continuous work on images while other files are rendered and saved in the background, similar to Camera Raw.

NIKON CAPTURE

Nikon Capture is a well-thought-out RAW conversion program that offers added benefits to Nikon users and the NEF file, Nikon's type of RAW file. However, Capture NX goes further and incorporates a unique technology from Nik Software called U-Point that changes the way you adjust an image. (You can even use it with JPEG files from other manufacturer's cameras.) With NX, you set control points on the image and adjust specific tones and colors, which are then restrained to just the areas where you want the adjustment.

Capture was developed from the start to help pros make the most of a RAW file's capabilities and has continually evolved over the many years it has been

on the market. Nikon has managed to keep Capture current with all versions of NEF files, and even offers a plug-in for Photoshop to make Capture more convenient, because it loads directly into Photoshop. For a long time, however, Capture had a reputation of being very slow, especially with Mac computers, but that is past history now.

Like most RAW converters, Capture lets you crop the image, adjust its size and resolution, change exposure and color, and batch process. It offers a different interpretation of colors than Camera Raw, but both are certainly good. It includes a Histogram tool that allows you to click on an image and capture that point's brightness value on the histogram display for further adjustment. Other unique features include the Noise Reduction filter that works well on images shot with higher ISO settings, image straightening (to adjust for a crooked horizon), the highly distinctive D-Lighting feature (a semi-automated way of getting more from poorly exposed images), an LCH (luminance/chroma/hue) editor (including curves for luminance and chroma), a Color Booster palette, and Image Dust Off (to remove problems from sensor dust). In addition, Capture allows you to add Nik Color Efex filters for even more control at the RAW stage.

Nikon makes a big deal about its NEF files being able to store several things: the RAW data, a thumbnail version of the photo, and an Instruction Set. That really isn't that different than most modern RAW files, but according to Nikon, its Instruction Set has more information and is more easily used for better workflow than competitors. Capture does have an excellent feature set to access NEF file capabilities. You can also save multiple Instruction Sets and apply them to more than one file.

Olympus Studio

Olympus Studio is multipurpose, digital processing software that can be used for managing and viewing Olympus digital images as well as high-speed processing of Olympus RAW files. It also includes the ability to remotely control Olympus E-series digital

SLRs. It includes some standard browsing features, but adds a unique Light Box Mode. This provides some interesting capabilities for working with multiple images, including a two or four group of magnified photos for comparison and a Collection Area to make sorting of images easier.

The RAW conversion part of Studio includes the adjustment of exposure compensation (+/- 2 stops in increments of 0.1 steps), overall white-balance control, white-balance fine adjustments in up to +/- 10 steps (including gray point selection), +/- five steps of contrast adjustment, +/- five steps of sharpness adjustment, five steps of saturation change, a very interesting memory color emphasis selection (lets you choose presets such as red emphasis or body warmth emphasis), ten steps of false color suppression control (makes better color interpretations from a RAW file), and ten steps of noise reduction. Batch processing is possible.

Pentax Photo Browser/Laboratory

Pentax offers its browser and RAW converter in two different programs, Photo Browser and Laboratory. Photo Laboratory is a standard sort of RAW converter designed specifically for the Pentax RAW files. It includes multiple white-balance controls as well as simple contrast and tonal range adjustments. There doesn't seem to be anything particularly unusual about it except that it is optimized for the Pentax files.

Sigma Photo Pro

Sigma's digital cameras originally offered an unusual approach to digital photo files. You could only shoot RAW files. At first, the software was the only software that even recognized, let alone processed, the files. That is not true today, as programs like Camera Raw recognize the Sigma files and Sigma cameras use JPEG, too. Sigma's foray into the digital SLR world is quite unique in that it is the only company to use the once-hyped Foveon sensor. This sensor promised improved color rendition but never

really proved to be any better than the advanced sensors all the other camera companies used.

Photo Pro works in several ways to adjust white balance, exposure, color, and contrast. The X3F mode uses auto settings and manual adjustments to convert RAW data much like Camera Raw does. X3 Fill Light is an alternate mode that increases the dark values of images with high contrast or for backlit photos. The underexposed areas of the photo are increased in brightness without changing the highlights. In addition, the processing can be reversed, in a sense, allowing you to bring out highlight detail without changing dark areas.

SONY RAW SOFTWARE

I have not used Sony's RAW conversion software. However, the Sony Alpha digital single lens reflex (SLR) cameras are based on the Konica Minolta Maxxum digital SLRs (which are no longer being made). Konica Minolta introduced RAW software called DiMAGE Master for image management and RAW file conversion. Their engineers developed something called their 3D Lookup Table for RAW processing that they claim provides more accurate color reproduction. There is likely some truth in that as typically the camera manufacturers can do excellent color translation with their own RAW files. As I understand it, Sony has done something similar with their software.

INDEPENDENT RAW CONVERTERS

Independent manufacturers have developed their own unique algorithms for converting RAW files. They also include some unique features not found in other software, plus they can be used for all RAW files from all cameras, just as in Camera Raw.

DxO RAW ENGINE

DxO Labs is a unique company that offers software unlike anything else on the market. It doesn't simply offer programs for converting RAW or adjusting digital files: It goes in and analyzes specific cameras and lenses, and then creates software that compensates for the weaknesses and limitations of those exact products, such as lens distortions (from astigmatism to barrel distortion to chromatic aberrations to vignetting) and image noise, all at the pixel level. The software won't work if you try to use it for lenses or cameras that aren't included; it is that specific in its correction of lens and camera problems.

DxO Optics Pro is the main software. Because it is based specifically on defined and recognized issues in image files, it is not adjustable; you just tell it which photos to work on and it just works. The company now includes its proprietary RAW converter, DxO RAW Engine, with Optics Pro. Based on its specialized research on specific cameras and lenses, the company developed RAW Engine with unique algorithms that it claims does a better job of putting together the RAW pixels for images that are sharper and more detailed. It also says its software creates images with less ghosting, false colors, or misaligned pixels. You might consider that the standard hype of software companies, but I have used DxO Optics Pro and found it quite remarkable in its capabilities. I have also met and talked with the key engineering types who run DxO labs, and to them, they can demonstrate very credible support for all of their claims. DxO RAW Engine includes all of the standard RAW conversion adjustments.

PHASE ONE CAPTURE ONE

Capture One was one of the first of the independent RAW converters and has been among the leading and most respected of the independents since it first came on the market. Phase One is a company that started with the sole purpose of marketing high-end digital imaging products, so no one thought it unusual that it would come out with RAW software geared to the professional. Right from the start, Capture One software has offered high image quality and speed. Speed has not always been a key part of other RAW conversion programs, including Phase One's.

Capture One comes in several versions, all of which are designed to meet the workflow needs of the professional; they include little touches like automatically optimizing the interface for horizontal and vertical images.

The software includes a useful browser function and keeps all of its adjustments on tabs like Camera Raw does. It includes, as they say, a full range of advanced features, including full color management, multiple tone response curves, unlimited batch capabilities, and a useful multiple output feature to allow you to immediately get multiple files from a single conversion. It also includes camera profiles, plus the ability to edit those profiles; a color editor; and IPTC (metadata captioning) support.

PHOTOSHOP ELEMENTS

Photoshop Elements is a popular sibling of the free version of Photoshop. It is not a dumbed-down or excerpted version of Photoshop like the old Photoshop LE was. (Photoshop LE was never a very good alternative to Photoshop.) This program is specifically designed to enhance the average photographer's digital processing of photographs while using some of the core elements of Photoshop's processing engine. There are actually some very useful features in Photoshop Elements that are not included in Photoshop, such as the Selection Brush (you can do something similar in Photoshop, but there is no specific tool like this one).

Before Photoshop Elements 3.0, RAW files could not be processed in this program. You would have to use the camera manufacturer's RAW converter or an independent program, and then reopen the files into Elements. With Photoshop Elements 3.0, 4.0, 5.0, and 6.0, Adobe includes RAW conversion capabilities based on Camera Raw.

When you open a RAW file into Photoshop Elements now, you see an interface that looks much like Camera Raw. For all practical purposes, it is simply a variant of Camera Raw. Each version adds some controls, almost giving you the last major version of Camera Raw. Many of the key controls I discuss in this book are there. Some of the advanced capabilities are not here, however: there is no tone curve, you can't do batch processing, you can't select an image size, and you can't affect colors individually. The interface is definitely simpler and does not include multiple tabs for different adjustments. Still, with core RAW adjustments, you can do much of what I describe in this book. It certainly does bring RAW capabilities to more casual photographers.

PIXMANTEC RAWSHOOTER

Pixmantec RawShooter was purchased by Adobe. The Vibrance control in Camera Raw and Photoshop Lightroom comes from RawShooter. Adobe says they will be using more of the RAW processing algorithms in RawShooter in future versions of their software.

PRO GLOSSARY

Adobe RGB (1998) A working color space based on the standard computer RGB colors created by Adobe Systems. It includes a wide gamut of colors that makes it a very flexible color space for using in Photoshop. Often just called Adobe RGB.

algorithm The computations, formulas, and procedures used in digital devices and programs to process data.

anti-aliasing Using software to soften and blend rough edges (called aliased).

archival storage External non-magnetic media, such as CDs, for storing information long-term.

artifact Defects in an image or other recorded data created by the tool used to record or output; something in an image that did not exist in the original scene but was inadvertently added to the photo by the technology.

batch processing A way of making one or more changes, such as new file type or image size, to a group or "batch" of image files all at once.

bit The smallest unit of data in a computer.

bit-depth Refers to the number of bits required to represent the color in a pixel. With more bit-depth, more colors are available. This increases exponentially. True photo color starts at 8-bit. Most cameras capture RAW files at 12-bit, though some do 14-bit; a few, very high-end pro cameras capture at 16-bit.

Blacks A control in the Basic adjustment panel that used to be called Shadows. It is called Blacks, even though there technically is only one black in a photo, because it affects the multiple areas of black throughout a photo.

browser 1) A program that's used for examining sites on the World Wide Web; 2) A software program designed to show small, thumbnail images of digital files.

CCD (charge-coupled device) A common type of image sensor used in digital cameras. The CCD actually only sees black-and-white images and must have red, green, and blue filters built into it in order to capture color.

CD-ROM (CD-Read-Only Memory) A compact disc that contains information that can only be read, not updated or recorded over.

chip A common term for a computer-integrated circuit; the "brains" of a computer.

chroma Noise in a digital image that has a strong color component to it; commonly found in dark areas in long exposures. See also *color noise*.

clarity A control in the Basic adjustment panel that intensifies the midtones in an image.

CMOS (complementary metal oxide semiconductor) A chip used as a sensor in digital cameras. CMOS sensors use less energy than CCD chips.

CMYK (cyan, magenta, yellow, black) These are the subtractive primary colors and the basis for the CMYK color space. They're used in so-called four-color printing processes used in books and magazines because they produce the most photo-like look for publications.

color noise Noise in a digital image that has a strong color component to it; commonly found in dark areas in long exposures. See also *chroma*.

color space Colors in the computer are described by a set of numbers and these numbers can be interpreted differently by different devices. Models of color are based on a range of color that can be described by a particular digital device. This is its color space. There are many color spaces, though the two main ones used for photography are RGB and CMYK. Within those spaces are subsets of spaces such as Adobe RGB 1998 (larger) and sRGB (smaller). See also *RGB*, *CMYK*, *Adobe RGB 1998*, and *sRGB*.

continuous tone The appearance of smooth color or black-and-white gradations as in a photograph.

copyright A legal term that denotes rights of ownership and, thus, control over usage of written or other creative material. Unless otherwise noted, assume all images are copyrighted and can't be used by anyone without permission of the photographer.

data compression The use of algorithms to reduce the amount of data needed to reconstruct a file.

DNG files A type of RAW file developed by Adobe; this was meant to become a standard for a universal RAW format, but camera manufacturers have largely ignored it.

dpi (dots per inch) Resolution of a peripheral as a measurement of the number of horizontal or vertical dots it's able to resolve in input or output. This is confusing because dpi for a scanner is the same as ppi of an image, yet both are different than the dpi of a printer. Dpi for a printer refers to the way ink droplets are laid down on paper.

dye-sublimation Printing technology that results in continuous-tone images by passing gaseous color dyes through a semipermeable membrane on the media surface.

dynamic range The difference between the highest and the lowest values, as in the brightest highlights and the darkest shadows in an image.

EVF Electronic viewfinder.

exposure 1) The combination of shutter speed and f-stop used in a camera to control the light hitting the sensor or film; 2) a specific control in Camera Raw that affects highlights.

file format How the data that makes up an image is defined and organized for storage on a disk or other media. Standard image formats include JPEG, RAW and TIFF. Format also refers to how a memory card, hard drive or other memory device is cleared of data. Format in that sense doesn't actually remove the data,

but instead removes the references or addresses of the data so the camera or computer sees the memory space as vacant.

fill light A control in the Basic adjustment panel that brightens very dark tones in an image.

FireWire A very fast connection (meaning lots of data transmitted quickly) for linking peripherals to the computer; also called IEEE 1394 and i.Link. The fastest version is FireWire 800.

graphics tablet and pen A way of controlling your cursor's movement and actions by using an electronic tablet that senses where its graphic pen is moving; an alternative to the mouse.

gray scale (or grayscale) A black-and-white image composed of a range of gray levels from black to white.

halos White or black artificial borders at distinct edges in a photo; they are important to sharpening, but become too obvious when a photo has been over-sharpened.

histogram An important tool for adjusting a photo that is a graph of pixels at different brightness levels in the photo, with black represented at the left, white at the right, and gray in between.

hue The actual color of a color.

inkjet A digital printing technology where tiny droplets of ink are placed on the paper to form characters or images.

interpolation A way of increasing the apparent resolution of an image by increasing the number of pixels in an image by filling in the gaps between the original pixels.

JPEG (Joint Photographic Experts Group) A file format that smartly compresses image information to create smaller files; the files are reconstructed later. JPEG files do lose quality as compression increases. See also *lossy compression*.

JPEG artifacts Image defects due to file size compression that look like tiny rectangles or squarish grain.

LCD (liquid crystal display) A display technology used for small monitors that acts as a viewfinder and playback display for digital cameras.

lens aberration A defect in the optical path of a lens that creates optical artifacts, such as color fringing, that can affect color and sharpness of a lens.

lossless compression Any form of file compression technique where no loss of data occurs.

lossy compression Any form of file compression technique where some loss of data occurs.

luminance noise Noise in a digital image that looks like a dark/light pattern without colors in it (other than the original subject colors).

masking A way of limiting adjustment to part of a photo by blocking it from other parts; used in the Detail tab to limit where sharpening occurs.

noise An artifact of the digital technologies, largely the sensor, that shows up in the photograph as a fine pattern that looks like grain or sand texture.

parametric Adjustments to the Tone Curve that use sliders based on parameters or specific types of tonal adjustments: Highlights, Lights, Darks, Shadows.

photosite The individual, actual photosensitive site on a sensor that captures the brightness for a single pixel in the image. There is one photosite for every pixel in the image.

pixel Short for picture element (pix/picture, el/element). The smallest element of a picture that can be controlled by the computer.

ppi (pixels per inch) A way of measuring linear resolution of an image; refers to how the pixels are spaced, meaning the number of pixels per inch in an image; often used interchangeably with dpi. See also *dpi*.

PSD file The native file format for Photoshop and Photoshop Elements. It allows the saving of layers, layer masks and more.

RAM (Random Access Memory) The computer's memory that's actually active for use in programs; comes on special chips.

RAW file An image file that is minimally processed after it comes from the sensor in a camera. Data comes from the sensor and is translated to digital in the A/D converter; that data is then packaged for the RAW file. A RAW file is not generic; there are actually proprietary files made by each camera manufacturer.

recovery A control in the Basic adjustment panel that darkens very light tones in an image.

red eye A condition seen in photographs of people made in dark environments with a flash close to the lens (usually a built-in flash); the pupils of these people dilate in the dark, allowing the flash to come into the eye and reflect off the back, creating a red glow.

resolution The density of pixels in an image or the number of pixels or dots per inch in an image or that a device, such as a scanner, can capture.

RGB The primary color system of a computer based on red, green, and blue, the additive primary colors. Computer monitors (CRT and LCD) display RGB-based screen images.

saturation The amount of brilliance or intensity of a color; how colorful or dull a color is; also a control in the Basic adjustment panel.

sensor The light-sensing part of a digital camera, usually a CCD or CMOS chip. See also *CCD* and *CMOS*.

split toning A way of adding color separately to the highlights and shadows of a photo.

sRGB A common color space in the RGB color system that is more restricted than others.

thumbnail A small, low-resolution version of an image.

TIFF (Tagged Image File Format) An important, high-quality image format common to most image-processing programs.

tonal range The difference in brightness from the brightest to the darkest tones in an image.

tone curve An adjustment for tonal values in an image that offers a great deal of flexibility. It appears first as a 45° angle line running up to the right in a graph. When that line is clicked on and moved, it changes tones in the image. The upper part of the curve is light, the bottom dark. Moving the curve up lightens tones, down darkens tones. It is possible to move parts of the curve in different directions.

unsharp masking (USM) The name is misleading because it is based on an old commercial printing term; it is a highly controllable adjustment used for sharpening an image and includes three settings: Amount, Radius, and Threshold.

USB A standard computer connection for linking peripherals to the computer; high-speed USB 2.0 is very fast, comparable to FireWire. USB stands for Universal Serial Bus.

vibrance A control in the Basic adjustment panel that intensifies colors, similar to the Saturation control, but with more nuance in that it affects less saturated colors more than saturated colors.

vignetting The darkening or lightening of the outer part of an image due to the way the photograph was shot (either the lens used or special vignetting techniques employed).

white balance A special digital control that tells digital still and video cameras how to correctly represent color based on the color temperatures of different light sources. All cameras have automatic white balance; most also let photographers adjust it manually.

index

continued

continued

continued